# THE ETCHINGS OF
# JAMES McNEILL WHISTLER

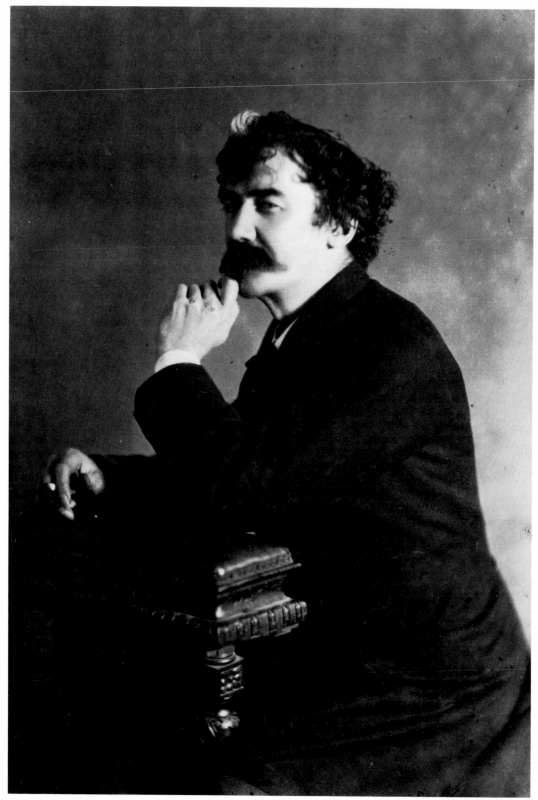

1. Whistler, *James McNeill Whistler*, January, 1879. Glasgow University Library.

THE ETCHINGS OF JAMES McNEILL

# WHISTLER

Katharine A. Lochnan

*Published in association with the Art Gallery of Ontario by*

YALE UNIVERSITY PRESS · NEW HAVEN AND LONDON · 1984

Designed by Caroline Williamson.
Set in Monophoto Baskerville and printed in Great Britain by BAS Printers Limited, Over Wallop, Hampshire.

**Library of Congress Cataloging in Publication Data**

Lochnan, Katharine Jordan.
   The etchings of James McNeill Whistler.

   "The Metropolitan Museum of Art, New York, September 14th–November 11th, 1984; the Art Gallery of Ontario, Toronto, November 24th, 1984–January 13th, 1985."
   1. Whistler, James McNeill, 1834–1903. 2. Etchers—United States—Biography. I. Whistler, James McNeill, 1834–1903. II. Metropolitan Museum of Art (New York, N.Y.) III. Art Gallery of Ontario. IV. Title.
NE2012.W45L6  1984    769.92′4    84-40185
ISBN 0-300-03275-7
ISBN 0-300-03283-8 (pbk.)

# CONTENTS

# PREFACE

James McNeill Whistler was a mystery, and he liked it that way. From the time that du Maurier described him as an exclamation mark on the wall of a Paris studio in 1857 until his death in 1903, he promulgated the idea, articulated by Walter Sickert, that he had "sprung completely armed from nowhere."

Starting at the cutting edge of new developments in French and English art in the late 1850s, he assiduously avoided both the academic and avant-garde mainstreams, striving always to be independent and above all different. He fought growing criticism with wit, and is remembered for his bravado and pithy remarks. The majority of his contemporaries who, like Oscar Wilde, delighted in repeating his clever sayings, rarely guessed their deeper meaning. Whistler joked about the things he took most seriously, and by assuming the role of antagonist, did much to blow away the dust of the past, and prepare both critics and general audience for the audacious experiments of twentieth-century art.

During his lifetime Whistler moved from a position rooted in the study of seventeenth-century Dutch art and contemporary naturalism and realism to an aesthetic based in the study of the art of Greece and Japan. Born in America, raised in Russia, educated in Paris, and resident in London, Whistler was the product of no single country or school. Like the "butterfly" which he took as his symbol, he moved easily from one to the other, carried influences back and forth across the Channel, and created a new synthesis of his own.

Throughout his life, Whistler remained devoted to etching. It was not a secondary medium; from the time of his earliest days at the Coast Survey in 1855, until his last holiday on the island of Corsica in 1901, he made 450 etchings, and laid down his needle only for two seven-year intervals. The great variety of style found in his etched work shows him as a printmaker of great integrity, who never ceased to search for new "variations" on old "themes" which, while they were always based in nature, became increasingly suggestive and abstract. He was compared to Rembrandt by his contemporaries; and no other etcher has had such

a profound effect on the history of the etching medium.

The narrative which has been pieced together here from the artist's correspondence and other primary sources should not only help to elucidate his work as an etcher, but also provide a key to understanding his related development in other media. In the exhibition which accompanies the publication, Dr. Katharine Lochnan, Curator of Prints and Drawings at the Art Gallery of Ontario, has set out to divide the artist's work into distinct chronological and stylistic phases, and to explore his stylistic evolution by placing it in its historical and contemporary context. Studies of Whistler's etchings during the past decade have concentrated on exploring Whistler's impact on other artists in the "Whistler circle," but the fundamental question of Whistler's own artistic identity still remains to be addressed. This exhibition attempts to situate him among his forebears back to Rembrandt, and among his French and English contemporaries, by juxtaposing a few key works in each section by those who influenced him at a particular time. In addition, the exhibition explores his technical evolution by including multiple impressions from the same plate, which show that few impressions are ever the same.

It is most fitting that the exhibition, with this accompanying publication, which marks the 150th anniversary of the birth of this great American artist, should open at the Metropolitan Museum of Art. The artist himself could not have hoped for more. It has been a great pleasure for us to work with the Curator of Prints and Drawings, Colta Ives, and the Assistant Curator of Prints and Photographs, David W. Kiehl, as well as other members of the staff of the Metropolitan Museum.

William J. Withrow
Director, Art Gallery of Ontario

# ACKNOWLEDGEMENTS

This work has now been nine years in the making, and has involved the support, encouragement and assistance of librarians, curators and scholars in Britain, France, the United States, and Canada.

It began as a thesis for the Courtauld Institute in 1975 at the suggestion and under the direction of Alan Bowness. When I felt that the sheer volume of Whistleriana might conspire to prevent me from putting pen to paper, he patiently encouraged me to take the plunge, read the first draft, and made many valuable remarks. After Mr. Bowness became director of the Tate Gallery, John House agreed to take on the role of advisor. It was under his thoughtful and perceptive supervision that the manuscript took on its final form. Robin Spencer not only provided a valuable critique of the thesis, but has been an ongoing source of support since I began to reconstruct its contents and add to them in creating this publication. In Toronto I have been greatly aided by W. McAllister Johnson of the University of Toronto, who has stood by with advice and encouragment at every phase of the project.

Much of my archival research was conducted at the Library of Congress and at Glasgow University Library. My guide to Whistler's papers was the indispensable Margaret MacDonald who assisted the late Andrew McLaren Young in setting up the Birnie Philip archives at Glasgow. In recent years I have been helped by her successor, Nigel Thorp, who generously offered to check quotations, supply photographs, and draw new acquisitions to my attention. I would like to thank the Library of Congress, the Court of the University of Glasgow, the New York Public Library, the Pierpont Morgan Library, the British Museum Department of Prints and Drawings, the Freer Gallery of Art, the Fine Art Society, the Baltimore Museum of Art, the Victoria and Albert Museum library, and the Art Institute of Chicago for permission to quote from the manuscript material in their possession.

My initial research was conducted during a year as Volunteer Assistant in the Department of Prints and Drawings at the British Museum in 1975–6. I cannot thank enough the Keeper John Rowlands, or his predecessor John Gere, for allowing me the freedom of the

collections during that year and on successive visits. I am deeply grateful to the members of that department who have provided me with every kind of assistance and advice, especially Antony Griffiths, Frances Carey, Andrew Wilton, Lindsay Stainton, and Reginald Williams. I am also grateful to Lawrence Smith and Roy Ralph in the Department of Oriental Antiquities, who have helped me in my work with Japanese prints. I would like to thank the British Museum for its generous support of our loan request, which includes a number of rare or unique items.

I have received a warm welcome from colleagues in other print rooms in Britain and North America. I am especially grateful to Martin Hopkinson at the Hunterian Museum at the University of Glasgow; to Keith Andrews at the National Gallery of Scotland in Edinburgh; to Charlotta Kotik at the Albright-Knox Art Gallery, Buffalo; to Jay Fisher at the Baltimore Museum of Art; to Susan Reed and Barbara Shapiro at the Museum of Fine Arts Boston, to Sinclair Hitchings at the Boston Public Library; to Suzanne McCullagh and Esther Sparks at the Art Institute of Chicago; to Ann Lockhart at the University of Michigan Museum of Art; to John Ittman at the Minneapolis Institute of Arts; to Andrew Robison and Ruth Fine at the National Gallery of Art, Washington; to Douglas Druick and Mimi Cazort at the National Gallery of Canada, Ottawa; to Robert Rainwater at the New York Public Library; to Deborah Johnson at the Rhode Island School of Design; to Katharine Martyn at the Thomas Fisher Rare Book Library, University of Toronto; to Barbara Stephen at the Royal Ontario Museum; to Roberta Waddell at the Toledo Museum of Art, and Richard S. Field at the Yale University Art Gallery. I would like to thank all of these individuals and their institutions for generously agreeing to lend fine Whistler impressions to the exhibition. In addition, I would like to thank Martin Amp at the Freer Gallery of Art for his assistance on numerous visits. Unfortunately, the Freer Gallery is constrained from lending under the terms of Freer's will.

I would also like to thank a number of individuals for advice and assistance, among them David Curry, Robert Getscher, Jean Harris, Susan Hobbes, Paul Marks, John Klein, K. Corey Keeble, Alexis Pencovic, Nancy Pressly, Leonée Ormond, Nesta Spink, Richard Schneiderman, Tom Quirke, John Vollmer, Gabriel P. Weisberg, and Christopher White. I am very grateful to Eleanor Sayre and the late Harold Joachim, who took an early interest in the exhibition, and supported and encouraged me in many important ways.

I would especially like to thank Colta Ives and David Kiehl at the Metropolitan Museum of Art, whose enthusiastic response to the exhibition led to the happy partnership between our institutions. I have David to thank for many kindnesses over the years, and for the efficient editing of the exhibition to fit the galleries at the Metropolitan Museum. I would like to thank Paul Walter for embracing and lending to this exhibition, which is being shown at the Met in conjunction with an exhibition of lithographs from his own collection.

This project has been undertaken while carrying out my curatorial duties at the Art Gallery of Ontario. My single greatest debt of gratitude is owed to my director, William J. Withrow, who has supported this venture from its inception, and has shown lively and ongoing interest in its progress. Successive chief curators, Richard J. Wattenmaker and

Roald Nasgaard, have willingly agreed to the necessary adjustments in my work schedule without which research and writing would have been impossible. I have received help from many members of staff and volunteers: my drafts have been read by Margaret Machell; French translations scrutinized by Lucy Amyot; research facilitated by the late Sybille Pantazzi, Larry Pfaff and Randall Speller in the Library; the mechanics of nineteenth-century photography explained by Maia-Marie Sutnik; and photographs taken by Larry Ostrom. The last minute checking of details has been undertaken by my assistant, Brenda Rix, who kept the office going during my long absences, and blossomed in the process. The enormous job of typing the manuscript has been most ably handled by my secretary, Karen Bryce, assisted in emergencies by Shirley Hrebik.

The nature and format of the publication grew out of discussions with John Nicoll at Yale University Press in London. It has been a great pleasure to work with Mr. Nicoll and his editor, Caroline Williamson. His enthusiasm for making the publication as comprehensive as possible has taken the drudgery out of the final revisions.

As we all know, it is the members of the immediate family and close friends who have the greatest burden to bear when books are in progress. I cannot thank my husband, George M. Yost, too much for wholeheartedly endorsing this venture from the start, and for designing and building me a study at home in which to work. I would like to thank our close friend Enid Maclachlan for her support through thick and thin over the past few years. Finally, none of it would ever have happened if it had not been for my father Carl J. Lochnan, whose interest in prints got me started, and my late mother Barbara, who watched the initial stages of its progress with great satisfaction.

<div align="right">

Katharine A. Lochnan
Toronto, 1984

</div>

## ON ART HISTORIANS

*There are those also, sombre of mien, and wise with the wisdom of books, who frequent museums and burrow in crypts; collecting—comparing—compiling—classifying—contradicting.*

*Experts these—for whom a date is an accomplishment—a hall mark, success!*

*Careful in scrutiny are they, and conscientious of judgement—establishing, with due weight, unimportant reputations—discovering the picture, by the stain on the back—testing the torso, by the leg that is missing—filling folios with doubts on the way of that limb—disputatious and dictatorial, concerning the birthplace of inferior persons—speculating, in much writing, upon the great worth of bad work.*

*True clerks of the collection, they mix memoranda with ambition, and reducing Art to statistics, they "file" the fifteenth century, and "pigeon-hole" the antique!*

Whistler, *Mr. Whistler's "Ten O'Clock"* (1888)

# CHAPTER ONE

# *The Early Years: London, Washington and Paris, 1834–58*

## 1. Whistler's Early Years

James Abbott McNeill Whistler, despite his later protestations, was born on July 10, 1834, at Lowell, Massachusetts. He did not "choose" to be born at Lowell; he much preferred to claim Baltimore or St. Petersburg as his place of birth, which he did on separate occasions, giving rise to great confusion among the writers of his obituary notices.

The artist's father, George Washington Whistler (1800–49), had been born into military life at Fort Wayne, and grew up largely in the southern United States at military posts where his own father was stationed. Following in the family tradition he was sent to West Point Military Academy at the age of fourteen.

George Washington Whistler combined artistic leanings with a practical bent. West Point had the only school of engineering in America at the time, and Whistler directed his considerable talents as a draughtsman towards a career in this area, becoming a distinguished topographer. After leaving West Point, he served on the Commission that traced the North West Boundary from Lake Superior to the Lake of the Woods, between Canada and the United States. His topographical activities included improvements to the harbour at Salem, Massachusetts, where he resolved the problem of representing the shores by using horizontal contour lines to indicate altitude. He was subsequently credited with having made the first contour maps of the United States.[1]

There was a great demand for civil engineers in America and a dearth of men available. At the age of twenty-eight, Whistler was seconded from the army to build the Baltimore and Ohio Railroad. In 1833, having achieved the rank of major, he resigned his army commission to devote himself entirely to civil engineering.

In 1821 Whistler married Mary Swift, who died only six years later leaving him with three children: Joseph, who died in childhood, George, who was also to become an engineer, and a daughter named Deborah.[2]

In 1831 Whistler married Anna Mathilda McNeill (1804–81), a friend of his late wife, who took over the upbringing of the children. Following their move to Lowell, Massachusetts, Anna gave birth in 1834 to James, the artist, and in 1836, to William, who was to become a doctor. She also had several other children who died in infancy.

The Whistlers moved three times during James's first seven years, which may help to account for his later peregrinations. After living in the new industrial town of Lowell, the centre of the burgeoning textile industry, the family moved in 1837 to Stonington, Connecticut, a much older and more picturesque town, where they took up residence in a gabled house looking out to sea. In 1840 Major Whistler's work took the family to Springfield, Massachusetts, an attractive town located on a gentle curve of the Connecticut River.[3]

By this time, Major Whistler had developed a considerable reputation as a builder of railroads and designer of rolling stock. In 1842, after conducting a search throughout Europe and America, Tsar Nicholas I of Russia invited him to build the St. Petersburg to Moscow railroad. This involved supervising the building of 420 miles of track, 200 bridges and 70 aqueducts. The award of the contract to Whistler constituted the greatest honour ever paid to an American civil engineer. He accepted without delay, and set out for Russia in the summer of 1842, to be joined a year later by his wife and children.

Mrs. Whistler and the children left America in August, 1843, and travelled to Russia via England, where they stopped to visit Anna's two half sisters in Preston, Lancashire. After a brief visit to London, where they rowed down the Thames by lamplight and starlight, the family travelled by carriage and steamer to St. Petersburg, where Major Whistler took a large house on the most exclusive street, the Galernaya.

There the family lived in considerable luxury on a salary of $12,000 a year, with a household of servants, and all the privileges regularly accorded to friends of the Tsar and the American ambassador. Anna Mathilda went out of her way to preserve an American lifestyle. Their closest friends were Ross Winans from Baltimore and his partners Harrison and Eastwick from Philadelphia. Thanks to Major Whistler, the Winans's engineering firm made a fortune supplying the materials for the railroads, bridges, and rolling stock.

Mrs. Whistler assiduously avoided the glittering social life of St. Petersburg, believing as a result of her strict Episcopalian upbringing that social pleasures indulged in for their own sake were temptations to be avoided. She devoted her time to religious reading and reflection, the education of her children, and the writing of diaries and letters.[4] From these it is possible to reconstruct the early years of her artistic son.

James Whistler greatly enjoyed his upbringing in Russia. He was tutored privately at home, and began weekly drawing classes with Alexander Karitzky soon after arriving in St. Petersburg. In April, 1845, he entered the Imperial Academy of Fine Arts, where he had lessons three times a week. He worked hard at his drawing and received a first when he was examined in March, 1846.

His childhood was marred by poor health, to the endless consternation of his mother who watched constantly for signs of rheumatic fever. In the spring of 1847 he had a severe attack and was confined to bed

2

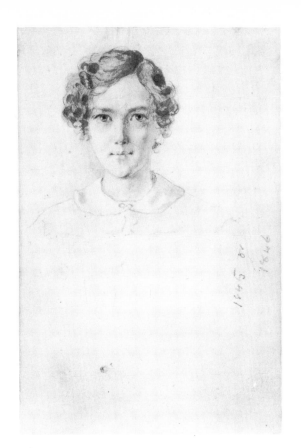

2. American School, *Portrait of Whistler*, c. 1845–6. Pencil and watercolour, 11.8 × 7.8 cm. Courtesy of the Freer Gallery of Art, Smithsonian Institution, Washington, D.C.

for six weeks and forbidden to draw. Fortunately, his half sister Deborah borrowed an album of Hogarth etchings to keep him amused while he lay in bed. His mother recorded his delight in her diary, writing:

> We put the immense book on the bed, and draw the great easy chair close up, so that he can feast upon it without fatigue. He said, while so engaged yesterday, "Oh, how I wish I were well, I want so to show these engravings to my drawing master, it is not everyone who has the chance of seeing Hogarth's own engravings of his originals," and then added, in his own happy way, "and if I had not been ill, mother, perhaps noone would have thought of showing them to me."[5]

The incident signals the beginning of Whistler's interest in etching as well as his lifelong love of Hogarth.[6] He later told his biographers that ever since his childhood in Russia "there had always been the thought of art."[7] His talents, while modest at the time, favourably impressed Sir William Allen, a member of the Scottish Royal Academy who visited Russia in 1844. He told Anna Mathilda that her son had "uncommon genius."[8]

In order to aid his complete recovery, Mrs. Whistler took the children to England in June, 1847, where they stayed with their aunts in Preston. Deborah, whose relationship with her stepmother had become increasingly strained, spent the summer in Switzerland, with the widow and children of a distinguished British surgeon, Charles Thomas Haden. Deborah formed a romantic attachment to one of the sons, a young

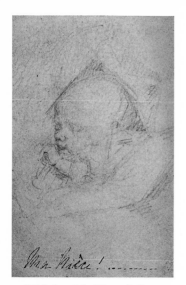

3. Whistler, *Ma Nièce*, 1848. Pencil, 7.0 × 4.5 cm. Hunterian Art Gallery, University of Glasgow, J. W. Revillon Bequest.

doctor, Francis Seymour Haden, and before the summer was out they were engaged. Mrs. Whistler readily agreed to her step-daughter's marriage, and wrote to secure her husband's consent. Major Whistler made a special trip to England to meet Haden, and apparently took an instant dislike to him. James, who was present at the first meeting of Haden and his father, said, "I was with him, and from the first, disliked him. Haden patted me on the shoulder and said it was high time the boy was going to school."[9] Nonetheless, the couple were married on October 16, 1847, at the Old Parish Church in Preston: James was "the only groomsman, and very proud of the honour."[10]

The following summer Mrs. Whistler brought the children once again to England for a holiday. She found Deborah and Seymour comfortably ensconced in the large London house at 62 Sloane Street in South Kensington which Haden had inherited from his father. Deborah was flourishing, and Mrs. Whistler wrote in her diary, "The couple are truly one, their tastes the same, perfect harmony and cheerfulness reign. I only missed one comfort in their home; family worship."[11]

Following a long summer holiday on the Isle of Wight, Mrs. Whistler decided to leave James with the Hadens for the winter rather than risk taking him back to St. Petersburg. He had suffered another serious attack of rheumatic fever that spring, and she feared the cholera epidemic which had just broken out in St. Petersburg. Haden was put in charge of the boy's health, which he was singularly well equipped to supervise. The son of a famous paediatrician, Haden ran a large general practice out of the house with a speciality in obstetrics.[12]

In keeping with the sentiments expressed to Major Whistler, Haden sent James to boarding school at Eldon Villa during the autumn term of 1848. He returned to London at the end of term in time for the birth of the Hadens' first child, Annie, on December 14. Whistler was enchanted by his niece, and set to work on a drawing of her to send to his mother (pl. 3). Haden, who played the role of drawing instructor, corrected Whistler's sketch, much to his annoyance. He wrote to his mother saying, "began a sketch of her (the Babie) which Seymour finished and made really very like her," and added, "when I have done a nice likeness all by myself, I shall send it to St. Petersburg."[13]

---

Haden was a talented draughtsman in his own right, having attended a government art training school while studying medicine at the Sorbonne in Paris. He initially undertook the study of drawing and etching "to better train the hand and eye for surgery"; etching, however, was to provide him with a most agreeable pastime.

Following the completion of his medical studies, from February to August, 1844, Haden travelled through Italy and Switzerland.[14] He went on regular sketching expeditions, and carefully recorded the appearance and inscriptions found on the ancient Roman monuments. His artistic interests grew out of his habit of empirical observation, and led to a belief in the importance of applying scientific method to the study of art. Haden's objective approach was qualified by a poetic turn of mind. A child of the Romantic era, his travel notes reveal a familiarity with the poetry of Rogers and Byron and the paintings of Turner. His

4

sensitive and appreciative descriptions of Venice, of which he wrote, "it *really* is a city rising out of the sea,"[15] may well have given rise to Whistler's desire to visit the city.

It has long been assumed that Haden made his first etchings on the journey to Italy in 1844, but no mention is made of this activity in his journals. He probably selected his favourite sketches for etching upon his return to London.[16] His interest in the technique appears to have surfaced after he was established in his Sloane Street practice, at which time he began to turn to it increasingly for recreation.

In 1845 he discovered a print shop in the old Quaker district of London, owned by a man named Love, and arranged to borrow portfolios of etchings to study overnight. Some years later he recalled this time with pleasure:

Fifty years ago—in 1845-6-7 and 48—there existed in Bunhill Row, in the old Quaker quarter of London, a second-hand print shop kept by a man of the name of Love. That shop was in one respect unique. Not only was not a single modern print to be found in it, but as to condition and impression, not a print of any kind that was worth five shillings; and, on the other hand, not a print which was not either a real or reputed example of Old Master Engraving. That shop, at the impressionable and impecunious age of five-and-twenty was to me an irresistible attraction, so that, after the day's work at the West End, I would ride or drive down to it, and having, by permission of its proprietor, possessed myself of one of its many crazy portfolios, would carry it home with me and sit up half the night with it. I doubt if anyone indisposed, or unable by temperament, to see the difference between two etched lines can have any idea of the engrossing charm to me of those early "Noctes Ambrosianae": of the keenness with which I devoured and sought to penetrate the precise value and intention of every such line: and to follow it out till the whole "ordonnance" of the plate was revealed to me.[17]

It can be safely assumed that Mr. Love's portfolios were returned to him in the morning considerably lighter, for Haden's collection of etchings grew with great speed. When it was finally broken up at the turn of the century, it numbered hundreds of sheets. Around 1889, when he finally decided to sell it after encroaching blindness had robbed him of his pleasure, he described it to the New York collector Samuel P. Avery as follows:

The whole collection consists, as you know, of two large groups, an ancient and a modern—the ancient consists of the old master etchers from A to Z—the moderns of Meryon, Whistler, Haden and the principal masters from the French and English school—the entire collection being got together as a complete representation of the whole subject of painter-etching as it was possible to get and in the finest possible states. To obtain these I have never hesitated at price, and have outbid all comers—and this has been going on for 45 years. ... As a nucleus for a national print room they are simply invaluable.[18]

It is not surprising to discover that Haden's collection was strongest in the area of seventeenth-century Dutch etching, for it was in Holland, in the circle of Rembrandt, that the art was born and came to fruition. Despite his trip to Italy, and his interest in ancient monuments, the works of the Italian etchers are notable by their absence. Haden's taste clearly lay in the art of the North. The largest individual groups of works, were by Rembrandt, Van Dyck, Van Ostade, Karel du Jardin, Zeeman, Hollar and Claude. All were represented by the finest states and impressions, as the notes in the 1891 Sotheby catalogue, citing quality, paper type and provenance, indicate. On each impression Haden placed his stamp or his pencilled cipher "S.H." Despite his attempts to keep the collection together it was broken up, and fine sheets bearing his mark may now be found in museums all over the world.[19]

No area of the collection was assembled with greater care than the group of 129 Rembrandt etchings which lay at its core.[20] Haden may have been spurred to acquire his outstanding group of Rembrandts after reading Joseph Maberly's book *The Print Collector*, 1844, which he owned and annotated. Maberly observed that "At the present day, the etchings of Rembrandt stand the prime favourite of collectors," and noted that the formation of a collection of Rembrandt etchings was a goal to which all print connoisseurs should aspire.[21] Many of Haden's impressions had illustrious provenances, and had belonged to Mariette or Pond or were acquired as duplicates from the Berlin, Amsterdam and Fitzwilliam Museum print rooms. He had a host of rare proofs, counter proofs, and impressions on vellum and Japanese paper.

It was in the mid to late 1840s that Haden began his serious study of Rembrandt etchings, a study which was to lead him to revise completely both the organization of subsequent catalogues of Rembrandt etchings, and also the accepted *corpus* of prints ascribed to the artist. He attempted to put the work of the artist in chronological order, and in doing so was able to detect minute changes of style which led him to question seriously works which seemed inconsistent with Rembrandt's stylistic and technical evolution. He rejected the old method of organization by subject used by earlier cataloguers and adopted by Bartsch, claiming that "the arrangement according to subject was fatal to the comprehensive study of such works."[22] Many years later, in 1877, he organized a chronological exhibition of Rembrandt's etchings for the Burlington Fine Arts Club, and in 1895 published *The Etched Work of Rembrandt True and False*. In this book, the result of a lifetime of study, Haden rejected many long-accepted but doubtful works.

It is impossible to overemphasize the importance of this activity for Whistler's future development as an etcher. He must have shared Haden's *noctes ambrosianae* sitting at his elbow, while seeking "to penetrate the precise value and intention of every line: and to follow it until the whole 'ordonnance' of the plate was revealed." This was in fact the method of study employed by Rembrandt, as Haden liked to point out. Rembrandt had owned over one hundred volumes of prints, and it was through their study, according to Haden, that he "broke through the prescription of two centuries and became an etcher."[23] Whistler would have developed an extraordinary knowledge not only of Rembrandt's etchings at this time, but also of the etchings

6

of the seventeenth-century Dutch school which Haden was accumulating with great speed.

———

At Christmas, 1848, Whistler announced his decision to become an artist. He wrote on January 26, 1849, to thank his father for a copy of Reynolds's *Discourses* saying, "I hope, dear father, you will not object to my choice, viz: a painter, for I wish to be one so very much and I don't see why I should not, many others have done so before."[24] His father's response was not encouraging; he cautioned his son not to allow his taste in art to become "too poetical," and recommended that he "cultivate now as an *artist* if you please, an acquaintance with, and a taste for works of art—useful works"[25] which would lead to a career in engineering or architecture. To the words of her husband, Mrs. Whistler added a caveat: "I only warn you not to be a butterfly sporting about from one temptation to idleness to another."[26]

The climate of support at 62 Sloane Street was to provide Whistler with the courage and means to pursue his ambitions. The painter Sir William Boxall, who was later to become Director of the National Gallery, had been commissioned by Major Whistler to make a portrait of his son. Boxall took Whistler to Hampton Court to see the Raphael Cartoons in January, and James wrote in great excitement to his father saying, "Fancy being so near the work of the greatest artist that ever was!"[27] Boxall encouraged an interest in the artists of the Italian Renaissance and gave him Mrs. Jameson's *History of the Early Italian Painters*.

Haden arranged for Whistler to attend a series of lectures given by Charles Robert Leslie at the Royal Academy Schools in March, 1849. Leslie had grown up in America, and after a period of training in London under Benjamin West had become drawing master at West Point.[28] He was a great educator, and his series of lectures was very popular and well attended.[29]

While Haden must be given credit for directing Whistler's interests toward Rembrandt and seventeenth-century Dutch art, Leslie reinforced this tendency. He firmly believed that it was only through the study of nature that young artists could develop their originality. In one of his lectures, which were reprinted in the *Athenaeum* he said:[30]

> It is easy to add capricious and eccentric novelties of style to what exists; but to present some genuine quality of Nature for the first time or some new combination of what is already known to Art is the great difficulty: and yet I believe it might be oftener and more easily accomplished than it is, if we would allow the art to lead us to Nature, rather than erect it into a barrier against all in Nature that is not already admitted into its confines. He who believes that Nature is not exhausted will, I am convinced, if he truly loves her, find that she is not. It is this faith in her abundance that has caused every revival of Art from its slumbers. It was this faith that inspired Rubens and Rembrandt to restore the glories of the Flemish and Dutch schools; not by attempting their exact revival, but by opening new views of Nature, and creating each a style of his own, which, in spite

of many and great faults, has placed them forever among the most illustrious benefactors of painting.[31]

Leslie praised a number of artists who worked from nature including Hogarth, whom he mentioned in the same breath as Raphael, so greatly did he admire the English painter. His highest praise was reserved for the seventeenth-century Dutch school, and in particular for Pieter de Hooch, whom Leslie called "the most consummate painter in his particular style that ever lived."[32] Unlike the majority of his contemporaries, Leslie greatly admired the Dutch still life, and urged his students to "try to paint the commonest object as the best Dutch painters would have painted it."[33] He also admired the Dutch interior, with its close vantage point and horizontal perspective. He was much less complimentary about low-life genre subjects, saying that both Rembrandt and Van Ostade sought "ugliness and even deformity, as other artists have sought for beauty."[34]

Leslie referred frequently to his great predecessor at the Academy Schools, Sir Joshua Reynolds. Reynolds, while acknowledging the merits of studying both art and nature, had emphasized the primary importance of the former in the training of the artist. Whistler, who had read the *Discourses*, would have known that Reynolds had mixed feelings about the seventeenth-century Dutch school, accusing it of "catching at applause by inferior qualities,"[35] while acknowledging that students should examine the Dutch for the qualities in which they excelled. His criticism was not levelled at their ability to describe nature, but at their inability to transcend everyday life in dealing with grand themes. He wrote, "the painters of this school are excellent in their own way; they are only ridiculous when they attempt general history on their own narrow principles, and debase great events by the meanness of their characters."[36]

Reynolds provided a good deal of practical advice to the aspiring artist, which Whistler no doubt took to heart. He said that the first step was to learn to master the tools of drawing, especially the pencil, but also the pen and the brush. Whistler never stopped drawing in his youth; one of his early sketches bears the motto "nulla dies sine linea," and there seems little doubt, from the immense body of juvenilia which survives, that he lived up to it.

In 1848 he sent a number of sketches to his father, which were routinely criticized by his parent for "lack of finish." Major Whistler, used to drawing minute topographical details, saw his son's lack of conventional finish as a sign of laziness, and reprimanded him saying, "finish your work my boy . . . with your natural talent and fondness for drawing, had it been accompanied by regularity and perseverance, you would have made very great progress."[37] Whistler nonetheless continued to produce "unfinished" work, as the sketch entitled *Ma nièce* (pl. 3) demonstrates in its economy of means and lack of peripheral detail.

Whistler was well aware of the theories of Reynolds and Leslie regarding finish. Reynolds had said that when an artist "knows his subject, he will know not only what to describe, but what to omit; and this skill in leaving out is, in all things, a great part of knowledge and wisdom."[38] Leslie concurred, saying that "all pictures are finished if

8

the intention of the master be fully conveyed."[39] Whistler, who was a great admirer of Turner at this time, may well have read Volume One of John Ruskin's *Modern Painters* in which Ruskin defended Turner's method of "selectivity," and maintained that a work of art had greater visual power in proportion to the omission of unnecessary detail: "The less sufficient the means appear to the end, the greater will be the sensation of power."[40]

Reynolds recommended that instead of learning the methods of the masters by copying their works, young artists maintain their integrity and exercise their intellectual faculties by entering "into a kind of competition by painting a similar subject, and making a companion to any picture that you consider a model."[41] Whistler may have taken his advice to heart, for while he did employ subjects and styles made famous by other artists during his formative years, he never quoted the work of any artist directly. This tendency to avoid imitation from the start makes the identification of Whistler's sources extremely difficult. Throughout his life he deeply resented any reference to influences.

———

This early phase of Whistler's artistic development came to an untimely halt with the death of Major Whistler on April 7, 1849, at the age of forty-seven. He had fallen victim to the cholera epidemic which raged with increasing intensity throughout the winter of 1848–9. The fortunes of the Whistler family plummeted; the high cost of living at St. Petersburg had absorbed all the Major's income and left the family with nothing. Although the Tsar told Mrs. Whistler that her sons could be educated free of charge at the Imperial School for pages, she declined his offer and decided to take the children back to America. In April she broke her journey in England to collect James, and, after spending three months in Preston and London, set sail on July 29, 1849.

The ideas and works of art to which Whistler had been exposed in the Haden household continued to inspire his juvenile work in America and laid the ground work for his mature artistic career. He owed a considerable debt to Seymour Haden for supporting his wish to become a painter, and for introducing him to the study of Rembrandt etchings and the seventeenth-century Dutch school. The picture which emerges from the letters and diaries of this period is one of two enthusiastic amateurs, albeit fifteen years apart in age, pursuing their interest side by side, the elder directing the younger.

## 2. Whistler in America

The six-year period from 1849 to 1855 was dominated by Anna Mathilda's frustrated efforts to fulfill her late husband's wishes for James' education. Whistler went through the ritual which this entailed, first spending three years as a cadet at West Point and then a few months at the U.S. Coast Survey Office, before convincing his mother that he would never become an engineer or topographer, and should be allowed to pursue the study of art in Paris.

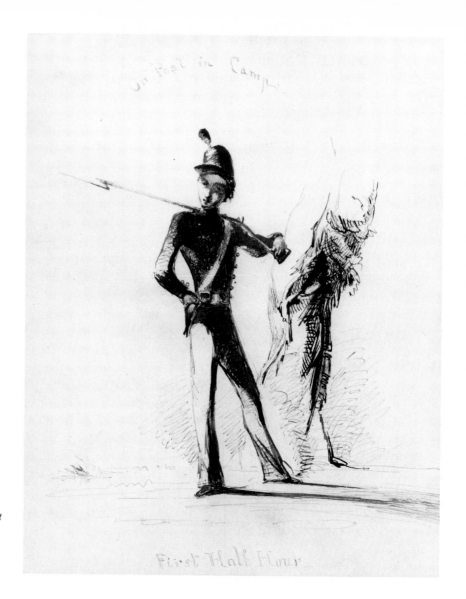

4. Whistler, *On Post in Camp: First Half Hour*, 1851–4. Pen and ink, 24.1 × 20.4 cm. West Point Museum, United States Military Academy Collection.

Following their return to America, the impoverished family moved into a simple rural farmhouse near Pomfret, Connecticut. Mrs. Whistler managed with difficulty to save the tuition fees required to send her sons to a good private school, Christ Church Hall in Pomfret. In 1851, motivated by his late father's wishes and his mother's financial situation, Whistler sought one of the coveted and fully subsidized appointments to the United States Military Academy at West Point.[1] On February 19, through the agency of the Secretary of State Daniel Webster, Whistler became one of ten cadets appointed "at large" from across the United States by President Millard Fillimore.

On June 3, 1851, following in the steps of his father and of an uncle and cousin, Whistler arrived at West Point, and joined the privileged corps of cadets. The strict discipline of army life was unsuited to the temperament of the reluctant cadet, who from the time of his arrival accumulated the maximum number of demerit points permitted annually. His West Point records were filled with lists of infractions such

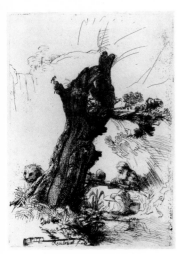

5. Rembrandt, *St. Jerome Beside a Pollard Willow*, B. 103, 1648. Etching, 18 × 13.3 cm. Reproduced by permission of the Trustees of the British Museum.

as laughing and talking in ranks, changing ranks without permission, playing cards, and holding arms incorrectly.[2]

During the first year his course did not include a drawing class; Whistler nonetheless spent hours sketching, and borrowed books and illustrated periodicals from the library in which he found subjects for humorous and satirical illustrations. Instead of doing his homework, he would "while away the time drawing sketches of cadets and various other phenomena" under the watchful eye of his room-mate.[3]

During the summer encampment of 1852, he made a series of four sketches entitled *On Post in Camp* which shows the progress of a bored cadet who falls asleep on duty. The concept recalls more illustrious sequences such as Hogarth's *The Rake's Progress* or *The Four Stages of Cruelty*. In the first sketch, subtitled *First Half Hour* (pl. 4), Whistler drew a cadet standing next to a large tree trunk. Although the drawing of the cadet is schematized, and indicates more interest in conventional methods of comic illustration than the study of anatomy, the drawing of the tree reveals a careful study of nature as well as of the etchings of Rembrandt. The bark is drawn using passages of cross-hatching to indicate shadow; with its outcroppings of foliage, lumps and bulges, it recalls the tree in Rembrandt's *St. Jerome Beside a Pollard Willow*, B. 103, 1648 (pl. 5), which Whistler would have known from the Haden collection. The juxtaposition of the bored and stereotyped cadet with the vigorous Rembrandtesque tree may be seen as a metaphor of Whistler's predicament.

While Whistler continued to go through the motions at West Point, he never lost his desire to become an artist. In the fall of 1852 he was admitted to the drawing class conducted by Professor Robert Walter Weir (1803–89) who had succeeded Charles Robert Leslie in 1834. Drawing was designed to equip the cadet with the ability to make maps and sketches of fortifications and battlefields. Whistler quickly demonstrated his ability to Weir, who was sympathetic to the young man's artistic ambitions. Whistler's abilities were a source of amazement to his fellow cadets, and during drawing classes "he was always the center of a knot of boys attracted to him by the instinctive knowledge of his talent."[4]

Whistler's mother had gone to England in October of that year, and was staying with the Hadens who had become parents for the third time. Deborah and Seymour continued to encourage Whistler's artistic ambitions[5] and went out of their way to try to help Mrs. Whistler to understand her son's enthusiasm. Seymour took her to the Society of Arts, the British Museum, and to the National Gallery. He also took her in February, 1853, to see Mr. Stokes's Turner collection, so that she could, as she wrote, "enjoy the retrospect with my cadet."[6] From her correspondence it is clear that Turner, who had died in 1851, was Whistler's favourite contemporary artist.

No doubt this mention of London, the Hadens and Turner only fed Whistler's growing impatience to return to Europe to study art. He may well have deliberately planned his dismissal from West Point.[7] In 1853 his academic record and his demerit points disqualified him for the most prestigious military appointments open to graduating cadets. He could have sought discharge either by accumulating more demerit points than were allowed, or by failing an academic subject. He appears to have

selected the latter route, perhaps to save the family honour. While passing the formidable Natural Philosophy examination, he failed the relatively easy Chemistry examination. When asked to discuss silica, Whistler began, "silica is a gas" . . . "That will do, Mr. Whistler," the examiner replied. In later years, Whistler liked to say "If silica had been a gas, I might have become a general."

---

In July, 1854, after making an unsuccessful attempt at reinstatement, no doubt prompted by his mother, Whistler went to visit Thomas Winans at Alexandroffsky in Baltimore. The environment of the palatial mansion, built with the fortune made in Russia, suited Whistler very well. It was surrounded by gardens containing classical sculpture, and with its large domestic staff resembled a southern plantation.

The Winans family never forgot its debt to Major Whistler upon whose recommendations its fortune were founded. Tom Winans, Ross's son, assisted Anna Mathilda financially, and provided employment for her sons. In 1853, Whistler's half brother George married Tom's sister Julia, and became Winans's business partner. Whistler's brother William worked part time at the firm while studying medicine at Columbia. It was probably taken for granted that James would join the locomotive works, but on visits to the factory he spent his time "loitering in his peculiar *bizarre* way about the drawing office and shops,"[8] where he would sketch all over the carefully stretched papers, as well as the drawing boards themselves, and "ruin" all the best pencils.

The puritanical Anna Mathilda must have became increasingly annoyed with her son who felt so at home in the luxury of Alexandroffsky, and showed no sign of developing a more responsible frame of mind or settling into a "useful" occupation. In November, 1854, probably to please her, he went to Washington where he saw Captain H. W. Benham, an old friend of his father, at the United States Coast Survey Office. Captain Benham, out of a feeling of loyalty, agreed to take him on.

The Coast Survey Office was responsible for making detailed maps of the coastline of the United States, an immense undertaking. Whistler was well equipped to help with this. His abilities had been demonstrated in the fine maps which he had made at school, such as *The Map of the Western Hemisphere* (pl. 6), made for a geography class in Pomfret in 1851. In addition, he had acquired professional mapmaking skills at West Point.

The Coast Survey Office was broken into Drawing and Engraving Divisions. Whistler was assigned to the Drawing Division when he joined the staff in November, and to the Engraving Division in December. From the start he disliked the "tiresome drudgery"[9] of mapmaking, but seized the opportunity to learn how to etch. A classmate of Whistler's, John Ross Key, recalled Whistler's first etching lesson in a memoir:

Mr. McCoy, one of the best engravers in the Office, went over the whole process with us—how to prepare the copper plate, how to put on the ground, and how to smoke dark, so that the lines made by

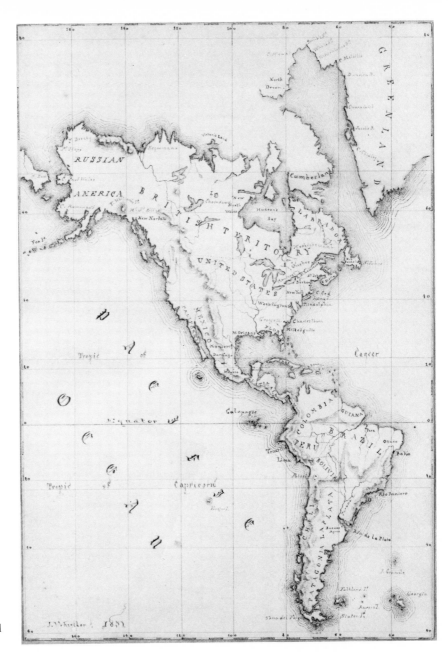

6. Whistler, *Map of the Western Hemisphere*, c. 1849–51. Pen and ink, 19.8 × 13.7 cm. Metropolitan Museum of Art. Gift of Margaret C. Buell, Helen L. King, and Sybil A. Walk, 1970.

the point could be plainly seen. For the first time since his entrance into the office, Whistler was intently interested . . . He seemed to realize that a new medium for expression of his artistic sense was being put within his grasp . . . Having been provided with a copper plate . . . and an etching-point, he started . . . his first experiment as an etcher . . . At intervals, while doing the topographical view he paused to sketch on the upper part of the plate, the vignette of "Mrs. Partington" and "Ike", a soldier's head, a suggestion of a portrait of himself as a Spanish hidalgo, and other bits which are the charm of the work. After he had finished etching, I watched him put the wax preparation around the plate, making a sort of reservoir to hold the acid as McCoy

7. Whistler, *The Coast Survey Plate*, K. 1, 1855–6. Etching, 14.5 × 25.9 cm. Courtesy of the Freer Gallery of Art, Smithsonian Institution, Washington, D.C.

had instructed. Then he poured the acid on the plate, and together we watched it bite and bubble about the line, as with a brush he carefully wiped about the line to prevent the refuse accumulating and biting unequally . . . Finally we went to the basement where the printer washed the plate, and an impression was then taken of Whistler's first etching.[10]

Whistler's experimental plate of a coastal elevation is known as *The Coast Survey Plate*, K.1. (pl. 7). It was later sold to Key for the price of the copper, and brought by him to public attention in 1897. All the

8. Whistler, Detail from *View of the Eastern Extremity of Anacapa Island from the Southward*, K. App. I, 1855– 6. Transfer lithograph, 22.2 × 13.3 cm. Courtesy of the Art Institute of Chicago, Walter S. Brewster Collection.

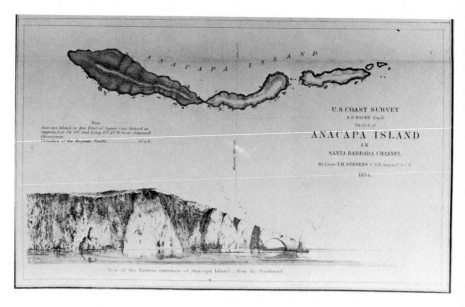

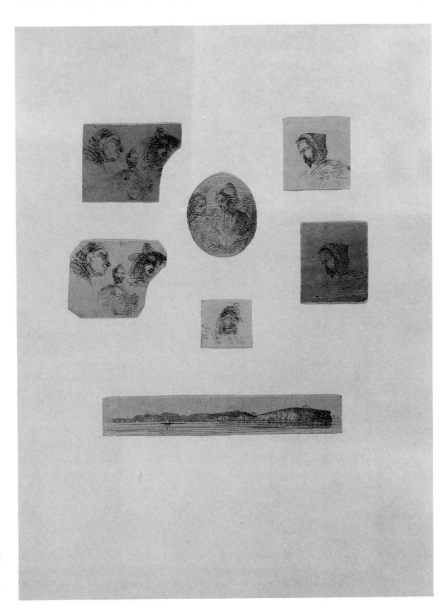

9. Whistler, *Seven Fragments from Coast Survey Plate No. 1*, K. 1. Etching, from the Winans Scrapbook. Metropolitan Museum of Art. Gift of Margaret C. Buell, Helen L. King, and Sybil A. Walk, 1970.

impressions, with two exceptions, were printed between 1897 and 1913, when the copper plate was sold to Charles Freer of Detroit.[11] The two proof impressions made at the Coast Survey were carefully dismembered by Whistler, who appears to have discarded the maps before pasting the freehand vignettes into a scrapbook assembled for Tom Winans in the spring of 1855.[12] One sheet of fragments was carefully arranged in a pattern (pl. 9).

While this plate appears to have been undertaken as a technical experiment, another plate made at this time, *View of the Eastern Extremity of Anacapa Island from the Southward*, K. App. 1 (pl. 8), was intended for publication, and was not embellished with marginal sketches. No impressions appear to have been taken from the copper plate. Howard Mansfield examined the plate at the Coast Survey Office in 1907, and

10. American School, *Portrait of John Ross Key*, 1854. Pastel, crayon and chalk, 51.5 × 31.0 cm. Courtesy of the Freer Gallery of Art, Smithsonian Institution, Washington, D.C.

noted that since it had never been electrotyped, it must have been intended from the start for transfer to a lithographic stone.[13] Together with related views by Whistler's fellow students C. A. Knight and J. Young, the lithograph was first published in 1857 on a sheet entitled *Chart of Anacapa Island and the East End of Santa Cruz*. It is likely that both of these plates were made in December 1854 when Whistler was in the Engraving Division.

There is greater sureness and looseness of line in the published plate than in the experimental *The Coast Survey Plate*. Whistler's love of picturesque detail led him to elaborate the subject and texture beyond the requirements of topographical drawing. He experimented with reflections, and used a system of minute hachures, zigzags and dots to describe the cliff face, which anticipate the linear vocabulary of the "French Set" etchings of 1858. The skill with which he plied the needle, and the wide variety of linear conventions which he successfully employed, indicate with what care he must have studied the etchings in the Haden collection.

While it is rumoured that Whistler also made a plate of the Delaware River, it has never come to light. Pennell wrote:

There is said to be a third plate, a chart of the Delaware River, but we have never seen it and can find out nothing about it. Mr. E. G. Kennedy and Mr. Frederick Keppel have shown us tiny drawings and prints of soldiers and other figures which they believe were done at this time. They were no doubt made on scraps of copper salvaged at the Coast Survey Office.[14]

It seems unlikely that there would have been many opportunities for experimentation. Bored by the mechanical activity of mapmaking, Whistler rapidly developed a reputation for tardiness and truancy, and in January, 1855, reported for work on only six-and-a-half days. By February he had made the decision to go to Paris to study art the following summer.[15] Influenced by Henry Murger's *Scènes de la vie de bohème*, published in 1848, and Gavarni's illustrations of the students of the Latin Quarter, Whistler adopted bohemian dress and spoke of Paris with enthusiasm at the Coast Survey Office.[16] On February 12, he resigned and left behind on the wall of the stairs the "clever, droll, or humourous sketches" of soldiers and heads, which he touched up every time he walked by.[17]

11. Thomas Winans photographed by Kuhn and Cummins. Glasgow University Library.

Whistler had been counting the days to his twenty-first birthday on July 10, when he was due to come into a small inheritance from his father which would enable him to enjoy a modest degree of financial independence. After remaining in Washington for two months, he was invited to come to Alexandroffsky in April and to bring his brushes and easel. Tom Winans, realizing that Whistler's heart was set on becoming an artist, began to assist him with loans for materials, and had him put together the scrapbook of early drawings now in the Metropolitan Museum. It is apparent from Anna Mathilda's letters to her son that Winans had consciously assumed the role of patron, one which survived Whistler's student days in Paris.[18]

16

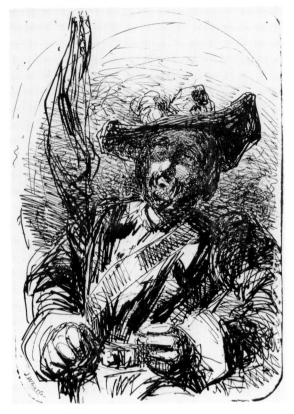

12. Whistler, *The Standard Bearer*,
L. 3, 1855. Lithograph,
20 × 14.2 cm. The Library of
Congress, Prints and Photographs
Division.

13. Rembrandt, *Rembrandt
Bareheaded : Bust Roughly Etched*,
B. 338. Etching, 17.4 × 15.5 cm.
Reproduced by permission of the
Trustees of the British Museum.

If one work of art embodied Whistler's jubilant spirit on the eve of his departure for Europe, it was the pen lithograph *The Standard Bearer*, L.2 (pl. 12), made a week after his birthday, under the supervision of a Baltimore artist, Frank B. Mayer. The lithograph, drawn directly onto stone, was signed like old master prints "J. Whistler fecit," and inscribed "Baltimore, 1855, 17 July, To Frank B. Mayer."

The subject and bravura pose of *The Standard Bearer* recall the work of Rembrandt and Frans Hals. The large good-natured face with its bulbous nose and contorted mouth, executed in a heavy undisciplined line, may be compared with Rembrandt's etching *Rembrandt Bareheaded : Bust Roughly Etched*, B. 338 (pl. 13). The commonness of feature borrowed from seventeenth-century Dutch art anticipates Whistler's later interest in naturalism and realism. While *The Standard Bearer* is not a self-portrait, it has autobiographical connotations, and may be seen as Whistler's youthful statement of intent to take Europe by storm under the banner of Rembrandt and the Dutch. While leaving his more mundane military aspirations behind in America, he took with him his fighting spirit.

A few days later, Whistler notified his mother of his intentions, and wasted no time leaving for Europe.[19] On July 28, two weeks after his coming of age, his passport was issued in Washington.[20] Upon his arrival in Britain on October 10 he went straight to London to visit the Hadens, who had remained sympathetic throughout the six long years when he had tried to fulfill his late father's ambitions for the sake of his widowed mother. Although Whistler was to claim American citizenship for the rest of his life he never again set foot on his native soil.

# 3. Naturalism and "the road to Holland"

Whistler spent almost three weeks with his sister and brother-in-law, and met his nephews Seymour and Arthur, before continuing his journey. He must have discussed his plans at length with Haden, and spent many happy evenings looking through the print collection, which would have grown considerably between 1849 and 1855.

He arrived in Paris on November 3, 1855. After securing lodgings, he registered on November 20 at the École Impériale et Spéciale de Dessin for the "cours du soir."[1] He had decided to devote himself to the study of drawing before entering a painting academy; this would give him time not only to choose between academies, but to launch himself into the yet unexplored delights of *la vie de bohème*.

It was not until June, 1856, six months after his arrival, that Whistler began his studies at the popular Academie Gleyre.[2] Charles Gleyre (1806–74) had a reputation for providing his students with a solid groundwork; he was known to encourage individuality; and he refused to charge fees other than those required to cover the cost of the rented atelier and the hired models. This made the Academie Gleyre a mecca for independent and impecunious students such as Whistler.

Gleyre worked in the classical academic tradition, and based his teachings on the theories of Jean Auguste Dominique Ingres, (1780–1867), the leader of the French classical school. He encouraged his students to humanize their classical subject matter by employing simple themes and natural poses, but insisted that drawing and painting after nature be subordinated to the classical ideal. When, a few years later, he found young Monet making a drawing after the nude without taking classical proportion into consideration, he rebuked him saying, "Whenever one is making a work of art, one must think of the Antique." At the Academie Gleyre, nature required correcting.[3]

There is no reason to believe that Whistler was firmly committed to any one school or perspective by 1855. Like Gleyre, he probably accepted the supremacy of Raphael and Ingres. On June 17, 1856, following his admission to Gleyre's Academy, he was issued with a pass to the Louvre.[4] It was here, that Whistler copied paintings, learned the history of art and developed a sense of quality. At this time he maintained that the Venus de Milo was "the finest thing that had ever been made by the hand of man."[5] Years later he proclaimed "My standard is the Louvre. What is not worthy to go into the Louvre has nothing to do with art."[6]

Outside the Louvre, Whistler was a *flâneur*, an urban spectator. He was seen walking the streets of the Left Bank wearing unconventional dress, meticulously groomed in the manner of a dandy. Although registered at Gleyre's Academy, his attendance was sporadic, and his reputation for truancy and laziness led George Du Maurier to refer to him in his novel *Trilby*, as "the idle apprentice." By 1857 Whistler had discovered that more valuable sources of stimulation were to be found in the Louvre, the cafés, and the streets of the Latin Quarter.

So little documentation exists for Whistler's artistic development before 1858 that an inordinate amount of importance is attached to those things which do survive. The copies which he made in the Louvre

were generally commissioned by well-intentioned American patrons, and do not necessarily reflect his own taste. The handful of drawings and etchings which survive provide a better indication of his artistic interest and sense of direction.

Most of his early drawings were destroyed either by his *grisette* Fumette, or by his mother. Appropriately nicknamed "the tigress," Fumette apparently tore up Whistler's drawings in a rage one day. Henry Oulevey said that they were "something in the manner of Gavarni, of all sorts of people and things in the Quartier—of lovers and other rather childish subjects."[7] Fortunately Fumette spared at least one sheet, perhaps because the *recto* bore a drawing of herself. The *verso* is filled with sketches of Pierrot dancing (pl. 15), which bear an unmistakable resembalnce to Gavarni's Pierrot in the *Carnival* lithographs of 1846–7, and may be compared to "Air: Larifla! . . . Nos femm' sont cou-cou!" from *Impressions de ménage* (pl. 16). Whistler probably made his studies at one of the student balls which preceded Lent, and which he regularly attended. It must have been drawings of this type from which his mother sought to protect his younger brother William, for she wrote to rebuke Whistler for sending drawings which "caricatured only the depravity of city life," and told him that she had kept "the songs" and a few others, including "the Masque coloured," but had burnt the rest.[8]

It is not known when Whistler first encountered the writings of Charles Baudelaire, although his ideas must have been circulating

15. Whistler, "Dancing Pierrot" (verso of *Fumette*), *c.* 1857. Pencil, 21.6 × 15.0 cm. Courtesy of the Freer Gallery of Art, Smithsonian Institution, Washington, D.C.

among art students at this time. Ten years earlier, in 1846, Baudelaire had written an influential essay entitled *On the Heroism of Modern Life* in which he had pointed to the decadence and artificiality of contemporary academic painting, and urged young artists to work from nature and to look to modern life. He felt that the history of French art was at a turning point, and that "the great tradition" had been lost, while "the new one" was not yet established.[9]

Whether consciously or not, Whistler was fulfilling Baudelaire's mandate by working in the manner of Gavarni. Gavarni was one of the few modern artists of whom Baudelaire wholeheartedly approved. Like Baudelaire, Gavarni was a *flâneur* and a dandy, and in his essay

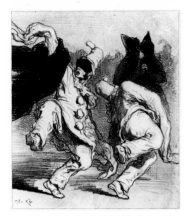

16. Gavarni, *"Air; Larifla! . . . Nos femm' sont cou-cou!"* from *Impressions de ménage*, 2nd series, 1846–7. Lithograph, 19.9 × 17.0 cm. Yale University Art Gallery, Gift of Frank Altschul B.A., 1908.

of 1857, "Some French Caricaturists," the critic observed that Gavarni had made a deep impression on the youth of the Latin Quarter, who had "succumbed to the influence of his students."[10] Gleyre, on the other hand, was the sort of academic artist Baudelaire detested.[11]

———

Whistler rapidly developed a wide circle of French and English friends. Following his registration at Gleyre's he met two English art students, Edward J. Poynter and L. M. Lamont, with whom he shared rooms during the summer of 1856.[12] They were soon joined by George du Maurier, who had recently arrived from London, and Thomas Armstrong, a pupil of the Romantic follower of Delacroix, Ary Sheffer. By the autumn of 1856 the "English Group," under the leadership of Armstrong, had developed a close kinship and decided to rent a studio together.

Although Whistler enjoyed their company, he clearly preferred to share the bohemian lifestyle of the French art students, whose language he had learnt in Russia and spoke fluently. He did not move into the studio at 53 rue Notre-Dame-des-Champs which had been leased by the English Group on New Year's Eve 1856, but he did check in with regularity and was considered a member of "Ye Societie of our Ladye in the Fieldes." Whistler's relationship with the Group was social rather than theoretical; unlike Whistler, the English students were in Paris "to learn the craft of Painting, not to question its basic principles."[13] As Whistler became increasingly unconventional he also became more and more of an enigma to them. Du Maurier drew a caricature of Whistler on the studio wall which began with a clear sketch of the artist, followed by a fainter one, and finally by a note of interrogation.[14]

It was nonetheless with this group in the spring of 1857 that Whistler proposed a joint etching venture to be entitled "PLAWD."[15] The title was undoubtedly intended to be satirical, and the two plates which survive make it apparent why the proposed publication never saw the light of day. Its reconstruction would be all but impossible without Thomas Armstrong's reminiscence:

Whistler took up etching in 1857, a process with which he was already familiar from some practice he had while engaged on a government survey in the U.S. . . . He was very keen about it, and suggested that we all get plates and try our hands. It was decided that each should choose his own subject, and that prints from the plates should be sent to some literary person in England, and he should build up from them a story for publication to be called "Plawd", a word composed of the first letters of our names—Poynter, Lamont, Whistler, and Du Maurier . . . Three of them were executed, Whistler's represented an interior. I don't remember it well, but I think it was, in composition, something like Tassaert's well-known picture in the Luxembourg, a garret with female figures. Poynter's was in the style of the illustrations to Balzac's *Contes Drolatiques* by Doré, his best work with which we were all much impressed at that time. It represented a French castle with many turrets dark against the sky, and from the upper part of it, a beam or gallows projected with a skeleton dangling from

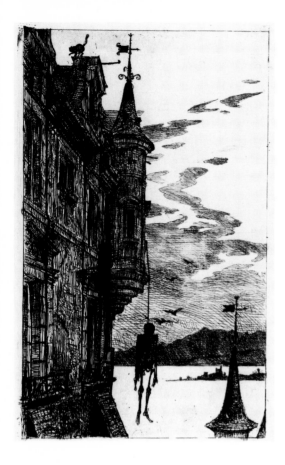

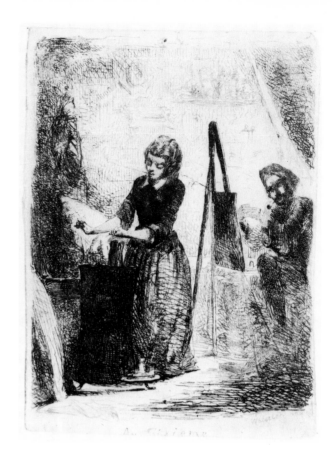

17. Poynter, *Untitled*, 1857.
Etching, 16.3 × 10.7 cm.
Reproduced by permission of the
Trustees of the British Museum.

18. Whistler, *Au Sixième*, K. 3,
1857. Etching, 10.8 × 7.7 cm.
Hunterian Art Gallery, University
of Glasgow, Revillon Bequest.

it. I cannot recollect what subjects Lamont and I chose, but I believe
the plates were never bitten, certainly mine was not.[16]

At least three of these plates can be identified. The title of Du Maurier's
plate, according to Ormond, was *George Louis Palmella, Comte Busson du
Maurier, with Madame la Comtesse and Monsieur le Vicomte*, which survived
in at least one impression owned by Armstrong until his death in 1911.[17]
Poynter's untitled plate survives in what may be a unique impression
in the British Museum, and fits Armstrong's description exactly (pl. 17).
   Armstrong's description of Whistler's etching as being "something
like Tassaert's well-known picture in the Luxembourg, a garret with
female figures," makes it possible to identify his contribution to PLAWD
as *Au Sixième*, K.3. (pl. 18). The painting in question is *An Unfortunate
Family* or *The Suicide* (pl. 19), which was commissioned by the state in
1849, and greatly praised at the Salon of 1850/1.[18] Although the subject
of Whistler's work is as light-hearted as Tassaert's is grim, the composi-
tion is not dissimilar, and employs much the same type of sloping garret
roof and chiaroscuro lighting effects as the painting. Tassaert, whom
Baudelaire called "an outstanding artist who only the *flâneurs* appreciate
and whom the public does not know well enough,"[19] was a neighbour
of the English Group at 5 rue Notre-Dame-des-Champs in 1857.[20]
   *Au Sixième* seems to be the first etching which Whistler made after
his arrival in Paris. Only two impressions appear to have survived, and

19. Tassaert, *An Unfortunate Family or the Suicide*, 1852. Oil on canvas, 45 × 38 cm. Montpellier, Musée Fabre. Photograph Claude O'Sughrue.

it is likely that they were pulled on a hand press in the rue Campagne-Première to which Whistler had access in 1857–8.[21] He gave one impression to Haden, and kept one for himself. Haden wrote on the back of his, "probably the first of Whistler's etchings. I never saw but this one."[22] The style and subject are related to three pen drawings: *The Artist's Studio, A Scene from Bohemian Life,* and *An Artist in His Studio,* (pl. 14) made during his first two years in Paris. These works, with their narrative content, tiny hair-like hatchings, discontinuous verticals describing the wall surface, and zigzag lines animating the composition, show the early influence on Whistler of the illustrator George Cruikshank.

While it is not possible to identify the figures or the location with certainty, the man at the easel in *Au Sixième* could well be Whistler's friend Ernest Delannoy with whom he shared a room "on the sixth floor" in 1857–8. The girl making coffee on the stove bears a close resemblance to Fumette.

———

By the spring of 1857 Whistler was still employing much the same style and subjects in his private work which he had used before leaving America. It is not known whether he had encountered naturalist and realist art theories by 1857, but he was gradually drawn toward them, and probably learnt of them largely through what was being exhibited and talked about.

The Salon of 1857 was the first to take place following his arrival in Paris, and although there is no record of his having gone to it, it is unthinkable that he would have missed it. The biennial salon was the centre of interest for aspiring artists, and the successful entries must have been a lively and contentious topic of conversation in the academies and cafés among students and teachers, all of whom were dependent on the Salon to make and sustain their reputations in official art circles.

The Salon of 1857 marked a turning point in the history of French art, a fact which was immediately seized upon and noted by a young critic called Castagnary. Ever since Baudelaire's anti-academic pronouncements a decade earlier, a major shift had taken place in the balance of subjects exhibited at the Salon. By 1857 pretentious historical and allegorical paintings were no longer dominant, and "the gods had fled,"[23] as Castagnary noted. The proportion of "minor" subjects, lumped together under the category "genre," had increased annually until by 1857 until they formed the largest single group.[24]

Like Baudelaire, Castagnary encouraged young artists to look to domestic interiors, landscape and portraiture for their subjects, assuring them that there was a rich source of inspiration to be found there. He praised the high quality of landscape painting at the Salon, and selected members of the Barbizon School for special attention. He was disappointed at the level of the portrait submissions. While the landscapes would not look out of place next to Hobbema, Cuyp, and Ruysdael, he felt that the portraits could never hold their own next to Van Dyck and Rembrandt.

The Salon of 1857 was also characterized by the absence of major figures. Neither Delacroix nor Ingres, the two aging masters of the

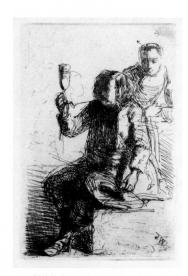

20. Whistler, *The Dutchman Holding a Glass*, K. 4, 1857. Etching 8 × 5.6 cm. Courtesy of the Freer Gallery of Art, Smithsonian Institution, Washington, D.C.

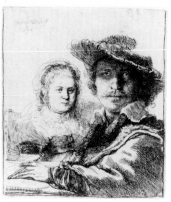

21. Rembrandt, *Rembrandt and His Wife Saskia*, B. 19, 1636. Etching, 10.5 × 9.4 cm. Art Gallery of Ontario.

French School, was represented, and no clear line of succession had begun to emerge. While Castagnary had no hesitation predicting that this salon pointed the way to "a new art: a humanitarian art," he decried the lack of leadership.[25] In a metaphor which would have greatly appealed to Whistler the critic wrote: "In the great army of art, I see many soldiers, a general staff, perhaps, but no general. From where will that artist come who will claim the leadership by virtue of his genius, and take his place at the head of the column?"[26]

———

On September 11, 1857, Whistler crossed the Channel and went to see the widely acclaimed Manchester Art Treasures exhibition. Housed in a specially constructed crystal palace, this extraordinary exhibition included masterpieces of all periods and schools drawn from English private collections. The result, as the French press was quick to point out, was an exhibition which in itself was "even more vast than the Louvre."[27] Throughout the summer laudatory articles appeared in Paris and London, and crowds flocked to Manchester from both sides of the Channel.

The exhibition gave Whistler the opportunity to see an outstanding selection of Dutch seventeenth-century painting. According to the French expatriate art critic, Thoré-Bürger,[28] it was the Dutch School which "shone most brilliantly at Manchester." Among the works on view were outstanding paintings by "the most magical of painters," Rembrandt.[29] After thoroughly studying the exhibition, Thoré reached the conclusion that the art of the North was the fountainhead of the art of the future. He became convinced that to work in imitation of the great Italian masters, whose subjects and sentiments were remote from modern reality, was to choose the road to artistic sterility.[30]

In addition to seventeenth-century Dutch painting, Whistler must also have seen the extraordinary display of etching and engraving, itself a landmark in the history of print exhibitions, which gave the public its first opportunity to view "a complete chronological series of prints from the commencement of the art to the present time." George Scharf wrote that "fine specimens of various epochs are from time to time shown in glazed frames in the French museum, and the officers in charge of the print department at the British Museum have long desired to adopt some such course,"[31] but there was still no regular centre for the display or study of prints in Paris or London. The exhibit at Manchester made it possible to study the evolution of etching and engraving in proof impressions and multiple states "as crisp and as fresh after several centuries as if they had just left the hands of the printer."[32]

For those unfamiliar with it, Blanc defined the term "original" etching. This was necessary because etching had been in eclipse since the seventeenth century, and the nineteenth-century revival of interest in the technique only began to gather momentum in the late 1850s. He described etchings as "prints made by painters who, instead of copying the compositions of others, express their thoughts directly onto copper, allowing their needle to wander freely over varnish, just as they would have allowed their pen or chalk to traverse a sheet of paper."[33] He pointed to the supremacy of the etchings of the seventeenth-century Dutch

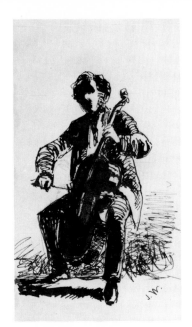

22. Whistler, *Sir Seymour Haden Playing the Cello*, c. 1858. Pen, 6.3 × 9.9 cm. Courtesy of the Freer Gallery of Art, Smithsonian Institution, Washington, D.C.

23. Whistler, *Annie Haden with Books*, K. 8, 1857–8. Etching, 7.8 × 6.4 cm. S. P. Avery Collection, The New York Public Library, Astor, Lennox and Tilden Foundations.

School, particularly those of Van Dyck, Ostade, Dujardin, Waterloo, Berchem and Zeeman, while drawing particular attention to "the most beautiful etchings in the world, those of Rembrandt," which could be seen at Manchester in "remarkable and uniquely beautiful proof impressions."[34]

Whistler's visit to the Manchester Art Treasures exhibition undoubtedly stimulated his interest in the Dutch School, which had for centuries been considered inferior to the Italian. He turned his back on any intention he may ever have had of becoming a Néo-grec, like Gleyre's most successful pupils, and consciously set out on "the road to Holland."[35] While Gleyre laboured over his ambitious salon submission *The "Helvetii" under the Leadership of Divicon, make the Romans Pass Under the Yoke*, Whistler devoted his time instead to portraits, landscapes, and domestic interiors from nature, drawing on the seventeenth-century Dutch tradition.

His interest in Dutch art, and the sight of so many fine etchings at Manchester, may have inspired him once again to take up his etching needle. Whistler made his second etching, and the only one overtly connected with the seventeenth-century Dutch school, *The Dutchman Holding a Glass*, K.4., 1857 (pl. 20), at this time. It was probably made following his return to Paris and printed in a handful of impressions on pale blue paper on the press in the rue Campagne-Première. While Whistler only meant it to be viewed as a characteristic Dutch subject, the composition does recall Rembrandt's etching *Rembrandt and his Wife Saskia*, B. 19 (pl. 21), and the theme, Pieter de Hooch's *The Declined Glass of Wine*, which was then in the Sheepshanks Collection. In its use of period costume and overt reference to a school of the past, it is unique in Whistler's etched *oeuvre*. The sketchy delineation of the figures in the manner of Rembrandt marks the beginning of Whistler's increasing selectivity of line in etching, and represents a major stylistic advance beyond *Au Sixième*.

———

Early in 1858 Whistler fell, and was discovered by his American friend George Lucas in a Maison de Santé Municipale in Paris. He left for England on January 21, and must have gone to recuperate with the Hadens.[36] He does not appear to have returned to Paris until the beginning of April, and probably spent the intervening period of eight or nine weeks at 62 Sloane Street.

It was during his illness in the spring of 1858 that Whistler appears to have devoted himself seriously to etching for the first time. The most convenient subjects were himself, his niece, Annie, aged nine, and his two young nephews, Seymour, aged seven, and Arthur, five. He made six etchings in the Haden household: *Seymour Standing*, K.6, *Seymour Seated*, K.29, *Little Arthur*, K.9, *Annie*, K.10 (pl. 24), *Early Portrait of Whistler*, K.7, and *Annie Haden with Books*, K.8 (pl. 23).[37] Unlike the sketches on *The Coast Survey Plate*, *Au Sixième* and *The Dutchman Holding the Glass*, these plates were all made directly from nature, and were unadorned and uncorrected. The Haden children have the dishevelled appearance of children who are bored, restless and untidy after being pressed rather reluctantly to sit still for "Uncle Jim." In these etchings, Whistler captured the *naiveté* which made children such popular subjects

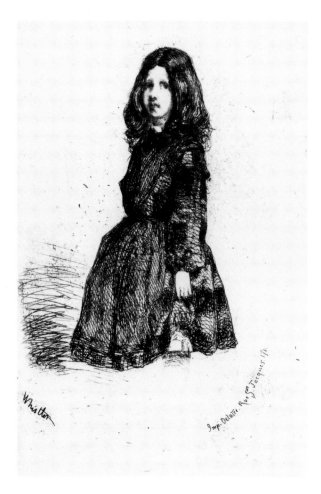

25. Millais, *Autumn Leaves*, 1856.
Oil on canvas, 104 × 74 cm. City of
Manchester Art Galleries.

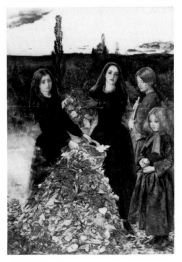

with the naturalists. Annie, the eldest, with her slightly melancholy
expression, recalls the adolescent girls in *Autumn Leaves* (pl. 25) by John
Everett Millais which Whistler could have seen at Manchester.

Only one of these etchings, *Annie Haden with Books* (pl. 23), reveals
Whistler's childhood propensity for caricature. This plate was clearly
intended to be humorous, and recalls with its large head and diminutive
hands the popular illustrations of Hablot K. Browne ("Phiz"), Leech
and Tenniel, which Whistler would have known from *Punch* and the
comic almanacs in Haden's library. The books over which the unhappy
child is peering are labelled "Directorium Inquisitorium," "Mach Bel-
phegor," and "Swedenborg." One is given the impression that she is
being forced to absorb a great deal of meaningless rubbish of a kind
which her sympathetic uncle had done his best to avoid.

Whistler's etching activity must have stimulated Haden, for he took
out his etching needle in 1858 and made his first dated plate, a portrait
of his youngest son. Entitled *Arthur*, H. 7 (pl. 26), and inscribed "April,
1858," it is very similar in style to Whistler's *Little Arthur* (pl. 27), and
may have been made during the same sitting or shortly thereafter. Both
plates show a debt to Rembrandt's etched portraits, being diminutive
in scale, and employing webs of crosshatching to create strong
chiaroscuro effects. They mark the beginning of several years of close
collaboration between Whistler and Haden.

26

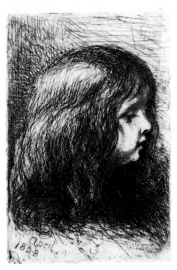

26. Haden, *Arthur*, H. 7, 1858. Etching, 7.6 × 5.4 cm. S. P. Avery Collection, The New York Public Library, Astor, Lennox and Tilden Foundations.

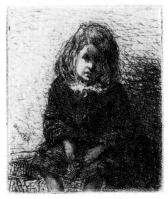

27. Whistler, *Little Arthur*, K. 9, V/V, 1858. Etching, 5.7 × 4.6 cm., from the Winans Scrapbook. Metropolitan Museum of Art. Gift of Margaret C. Buell, Helen L. King, and Sybil A. Walk, 1970.

Haden regarded Whistler as his ward, and assumed the role of mentor in artistic matters. He did not approve of the way in which Whistler terminated his full-length portrait of *Annie* (pl. 24) at the knees, like vignettes found in popular illustration. He "added legs", just as he had "finished" Whistler's sketch of her as a baby. While Whistler tolerated Haden's amendments at the time, he later wrote on one impression "Legs not by me, but a fatuous addition by a general practitioner."[38]

With the exception of *Little Arthur* and *Annie*, which were later published in the "French Set," Whistler's early portrait etchings were printed in only one or two impressions on old laid paper and were probably only intended for circulation within the family.

The spring of 1858 marked a turning point in Whistler's career. Since his period at Gleyre's Academy was nearly over, Haden tried unsuccessfully to persuade him to stay in London and attend the Royal Academy Schools. His mother wrote on May 7 saying, "it is in vain for me to wish you could have contented yourself at the Academy in London! I have such a just estimate of Seyrs' judgment, and as an artist I wonder you do not look up to him and profit by intercourse with him."[39] Whistler returned to Paris early in April, no doubt leaving Sloane Street as soon as his health would permit.

## 4. Realism and Urban Working Women

Following his return to Paris in April, Whistler began a series of seven etchings of Paris working women, five of which were made before he left on a journey through Alsace and up the Rhine in August, and two after his return in October. They not only reveal his premature mastery of the etching technique and his uncanny genius with the needle; by their choice of subject and their approach to it they demonstrate Whistler's affiliation with the realist current of the naturalist movement.

It is not known when Whistler first encountered the radical ideas of Gustave Courbet, which were ridiculed by the press and hotly debated by art students following the appearance of his "Manifesto" in 1855. When Whistler first arrived in Paris in November, 1855, Courbet's one-man exhibition was still hanging in the Avenue Montaigne. While there is no record of his having seen it, Whistler was always drawn like a magnet to controversy. It is not impossible that he might have known of the important series of articles which appeared in *L'Artiste* between September and December 1855, debating the merits of Courbet and Realism.

In an essay entitled "Du Réalisme: Lettre à Madame Sand," which appeared in the September issue, Courbet's apologist, the realist critic Champfleury, defended the artist's position as it was set forth in his "Manifesto."[1] Courbet maintained that it was the artist's right to paint lower-class portraits and genre subjects if he wished; to clothe his sitters in modern dress rather than in outmoded historical costume, and that all people were equally appropriate as subjects for art, whether they were beautiful or ugly. Moreover, he maintained that the artist should be able to paint ordinary people on the large scale formerly reserved for royalty or aristocracy. To a generation brought up on academic

27

painting this seemed monstrous. Because Courbet's work was considered scandalous, and was routinely refused by the Salon jury, the artist organized his own one-man exhibition in 1855.

By 1857, Courbet was at the height of his powers, having already painted his best known and most notorious works. Although his *Young Women on the Banks of the Seine* was accepted at the Salon, it was vigorously attacked until the close of the exhibition in August. The painting, which showed two voluptuous courtesans lounging on the banks of the Seine, was accused of committing "a double injury to Paris and to the people."[2] Whistler could not possibly have missed seeing the painting or hearing of Courbet in conjunction with this event.

If Whistler had been seriously interested in having a painting accepted at the next salon, he would have listened carefully to the advice given by Achille Fould to the prize-winners at the Salon of 1857. Fould's address was a model of conservative thinking. He advised young artists to adhere to "the high and elevated regions of the beautiful and traditional paths of the great masters" and to look for their subjects in poetry, morality, religion and history. He warned them against the new school of realism, saying "it no longer seeks for anything but a servile imitation of the least poetic and least elevated aspects of nature."[3]

Totally neglecting this advice, Whistler began to devote himself to painting realist portrait heads using a palette knife in the manner of Courbet. While his early paintings are not yet securely dated, he maintained that his first independent painting after arriving in Paris was *La Mère Gérard*, Y.26, which appears to have been begun in the summer of 1858 and completed in the spring of 1859.[4] In addition to the head of the old flower seller, Whistler painted the head of a seller of chamber pots entitled *Head of an Old Man Smoking*, Y.25 (no doubt inspired in part by Courbet's portrait *L'Homme à la pipe*), and a second study of *La Mère Gérard*, Y.27. He also painted a self portrait, *Portrait of Whistler with Hat*, Y.23, which reveals both the influence of Courbet and Rembrandt.[5]

The Paris etchings made during the summer of 1858 also demonstrate realist leanings. Seymour Haden, who was closely involved with their production, placed them in the following sequence, prior to the etchings Whistler made in Alsace: *La Rétameuse*, K.14, *En plein soleil*, K.15, *La Mère Gérard*, K.11, *Fumette*, K.13, and *La Mère Gérard Stooping*, K.12. The remaining two etchings in this group, *La Vieille aux loques*, K.21 and *The Rag Gatherers*, K.23, were made after his return from the Rhine, and before his departure for London at the beginning of November.

Whistler's choice of sitters reflects his new realist tendencies. From the streets around him he drew working women from the lowest echelon of society: ragpickers, tinkers, flower-sellers and dressmakers, all of whom were favourite subjects with naturalist painters at the time.[6]

He carefully described their faces and personalities, making no attempt whatsoever to idealize them. The face of the unadorned tinsmith, *La Rétameuse* (pl. 28), is excessively plain, and reveals years of hard labour, her carefully folded hands indicating pride and resignation. Whistler was apparently drawn to *La Mère Gérard* (pl. 33) by her "picturesque appearance," and indeed the detail of her costume does detract from her rather sinister face. Whistler etched her with such accuracy that her near blindness can be detected in the slightly vacant

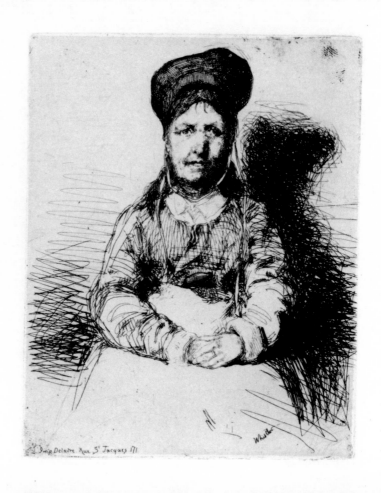

28. Whistler, *La Rétameuse*, K. 14, II, 1858. Etching, 11.1 × 8.9 cm., from the Winans Scrapbook. Metropolitan Museum of Art. Gift of Margaret C. Buell, Helen L. King, and Sybil A. Walk, 1970.

expression of her eyes. From a more privileged background than the tinsmith, she had fallen from bourgeois status to become a flower-seller at the door of the bal Bullier.[7]

Whistler was always attracted to pretty women, and from the beginning established an unbroken sequence of intimate relationships which was only to end with his marriage in 1888. The first of these was with a bohemian *grisette* of the type immortalized by Gavarni. Whistler's *grisette*, Fumette, was a dressmaker who earned her living in the Latin Quarter. In his etching *Fumette* (pl. 29), she is shown in a crouched pose, and her unpredictable and intrepid nature can be sensed from the slightly mocking smile on her face and darting look in her eye. While the identity of the girl seated with her parasol on the bank in the etching *En plein soleil* (pl. 30) is not known, she appears to be a *grisette* enjoying a day in the sun. As such she recalls both Courbet's painting of the *Demoiselles* as well as his earlier "scandale," *Les Demoiselles de Village* of 1851 (pl. 31).

The term "realist" cannot be applied strictly to Whistler's work. It was with the anti-academic stance of Courbet and his supporters rather than their socialist political views, that Whistler sympathized. Whistler

29

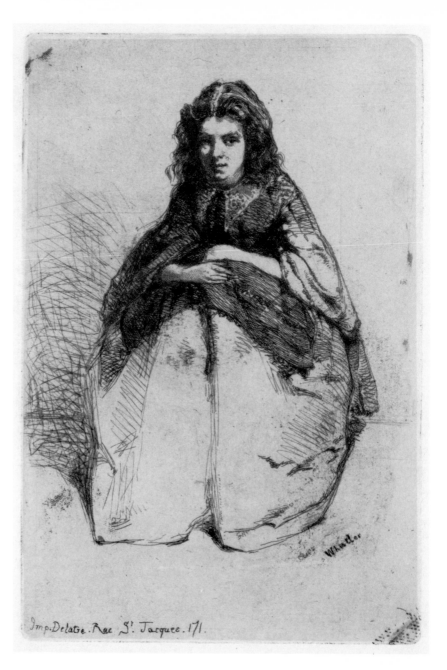

29. Whistler, *Fumette*, K. 13, 1858. Etching, 16.2 × 11.0 cm., from the Winans Scrapbook. Metropolitan Museum of Art. Gift of Margaret C. Buell, Helen L. King, and Sybil A. Walk, 1970.

can be described as a "naturalist" with realist tendencies, believing, like the Dutch, that it was legitimate to paint what exists in nature. Using Joseph Sloane's useful set of definitions, Whistler can be seen as an "objective naturalist,"[8] who depicted his sitters with the objectivity characteristic of a daguerrotype. His lower-class subjects tend to confront the viewer without apology, staring out at them from the picture space. Whistler avoided all personal comment, never idealizing, sentimentalizing, or endowing his sitters with universal significance. It is not so much his choice of subject as his detached approach which indicates his sympathy with the realist current of the naturalist movement.

Although he would have been familiar with the range of naturalist

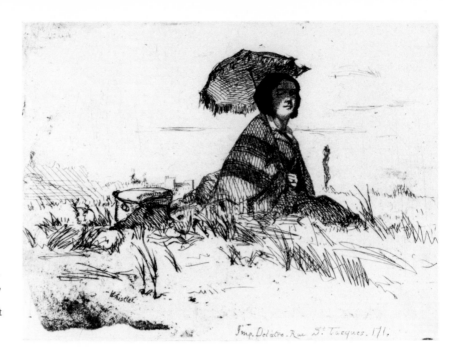

30. Whistler, *En plein soleil*, K. 15, II, 1858. Etching, 10.1 × 13.3 cm., from the Winans Scrapbook. Metropolitan Museum of Art. Gift of Margaret C. Buell, Helen L. King, and Sybil A. Walk, 1970.

31. Courbet, *Demoiselles de Village*, 1851. Oil on canvas, 19.5 × 26.1 cm. Metropolitan Museum of Art, Gift of Harry Payne Bingham, 1940.

themes from the Salon of 1857, Whistler also seems to have known the source books illustrating urban types which were popular in naturalist circles. These included *Le Diable à Paris*, published in 1845, and *Les Français peints par eux-mêmes*, which was so popular that it was reissued in a two-volume abridged edition in 1853 and 1858. He may have known the latter before leaving America, for there is a close similarity between a number of pen drawings in the Winans album and Gavarni's wood-engraved illustrations for *Le Diable à Paris*.[9] Since beggars and ragpickers were among the most popular subjects at the Salon of 1857, it is not surprising to find the maturing Whistler focussing on a theme to which an entire fascicle of *Les Français peints par eux-mêmes* had been devoted. This had also been used by the realist François Bonvin as a source for a drawing entitled *The Ragpicker*, in 1853,[10] and was to be used the following year by Edouard Manet in conceiving his painting *The Absinthe Drinker* of 1859.[11]

Whistler's etching of *La Mère Gérard* (pl. 33) can be compared with such woodcuts after Gavarni as "Le Portugal et le Banc de Terre-Neuve" from *Le Diable à Paris* (pl. 32) and "Le Bas-Bleu" from *Les Français peints par eux-mêmes* (pl. 34). But while Gavarni placed his picturesque and uncomplicated urban types in front of walls barely indicated by a schematized shadow, Whistler used a thick web of Rembrandtesque crosshatching to create a dramatic and evocative shadow hinting at the complex personality and disturbed mind of the old woman, who was convinced that she had a giant milk-loving tapeworm in her intestinal tract.

No discussion of Whistler's interest in the low-life tableau would be complete without reference to Rembrandt. There can be little doubt that behind the contemporary sources for *La Mère Gérard* lies the all-pervasive influence of such Rembrandt etchings as *Beggar in a High Cap, Leaning on a Stick*, B.162 (pl. 35), and *Old Beggar Woman with Gourd*, B.168.

31

32. Gavarni, "*Le Portugal et Le Banc de Terre Neuve*" from *Les Gens de Paris*, in *Le Diable à Paris*, 1845. Wood engraving, 26.7 × 18.1 cm. Reproduced by permission of the Trustees of the British Museum.

33. Whistler, *La Mère Gérard*, K. 11, 1858. Etching, 12.8 × 9.0 cm., from the Winans Scrapbook. Metropolitan Museum of Art. Gift of Margaret C. Buell, Helen L. King, and Sybil A. Walk, 1970.

34. Gavarni, "*Le Bas-bleu*" from *Les Français peints par eux-mêmes*. Wood engraving, 26.9 × 17.2 cm. Reproduced by permission of the Trustees of the British Museum.

Like *La Mère Gérard*, these figures are shown standing within the picture space against a background defined only by a shadow, and their visual interest depends largely on the picturesque details of their timeless folds and tatters. Like Rembrandt's beggars, *La Mère Gérard* is of her own time, and stands proudly upright in her colourful and eclectic costume.

Whistler probably pulled the first proofs of these plates on the press in the rue Campagne-Première. He began to sell his first etchings at this time. Henry Oulevey recalled how

A rich American friend wanted an etching and came to the studio, and Whistler asked a good price for it. He got to work, prepared his plate, pulled a print. It wasn't good enough, he said, and he crumpled it up, and threw it on the ashes in the fireplace, and the next three or four were thrown after it. At last, he pulled one that would do, and with every care, put it in a flat box, and the American went off with it. No sooner had he gone than Whistler pounced upon the first print in the ashes, smoothed and pressed it. "There", he said, "is the best proof, and it is for me."[12]

Of the group of five etchings made during the summer, four were

32

35. Rembrandt, *Beggar in a High Cap, Leaning on a Stick,* B. 162. Etching, 15.6 × 12 cm. Reproduced by permission of the Trustees of the British Museum.

published in late autumn as part of the "French Set." Only *La Mère Gérard Stooping* was omitted. A small and not ambitious plate, it appears to exist in a unique impression.

By the summer of 1858, any lingering thoughts about Gleyre, Raphael or Ingres must have been swept away. Whistler began to plan an artistic pilgrimage to Amsterdam, where he might see the great seventeenth-century Dutch masters, and Rembrandt in particular. Although he does not appear to have known of Thoré-Bürger's writings, his enthusiasm for making the trip at this time reflects the climate of interest generated by the publication that spring of Thoré's *Musées de Hollande: Amsterdam et la Haye.* Within a few months of its appearance, it was widely read and on the shelf of every art library,[13] including that of Seymour Haden.[14] On July 18, Thoré published an excerpt from his forthcoming book on Rembrandt in *L'Artiste,* saying of the "Night Watch": "it is amazing that this picture, the most fantastic ever painted, beyond compare, is also the most realistic."[15] Whistler developed an insatiable desire to see it.

His mother, who could not have understood her son's theoretical position, was clearly unaware of his change of direction. She wrote impatiently on August 1, saying, "Jemie dear shall you not spend next winter in Italy? Three years already gone, alas, how can you loiter so!"[16] Two weeks later Whistler set off instead for Amsterdam, which was to be the grand finale of a trip through Alsace and up the Rhine. Buoyed by the success of his summer work, he had decided to make a series of rural genre subjects to complement his urban types, and to put together a publication upon his return which would firmly establish his reputation as an etcher.

## 5. Whistler's Rhine Journey

Whistler planned his journey through Alsace and up the Rhine with considerable forethought. Having "made a little money,"[1] perhaps by selling proofs of his Paris etchings, he invited the penniless Ernest Delannoy to accompany him. They purchased identical broad-brimmed hats and brown linen suits so that Ernest could pose in Whistler's place in the sketches and etchings he intended to make. He probably purchased cheaply along the *quais* the 1846 map of the area showing the rail routes, *Neue Post- und Eisenbahn-Karte von Deutschland* (pl. 36), which survives among his affects at Glasgow. He carried his clothing, pencils, sketchbooks, etching needles and half a dozen copper plates, in a knapsack on his back.

It is not known exactly how many copper plates Whistler took with him, but he etched five or six of the ten plates conceived on the journey *en route,* and four in Paris following his return. Although he planned to work from nature, he did not view the use of a preliminary drawing at this time as interfering with this process, and made numerous sketches which he could use later as the basis for etched compositions.[2] He may have adopted this method as a result of the precedent set by Haden on his Italian trip. It had a very practical aspect: not only did it provide the young and uncertain draughtsman with the opportunity to select

# POST- UND EISENBAHN-KARTE VON DEUTSCHLAND

38. Whistler, *Liverdun*, K. 16, 1858. Etching, 10.8 × 15.3 cm., from the Winans Scrapbook. Metropolitan Museum of Art. Gift of Margaret C. Buell, Helen L. King, and Sybil A. Walk, 1970.

39. Whistler, *The Unsafe Tenement*, K. 17, 1858. Etching, 15.7 × 22.4 cm. Art Gallery of Ontario, Gift of Enid Maclachlan in memory of Peter Maclachlan, 1984.

40. Jacque, *Chaumière de paysans*,
G. 78. Etching, 15.8 × 22.7 cm.
Reproduced by permission of the
Trustees of the British Museum.

41. Jacque, *Maison de paysan à
Cricey*, G. 14. Etching,
11 × 12.6 cm. Reproduced by
permission of the Trustees of the
British Museum.

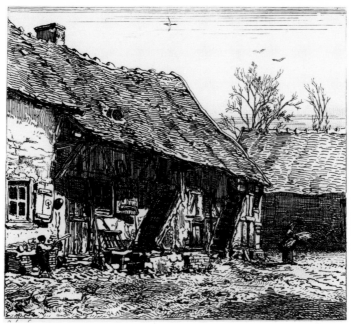

42. Ruisdael, *The Little Bridge*,
B. 1. Etching, 19.5 × 27.7 cm. Art
Gallery of Ontario, presented by
John M. Lyle, Toronto, 1942.

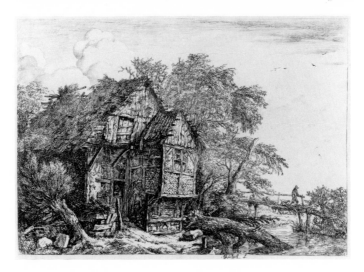

only his most successful compositions for etching, and thereby avoid spoiling any of his precious copper plates, it also gave him the opportunity to collect ideas which could be used at a later date.

Whistler and Ernest must have begun by selecting their route. This involved travelling through Alsace to Strasburg, crossing the German border into Baden, following the Rhine to Cologne, then continuing on to Amsterdam before returning to Paris. The trip must have begun soon after Whistler's passport was stamped for Baden at the legation in Paris on August 14. They "started out gloriously to Nancy and Strasbourg,"[3] presumably by train, making several stops on the way to Germany: first at Liverdun, north-west of Nancy, then at Maladrie, Lutzelbourg and Saverne, which are all close together on the rail line from Nancy to Strasbourg.

The French section of the route provided Whistler with ample opportunities to sketch an unspoilt rural area. In choosing this venue, Whistler must have been influenced by the Barbizon painters and etchers, particularly Charles Jacque, whose hundreds of etchings of rural France were extremely popular with collectors at that time.[4] Jacque was the leading exponent of naturalism in etching, and his work constituted an important link between the seventeenth-century Dutch etching tradition and the etching revival of the 1850s. He created his own rustic vocabulary of dilapidated French farmyards inhabited by peasants going about their daily work.

At Liverdun, Whistler made his first etching from nature entitled *Liverdun*, K.16 (pl. 38). In it, and in two subsequent plates made at a farm in Alsace,[5] *The Unsafe Tenement*, K.17 (pl. 39) and *The Dog on the Kennel*, K.18, Whistler reveals a debt to Jacque and to the seventeenth-century Dutch etching tradition. *The Unsafe Tenement* may be compared to Jacque's plates *Chaumière de paysans*, G.78 (pl. 40) and *Maison de Paysan à Cricey*, G.14 (pl. 41), both of which take dilapidated half-timbered farmhouses for their subjects and employ peasant figures for staffage. Whistler used the same vocabulary of line and strong chiaroscuro found in Jacque to describe some areas of the wall in minute detail, while leaving others virtually unworked. He dramatized the composition by showing the building in raking light with a great web of black shadow. The carefully delineated contours and the short curved and vertical lines, sometimes crossed by horizontal lines to create a grid of shadow, once again recall the line of Charles Jacque.

Jacque had learned to etch when the technique had been all but forgotten by studying the work of the seventeenth-century Dutch etchers Rembrandt, van Ostade, Ruysdael and Du Jardin. Whistler would have been familiar with their work in the original from the Haden collection, and in etching *The Unsafe Tenement* was probably thinking of such Dutch prototypes as Jacob van Ruisdael's *The Little Bridge*, B.1 (pl. 42).

At Maladrie Whistler began to make preliminary drawings for etching,[6] the most notable of which is a study of a figure silhouetted against a window, annotated Chambre à la ferme de Maladrie (pl. 43). He had become very interested in *contre jour* compositions, and explored this idea in a number of plates made during the next few weeks. He did not return to this sketch until 1861, when he made a drypoint from it entitled *The Miser*, K.69 (pl. 44).[7]

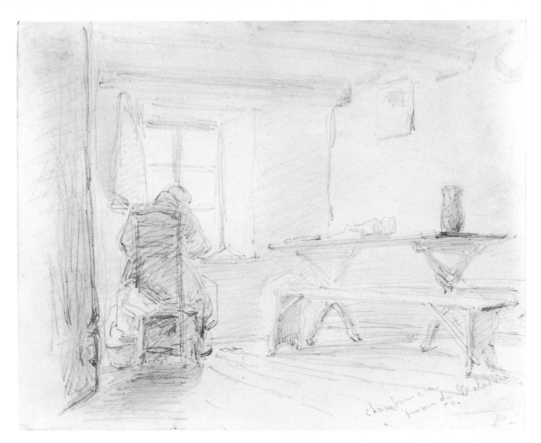

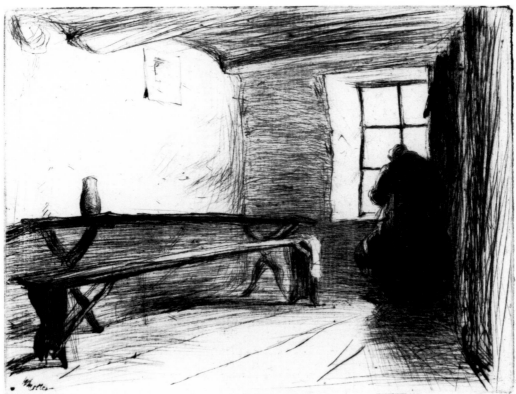

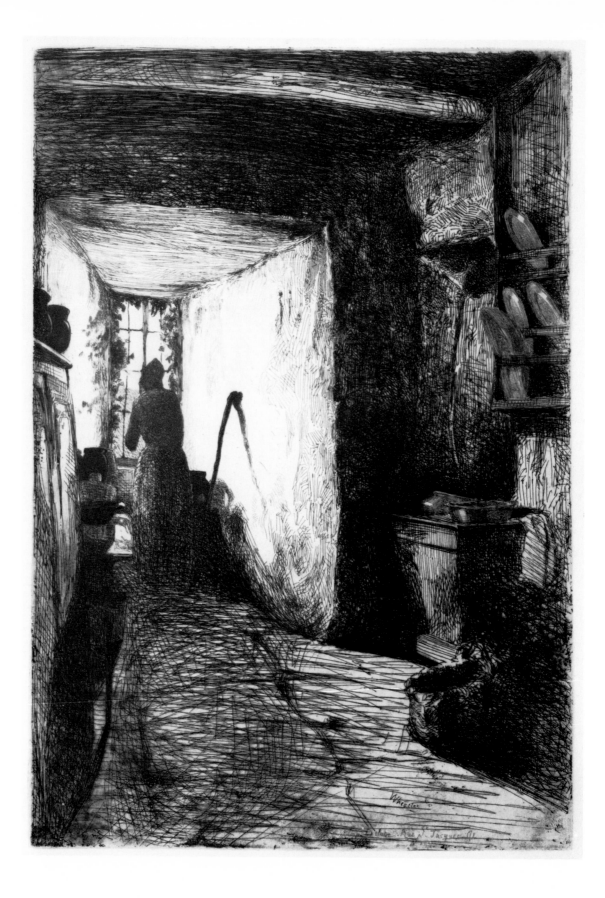

46. Whistler, *A Kitchen at Lutzelbourg*, 1858. Pencil, 21.4 × 16.0 cm. Courtesy of the Freer Gallery of Art, Smithsonian Institution, Washington, D.C.

47 (right). Whistler, *The Kitchen*, 1858. Pencil and watercolour, 30.4 × 19.7 cm. Courtesy of the Freer Gallery of Art, Smithsonian Institution, Washington, D.C.

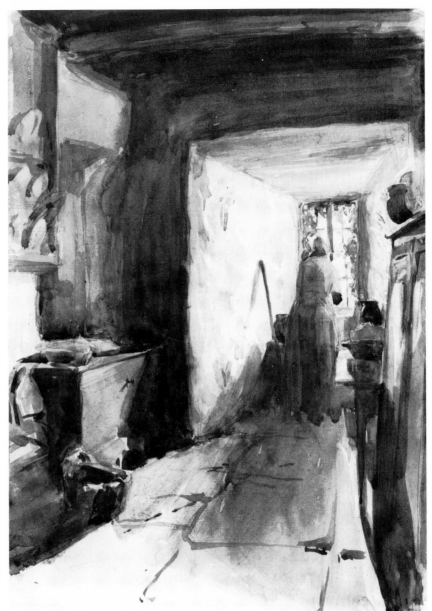

48. Bonvin, *Sortie de cave*, 1857. Oil on canvas, 44.4 × 33 cm., Collection of Dr. and Mrs. Gabriel P. Weisberg.

45 (left). Whistler, *The Kitchen*, K. 24, 1858. Etching, 22.7 × 15.6 cm. Courtesy of the Freer Gallery of Art, Smithsonian Institution, Washington, D.C.

A few miles east of Maladrie, Whistler and Ernest stopped at Lutzelbourg, where they appear to have stayed for a few days. It was here that he conceived one of his finest early plates, *The Kitchen*, K.24 (pl. 45), which he did not sketch onto copper until after his return to Paris. He made a preliminary sketch, *A Kitchen at Lutzelbourg* (pl. 46), as well as a handsome watercolour, *The Kitchen* (pl. 47), which was used as the basis for the etching. Like the other preliminary drawings made on this trip, the watercolour is the mirror image of the etching. The composition was reversed in the process of transferring it to the copper plate.

The subject and handling of this watercolour reveals Whistler's years of practice and a knowledge of the realist watercolours of Bonvin, which

49. De Hooch, *The Courtyard of a House in Delft*, 1658. Oil on canvas, 73.5 × 60.0 cm. Reproduced by courtesy of the Trustees, National Gallery, London.

50. De Hooch, *Arrière-cour d'une maison*. Oil on canvas, 60 × 47 cm. Musée du Louvre.

the artist sold to support himself.[8] Bonvin's favourite subjects were scenes of quiet domesticity, showing women absorbed in simple household tasks of a timeless nature. He based many of his subjects and compositions on Chardin and Pieter de Hooch. In 1857 he painted *Sortie de cave* (pl. 48), which in its compositional structure, stillness, and clarity appears to have been modelled on de Hooch.[9]

Whistler's attention had been drawn to the work of de Hooch by Charles Leslie, who praised him as one of the "most consummate painters in his particular style" who ever lived.[10] Leslie instructed his pupils to study the construction of the Dutch interior carefully, noting the use of the close vantage point and horizontal perspective. He drew their attention to several paintings by de Hooch, including *The Courtyard of a House in Delft* (pl. 49), which was then in the Peel Collection.[11]

Whistler would have noted the underlying geometry of de Hooch's picture space, and the devices which were used to carry the eye around the picture plane and into its hidden recesses. De Hooch accomplished this by the rhythmic juxtaposition of light and dark, and by creating a sequence of spaces receding from the picture plane. Broad spaces are juxtaposed with narrow ones; open with closed, light with dark. Dark figures are set off against light grounds, and light figures against dark grounds.

In both the watercolour and the etching of *The Kitchen,* Whistler constructed the picture space in the manner of de Hooch, perhaps thinking of *The Courtyard of a House in Delft* or of *Arrière-cour d'une maison* (pl. 50), which hung in the Louvre. The figure is silhouetted *contre-jour* against

the window, and at the end of a narrow recess, which is accentuated and made more dramatic in the etching. The use of strong chiaroscuro, whereby a light area is framed by a dark one, recalls de Hooch, as does the stillness and timelessness of the subject itself.

Although Whistler did not etch the plate until after his return to Paris, he remained faithful to the watercolour, and therefore to nature, in transposing it. Areas of shadow had been carefully conceived in watercolour. Whistler may well have used pencil in his preliminary drawings when planning an etching which depended on line for effect, and added watercolour wash when his principal interest lay in dramatic chiaroscuro and tonal values.

From Lutzelbourg, the two artists continued on to Saverne, a few miles to the east, where they planned to visit a fellow student from Gleyre's Academy. Here Whistler made an elaborate drawing with pencil and coloured wash annotated "Place St. Thomas" (pl. 52), which was transposed to copper in the course of the journey, and given the title *Street at Saverne*, K.19 (pl. 53). While there are a few minor modifications in the etching, such as the elimination of the second row of windows on the extreme right, Whistler remained remarkably faithful to the drawing, incorporating even the lines describing the texture of the wall into the etching. Areas of wash were accurately translated into areas of dense hatching to create a palpable web of shadow.

Whistler's interest in nocturnal subjects lit from within by a lamp reflects his knowledge of Rembrandt's use of this device in such etchings as *The Adoration of the Shepherds: A Night Piece*, B.46, and *The Star of the Kings*, B.113 (pl. 276), which he would have known from the Haden collection. In *Street at Saverne*, Whistler chose a subject which recalls the work of his great contemporary, the brilliant if emotionally disturbed etcher Charles Meryon. The sinister mood of the dramatically projecting house with its high pitched gable recalls such gothic streetscapes by Meryon as *Rue des toiles à Bourges*, L.D. 55, 1853 (pl. 51). Although it is unlikely that Whistler ever met Meryon, who was ill at this time, he may have known of the etcher's work through Seymour Haden, who was already collecting it for the South Kensington Museum by 1860.[12] Meryon's *Eaux-fortes sur Paris*, which were exhibited at the Salon in the early 1850s, were recognized by etching connoisseurs as a landmark in the history of the etching revival of the mid-nineteenth century.

From Saverne, Whistler and Ernest must have proceeded by train to Strasbourg, which was then on the French side of the border,[13] and travelled up the Rhine to Baden-Baden. Whistler made a number of sketches of the elegant spa where royalty and aristocracy congregated to take the waters.[14] From here they travelled north to Heidelberg, where Whistler met a pretty young girl named Gretchen Schmidt, and made an etching entitled *Gretchen at Heidelberg*, K.20. She proposed that Whistler and Ernest stay at her father's inn when they reached Cologne.

From Heidelberg the two artists appear to have sailed up the Rhine, for Whistler made a number of sketches from a boat. One sheet of minute water landscapes bears the place names "Worms" and "Oppenheim" in Whistler's hand. At Mainz, after Whistler had made a sketch of boats on the water, they continued up the Rhine to Koblenz, and from there to Cologne where they went to stay with Herr Schmidt. While they were there, Whistler ran out of money. Without fully revealing his

51. Meryon, *Rue des toiles à Bourges* L.D. 55, 1853. Etching, 20.5 × 11.2 cm. Reproduced by permission of the Trustees of the British Museum.

52. Whistler, *A Street at Saverne*, 1858. Pencil and watercolour, 29.8 × 19.7 cm. Courtesy of the Freer Gallery of Art, Smithsonian Institution, Washington, D.C.

53. Whistler, *Street at Saverne*, K. 19, 1858. Etching, 20.8 × 15.7 cm. Metropolitan Museum of Art, Harris Brisbane Dick Fund, 1917.

54. Whistler, *La Marchande de moutarde*, 1858. Pencil, 15.2 × 9.8 cm. Courtesy of the Freer Gallery of Art, Smithsonian Institution, Washington, D.C.

55. Whistler, *La Marchande de moutarde*, K. 22, III, 1858. Etching, 15.7 × 9.0 cm., from the Winans Scrapbook. Metropolitan Museum of Art. Gift of Margaret C. Buell, Helen L. King, and Sybil A. Walk, 1970.

situation to the innkeeper, he wrote for money "to everybody—to a fellow student . . . to Seymour Haden—to Amsterdam where I thought letters had been posted by mistake."[15]

Meanwhile he and Ernest spent ten days in Cologne making sketches, some of which would be used later as the basis for etchings. The most important of these, annotated "Marchand de Potions à Cologne" (pl. 54), which was executed in pencil, was etched after Whistler's return to Paris and given the title *La Marchande de moutarde*, K.22 (pl. 55). The etching depends for its effectiveness on complex linear patterns; although the basic composition was worked out in the drawing, the lines, especially around the doorway, were considerably elaborated in the etching. The linear vocabulary recalls Jacque's etching *Récureuse*, G.33 (pl. 56), with its careful description of crumbling plaster and objects hanging on the wall.[16]

While the motif of the woman standing in the doorway was ultimately derived from the Dutch, most likely de Hooch, Whistler's adaptation has the stamp of Bonvin on it. Bonvin used a similar compositional

56. Jacque, *Récureuse*, G. 33, 1844.
Etching, 10 × 16.4 cm. Art Gallery
of Ontario, Gift of Messrs.
Heintzman and Knoedler, 1927.

device in *Paysanne tricotant* of 1855 (pl. 57), as well as in other sketches
of this period,[17] which Whistler probably knew by this time.

Whistler made at least one, and possibly two more sketches at Col-
ogne which were later used as the basis for etchings. They are related
in subject, and show Ernest seated in the open air sketching, watched
by a group of interested locals. One of these was given the title *Mr. Whistler
Seated, Sketching, three people watching him* (pl. 63) and the other *Succès
d'Ernesti à Cologne* (pl. 65). They were both transposed onto copper fol-
lowing Whistler's return to Paris. The first became *Treize eaux-fortes
d'après nature* (pl. 64), the discarded title page to the "French Set", and
the second, the published *Title to the "French Set", K.25* (pl. 67). The
influence of Gavarni may be detected in the published plate, which
recalls the title page of *Les Français peints par eux-mêmes*, where the artist
is seen sketching surrounded by people from all walks of life. It may
also be seen in the caricature of the elliptical child on the extreme right
with the mask-like shadow across her face, who recalls Gavarni's absurd
*Carnival* characters.

Every day Whistler and Ernest went to the Post Office to see if money
had arrived, and every day the officials said "Nichts, Nichts!"[18] Finally,
they were forced to reveal their situation to Herr Schmidt, and to set
out on foot for the nearest American consulate at Aix-la-Chapelle.
Whistler put his copper plates in his knapsack and asked Schmidt to
place his seal on them and keep them safely, "with the greatest care
as the work of a distinguished artist—once back in Paris, I would send
money to pay the bill, and the landlord would then immediately send
the knapsack . . . he agreed . . . Then with a supply of paper and pencils
we started off for Paris on foot."[19] Whistler recounted the events in a
letter to his sister written a few days later:

57. Bonvin, *Paysanne tricotant*, 1855.
Black chalk heightened with white
on blue paper, 24.2 × 15.6 cm.
National Galleries of Scotland,
Edinburgh.

Having hopelessly waited for an answer to my letter during ten long
days, Erneste [sic] and I made up our minds (and our sacs) for the
worst, how we, or rather I, explained to Mynherr Schmitz, that there
was no use putting off any longer—how Mynherr Schmitz suffered

58. Whistler, *Deux artistes célèbres de Paris*, 1858. Pencil, 20 × 24.5 cm. Courtesy of the Freer Gallery of Art, Smithsonian Institution, Washington, D.C.

severely from doubts as to the value of our property,—how we nearly wept "tears of anguish" on being obliged to trust the same in his coarse, unappreciating hands,—how we sorrowfully took leave of our host and our collection of drawings, the result of so much hearty work—of my series of etchings—my chefs d'oeuvres upon which I had built so bright and so certain a future. [20]

On the way to Aix-la-Chapelle, the two artists made their living by drawing portraits for a few sous using the supply of paper and pencils they had brought with them from Cologne. They fell in with a group of performers travelling to the fall fairs, who gave entertainments in the villages through which they passed. A number of drawings survive from this stretch of the journey, including *Deux artistes célèbres de Paris! Descendus à la cour profonde, font des portraits à trrrois frrrancs ! ! !* (pl. 58). Their shoes wore out, and each evening Whistler, who had worn patent leather, pieced them back together. All hopes of reaching Amsterdam had by this time evaporated. [21]

Finally, after walking thirty-five miles from Cologne to Aix-la-Chapelle, Whistler got money from the American Consul. On October 7 his passport was stamped at Liège "Chemin de fer de Paris à la Frontière Belge, Bon pour la France," and within a few hours he and Ernest got off the train in Paris. They had been expected back at least ten days earlier. George Lucas had gone to look for Whistler on September 28, and noted in his diary in cryptic fashion "To see Whistler, not returned." [22]

Following his arrival, Whistler went straight to the Louvre. A young painter, Henri Fantin Latour, who was engaged in copying Veronese's *Marriage Feast at Cana*, noticed a "strange character wearing a bizarre

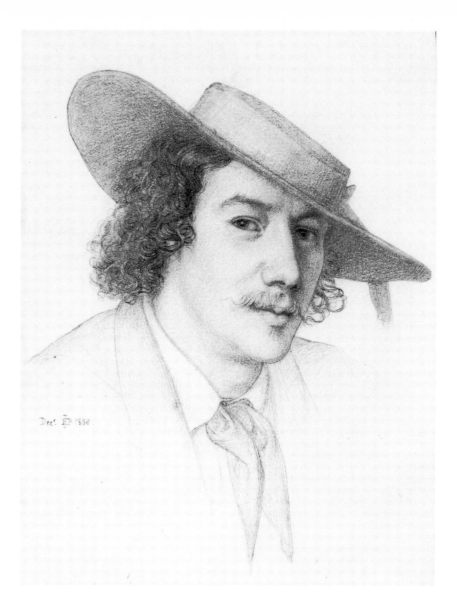

59. Poynter, *Portrait of Whistler*, Dec. 1858. Pencil, 18.6 × 13.2 cm. Courtesy of the Freer Gallery of Art, Smithsonian Institution, Washington, D.C.

hat,"[23] who stopped to chat with him. Clearly taken with Whistler, Fantin invited him to meet some of his friends at the Café Voltaire that evening. Here Whistler recounted his adventures and described his latest etchings to Fantin's circle which included the etchers Alphonse Legros, Félix Bracquemond and the painter Edouard Manet. This was the beginning of his association with the young realists who immediately recognized him as a kindred spirit.

## 6. The "French Set"

The remaining three weeks of October were taken up with the proving of the plates and the execution of six more etchings, four from drawings made on the Rhine journey, and two from nature. It is not surprising that Whistler's mother, who had heard about the trip at second hand,

49

60. Millet, *La Cardeuse*, L.D. 9,
1855. Etching, 10.7 × 7.4 cm. Art
Gallery of Ontario, Gift of the Sir
Edmund Walker Estate, 1926.

was confused as to whether he had made etchings or drawings on the
journey. She wrote to a friend saying: "during a pedestrian tour through
parts of France and Germany this Autumn, [he] was inspired by the
beauty of nature to sketch ... then on his return to Paris to impress
on copper plates the etchings."[1] It would appear from the cor-
respondence between Haden and Mansfield that Whistler, in fact, did
both (see Appendix A).

He wasted no time retrieving his plates and making arrangements
to have them proved at the press of Auguste Delâtre at 171 rue
S. Jacques. Whistler must already have known of Delâtre's outstanding
reputation as a printer of etchings, and may have been advised to go
to him by Legros or Bracquemond, whose plates he had already
printed.[2]

In his shop on the rue S. Jacques, Delâtre regularly printed for the
men who are now considered the pioneers of the etching revival. It had
two windows looking out onto a garden, a loud clock in the corner,
and a large press on which trial proofs were pulled and editions run.
Delâtre apparently stored the copper plates of those who came to him,
as well as impressions taken from the plates. His shop became a centre
for the dissemination of technical information, and a place where con-
temporary etching could be viewed by artists and collectors.

Whistler must have spent time going through Delâtre's portfolios,
where he could have seen, among the recent work, the etchings of Jean
François Millet. The great Barbizon painter had learnt to etch from
his neighbour Charles Jacque, and made a handful of monumental etch-
ings in the mid 1850s. Two of these, *La Couseuse*, L.D. 9, 1855 and *La
Cardeuse*, L.D. 15 (pl. 60), portray peasant women quietly sewing or
carding in shadowed interiors. The stillness and intimacy of the subject
recalls the Dutch interiors of the seventeenth century.

Continuing where he had left off in the summer, Whistler looked for
new subjects in the streets of Paris, and made two plates from nature,
*La Vieille aux loques*, K.21 (pl. 61), and *The Rag Gatherers*, K.23 (pl. 62).
The first of these recalls the large figure in Millet's *La Cardeuse*, and
is the first of Whistler's seated female profile portraits. His interest in
the motif of the women silhouetted in a doorway, thrown into relief
by a shadowed interior, was anticipated in his drawings for the etchings
*La Marchande de moutarde*, K.22 (pl. 54), and *The Kitchen*, K.24 (pl. 47),
which he transposed to copper at this time. In *The Rag Gatherers*,
Whistler made the doorway itself, festooned with rags, into the subject;
he was unhappy with the result and added two standing figures in 1861.
It was in this group of etchings more than any other that Whistler
demonstrated his debt to the Dutch, to the realist Bonvin, and to the
Barbizon etchers Jacque and Millet. The motif of the figure in the door-
way was one of the earliest "themes" to enter his etched work, and one
which would resurface in the Venice, London and Paris etchings.

The last etchings to be made were probably the two title plates, the
first of which was abandoned after the pulling of a single trial proof.
It was made from a drawing executed on the journey entitled *Mr.
Whistler, seated, sketching; three people watching him* (pl. 63), and was copied
unchanged onto the copper plate except for the figure of the artist,
which was turned with its back to the viewer and made to look more
like Whistler than Ernest Delannoy who posed for it. The title *Treize*

61. Whistler, *La Vieille aux loques*,
K. 21, 1858. Etching,
20.8 × 14.7 cm., from the Winans
Scrapbook. Metropolitan Museum
of Art. Gift of Margaret C. Buell,
Helen L. King, and Sybil A. Walk,
1970.

50

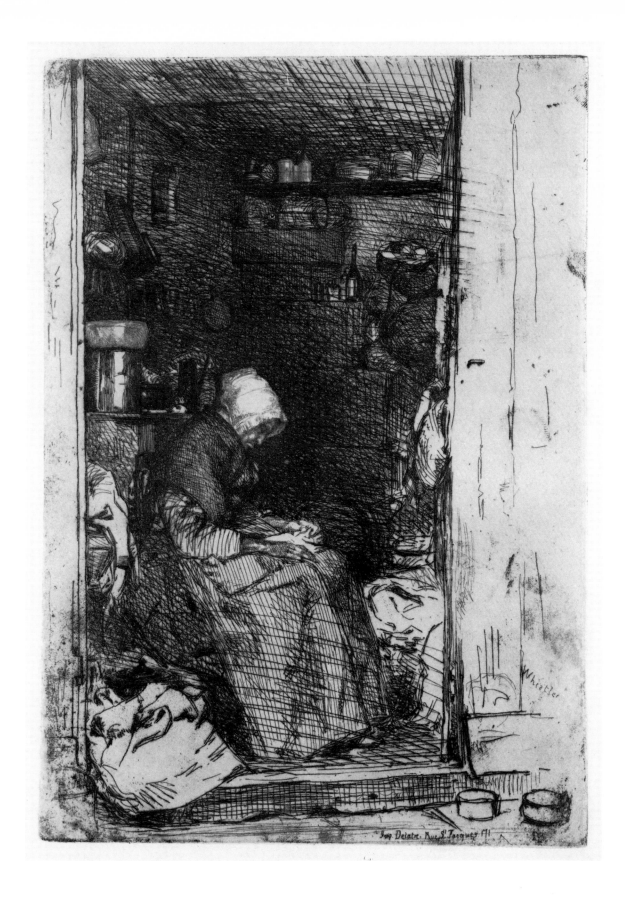

Imp. Delâtre. Rue St Jacques 171.

Whistler

62. Whistler, *The Rag Gatherers*, K. 23, 1858. Etching, 15.3 × 9.0 cm. Reproduced by permission of the Trustees of the British Museum.

*eaux-fortes d'après Nature* (pl. 64) was inscribed above the image, and the dedication "à mon vieil ami Seymour Haden" was placed below. It is not clear why Whistler discarded the plate; a number of letters were accidentally etched backward, and the composition was rather awkward in reverse.

Whistler then took out another sketch on the same theme, *Succès d'Ernesti à Cologne* (pl. 65), and transferred the composition to a grounded copper plate by tracing it from the front with a pointed stylus (pl. 66).[3] This is the only time that he appears to have used this old technique for transposition. The composition came out the reverse of the drawing, and was inscribed with the new title *Douze eaux-fortes d'après Nature* (pl. 67), while retaining the dedication to Haden.

Delâtre probably showed Whistler how to mix the "Dutch mordant" in which the plates were bitten.[4] Whistler used the technique of multiple biting at this time, removing the plates from the acid bath and using stopping out varnish to cover the areas which were sufficiently well bitten, before immersing the plate once again in order to etch the dark lines more deeply. The foul biting, which appears along with Whistler's fingerprints in the margin of such plates as *La Vieille aux loques* (pl. 61), shows how much the ground was weakened by the manipulation of the plate.[5] Whistler does not appear to have minded these "accidents of

52

the bath,'' which were not uncommon in the etchings of Rembrandt.[6]

Before proving the plates, Delâtre probably dispatched Whistler to look for pieces of antique paper on which to pull experimental proofs. According to the Pennells, by 1858 Whistler was "already hunting for beautiful old paper, loitering at the boxes along the 'quais', tearing out flyleaves from the fine old books he found there."[7] Most contemporary paper was highly acidic and bright white following the introduction of wood pulp and chlorine bleaches into the paper-making process during the first half of the nineteenth century. The etching revival brought with it a new aesthetic sensitivity to the tone and structure of old hand-made rag papers, and an interest in the history of paper itself.[8] Etchers, most notably Meryon, had begun in the early 1850s to hunt for antique European papers, as well as for the lustrous, silky Japanese papers which found their way to Europe in increasing numbers after the opening up of Japan to trade with the west in the late 1850s.

Following Rembrandt's example, Whistler searched constantly for loose sheets of paper and old books which he could break up to provide paper for proofs. Throughout his life his favourite papers for printing both etchings and lithographs were "old Dutch" and "most precious Japanese." "Old Dutch" was creamy eighteenth-century Dutch laid paper of very high quality. Made from rags on finely constructed wire moulds, it was produced in enormous quantities and exported all over Europe; in Whistler's day it was still possible to find great packages of it in Paris, London and Amsterdam.[9] Japanese paper came in a variety of tone and thickness. Made from the bark of the mulberry tree, it differs in colour and texture from pale cream to a pronounced yellow. It was available in a variety of weights: some called "japon fort" were

63. Whistler, *Mr. Whistler, seated, sketching; three people watching him,* 1858. Pencil, 20.7 × 15.4 cm. Courtesy of the Freer Gallery of Art, Smithsonian Institution, Washington, D.C.

64. Whistler, *Treize eaux-fortes d'après nature,* K. App. 443, 1858. Etching, 15.8 × 10.8 cm. Reproduced by permission of the Trustees of the British Museum.

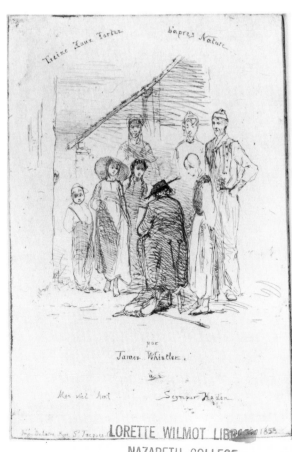

65. Whistler, *Succès d'Ernesti à Cologne*, 1858. Pencil, 9.8 × 15.1 cm. Courtesy of the Freer Gallery of Art, Smithsonian Institution, Washington, D.C.

66. Whistler, Verso of pl. 65, showing the stylus marks used to transfer the drawing to the copper plate.

67. Whistler, *The Title to the French Set*, K. 25, 1858. Etching, 11.1 × 14.6 cm., from the Winans Scrapbook. Metropolitan Museum of Art. Gift of Margaret C. Buell, Helen L. King, and Sybil A. Walk, 1970.

as heavy as vellum, and others known as "japon mince" were as thin as onion skin. Whistler preferred the silky texture of the thin papers which when held up to the light have the translucency of porcelain and show off the lines of etching beautifully, as Rembrandt had been the first to demonstrate.[10]

Whistler took proofs of the etchings of 1858 on interesting sheets of paper of the kind preferred by Rembrandt.[11] These included heavy grey "oatmeal," soft and rugged in appearance, which was used for a proof impression of *The Unsafe Tenement* (Rosenwald Collection, National Gallery of Washington). It also included pale blue *papier bleuté* which was used for several impressions of *Street at Saverne* (Rosenwald Collection), and the pale green *papier verdâtre*, loved by Meryon, for an impression of *La Vieille aux loques* (Victoria and Albert Museum). At this time, Whistler had a small hoard of very thin, pale Japanese paper, traversed by dark brown mulberry bark fibres the colour of toasted coconut, which he saved for special proofs. It was used for impressions of *The Kitchen* and *La Vieille aux loques* (Boston Public Library).

While Whistler and Delâtre were still engaged in the process of pulling trial proofs, Seymour Haden came to Paris on business and went to check up on his young brother-in-law. Whistler took him to Delâtre's to watch the proofs being pulled, and Haden, who was "surprised by the beauty of his work,"[12] was apparently fascinated by the process. According to Whistler, Haden developed "his strong sense of good printing . . . while watching the proofs of the French Set as they were proved by me and printed by Delâtre to whom I introduced him."[13]

They must have been greatly impressed by the artistic effects which Delâtre was able to achieve with the plate *Street at Saverne*. He had developed much of his technical knowledge while printing Rembrandt's reworked plates, and had experimented in the manner of the Dutch master with the use of plate tone to create *chiaroscuro* effects. This process involved leaving residual films of ink on selected areas of the plate, and wiping it clean wherever highlights were wanted. Delâtre referred to his method as "artistic printing." By manipulating the amount of plate tone on the surface of the copper plate, he was able to make the shadow lighter or darker, and the area around the wall lamp more or less obscure, transforming the time of day from early evening to dark night. By varying the colour of the ink from warm brown to black, and the paper from yellow *japon mince* to blue or grey laid, he could also change the tone of the work from warm to cold, and with it the mood, which became by turns intimate or sinister. This important plate owes much to Rembrandt's manipulation of surface tone over line to create special nocturnal effects, which may be seen most dramatically in the radical changes to the plate *Christ Crucified between the Two Thieves*, B.78 (pls. 68–69). It was Delâtre's method of "painting" with ink on the plate which inspired Whistler and Haden to experiment with chiaroscuro effects and the lighting of compositions from within a few weeks later.

Whistler must already have been engaged in making the final selection of plates to be included in his first published set of etchings when Haden arrived in Paris. He had not completely recovered from the effects of exposure on the long walk from Cologne to Aix-la-Chapelle, and according to Mrs. Whistler, Haden, "pained to see him not taking care of his health, coaxed him into consenting to spend the winter in

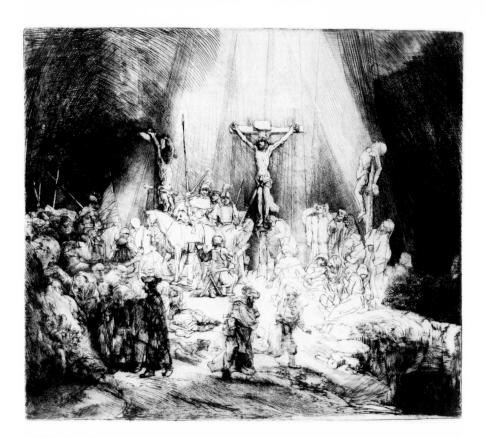

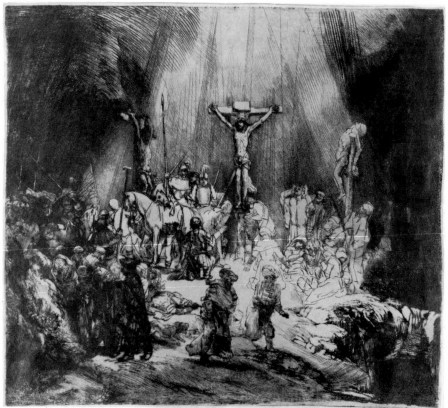

their home, and realizing a competency from the sale of his work." [14] Whistler agreed, and only remained in Paris long enough to see the first sets printed.

The final selection of plates was listed on the Prospectus which accompanied the set as follows:

1. Liverdun
2. La Rétameuse
3. En plein soleil
4. The Unsafe Tenement
5. La Mère Gérard
6. Street at Saverne
7. Little Arthur
8. La Vieille aux loques
9. Annie
10. La Marchande de moutarde
11. Fumette
12. The Kitchen

At first the selection appears to be random, and is neither "French" nor a "Set" in conventional terms. Whistler had chosen two of the five etchings of the Haden children, five of the seven Paris etchings made during the summer and autumn, and five of the ten plates made or conceived on the Rhine journey. Stylistically the plates are uneven, a fact which does not help to give the set visual integrity, though it does demonstrate Whistler's rapid evolution as a draughtsman and his growing mastery of the etching technique. The viewer might well ask why he chose to include such tentative early efforts as *Little Arthur* along with such complex plates as *The Kitchen*.

The key to understanding the selection may be found in the titles to the set, both published and unpublished. Whistler, who always referred to it as the "French Set," could not have intended the generic title to be taken literally, for the plates were made in England, France and Germany. However, the chief sources of inspiration which lay behind it were to be found in the *avant-garde* artistic and intellectual circles in Paris, of which Whistler had become a part.

The first of many forgettable titles to Whistler's sets of changes, *Douze eaux-fortes d'après Nature*, unequivocally reveals Whistler's allegiance to the naturalist movement, and quite deliberately avoids emphasizing narrative or thematic elements. In selecting and mixing at random portraits of children, friends, the urban working poor, and urban and rural genre, Whistler demonstrated his awareness of the direction in which French art was heading after the Salon of 1857. He selected for inclusion not the most consistent group of etchings which he had made to date, but those which demonstrated the virtuosity of his realist repertoire. His subjects were all contemporary, all taken from nature, and were all drawn from his domestic environment or from the lower-class life of the streets and villages. The plates executed or conceived on the journey through Alsace and up the Rhine made no effort to draw on the poetic or romantic possibilities of the landscape, so recently immortalized by Turner. The scenes chosen are characterized by their very banality and by the fact that they could have been found

almost anywhere in rural France or Germany. The subjects themselves, and the neutral approach which he adopted towards them, placed him at once among the objective naturalists or realists.

In addition to revealing an adherence to naturalism in his choice of subjects, Whistler demonstrated his debt to certain painters and etchers, ancient and modern, who were seen as part of the naturalist movement. They included Rembrandt and Pieter de Hooch, Jacque, Gavarni, Meryon, Millet, Bonvin and Courbet. By emulating the style and subjects of these men, Whistler would have intended his contemporaries to see in this set not only a commitment to naturalism, but an admiration for certain of its adherents. Fantin Latour saw the etchings as having special significance and later reminded Whistler that he had been "the first to appreciate them and the one who had understood their significance at the Café Voltaire."[15]

The set was dedicated to Haden in part out of recognition for his role in assisting with its publication. More significantly, however, the dedication "to my old friend Seymour Haden" appears to be an acknowledgement of Whistler's debt to his brother-in-law for his initial orientation toward naturalism. In using the word "old," he was probably thinking of the influential year 1848–9 when Haden had introduced him to the etchings of Rembrandt and arranged for him to hear Leslie's lectures.

The published "French Set" was printed on *chine collé*, thin sheets of Japanese paper cut to the size of the copper plates and mounted onto larger sheets of machine-made wove paper of equal dimensions. The creamy yellow "chine" used in the first edition, which has a tendency to turn golden or orange, provided a sympathetic surface for the printing of etched lines. The white wove backing reinforced the flimsy sheets, made them strong enough to frame, and gave the publication the requisite uniformity of scale. Twenty sets were issued in Paris at the beginning of November, and fifty in London a few weeks later. The only difference between the Paris and London editions is that the title page of the Paris edition was printed on *chine collé* and was included as a thirteenth sheet in the set, whereas in the London edition it was printed directly onto the front of the large dark blue paper wrapper which encased the other twelve sheets. The Prospectus which accompanied the set bore both French and English titles interspersed.

Before the whole edition had been printed, Whistler departed for London on November 6, only one month after his return from the Rhine. He went to 62 Sloane Street and awaited the arrival of Delâtre, whose bill was forwarded on November 9 by Ernest Delannoy.[16] A few days later the master printer arrived with the London edition, which was published from 62 Sloane Street. Haden, assisted by Mrs. Whistler in America, immediately set to work to market the Set. Mrs. Whistler wrote to all her friends saying that Haden "warrented" Whistler "25 subscribers at 2 gn. each in London, and depends on myself interesting 25 in Jemie's native land." She reassured them of the artistic merits of the etchings and the security of their investment by saying that "Mr. Haden who has superior artistic judgement and taste thinks them of rare beauty," and added that he would "forward safely to subscribers everywhere."[17]

Thus Whistler satisfied his ambition to create a set of etchings which

70. Whistler, *Auguste Delâtre*, K. 26, 1858. Etching, 8.2 × 5.6 cm. Courtesy of the Freer Gallery of Art, Smithsonian Institution, Washington, D.C.

71. Whistler, *The Wine Glass*, K. 27, 1858. Etching, 8.4 × 5.5 cm. Reproduced by permission of the Trustees of the British Museum.

72. Rembrandt, *The Shell*, 159, B. 1650. Etching, 9.7 × 13.2 cm. Reproduced by permission of the Trustees of the British Museum.

73. Haden, *Amalfi*, H. 10, 1858. Etching, 11.7 × 8 cm. S. P. Avery Collection, The New York Public Library, Astor, Lennox and Tilden Foundations.

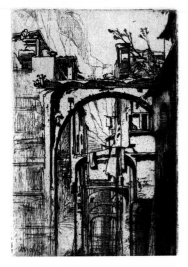

would launch his career. The publication of *Douze eaux-fortes d'après Nature* predates the painting of his first salon submission or any major work, and may be seen to mark the beginning of his mature artistic career. The precocity which he demonstrated with the etching needle placed him at once among the leading painter-etchers of his day and at the forefront of the resurgence of interest in etching which was just beginning in France and England at that time.

## 7. Domestic Genre Etchings

Delâtre arrived in London a few days after Whistler, and came to stay at 62 Sloane Street. Haden, greatly impressed by Delâtre's methods, took the printer to a meeting of the Etching Club, with which he had recently become associated, on November 16. After he had been introduced by C. W. Cope, as "Monsieur Delâtre, who has a reputation in Paris as a printer of etchings," the members of the Club "discussed with him the printing of their plates, which he thought capable of a much more artistic treatment," saying that "far more might be done by the printer."[1] It was decided that nine plates should be sent to him in Paris, and that he should return to London with the proofs and bring them to a meeting on January 14.

Stimulated by Whistler's recent success and by his presence in the house over Christmas, Haden began to devote himself seriously to etching. In late November or early December he appears to have installed a press in a room at the top of the house which contained "all the tools of the etcher."[2] It was in this "atelier" that Whistler and Haden now bit and proved their plates.

During the first few weeks of his visit to Sloane Street, Whistler made three diminutive plates: *Auguste Delâtre*, K.26 (pl. 70), *The Wine Glass*, K.27 (pl. 71),[3] and *Reading in Bed*, K.28.[4] The scale, style and subjects recall Rembrandt, and it is more than likely that Whistler was poring over Haden's growing Rembrandt collection at this time.

59

74. Seymour Haden Jr., *Porta di S. Giovanni* (with a portrait of Whistler). Etching, 11.3 × 27.8 cm. Charles Seidman Collection.

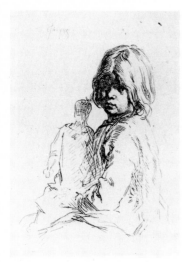

75. Jacque, *Ma Petite Fille*, G. 155, 1850. Etching, 8.3 × 6.4 cm. Crown Copyright, Victoria and Albert Museum.

76. Haden, *Cup and Saucer*, 1858. Charcoal, 16.3 × 23.5 cm. Albright-Knox Art Gallery, Buffalo, New York, Gift of Dr. Frederick H. James, 1891.

The first of these, the portrait of Delâtre, must have been made during the printer's visit in the second week of November. Whistler dedicated the work to the master craftsman who had worked so closely with him on the "French Set," inscribing on the plate the words "homage à M. Delâtre." It was the first of several portrait etchings and drypoints of fellow artists and men of culture executed by Whistler in 1858–9. Men of this genre, referred to by Castagnary as "hommes d'élite,"[5] were considered worthy subjects for realist portraiture.

*Reading in Bed*, K.28, is the first of Whistler's middle-class domestic genre subjects. It was undoubtedly suggested by the intimate glimpses of home life found in seventeenth-century Dutch painting, and in particular by such Rembrandt etchings as *Studies, with Saskia Lying ill in Bed*, B.369. Although a portrait of Deborah, it was conceived simply as a genre study, and was initially entitled "The Slipper."[6]

While he never focussed attention on still life as an end in itself, unlike Fantin, Whistler did make one small plate entitled *The Wine Glass*, K.27, which reveals his ability in this area. Leslie had encouraged his students to "try to paint the commonest object as the best Dutch painters would have painted it,"[7] and Whistler may have aspired in this work to emulate the minute scale, clarity and brilliance of Rembrandt's etching *The Shell*, B.159 (pl. 72).[8] Like the shell, the wine glass is a study of a form seen in light against a dark ground.

While Whistler was busy with these plates, Haden appears to have taken out his Italian sketches and made *Amalfi*, H.10 (pl. 73), the last etching based on a preliminary drawing. The row of diminishing and receding arches etched with a strong dark line recalls Piranesi and Meryon. Haden's interest in creating a convincing visual recession using a series of arches may have been stimulated by Whistler's Paris plates of figures in doorways executed a few weeks earlier.

Haden's young son Seymour appears to have asked his father and uncle to show him how to etch at this time. He may have begun *Porta di S. Giovanni (with a portrait of Whistler)* (pl. 74),[9] on a discarded plate of Whistler's which bears the outline of a male portrait head. Seymour must have worked from one of his father's Italian sketches, and no doubt received instruction from both his elders.

By the end of the first week of December, Whistler and Haden had progressed to more ambitious plates, and Whistler had begun a portrait of *Annie Seated*, K.30 (pl. 78). The style of this etching, with its detailed treatment of the face, and summary treatment of the body, reflects the study of Rembrandt, and may be compared to Jacque's *Ma Petite Fille*, G.155, 1850 (pl. 75).[10] The introspective, slightly melancholy note, distinctly contemporary, again recalls the adolescent girls of Millais.

Whistler's plate *The Wine Glass* may have inspired Haden to take up his chalk, for on December 19 he made a drawing of a cup and saucer (pl. 76), and on the following day, a wine glass.[11] The cup and saucer appear in two etchings: Haden's *A Lady Reading*, H.9 (pls. 79–82), and Whistler's *Reading by Lamplight*, K.32 (pl. 77). The brothers-in-law apparently sat side by side and etched while Deborah read, then took proof impressions of their plates on the press at the top of the house.

The two copper plates are virtually identical in scale, although Whistler placed his in a vertical position, while Haden used his horizontally. Haden must have been troubled by the vacant area to the right

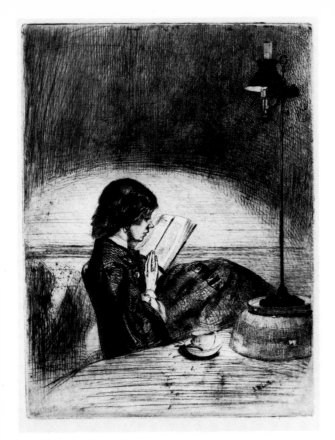

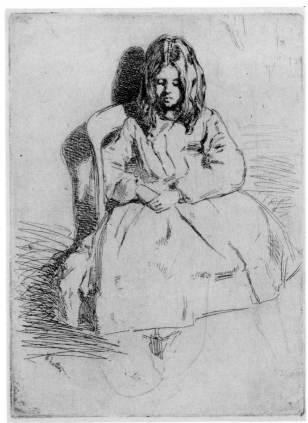

77. Whistler, *Reading by Lamplight*, K. 32, 1858. Etching 15.9 × 11.9 cm. Courtesy of the Freer Gallery of Art, Smithsonian Institution, Washington, D.C.

78. Whistler, *Annie Seated*, K. 30, 1858. Etching, 13.1 × 9.7 cm. Courtesy of the Freer Gallery of Art, Smithsonian Institution, Washington, D.C.

of the lamp, for after taking proof impressions "A" (pl. 79), and "B" (pl. 80), he filled it with a figure of Annie copied from Whistler's plate, *Annie Seated*, K.30. Haden readily admitted his borrowing when presented with proof state "C" years later, and wrote on the verso: "This plate was founded on, and done at the same time as two plates of Whistler's and was intended to suggest a composition for a picture. So far as I can recollect the only impression taken of the plate in this state was given to Whistler. If so, this must be the impression."[12] (pl. 81). Haden must not have found the figure satisfactory, for he burnished it out before taking proof "D" (pl. 82). Whistler's plate *Reading by Lamplight* was more sure than Haden's *A Lady Reading*, reflecting the experience gained from his recent publication.

In December, Whistler and Haden devoted themselves to experimenting with compositions lit from within, and to creating chiaroscuro effects. *A Lady Reading* provided Haden with an opportunity to explore the artistic printing methods of Delâtre by leaving varying amounts of plate tone on the surface of the copper plate. This interest in creating *tenebroso* effects must have been stimulated by the variety of effects achieved by Delâtre in printing Whistler's *Street at Saverne*. It stemmed from the primary example of Rembrandt, who had lit several etchings from within and used both line and plate tone to create nocturnal effects. During the course of their experiments, Whistler and Haden undoubtedly looked at Rembrandt's *Christ Crucified Between two Thieves*, B.78, which Haden owned in a rare first state printed on parchment.[13]

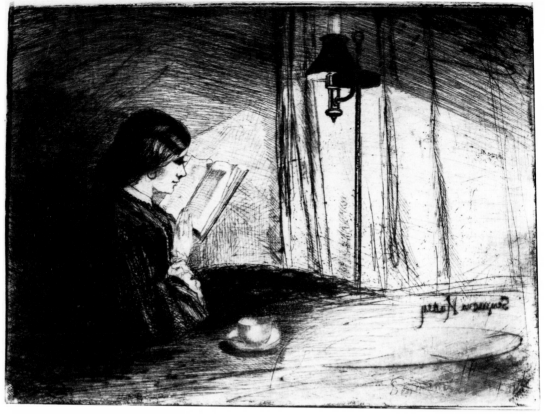

79. Haden, *A Lady Reading*, H. 9, Trial proof A. 1858. Etching, 11.8 × 15.5 cm. Reproduced by permission of the Trustees of the British Museum.

80. Haden, *A Lady Reading*, H. 9, Trial proof B, 1858. Etching, 11.8 × 15.5 cm. Reproduced by permission of the Trustees of the British Museum.

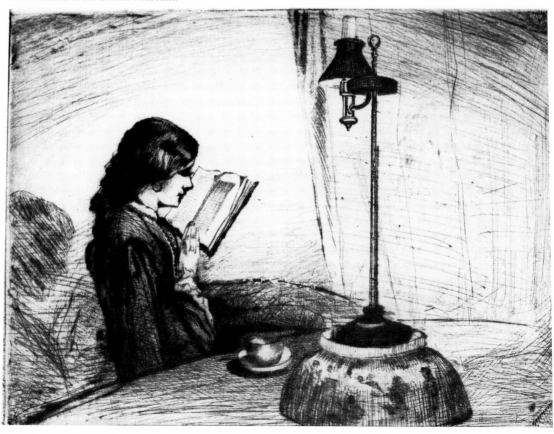

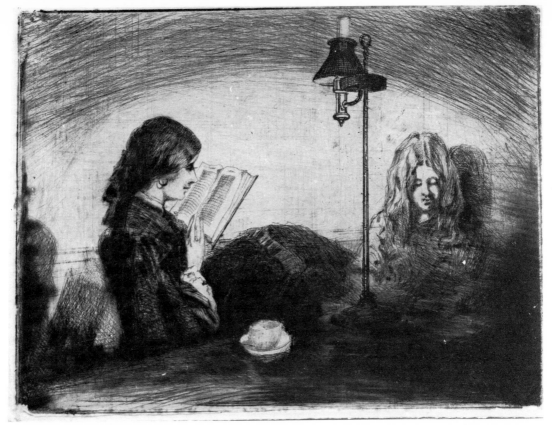

81. Haden, *A Lady Reading*, H. 9, Trial proof C, 1858. Etching, 11.8 × 15.5 cm. Metropolitan Museum of Art, Dick Fund, 1917.

82. Haden, *A Lady Reading*, H. 9, Trial proof D, 1858. Etching, 11.8 × 15.5 cm. Reproduced by permission of the Trustees of the British Museum.

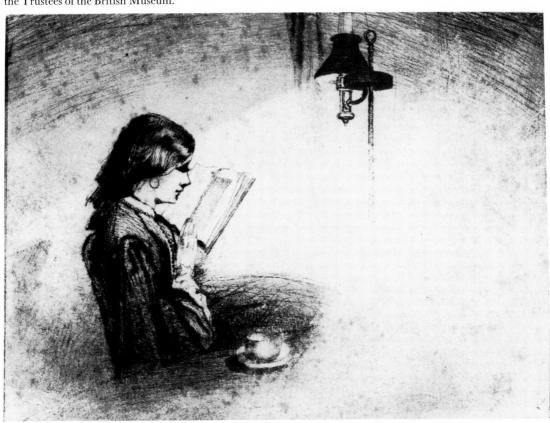

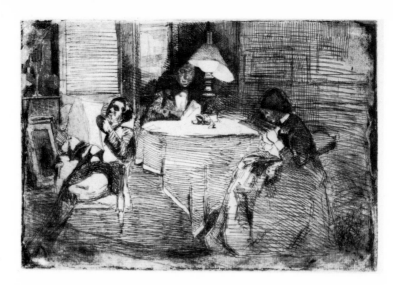

83. Whistler, *The Music Room*,
K. 33, First Trial Proof, 1858.
Etching, 14.5 × 21.6 cm. Courtesy
of the Museum of Fine Arts,
Boston, Gift of the Estate of Lee M.
Friedman.

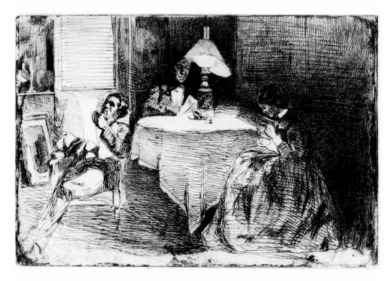

84. Whistler, *The Music Room*,
K. 33, Trial Proof, 1858. Etching,
14.4 × 21.7 cm. Reproduced by
permission of the Trustees of the
British Museum.

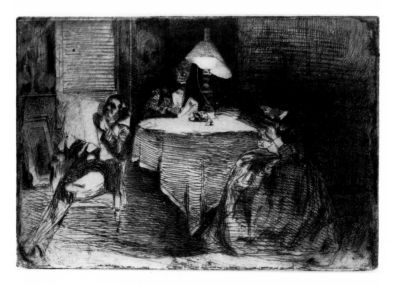

85. Whistler, *The Music Room*,
K. 33, Trial Proof, 14.4 × 21.7 cm.
Reproduced by permission of the
Trustees of the British Museum.

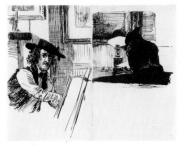

86. Poynter, *Whistler drawing*, 1858. Pen and ink, 18 × 22.5 cm. Courtesy of the Freer Gallery of Art, Smithsonian Institution, Washington, D.C.

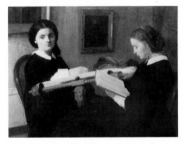

87. Fantin, *The Two Sisters*, 1859. Oil on canvas, 98 × 130 cm. The St. Louis Art Museum, Purchase.

88. Whistler, *At the Piano*, Y. 24, 1858–9. Oil on canvas, 67.0 × 90.5 cm. Taft Museum, Cincinnati, Ohio, Louise Taft Semple Bequest.

Rembrandt had taken this plate through several radical changes of state, and had employed a variety of inking effects whereby he was able to change the weather, time of day, and degree of tragic intensity, creating some of the most dramatic proofs in the history of etching.[14]

Haden's inscription on proof state "C" of *A Lady Reading*, "This plate . . . was intended to suggest a composition for a picture," is significant. It was over the Christmas season that Whistler began searching for an appropriate subject for his first salon submission. He wanted to paint a middle-class domestic genre scene which could hang with Fantin's *The Two Sisters* (pl. 87). Although it is not clear how much Whistler knew about his new friend's proposed submission, Fantin had been making studies of women embroidering and reading in bourgeois interiors for several years. It is likely that the two artists discussed ideas for salon submissions before Whistler left Paris for London in November.[15]

Whistler's next etching, *The Music Room*, K.33, may well have been linked to his search for a subject. Here he employed the theme of reading by lamplight once again, and a more complex composition which includes the figures of Haden, Deborah, and Haden's medical partner James Reeves Traer, sitting around a lamp in the music room of 62 Sloane Street. Whistler must have enjoyed pulling experimental proof impressions, judging by their great variety. Haden inscribed the first of these, which he probably watched Whistler print on the press at the top of the house, "This is the first rude impression pulled from the plate from which it will be seen the ink is scarcely wiped off. Whistler gave it to me and I gave it Burty" (pl. 83).[16] A remarkable series of proofs on different kinds of paper, employing different amounts of surface tone, may be seen in the Print Room of the British Museum (pls. 84–85). Whistler appears to have preferred the heavily inked impressions, and gave a dark one on Japanese paper to his friend and physician, Traer.[17]

Whistler finally found a subject for his salon painting in the music room, where his sister, an accomplished pianist, played the piano. In his first major painting, *At the Piano*, Y.24 (pl. 88), Whistler combined a number of the elements which he and Haden had explored in etching in recent weeks. Initially conceived as a portrait of Deborah playing the piano, Whistler added the figure of Annie listening as an afterthought,[18] and appears to have borrowed certain details of the composition from etchings. The head of Deborah closely resembles Haden's etched profile of *Dasha*, H.8 (pl. 89), made at this time, with its arched nose (which she hated), a slight double chin, and hair pulled back to the nape of the neck. The figure of Annie standing at the end of the piano recalls Whistler's etched portrait of *Annie*, K.10 (pl. 24), made the previous spring. The addition of a second figure is anticipated in Haden's double portrait of Deborah and Annie in proof state "C" of *A Lady Reading*, "intended to suggest a composition for a picture," and by Fantin's salon submission, *The Two Sisters*. The stillness which pervades Whistler's painting, and the use of a bourgeois setting and musical theme, reflect the artist's love of such seventeenth-century Dutch prototypes as Gerard Ter Borch's painting *Le Concert* in the Louvre.

The two months spent at 62 Sloane Street were extremely productive for Whistler and Haden. In November, Whistler had begun to market his first set of etchings with the aid of his family, while Haden, stimulated by Whistler's success, began to apply himself seriously to etching. After

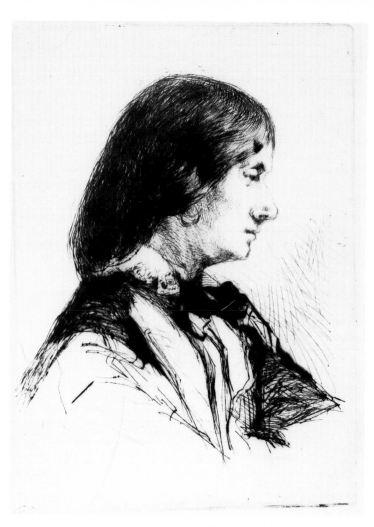

89. Haden, *Dasha*, H. 8, 1858.
Etching, 13 × 9.6 cm. Reproduced
by permission of the Trustees of the
British Museum.

learning the rudiments of fine printing from Delâtre, they began to pull
experimental proofs on Haden's press. Their etchings were closely
related in subject and style, anticipating several years of joint
endeavour. While Whistler's etchings of this period stand on their own
as works of art they appear to be related to his search for an appropriate
subject for his first salon submission. On January 12, 1859, he returned
to Paris, taking the unfinished painting with him.

# CHAPTER TWO

# *Whistler and Realism, 1859–67*

## 1. English Landscape Etchings

Following his return to Paris, Whistler devoted himself to the completion of the oil paintings *At the Piano* and *La Mère Gérard*, which he planned to submit to the Salon in time for the March deadline. He seems to have set aside his etching needle during the spring, since he already had "The French Set" from which to select submissions for the *Gravure* section.

The loose liaison with Fantin and Legros, which had begun in mid-October, solidified when Whistler was conscripted to the "Société des Trois" in the spring. This organization replaced the "Société des vrais bons," which had been formed during the previous autumn, by Fantin, Legros and Louis Sinet. The philosophy of the new association appears to have been modelled on that of its predecessor, described by a disenchanted contemporary as follows:

> Messrs. Sinet, Fantin and Alphonse Legros . . . in their enthusiasm, in their love of art, had founded and inaugurated the *painting of the future*. They had set themselves apart, erected a scaffolding built of artistic theories while demolishing everything around them. They had even established for their exclusive use—the *Société des vrais bons*. No sooner had these gentlemen set out on their explorations than they believed they had arrived: they imagined they had captured success; they paraded their future glories and from on high on the pedestal which they erected over the ruins of modern art, they watched the poor devils like ourselves, who had not had our share of their sunshine, floundering below.[1]

The members of the "Société" undoubtedly hoped to make a joint appearance at the Salon, but this was not to be. Only the work of Legros was accepted; Fantin and Whistler were both among those rejected by the academic jury. Fortunately, early in April, the realist painter

François Bonvin stepped into the gap. Fantin recalled how "Bonvin, whom I knew, interested himself in our rejected pictures, and exhibited them in his studio, and invited his friends, of whom Courbet was one, to see them. I recall very well that Courbet was struck with Whistler's pictures."[2] It is hardly surprising that Bonvin and Courbet took an interest in the young artist, for *At the Piano* was painted using a style and technique inspired by Bonvin, while *La Mère Gérard* shows the influence of Courbet's portraits executed with a palette knife. At this time Courbet was at the height of his powers, and recognized in the young trio a group of talented adherents. He made them welcome, and Whistler, who went to visit him at home, came away shaking his head and saying "He is a great man! A great man!"[3] Throughout the summer of 1859 Fantin and Legros continued to talk about their work with Bonvin and Courbet, and Fantin conveyed their regards to Whistler by letter after he returned to England early in May.

Despite the mixed reception given to his paintings, Whistler had no difficulty having his etchings accepted, and two works, *La Marchande de moutarde* and one entitled "Portrait de femme," were on view in the

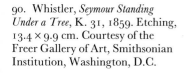

90. Whistler, *Seymour Standing Under a Tree*, K. 31, 1859. Etching, 13.4 × 9.9 cm. Courtesy of the Freer Gallery of Art, Smithsonian Institution, Washington, D.C.

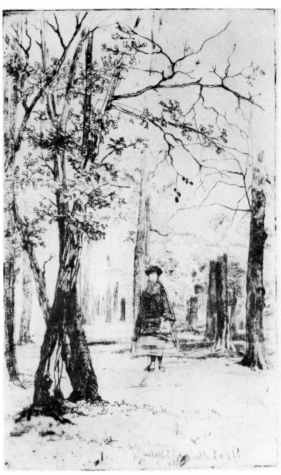

91. Haden, *Kensington Gardens*, H. 12, 1859. Etching, 15.9 × 11.9 cm. Reproduced by permission of the Trustees of the British Museum.

92. Whistler and Haden, *Trees in a Park*, K. 2, H. 13, 1859. Etching, 20 × 12.4 cm. Present location unknown.

Salon from May until August.[4] Seymour Haden had also submitted a work, and was probably responsible for sending etchings on behalf of both himself and Whistler to the annual exhibition of the Royal Academy. Whistler's two entries were listed as "etchings from nature," and were probably taken from the "French Set."[5] Haden's etching, exhibited under the pseudonym "H. Dean," entitled "Vue prise sur la Tamise," can be identified as *Thames Fisherman*, H.11, etched during the spring of 1859.

Whistler left Paris on May 6 to reach London in time to see his etchings at the Royal Academy which opened on May 9. No doubt buoyed by their success, the brothers-in-law took advantage of the fine summer weather to try their hand at *plein-air* etching. Accompanied by Annie and Seymour, they walked up Sloane Street to Kensington Gardens carrying grounded copper plates and etching needles. Whistler probably worked on *Seymour Standing Under a Tree*, K.31 (pl. 90), while Haden worked on *Kensington Gardens*, H.12 (pl. 91). They also collaborated on a plate entitled *Trees in a Park*, K.2, H.13 (pl. 92).

From the beginning it appears that Whistler had a predilection for the human subject and Haden for landscape. In Whistler's first landscape etching, *Seymour Standing Under a Tree*, the boy leaning against the trunk of the old tree dominates the composition, recalling Whistler's

69

early interest in Rembrandt's *St. Jerome Beside a Pollard Willow* (pl. 5). In this plate, Whistler followed Rembrandt's example closely, and gave the impression of having drawn every scale of the bark. This he did by adopting a similar system of describing the contours of the bark using a dark line, and areas of shadow with a series of diagonal lines or cross hatching. The trees in the background are treated in summary fashion, using vertical lines to describe the shadowed areas, crossed by loose zigzags which indicate the girth of the trunk. Foliage is represented by a series of freehand loops, while grass and reeds in the foreground are drawn with sharp linear flourishes. It was this method of describing landscape, focussing detail in the area of greatest interest, while giving more summary treatment to the periphery, that Whistler and Haden derived from their study of Rembrandt's landscape drypoints, which were well represented in the Haden collection. Haden perfected Rembrandt's method in his drypoint *Fulham*, H.19 (pl. 122), a few weeks later, and continued to employ it for years to come.

Haden's work was more laboured and less sure than Whistler's at this time, as a comparison of *Kensington Gardens* with *Seymour Standing Under a Tree* demonstrates. Whistler may have suggested the figure of Annie in Haden's Trial Proof A of *Kensington Gardens*, which was subsequently burnished out and replaced with a glimpse of Lord Harrington's house. It is very likely that the composition of *Trees in a Park* was developed in similar fashion; it has generally been assumed that Haden etched the lofty and elegant trees while Whistler etched the figure. The plate was signed in reverse by both men.

Haden frequently travelled to Greenwich on business, and early in the summer he and Whistler made an excursion to Greenwich Park taking grounded plates with them. They climbed part way up the hill and found an agreeable subject in the form of an elderly Greenwich pensioner semi-recumbent on the grass beneath the trees, enjoying the summer sun. Whistler sat closer to the old man than Haden, having chosen to make a full-length portrait study. Haden was more interested in capturing the mood of the summer day, and chose a much wider focus which included the trees overhead and the light filtering through the foliage. The titles of the plate reflect their divergent interests: Whistler called his straightforward approach to nature *Greenwich Pensioner*, K.34 (pl. 93), while Haden's more literary approach led him to replace the title "Greenwich Park", which Whistler inscribed on the plate for him, with *Sub Tegume*, H.17 (pl. 94). While Haden's plate is essentially a landscape, and incorporates the pensioner only as staffage, Whistler's plate is a perceptive and intimate portrait of an old man who may well have been a veteran of the Peninsular Wars. As such, he was a most suitable subject for realist portraiture.[6]

Whistler probably stayed at Sloane Street after arriving in London in May, but he quickly set about finding a studio in which to live and work, no doubt with the intention of making London his principal base of operations from this time on. He encouraged his Paris friends to join him, and began a lengthy correspondence with Fantin in which he told him of the great wealth which awaited them in London, Haden, who was more than willing to provide them with social *entrée*, invited Whistler's friends to visit, paid their fares, and put them up. The first to come was Ernest Delannoy, who returned to Paris after a visit in

93. Whistler, *Greenwich Pensioner*, K. 34, 1859. Etching, 12.7 × 20.3 cm. Courtesy of the Freer Gallery of Art, Smithsonian Institution, Washington, D.C.

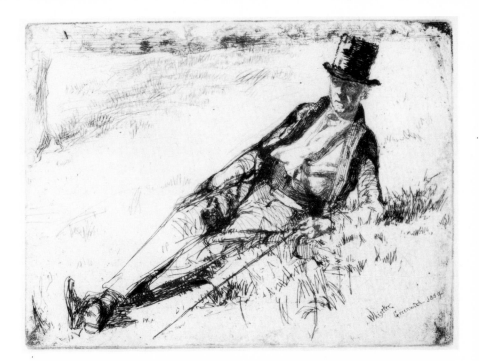

94. Haden, *Sub Tegume*, H. 17, 1859. Etching, 15 × 15.4 cm. Reproduced by permission of the Trustees of the British Museum.

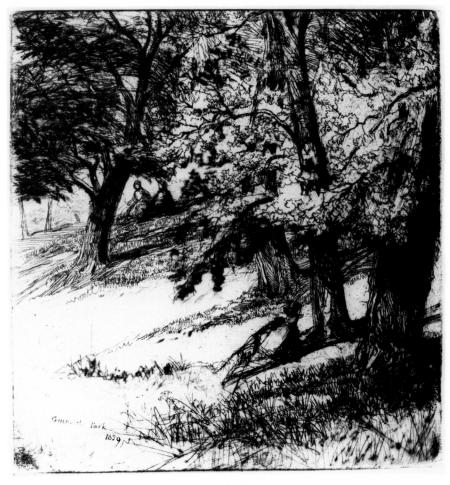

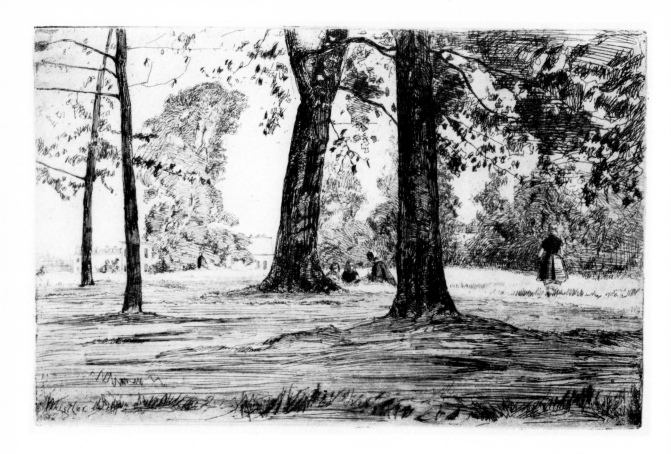

95. Whistler, *Greenwich Park*,
K. 35, 1859. Etching,
12.7 × 20.3 cm. Courtesy of the
Freer Gallery of Art, Smithsonian
Institution, Washington, D.C.

June and told Fantin of Whistler's "superb studio, so comfortable and
well equipped." On June 26, Fantin wrote gently rebuking Whistler
for not writing, and saying that he and Legros were dying to know what
Whistler was creating in the new studio. He reported that Whistler's
etchings had been greatly admired by a gentleman at the Salon, who
had already seen the whole group at Delâtre's,[7] and added that he found
Haden's etchings "devillishly handsome." No doubt gratified by this
response to his work, Haden promptly issued an invitation to Fantin,
who arrived in London two weeks later on July 10.

Fantin was delighted with his visit to the Hadens, and wrote to his
parents saying: "Mr. Seymour is a man whose goodness knows no
bounds; everything is charming, his family, his children, and what a
house!!!"[8] He appears to have greatly enjoyed himself during his three
week visit. Haden wasted no time showing him boxes of etchings, start-
ing with Dürer, Rembrandt and Marc Antonio Raimondi. Fantin was
astonished by the scale and importance of the collection, writing home
to say "there is a fortune in his portfolios." Haden tried to make an
etcher out of him, teaching him how to ground, etch, bite and print
his plates, perhaps in preparation for an etching expedition with
Whistler.[9] Fantin was most impressed by the etching room at the top
of the house, fitted with every piece of equipment the etcher could poss-
ibly want.

Fantin would not have come from Paris empty-handed. It is likely
that he brought the Salon reviews about which he had written in great

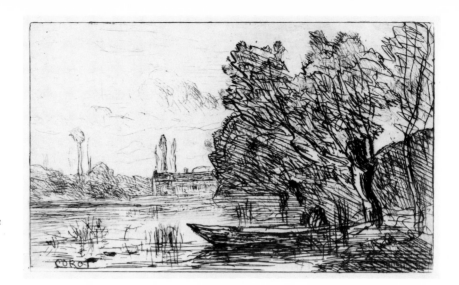

96. Corot, *Ville d'Avray: Le Bateau sous les saules*, L.D. 2, 1857. Etching, 12.1 × 7.2 cm. Reproduced by permission of the Trustees of the British Museum.

excitement to Whistler on June 26. Chief among these was one by Baudelaire, serialized in *La Revue Française* between June 10 and July 20. Fantin was deeply impressed by the sections which had appeared by the end of June, and by Baudelaire himself whom he found "so charming." The critic, who had noticed Legros's painting at the Salon, praised it in his review, saying "Perhaps I am wrong to be totally ignorant of Mr. Legros, but I will admit that I had never before seen a work signed with his name."[10] This marked the beginning of a fruitful relationship between the three young artists and the great poet and critic who had done so much to destroy the stranglehold of academic art following the Salon of 1846.

Whistler and Fantin must have discussed Baudelaire's attitude toward the "realists" or "positivists," as he called them, who were perfectly happy to paint nature as they found it, and in doing so fall victim to the "vice of banality."[11] The critic urged young artists to view nature as a "dictionary" from which to pick and choose, not as a source of ready-made compositions. He stressed the primary importance of the imagination, "queen of the faculties," and the superiority of the "imaginatives," who set out to "illuminate" things with their minds, over the "realists" or "positivists."[12] To all those who were united in opposition to the academic tradition, he wrote, "there is nothing more formidable in our battles with the ideal than a fine imagination disposing of an immense armoury of observed fact."[13]

Baudelaire's comments on the state of landscape at the Salon would have been of great interest to Whistler at this time. Baudelaire decried those who copied nature without bringing out its poetic aspects. His response to the leading group of naturalist landscape painters known as the Barbizon School was mixed. He singled out Corot for praise, seeing in his paintings "an infallible strictness of harmony" and "a deep feeling for the construction" of the picture space in which he maintained the "proportional value of each detail within the whole." Baudelaire defended Corot's much-maligned method of drawing, which was generally denounced as "childish scribble," and said that by using a

97. Whistler, *Landscape with the Horse*, K. 36, 1859. Etching, 12.6 × 20.1 cm. Courtesy of the Freer Gallery of Art, Smithsonian Institution, Washington, D.C.

98. Whistler, *Nursemaid with Child*, K. 37, 1859. Etching, 9.7 × 13.2 cm. Courtesy of the Freer Gallery of Art, Smithsonian Institution, Washington, D.C.

99. Legros, *The Angelus*, 1859. Oil on canvas. Formerly Cheltenham, Mr. Asa Lingard. Present location unknown.

"summary and broad manner" he had provided a much needed challenge to "the modern French school in its impertinent and tedious love of detail."[14]

Baudelaire's review may have given rise to Whistler's dramatic change of style in the landscape etchings of midsummer, 1859. He no longer employed the early manner derived from Rembrandt, adopting in its place the much broader method of Corot, combined with the *naïveté* which Baudelaire also admired in Legros's salon painting.

Whistler appears to have made three landscape etchings *Greenwich Park*, K.35 (pl. 95), *Landscape with the Horse*, K.36, and *Nursemaid with Child*, K.37, during Fantin's visit. The first of these came closest to Corot's drawings, and may have been made on a trip to Greenwich with Fantin. In it, Whistler indicated broad masses of foliage with a diagonal zigzag line, and treated the trunks of trees as areas of tone. A hasty and rather undisciplined "scribble" was used to describe grass and other elements. Such characteristics could be seen in Corot's second etching, *Ville d'Avray: Le Bateau sous les saules*, L.D.2 (pl. 96), of 1857, which Haden acquired for his collection in its extremely rare first state.

In *Landscape with the Horse* (pl. 97) and *Nursemaid with Child* (pl. 98), there is a tendency to flatten the image and to experiment with a deliberate *naïveté* unprecedented in Whistler's earlier work. At first sight the viewer familiar with the artist's earlier or later etchings might well doubt the authenticity of these two plates, their placement among Whistler's mature work, or his ability to draw. Their style appears to have been influenced by his close association with Legros and his admiration for Courbet's Realism.

Legros's work was strongly influenced by the paintings of the German "primitives," in which forms were flattened and the horizon line raised to provide a sense of recession unaided by the tools of Renaissance

100. Legros, *Banlieu de Paris, with a Portrait of Fantin*, M&T 99, 1854–5. Drypoint, 10 × 25.4 cm. Courtesy Wiggin Collection, Boston Public Library.

perspective. His Salon painting *The Angelus* (pl. 99) was roundly criticized by the public for its distorted perspective, but was defended by Baudelaire who, while admitting that the figures appeared to have been "stuck somewhat flatly on to the decoration which surrounds them," said that "by recalling the burning *naïveté* of the primitives," this "was for me but an added charm."[15] Seymour Haden, who purchased the painting after the close of the Salon, did not appreciate its spatial construction, and overpainted it, "correcting" the perspective.[16]

Legros was not the first to be accused of such awkwardness. Courbet had been criticized for the flatness of the figures in *Young Women on the Banks of the Seine*, and the naïve forms of the cows, which were said to be out of scale, poorly drawn and badly integrated with the landscape in his painting *Demoiselles de Village* of 1851 (pl. 31). Such anti-academic elements, which served to upset an art public raised to believe in the supremacy of the Italian High Renaissance tradition, became a trademark of Courbet and his followers.

As members of the "Société des Trois," Legros and Whistler shared only one thing: their mutual love of etching. Whistler would have known Legros's early etchings and drypoints, which displayed similar naïve tendencies. Fantin may have brought some of them with him when he came to England, for Whistler gave Fantin his new etchings to take back to Legros in Paris.

*Landscape with the Horse* is realist in both style and subject. Whistler used an undisciplined line in the sky which resembles that used by Legros in *Banlieu de Paris*, M. & T.99, 1854–5 (pl. 100). The horses are as awkward and out of scale with the landscape as the cows in Courbet's *Demoiselles*, and the buildings are strangely juxtaposed like Legros's suburban tenements. Men putting up telegraph poles inject a jarring modern note into the rural landscape. Jeanron had employed a similar theme in his painting *The Installation of the Electric Telegraph in the Cliffs of Cap Gris-Nez (Pas de Calais)* at the Salon of 1857, which had met with critical opposition on the grounds that this theme from modern life interfered with an appreciation of the beauty of nature.[17] Whistler's objectivity toward technological encroachments on the countryside would have held greater significance for the realists than nostalgic views of unchanged rural areas.

Whistler went further in the flattening of form in his etching *Nursemaid with Child*, which shows his sister Deborah Haden sitting in a park near Holloway with one of the younger children. Here the figures were reduced to geometric tonal areas, and made deliberately awkward and unattractive like the peasant women in Legros's *The Angelus*. In the etching, as in *Landscape with the Horse*, Whistler created a sense of recession by placing the figures closer to the viewer and by moving the horizon line two-thirds of the way up the picture space.

Whistler's interest in the rural landscape soon waned, and he turned instead to the river, making his first etchings of the Thames in late July. He began with two small plates, *Thames Warehouses*, K.38, and *Old Westminster Bridge*, K.39, which recall both in subject and style Hollar's views of London along the Thames, which were well represented in the Haden collection. These may have been the Thames etchings which Fantin took back with him to Paris when he left at the end of July. He wrote to Whistler on August 5 saying that while he had been unable to find

Legros who was out of town, he had given Whistler's etching of Greenwich, "the one which you made with me," to Valton, and that of the Thames to Sinet. He had also left etchings for Ernest and Drouet. Whistler's Paris friends were full of admiration for his new work.[18]

The landscape etchings made between May and July were never published, and were printed in small numbers for private circulation in black ink on cream-coloured laid paper. They were probably proved on the press at 62 Sloane Street during the summer of 1859.

This was Whistler's first and only excursion into traditional landscape etching. He had approached the subject from a variety of aesthetic and theoretical viewpoints, both naturalist and realist, but appears to have decided at this time to leave landscape to Haden. He may have been afraid of falling into Baudelaire's trap of "banality," but probably wanted to find a realist subject with more scope and variety which he could call his own. Following Fantin's return to Paris, Whistler went to live in the unsavoury reaches of the Thames around Wapping and Rotherhithe, where he was to find new material to spark his imagination.

## 2. The Thames Etchings of 1859

Whistler, having sought Courbet's advice before leaving Paris for London in May, saw himself in the summer of 1859 as belonging in the realist camp. Courbet would have told him, as he did other aspiring pupils, that he did not believe in schools, or in the master–pupil relationship, and did not see himself playing the role of teacher. He would have advised Whistler, as he did others, to apply his talents to painting the "ideas and objects of the age he lived in," representing only those things which are "tangible and visible."[1] Whistler would have known from Courbet's "Manifesto" that subjects for realist art could be either beautiful or ugly, and that common people could be given a prominent position. Although Whistler does not appear to have been deeply influenced by Courbet's political leanings he may have flirted with them briefly at this time. Fantin recorded an after-dinner conversation at the Hadens' on July 17 in which the guests discussed Socialism and Proudhon.[2]

Whistler does not figure largely in Fantin's letters home during the month of July, since the former was living in his studio on Newman Street. He took Fantin on excursions to the café Suisse, frequented by French expatriate republicans who opposed the restoration of Louis Napoleon, and on walks on the South Bank to see the "café chantant," gin palace and street vendors. Like Baudelaire and Gavarni, in London as in Paris, Whistler was a *flâneur* and made regular forays into poor districts in search of appropriate realist subjects.

The impetus to explore the area bordering on the Thames may well have found its origin in part eight of Baudelaire's Salon review, in which the critic, weary of landscape subjects, asked why there were no modern seascapes or cityscapes. He lamented the absence of

a genre which I can only call the landscape of great cities, by which

I mean that collection of grandeurs and beauties which results from a powerful agglomeration of men and monuments—the profound and complex charm of a capital city which has grown old and aged in the glories and tribulations of life.

He cited one exponent of the genre, the etcher Charles Meryon, who was mentally ill and living, like one of Fantin's sisters, at the hospital at Charenton. Baudelaire wrote:

Some years ago a strange and stalwart man—a Naval Officer, I am told—began a series of etched studies of the most picturesque views in Paris. By the sharpness, the refinement and the assurance of his drawing, M. Meryon reminded us of the excellent etchers of the past. I have rarely seen the natural solemnity of an immense city more poetically reproduced. Those majestic accumulations of stone; those spires "whose fingers point to heaven," those obelisks of industry, spewing forth their conglomerations of smoke against the firmament; those prodigies of scaffolding round buildings under repairs, applying their openwork architecture, so paradoxically beautiful, upon architecture's solid body; that tumultuous sky, charged with anger and spite; those limitless perspectives, only increased by the thought of all the drama they contain . . . But a cruel demon has touched M. Meryon's brain; a mysterious madness has deranged those faculties which seemed as robust as they were brilliant. His dawning glory and his labours were both suddenly cut short. And from that moment we have never ceased waiting anxiously for some consoling news of this singular naval officer who in one short day turned into a mighty artist, and who bade farewell to the ocean's solemn adventures in order to paint the gloomy majesty of this most disquieting of capitals. [3]

It would have taken Whistler no time at all to seize on the implications of this passage; it was but one short step for him to pick up where Meryon had left off, and to do for London what Meryon had done for Paris. As Bénédite was later to point out, Whistler "looked at the banks of the Thames as Meryon had looked at the banks of the Seine hemmed in between the high buildings of old Paris." [4]

While Whistler saw himself as a member of the "Société des trois" and of the modern French realist school, he planned to make his fortune in London, and set out to create an independent artistic identity by finding an English realist subject. In doing so, he must have been aware of such naturalist forebears as Hollar and Hogarth, who etched the City of London in the seventeenth and eighteenth centuries using the clear dark line of the topographer.

Haden had a very large collection of Hollar, and admired his work so much that he wrote:

If anyone want truth without pretension, let him go to Hollar. If he want perfection of "biting" and the precise degree of gradation required, let him go to Hollar. If he want to live in the time he undertook to illustrate, let him go to Hollar. People sometimes say to me, "What is it that you see in Hollar?" and I always answer, "Not quite, but nearly, everything." [5]

101. St. Mary Overy's Dock, Southwark, n.d. Royal Commission on Historical Monuments (England).

London

102. Hollar, *London Viewed from Milford Stairs*, P. 911. Etching, 9.6 × 17.3 cm. Sidney Fisher Collection, Thomas Fisher Rare Book Library, University of Toronto.

Many of Hollar's views were situated on the Thames, such as the famous *Views of London Before and After the Fire*, P. 1015, in which he recorded the riverside buildings with such accuracy that it is possible to reconstruct the early City. His more picturesque scenic views along the Thames, such as *London Viewed from Milford Stairs*, P. 911 from *London Views*, P. 907–910 (pl. 102), anticipate Whistler's Thames etchings with their foreground boats and wharves, and distant view of the city.

If Hollar was the great recorder of seventeenth-century London, Hogarth was the recorder of the eighteenth century. Whistler's childhood love of Hogarth remained undimmed in adulthood, nor would he have forgotten Leslie's observation that Hogarth "never lost sight of nature," and paid "close attention to the costume and manners of his time."[6] Despite the fact that Hogarth used caricature to draw attention to the social, political and religious ills of his time, he was also a committed realist. The background in many of his plates, such as the pendants, *Beer Street*, P. 185 and *Gin Lane*, P. 186 (pl. 103), document life in working-class London. His depiction of low life, and his careful drawing of buildings with lettered signs, must have greatly interested Whistler and remained in the back of his mind when he went looking for subjects in dockland. Like Hollar, Hogarth's etched line was based on the crisp line of the engraver, rather than the painterly line of Rembrandt and the Dutch etchers with its expressive potential for chiaroscuro. As such, it was well suited to the description of topography.

By midsummer 1859, both Haden and Whistler were interested in the

103. Hogarth, *Gin Lane*, P. 186, 1751. Etching, 36.1 × 30.5 cm. Private Collection.

Thames as a source of subject matter. Haden had etched *Thames Fisherman* early in the spring, and Whistler had begun a commissioned painting of old Battersea Bridge for Constantine Ionides after the opening of the Royal Academy.[7] They were interested in very different aspects of the river. While Haden took Fantin on weekend excursions to picturesque Richmond, where the river was flanked by "grandiose trees," and the sunset appeared to be made of "molten silver,"[8] Whistler took him on a tour of working-class London.[9]

After walking down Piccadilly and then through the Haymarket, Whistler and Fantin passed Westminster Abbey and crossed Southwark Bridge. From the South Bank they saw the City and St. Paul's Cathedral illuminated, before heading east toward Bermondsey. Here the streets were crowded with hawkers and vendors wearing colourful hats and costumes. After passing beneath the great iron viaduct of the London and South Western Railway,[10] they came to an area of "narrow streets leading to the Thames." In order to get into them, an experience Fantin found "frightful," they had to duck. These may well have been the alleyways lined with half-timbered houses in the area known as Jacob's Island, from whose "crazy wooden galleries" the occupants lowered buckets into the polluted river.[11] While Whistler undoubtedly found the area picturesque, it was considered one of the most squalid in London.

In 1859, the Thames where it passed through the City of London was little more than a cesspool into which a great quantity of lime was poured regularly to keep down the stench.[12] A growing fear of disease had led to a move to embank the river, and a bill was lodged in Parliament, which was finally passed in 1862. Medical men, such as Haden, would have been intimately aware of the problem. Decent people did not venture into the dangerous and infested areas around Wapping and Rotherhithe which fascinated Whistler. Dickens, another late-night prowler, who was collecting information for his forthcoming novel, *Our Mutual Friend*, saw the individuals who lived in this area as the human detritus of the diseased river. He described a trip which he must have made many times:

> The wheels rolled on and rolled down by the Monument, and by the Tower, and by the Docks; down by Ratcliffe, and by Rotherhithe; down by where accumulated scum of humanity seemed to be washed from higher grounds, like so much moral sewage, and to be pausing until its own weight forced it over the bank and sunk it in the river. In and out among vessels that seemed to have got ashore, and houses that seemed to have got afloat—among bowsprits staring into windows, and windows staring into ships—the wheels rolled on, until they stopped at a dark corner, river-washed and otherwise not washed at all.[13]

It was in this area that Whistler decided to settle for almost two months, from the beginning of August until early October. Here he found the subjects for eight plates, published as part of the "Thames Set" over a decade later in 1871. They included the large plates *Limehouse*, K.40, *Eagle Wharf*, K.41, *Black Lion Wharf*, K.42, *The Pool*, K.43, *Thames Police*, K.44, *Longshoremen*, K.45, and *The Limeburner*, K.46. Just

as he had chosen to live on the Left Bank in Paris, among the people who were the subjects for his early works, he now went to live at Wapping and became immersed in the life of the area.

Although he appreciated the picturesque disrepair of the wharfs and warehouses which lined its banks, Whistler structured his compositions around the working men whose lives were intimately connected with the river, and who lived in its boats and barges, docks and wharfs, and in the dark streets and alleys around Wapping and Limehouse. In three of the most dramatic plates, *Eagle Wharf*, K.41 (pl. 111), *Black Lion Wharf*, K.42 (pl. 112), and *The Pool*, K.43 (pl. 113), he placed them front and centre where they could not be viewed as incidental to the landscape, and made them disproportionately large in the picture space. They stare out at the viewer, making no apologies for their low social status or unkempt condition. They are never idealized, but are one with the landscape which is a physical extension of themselves. The working men of Wapping and their venue provided Whistler with a most appropriate realist subject: it was contemporary, it was working-class, it combined the elements of seascape and cityscape, and it was above all novel.

Whistler's secondary aim was to show the river "as it was in 1859," and to make of each plate "a little portrait of a place."[14] He was just in time to accomplish this, for by the time that the "Thames Set" was published in 1871, the review which appeared in *Punch* pointed out that Whistler's etchings of "tumble-down bankside buildings from Wapping and Rotherhithe to Lambeth and Chelsea—where all is pitchy and

104. Stanford's New Map of London, 1862, showing the river and its wharves at Wapping: 1. Black Lion Wharf; 2. Eagle Wharf; 3. Thames Police Station; 4. Tunnel Pier; 5. The Angel.

tarry, and corny and coally, and ancient and fishlike," were "all the more precious because the beauties they perpetrate are dying out."[15]

Whistler would have known that the proposed embankment would involve a great deal of demolition and a radical change in the character of the river which remained, despite the building of docks and innumerable wharfs, much as it had been for centuries. All of the wharfs which lined the Surrey side of Lambeth Reach, and many of those on the Middlesex shore between Westminster and Blackfriars Bridge, were scheduled for demolition. His preservationist's instinct appears to have been linked directly to that of Meryon, who had recorded areas of Paris which were threatened with demolition to make way for the ambitious building projects of the Second Empire. Philippe Burty interviewed Meryon in 1863 and pointed out how he had expressed, "with a clarity which is peculiarly French, the intimate and supreme poetry of old Paris which has only survived for our generation to demolish and disfigure without compassion."[16]

The sites which Whistler etched along the Thames are almost unrecognizable today. The area still retains a certain amount of its flavour, despite a century of remodelling and the devastations of the Blitz. It is possible to identify the locations of Whistler's major landscape plates by consulting river wharf charts and *Stanford's New Map of London* of 1862 (pl. 104). Whistler selected the sites for his etchings of 1859 along the north bank between London Bridge and the Thames Tunnel, with the majority situated in Wapping. Some of the images were drawn in reverse on the plate so that they appear the right way around after printing, while others were not, and are printed in reverse.

The most westerly site chosen was Billingsgate fish market, probably etched from Custom House Stairs. A view of London Bridge and the tower of St. Saviour's Church (Southwark Cathedral) is visible in the background. The composition was not reversed, and the scene appears the "wrong way" round in the etching *Billingsgate*. However, the image in *Black Lion Wharf* (pl. 112), which was made to the east of the St. Katharine's Dock, was reversed so that it appears to be the right way round in the etching. This can be determined by comparing the location of Black Lion Wharf which is to the left (west) of Hoare's Wharf in Whistler's etching, with the relative locations of these two sites on Stanford's map. The etching must have been made looking across the river from the South Bank, probably from the Horselydown New Stairs. While most of the area has been demolished, the great Hoare and Co. warehouse still stands, with its old painted sign clearly visible just east of the renovated St. Katharine Dock. Eagle Wharf was only a short distance east of Black Lion Wharf along Wapping High Street. The Thames police station which appears in the etching of that name stood by Wapping Wharf, slightly to the east of Eagle Wharf on the site of the current police station. The wharfs named in the etchings have all disappeared; only a few rotting and picturesque wooden piles remain.

Whistler's style underwent a great change between the etching of the "French Set" and "Thames Set" plates a year later. In the Thames etchings he abandoned the picturesque line which he had evolved from the study of Rembrandt and Jacque in favour of the clean line of the topographers Hollar, Hogarth and Meryon. Like Meryon, who had also been trained as a cartographer, Whistler had learnt the engraver's

105. Whistler, *Longshoremen*, K. 45, 1859. Etching, 15.2 × 22.4 cm. Art Gallery of Ontario, Gift of the Edmund Morris Estate, 1913.

106. Legros, *Le Souper*, M&T 117, 1858–60. Etching, 12.3 × 17.6 cm. Courtesy Wiggin Collection, Boston Public Library.

vocabulary of line. In drawing the figures, he used the naïve style which was eminently suitable for working-class subjects. The crudely drawn figures in the etching *The Longshoremen*, K.45 (pl. 105), can be compared to those in Legros's etching *Le Souper*, M & T 117 (pl. 106).

But the most revolutionary aspect of the early Thames etchings lies beyond the realm of subject matter, and is to be found in the construction of the picture space itself.

## 3. The Radical Reconstruction of the Picture Space

Whistler's interest in constructing the picture space by breaking it into geometric zones in the "French Set" etchings of October, 1858, appears to have been largely influenced by his study of de Hooch, the seventeenth-century Dutch interior, and the work of the realist François Bonvin. The new tendency to flatten his compositions in midsummer, 1859, was probably influenced by Alphonse Legros, and particularly

107. Day Place, Tower Hamlets, London, 1944. Royal Commission on Historical Monuments (England).

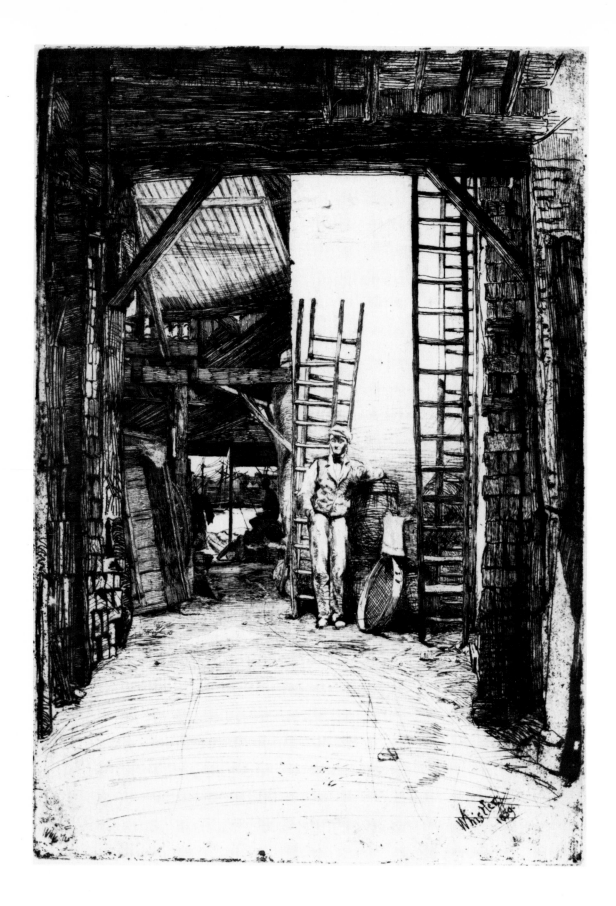

109. Jacque *Intérieur de ferme*,
G. 74. Etching, 16.2 × 24 cm. Art
Gallery of Ontario, Gift of Messrs.
Heintzman and Knoedler, 1927.

108. Whistler, *The Limeburner*,
K. 46, 1859. Etching,
25.3 × 17.8 cm. Reproduced by
permission of the Trustees of the
British Museum.

by his Salon painting *The Angelus*. In the great Thames etchings of late summer, he continued to explore new ways of constructing the picture space, and appears to have been looking closely at the work of two leading contemporary etchers, Charles Meryon and Félix Bracquemond, as well as at photographs and Japanese *ukiyo-e* prints.

The only plate which continued to build on the spatial geometry found in the "French Set" was *The Limeburner*, K.46 (pl. 108). With its succession of open and closed spaces, alternately light and dark, leading the eye deeper and deeper into the composition, it recalls the paintings of de Hooch. This method of constructing picture space in depth using receding archways or doorways was to become a recurring "theme" in Whistler's etched work. Charles Jacque had experimented with this idea, and it is probably from Jacque that Whistler borrowed the motif of the wooden beam supported on diagonal struts to frame his composition. Such a device may be seen in Jacque's plate *Intérieur de ferme*, G.74, 1845 (pl. 109).

Whistler was heir to an anti-academic movement which, early in the nineteenth century, began to experiment with new methods of constructing picture space which acknowledged the two-dimensional nature of the support and sought for alternatives to Italian Renaissance perspective. Like other realists, he looked outside the western artistic tradition to Japanese *ukiyo-e* prints and, it would seem, photography. The Japanese method of flattening and compartmentalizing space is not at all incompatible with the geometric divisions found in the Dutch interior, or with the shallow picture space of early photography. At this time, Whistler began to synthesize related ideas from a variety of sources, and to develop a new method of constructing his picture space.

The evidence of these new influences may be found in the etchings themselves. The major Thames landscapes, *Eagle Wharf* (pl. 111), *Black Lion Wharf* (pl. 112), and *The Pool* (pl. 113), are all constructed in much the same way. While the composition appears to recede, it also reads as a flat two-dimensional pattern, and hangs in a tense and delicate balance between two and three dimensions. It is divided into three horizontal zones running parallel to the picture plane, representing foreground, middle ground and background. The background appears to recede largely because of *repoussoir* devices. The composition is anchored in the foreground using a large figure seated on a wharf or in a boat. The middle ground, against which the figure is silhouetted, is unworked, and reads as water. The horizon line with its warehouses is raised almost two-thirds of the way up the picture space. Etched lines are not distributed evenly over the surface of the plate: areas etched in great detail alternate with areas which read as "blank" space. The eye is led from one patterned zone to the next, and from one "blank" zone to the next. The use of diagonal directional lines helps to link the three planes, and introduces a dynamic element into the composition. The diagonal shoreline and jutting wharf in *Eagle Wharf*, and the diagonal line formed by the lighters filled with coal in *The Pool*, lead the eye into the composition. Although linear in execution, these etchings group lines in such a way that they read as areas of half-tone. This is a very different approach from the picturesque hatching found in the "French Set" plates, and is closer in style to the etchings of Meryon and Bracquemond than it is to Rembrandt and Jacque.

87

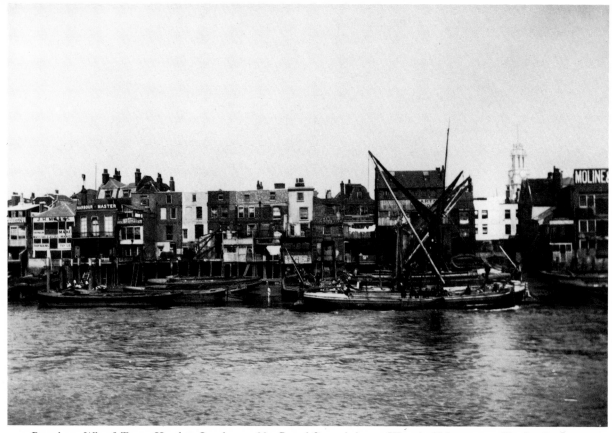

110. Broadway Wharf, Tower Hamlets, London *c.* 1885. Royal Commission on Historical Monuments (England).

111. Whistler, *Eagle Wharf*, K. 41, 1859. Etching, 13.8 × 21.4 cm. Courtesy of the Freer Gallery of Art, Smithsonian Institution, Washington, D.C.

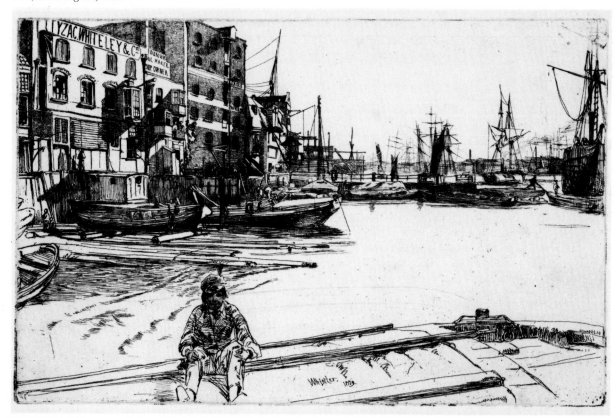

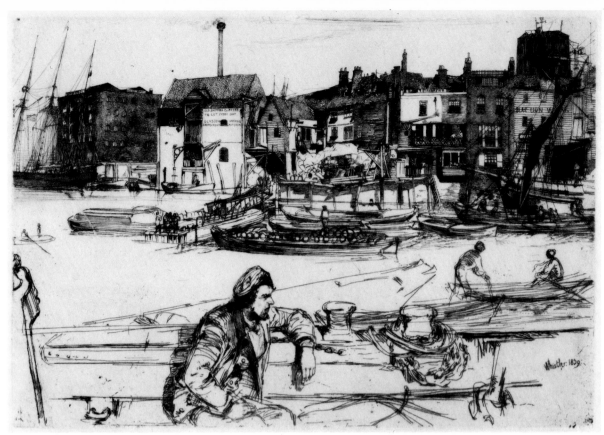

112. Whistler, *Black Lion Wharf*, K. 42, 1859. Etching, 15.2 × 22.6 cm. Art Gallery of Ontario, Gift of the Edmund Walker Estate, 1926.

113. Whistler, *The Pool*, K. 43, 1859. Etching, 13.8 × 21.3 cm. Courtesy of the Freer Gallery of Art, Smithsonian Institution, Washington, D.C.

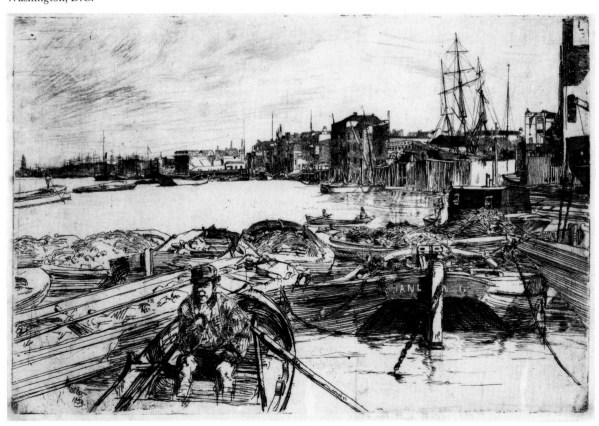

114. Millais, *The Vale of Rest*,
1858–9. Oil on canvas,
112.8 × 172.7 cm. Tate Gallery.

Whistler had recently been looking at the paintings of his precocious
English contemporary John Everett Millais at the Royal Academy, and
took Fantin to see them on July 11.[1] Fantin was already familiar with
Millais's work, and, like Whistler, was impressed by his 1859 entries,
which included a painting entitled *The Vale of Rest* (pl. 114). This work
was constructed in zones running parallel to the picture plane, and the
foreground was filled with two large *repoussoir* figures cut off at the lower
edge of the frame. The remarkable similarity between the spatial con-
struction of contemporary photographs and this painting was noted at
the time in the *Art Journal*,[2] and it is possible that Millais knew William
Henry Fox Talbot's *Kit Talbot and Lady Charlotte Talbot at Lacock Abbey*,
1842–4 (pl. 115), in which the figures are similarly positioned. The
spatial construction of Whistler's Thames etchings is sufficiently close
to that of Millais that it seems likely that Whistler not only admired
the painting but also its photographic appearance.

Several of Whistler's French contemporaries were interested in pho-
tography. Charles Meryon constructed his views of Paris along the Seine
using a space which is shallow and even breathlessly claustrophobic.
Whistler's *Black Lion Wharf* shares a similar formal structure with
Meryon's *The Morgue*, L.D.36 (pl. 116); the subject is approached fron-
tally and runs parallel to the picture plane, climbing vertically "up"
the picture plane, rather than moving away from it. The composition
is held together and a sense of recession created by alternating tonal
areas of light with areas of graded or intense shadow. The staccato
rhythm of the dark areas is responsible for the dramatic patterning and
visual impact of both *The Morgue* and *Black Lion Wharf*. The landscape
hangs like a theatrical backdrop to a foreground stage on which the
human action takes place.

In trying to explain the construction of Meryon's picture space, Jim
Burke has pointed to his interest in photography, and believes that "the
whole concept of Meryon's space owes something to photography and
optics." "From the camera too," he maintains, "comes the sharpness
of detail, over-contrast of tonal qualities, and general sense of light."[3]
Meryon is known, in fact, to have worked directly from a photograph
of San Francisco in making his great etched panorama of that city.

Photography was invented in 1839, and rapidly gained in popularity
during the early 1850s. Societies of amateurs were formed in England,
Scotland, and France, and photographic exhibitions began to take
place. In 1859 for the first time the Société française de photographie
held its annual exhibition in conjunction with the Salon, which included
1,295 photographs submitted by 148 exhibitors, and attracted 3,000
visitors.[4] It was one of the most comprehensive exhibitions of early pho-
tography, and it is very likely that Whistler saw it. The exhibition, which
was adjacent to the Salon, led Charles Baudelaire to decry the effect
of photography on art in his salon review, seeing the ability of photog-
raphy to reproduce nature scientifically as a revenge on those artists
who believed that "Art is, and cannot be other than, the exact reproduc-
tion of Nature." If it were, he pointed out, "Photography and Art"
would be synonymous.[5]

While no evidence has come to light to suggest that Whistler used
photographs in the production of the Thames etchings, he may well
have adopted some of the spatial characteristics of early photography

115. Talbot, Kit Talbot and Lady
Charlotte Talbot at Lacock
Abbey, 1842–4. Calotype.

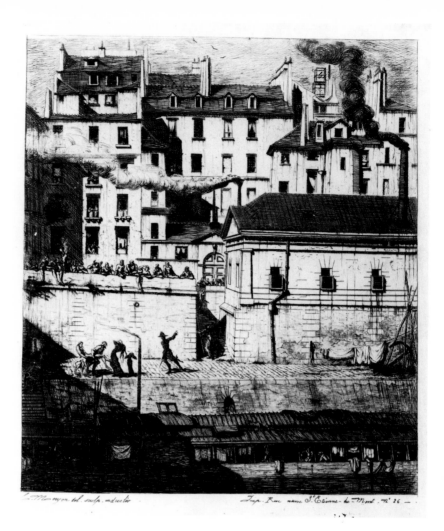

116. Méryon, *La Morgue*, L.D. 36, 1854. Etching, 21.3 × 19.0 cm. Art Gallery of Ontario, Gift of Touche Ross, 1980.

in much the same way as Meryon. It was the critic Philippe Burty, writing in the *Gazette des Beaux Arts* in 1863, who pointed out that in his opinion Whistler employed a false "theory of foregrounds," which had a "photographic appearance." Burty was well qualified to make such an observation, for he wrote reviews both of etchings and photography for the *Gazette des Beaux Arts*:

> The etchings of Mr. Whistler speak the purest English. The originality of his conception cannot be doubted. Unfortunately, Mr. Whistler has evolved a "theory of foregrounds" which imposes on his designs a certain undefined photographic appearance which is greatly to be regretted. He places in these unfortunate foregrounds figures or objects which he interprets without modelling, and in a relatively exaggerated scale. This greatly detracts from the interest of the work, which never begins before the middle or background. It is sufficient merely to glance at the admirable landscapes of Rembrandt to sense the error of the system devised by Mr. Whistler, who is so remarkably gifted in all other respects.[6]

117. Nègre, *Chimney Sweeps Walking*, 1851. Salted paper print, 15.2 × 19.8 cm. The National Gallery of Canada, Ottawa.

In this review Burty echoed a statement which he had made two years earlier in 1861, about the inability of the early photographic lens to separate out all the planes of a composition and suggest real depth of field: "Artists find fault with photography with reason, since it does not give the foreground the importance it has in nature. Forced by the laws of optics to stand at a distance from objects, photographers, while they want pictures with some degree of depth, can only obtain theatrical backdrops."[7] Burty believed that Whistler should look to Rembrandt as a model for etching, not to the inexact mechanical process of photography.

Whistler's landscape compositions lack depth of field, and, as in landscape photographs, their backgrounds hang like theatrical backdrops. Whistler's *Black Lion Wharf* can be compared to the construction of Charles Nègre's photograph *Chimney Sweeps Walking*, 1851 (pl. 117), made on the Left Bank of the Seine, a subject which would have greatly interested the realists. Both works are constructed in three shallow planes which run parallel to the picture plane. Foreground figures are used in both instances as *repoussoir* elements, and are silhouetted against the river in the middle ground. The series of buildings on the opposite bank hangs like a backdrop and does not recede in depth to the same extent that it does in nature. In order to create an illusion of aerial perspective Nègre actually used pencil shading on the negative.[8]

Félix Bracquemond was also interested in creating compositions which would not deny the two-dimensional nature of the paper support and would provide the illusion of being three-dimensional. He found his major source of inspiration in Japanese *ukiyo-e* woodcuts, and first employed a Japanese woodcut in creating an *oban*-shaped etching of a waterfall which was published in *Cahier de vues d'Italie* in 1850. As Jean-Paul Bouillon has recently pointed out, Bracquemond completely

92

118. Bracquemond, *Le Haut d'un battant de porte*, B. 110, 1865. Etching, 30.5 × 39.9 cm. Art Gallery of Ontario, Gift of Mr. and Mrs. Ralph Presgrave, 1977.

reconstructed the picture space in his etchings during the early 1850s as a result of his study of Japanese woodcuts.[9] His enthusiasm was fired in 1856 when he saw a copy of Hokusai's *Manga* while visiting Delâtre, and he tried unsuccessfully to persuade the printer to let him have it.[10] Fortunately, he was able to find another copy a year or eighteen months later in 1857 or 1858. From this time on, "Bracquemond had made it his breviary. He always carried it in his pocket, and showed it to everyone at every opportunity, enjoying the surprise, admiration and curiosity which it aroused".[11] Although, Whistler and Bracquemond were never close, Bracquemond recalled seeing Whistler in the Louvre at this time, and would also have seen him in the Café Voltaire.[12] It is very likely that Whistler was treated to a sermon on Bracquemond's theories about the *Mangwa* and understood its relevance to the work he was doing by 1859.

According to Bouillon, the encounter with Japanese prints did not "influence" Bracquemond; rather, he recognized in the work of the Japanese artists, particularly Hokusai, a similar interest in the construction of a convincingly three-dimensional space which did not deny the two-dimensional nature of the support. Conversely, Hokusai and his contemporary Hiroshige were working from a tradition based on a two-dimensional system of patterning toward a more three dimensional representation of space like the one they saw in the Western landscapes which were finding their way to Japan in increasing numbers. Bracquemond found in nineteenth-century Japanese prints the basis for the synthesis which enabled him to create a "bidimensional" picture space.[13]

During the 1850s, Bracquemond tried to "flatten" his compositions. In *Le Haut d'un battant de porte*, Ber.110, 1852 (pl. 118), he literally flattened three birds against a barn door, to which they were pinned as a warning to other birds. The picture space is composed of areas of detail which alternate with areas which are scarcely indicated. In the landscape *Sarcelles*, Ber.111, 1853 (pl. 119), he constructed a very shallow picture space which scarcely recedes from the picture plane. A sense of recession is created by reeds in the foreground which lead the eye to the reeds in the background. The diagonal motion of the ducks leads the eye up and out of the picture space, while the cutting off of the reeds in the left foreground at the plate line gives the viewer a sense of immediacy and includes him in the action.

The tendencies which appear in Bracquemond's plates which are relevant to the discussion of Whistler are attributed by Bouillon to the influence of Japanese prints. They are "the tendency to arrange the landscape vertically up the sheet, the asymmetrical composition, the motifs which are not at all in the classical tradition, and especially the silhouetting and interlocking of forms to create a flat surface."[14] By reserving large unworked "white" areas, alternating with "grey" areas and patches of "black," which do not appear to recede into the second plane, Bracquemond gave an overall pattern to the picture space which corresponds to the flat areas of colour and texture which are juxtaposed in Japanese prints.

While Whistler's collection of Japanese prints and other oriental *objets d'art* does not appear to predate the opening of Mme Desoye's second shop in the rue de Rivoli in Paris in 1862, Whistler was among her

119. Bracquemond, *Sarcelles*, B. 111, 1853. Etching, 26.8 × 32.5 cm. Metropolitan Museum of Art, Gift of Theodore de Witt, 1923.

120. Hiroshige, *The Fifty-Three Stages of the Tokaido: Shinagawa: The Departure of the Daimyo*, 1833–4. Ukiyo-e woodcut, 35.7 × 23.1 cm. Sir Edmund Walker Collection, Courtesy of the Royal Ontario Museum, Toronto, Canada.

first and most enthusiastic customers. There is no reason to believe that his taste had not already been whetted by seeing either Bracquemond's or Delâtre's copy of the *Manga*, or other prints which had found their way by this time to Paris or London.[15] His mania for collecting after 1862 may simply reflect the availability of oriental material on the Paris market.

Among the most popular contemporary *ukiyo-e* prints were Hiroshige's *One Hundred Views of Edo*, 1856–7, printed in several editions, which were among the first prints to be exported to a western audience eager to know what Japan looked like after being cut off for centuries from the rest of the world. In these, as well as in the earlier set of *Celebrated Scenes of Edo*, 1831, Whistler could have seen prototypes for the subjects he found on the Thames in 1859. This is due in part to the geographical similarity of Edo and London, which were both built on rivers traversed by wooden bridges.[16] However, the vision of Hiroshige, based as it was on a study of nature, was not incompatible with that of the occidental naturalists. Just as Edo was frequently compared to London by early travellers, so too were Hiroshige and Hokusai compared to Hogarth.

While Whistler's work does not incorporate overtly Japanese *objets d'art* until 1863, elements of *japonisme* may be detected in his earlier work in much the same form that they appear in the work of Bracquemond. Whether his encounter with Japanese prints was at first hand through the agency of Bracquemond or Delâtre, or at second hand through Bracquemond's etchings, cannot be established for certain.

It is useful to compare the structure of the space and the compositional elements in Whistler's *The Pool* with Hiroshige's *Shinagawa: The Departure of the Daimyo* from *The Fifty-Three Stages of the Tokaido*, 1833–4 (pl. 120). Like Hiroshige, Whistler flattened the picture space and raised the horizon line to create a sense of recession. A dramatic diagonal formed by the moored boats divides the foreground and middle ground into two triangular wedges, and leads the eye into the middle distance,

just as the row of houses does in the print of Hiroshige. A foreground *repoussoir* element in the form of a man in a boat is found in the Whistler, and a steep bank in the Hiroshige. In the woodcut, patterned areas are juxtaposed with flat areas of "colour," which are translated in the etching into areas of tone and void. The cutting off of the foreground figures at the margin, a characteristic of the Japanese print, was used in *The Pool* (pl. 113) by Whistler, who terminated his figure at the ankles. This device creates the same sense of immediacy which characterized amateur photography.

Burty did not detect the influence of *ukiyo-e* woodcuts in Whistler's Thames etchings, seeing in them only the vague influence of photography. However, as Bouillon has pointed out, the eminent *japoniste* also failed to ascribe similar characteristics in Bracquemond's etchings to this source in his critical review of February, 1863. He greatly regretted Bracquemond's system, and compared it to Epinal woodcuts, "the goal of which is to put on the plate only tonal values."[17]

Whistler had taken another step forward in these plates, going beyond the traditional means of representing space found in the Western artistic tradition. The speed with which he synthesized related ideas from a wide variety of sources ranging from the seventeenth-century Dutch interior to contemporary photography and Japanese prints is dazzling.

## 4. The Science of Optics and the Thames Etchings of 1859

One of the most arresting characteristics of Whistler's Thames etchings of 1859 is their tendency to focus in one area of the composition, while barely suggesting peripheral detail or eliminating it altogether. This radically new way of depicting space appears to have its roots in contemporary developments in the science of optics as it was applied during the 1850s to the understanding of the working of the human eye and improvements in the photographic lens. To a later generation, predisposed to view the world in the light of these discoveries, Whistler's pictorial construction may not appear particularly revolutionary. But it was his "theory of foregrounds"[1] which leapt out at Burty, who saw in it the influence of photography. It appears that Whistler, in his search for an individual approach to realism, took the concept of truth to nature one step further than his French contemporaries, and brought to etching a scientific understanding of the working of the lens of the human eye. In doing so, he placed a highly original stamp on his work.

If one looks closely at *Black Lion Wharf, Eagle Wharf, The Pool* and *Longshoremen,* it is immediately apparent that while some areas are "in focus," others are "out of focus," and that some fall beyond the range of peripheral vision. An area which is too close to the viewer to be seen clearly while focussing in the middle or far distance is indicated by only a handful of directional or structural lines. The warehouses in the background of *Black Lion Wharf* (pl. 112) are depicted in great detail, while the foreground, with the exception of the head of the *repoussoir* figure which intrudes into the frame of vision, is only barely indicated. In *Eagle Wharf* (pl. 111) the middle ground is "in focus," while the foreground

and background are summarily treated; in *The Pool* (pl. 113) it is the foreground which is "in focus." This approach was not confined to the landscape etchings, but was also applied to shallow picture spaces, as in *Longshoremen* (pl. 105), where the foreground is virtually omitted, and attention focussed on the head of the seated figure in the middle. While most objects in these compositions are stationary, the boat to the right of the seated figure in *Black Lion Wharf* is indicated with multiple overlapping contour lines. As Bernhard Sickert pointed out, these "sudden and arbitrary excursions into indefiniteness . . . merely indicate that the figures were in motion."[2]

In looking for the source of this novel approach, Phillipe Burty's observation that these works have "a certain undefinable photographic appearance" provides a starting point. By 1863, when he wrote his criticism of Whistler's Thames etchings, Burty was a close acquaintance of Haden, and Whistler and Haden were collaborating on a joint publication. Given that Burty placed the phrase "theory of foregrounds" in quotation marks, it is likely that Whistler may have articulated such a position to Haden or Burty. It is certainly worth exploring the possibilities.

Burty observed that Whistler's system was quite different from Rembrandt's and that while Rembrandt's was "admirable," Whistler's was "false". Whistler would have known Rembrandt's method from the fine group of seventeen landscape etchings in the Haden collection, and would have seen how Rembrandt focussed attention in certain areas of his composition while allowing others to fall into abeyance. In *Clump of Trees with a Vista*, B.222, Rembrandt focussed attention on the background, and used only a few lines to indicate foreground; in *Landscape with Sportsman and Dog*, B.211 (pl. 121), he focussed on the foreground while allowing the background to fall away. Rembrandt applied to his etching of landscape an intuitive understanding of the working of the human eye, realizing that it was not possible to focus on all areas at any one time. Haden greatly admired Rembrandt's powers of scientific observation,[3] and his method of focus became the basis of Haden's own approach to landscape.

It was undoubtedly through the study of Rembrandt's etchings that Whistler first approached the matter of focus and the elimination of peripheral detail, and it was this method which he employed in the "French Set" etchings. In *The Unsafe Tenement* (pl. 39) and *La Marchande de moutarde* (pl. 55), he depicted the half-timbering and the pots on the shelf in the dusky interior in great detail, while summarizing the foreground in a few lines. In the Thames etchings, however, the application of the principle was carried much further, and could no longer be explained, as Burty pointed out, in the light of Rembrandt's usage alone.

It should not be forgotten that Whistler's first great love was the work of J. M. W. Turner. John Ruskin in volume one of *Modern Painters*, first published in 1843, had pointed out at length in chapter four, "Of Truth of Space:—First as Dependent on the Focus of the Eye," the way in which Turner had applied his knowledge of the working of the human eye to the depiction of space in landscape.[4] Ruskin maintained that Turner's application of the principle of accommodation to his art was "altogether more truthful in the expression of the proportionate relation of all his distances to one another"[5] than were the old masters.

121. Rembrandt, *Landscape with Sportsman and Dogs*, B. 211, *c.* 1653. Etching, 12.9 × 15.7 cm. Reproduced by permission of the Trustees of the British Museum.

He pointed out that the eye could not see objects at different distances from the viewer at one glance.

> The eye, like any other lens must have its focus altered, in order to convey a distinct image of objects at different distances; so that it is totally impossible to see distinctly at the same moment, two objects, one of which is much farther off than another . . . objects at unequal distances cannot be seen together, not from the intervention of air or mist, but from the impossibility of the rays proceeding from both, converging on the same focus, so that the whole impression, either of one or the other, must necessarily be confused, indistinct, and inadequate.[6]

The difference of focus, according to Ruskin, is greatest within the first five hundred yards, or in the foreground area. When looking at a landscape, it is impossible to see both the foreground and middle ground "with facility and clearness" at the same time. If we focus on the middle ground and distance "we can see nothing of the foreground beyond a vague and indistinct arrangement of lines and colours;" if we look at the foreground, "the distance and middle distance become all disorder and mystery." The ramifications for painting, said Ruskin, are that if the artist does not wish "to violate one of the most essential principles of nature," he may not represent "that as seen at once which can only be seen by two separate acts of seeing," and must accept the fact that "if in a painting our foreground is anything, our distance must be nothing, and vice versa."[7] According to Ruskin, it was Turner who first made "a bold and decisive choice of the distance and middle distance," and who chose to sink the foreground in favour or representing the middle and background. He did this by expressing

97

... immediate proximity to the spectator, without giving anything like completeness to the forms of the near objects ... by a firm, but partial assertion of form, which the eye feels indeed to be close home to it, and yet cannot rest upon ... and from which it is driven away of necessity, to those parts of distance on which it is intended to repose.[8]

In the fifteen-year period which intervened between the publication of the first volume of *Modern Painters* and Whistler's execution of the first Thames plates, a great deal had occurred to place the knowledge of the working of the human eye onto a more solid scientific basis. The renowned German scientist Hermann Ludwig von Helmholtz (1821–94) invented the opthalmoscope in 1851, and published the most important work to date on the physiology and physics of vision. Entitled *Physiological Optics*, it appears in several volumes published between 1855 and 1866.

The opthalmoscope was an instrument designed to study the way in which the eye focusses or accommodates itself, and was immediately used for the diagnosis of such eye defects as "long" and "short" sight. It is very likely that Whistler, who had suffered from "short" sight in his West Point days, was examined with an opthalmoscope. His friend George du Maurier, who suddenly lost the vision in one eye, was examined with one by a Jesuit oculist at Louvain in 1857.[9] Its value for the understanding of the working of the human eye, and for the diagnosis of accidents of vision, was incalculable.

In *Physiological Optics*, Helmholtz explained the principle of accommodation, and the distinction between "direct" and "indirect" vision. He pointed out that the human eye adjusts itself with such rapidity to the area on which it wishes to focus, that people are not normally aware of how imperfect indirect or peripheral vision really is. He wrote, "Whatever we want to see we look at, and see it accurately; what we do not look at, we do not as a rule care for at the moment, and so do not notice how imperfectly we see it."[10] The image which we receive through the eye was likened to a picture "minutely and elaborately finished in the centre, but only roughly sketched in at the borders."[11] "To look at anything," he wrote, "means to place the eye in such a position that the image of the object falls on the smaller region of perfectly clear vision. This may be called *direct* vision, applying the term *indirect* to that exercised with the lateral parts of the retina."[12]

Whistler was no stranger to optical theory, which he had studied in his course on Natural Philosophy at West Point.[13] It is very likely that he would have heard of Helmholtz's theories while staying with the Hadens during the late 1850s. Helmholtz's papers, which were published throughout the 1840s and 1850s, brought his optical theories to the attention of medical men some years before his books appeared. In 1854 he visited London and spoke at the annual meeting of the British Medical Association. It is likely that Haden, who was Honorary Surgeon to the Department of Science and Art from 1851 to 1857, would have heard him speak and met him on this occasion. In 1862, Haden, who sat on the Jury of the International Exhibition, wrote a pamphlet on Surgical Instruments entitled *Report of Awards Made at the International Exhibition*. In it he paid the highest tribute to Helmholtz:

It cannot be doubted that opthalmic surgery has made immeasurably greater progress during the past than during the preceding decennium. The invention of the "opthalmoscope" by Helmholtz in 1851 marks the commencement of a new era in this branch of surgery. Its application to the diagnosis of the diseases of the internal coats and the transparent media of the eye, together with the great attention which has been given to the morbid anatomy of the organ, have yielded much exact knowledge concerning many affections which were previously imperfectly understood.[14]

For the general public, optical theory was made visible through the invention of photography. Helmholtz himself described the principle of accommodation by comparing the lens of the eye with the lens of the camera. He pointed out that the camera lens, which at that time had to be adjusted mechanically, could only focus on one area at a time: "A photographic camera can never show near and distant objects clearly at the same time, nor can the eye: but the eye shows them so rapidly one after the other that most people who have not thought how they see, do not know that there is any change at all."[15] Photography not only gave substance to Helmholtz's theories; it provided artists with tangible evidence of how the eye sees, although conditioned by a degree of distortion characteristic of early photography.

Whistler would have been familiar with the problems and limitations of the photographic lens. Both Haden and his medical partner James Reeves Traer, were amateur photographers, and Traer had been working for some time to perfect a method for photographing microscopic objects. On November 6, 1858, Traer published an article in the *Journal of the Photographic Society* entitled "On the Photographic Delineation of Microscopic Objects." In it, he pointed out the problems involved in trying to focus on the foreground and background at the same time:

> What is true of one object is true of all parts of objects. The perspective of near objects is what is called violent, and is still more exaggerated by the form of the camera. As most photographs are taken at short distances, the main cause of their distortion is as clear as the distortion is evident. A palliative for the evil is to take portraits at greater distances, and to omit the immediate foreground of landscapes altogether.[16]

This article appeared on the very day of Whistler's arrival from Paris after proving the "French Set." Traer was Whistler's personal physician and close friend, and they saw a good deal of each other over Christmas, 1858. The appearance of the article must have occasioned lively discussion on the subject of optics and photography.

Photographers were concerned to improve the lens and eliminate as much distortion as possible. For this reason they worked closely with scientists. As Claudet pointed out, photographers "who had never given a thought to these sciences became convinced that they had to understand them if they wanted their own art to benefit."[17] In addition to solving the problems of spatial distortion, they hoped to be able to speed up the shutter so that moving objects could be captured without leaving

a blur on the film. It was in August 1859 that the latter was finally accomplished by George Washington Wilson in Edinburgh.[18]

While scientific advances made during the 1840s and 1850s provided absolute information about how the eye sees, they also provided information on the way in which defects of vision condition an individual's view of reality. Ruskin had pointed out in *Modern Painters* "that these truths present themselves in all probability under very different phases to individuals of different powers of vision. Many artists who appear to generalize rudely or rashly are perhaps faithfully endeavouring to render the appearance which nature bears to sight of limited range."[19] Whistler's perception of nature was undoubtedly conditioned by his myopia. According to Thomas Armstrong, he had to use an eyeglass during his student days in Paris to see whether his shoes were clean.[20] His vanity undoubtedly prevented him from wearing glasses in public,[21] hence the adoption of the monocle which was far from being a dandy affectation. While Bernhard Sickert recalled him wearing "enormous goggles" in the studio during the 1880s,[22] Gil Blas recalled how Whistler would go through half a dozen monocles in the course of a dinner party as steam from the food clouded them.[23] Both Armstrong and Walter Sickert were dubious about his ability to see the detail which appears in the Thames etchings. Sickert suggested that he may have filled in some of the detail "at home with the microscope from Washington lying handy at the etcher's table."[24]

Whistler told the Pennells that he overcame the problem of etching long views across the Thames by moving back and forth across the river in barges, where he was occasionally cut off by the tide.[25] This may well have been the method employed in executing *Black Lion Wharf*, which has the most detailed of backgrounds. It may also account for his biographers' belief that it took Whistler three weeks to finish each plate. This could not, however, have been the case, since he executed eleven in approximately two months. It is not known whether he used photographs or preliminary drawings in preparing the Thames etchings. It is unlikely that he would have revealed their use to the Pennells in later years when he believed in working unaided from nature.

It seems likely that Whistler's "theory of foregrounds" was developed in the knowledge of contemporary photography and the new understanding of the working of the human eye which Helmholtz's research had contributed to the field of optics during the 1850s. It is impossible to say to what extent accidents of vision may have led him to see space in a particular way, for he clearly tried to compensate by selecting more than one vantage point. His interest in focus was undoubtedly prompted by a desire to carry the realist concept of "truth to nature" a step further, and to place it on a scientific basis. In doing so, he created a highly original method of representation in which he focussed on the foreground, middle or background, and allowed those areas which the eye was incapable of seeing clearly to fall into abeyance. Foregrounds were summarized in a few lines, and background details melted together. This, together with the two-dimensional patterning and shallow structure of the picture space, led to a highly original style of etching. It also led Whistler to further experiments with focus, and to the increasing elimination of peripheral detail which was to characterize his work throughout his career.

# 5. Whistler's First Drypoints

After spending about two months at Wapping, Whistler left for Paris on October 6, remaining there until shortly before Christmas. During this ten-week period he experimented with the drypoint technique for the first time.

Whistler greatly admired the special qualities of drypoint, a process more closely related to engraving than etching, in which a steel or diamond tip needle is used to draw on an ungrounded copper plate. Drypoint can be distinguished from other *intaglio* techniques largely by the distinctive copper ridge or "burr" which is forced up on either side of the needle as it is pushed through the copper. This traps the ink and prints with a velvety richness which varies with the depth of the drypoint line. Whistler wrote the following eloquent note in praise of drypoint:

> The tiny thread of metal ploughed out of the line by the point as it runs along, clings to its edge through its whole length and, in the printing holds the ink in a clogged manner, and produces, in the proof, a soft velvety effect most painter like and beautiful—and precious too, for this raised edge soon falls off the plate, from the continued wiping in printing—so that early proofs only have the velvety line and are also, because of its presence, valued . . . In an etching there is no "burr" as such ridge of the metal is immediately disolved [sic] by the acid and the line is left clean. The impression is consequently quite crisp and without the soft velvet effect of the dry point "burr."[1]

Because of the speed with which the burr wears down in the course of printing, only a small number of impressions of diminishing quality can be taken from a drypoint plate. The potential for linear delicacy and painterly richness, together with the limited number of impressions which can be taken from the plate, give the medium an aura of rarity which Whistler found appealing.

It is not clear just why Whistler decided to turn to pure drypoint

122. Haden, *Fulham*, H. 19, 1859. Etching and drypoint, 11.4 × 28 cm. Reproduced by permission of the Trustees of the British Museum.

125 (facing page). Whistler, *Drouet*, K. 55, 1859. Drypoint, 22.6 × 15.3 cm. Art Gallery of Ontario, Gift of Mr. and Mrs. Ralph Presgrave, 1976.

123. Whistler, *Soupe à trois sous*, K. 49, 1859. Drypoint, 15.3 × 22.5 cm. Art Gallery of Ontario.

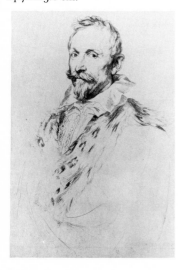

124. Van Dyck, *Jan Van den Wouver*, D. 23. Etching, 24.7 × 15.6 cm.

in the autumn of 1859. His interest may have been related to practical considerations, for he always disliked grounding his etching plates, and grounded plates were inconvenient when travelling. Drypoint was rarely used in England and France when Whistler took it up, as Haden pointed out.[2] In England, the technique was occasionally practised by David Wilkie and the Norwich School etchers. In France, Jacque had occasionally used it in conjunction with etching. By 1859, however, Alphonse Legros had made a number of studies in pure drypoint.

All these early attempts were eclipsed by Haden's sudden mastery of the medium, which must have startled Whistler. During the late summer, Haden had made several landscapes modelled on drypoints by Rembrandt in his collection.[3] Outstanding among these was *Fulham*, H.19 (pl. 122), which was closely modelled on Rembrandt's plate *The Omval*, B.209. The rich passages of velvety black shadow in the left foreground, together with the delicate rendering of buildings in the background, must have greatly interested Whistler when he compared the products of Haden's excursions on the rural Thames with his own.

Upon his arrival in Paris, Whistler made *Soupe à Trois Sous*, K.49 (pl. 123), in an all-night café. The low-life subject, naïve drawing, and construction of the picture space recall the Thames etching *Longshoremen*. The figure on the left, who is the focus of attention, was a former soldier named Martin who lost the cross of the Legion of Honour because of misconduct.[4] A sinister element is injected into the sordid surroundings by the black bottles at the elbows of the men who sleep seated or sprawling across the tables. They recall the prominently placed bottle in Edouard Manet's painting *The Absinthe Drinker*, refused at the Salon of 1859, which Whistler would have known.

Nine of the twelve drypoints which Whistler made in Paris during the autumn of 1859 were portraits of the artist or his friends. This was the first time that he devoted himself seriously to portraiture in print-making with the intention of bringing out the personality of his sitters.

He began with two drypoints of children. *Bibi Valentin*, K.50, was

Drouet Sculpteur.

Whistler 1859.

the child of an engraver in whose house Whistler had made his first etching, and *Bibi Lalouette*, K.51 (pl. 144), was the child of a restaurant owner who gave Whistler a line of credit.[5] In their delicacy of handling, these portraits stand in startling contrast to Whistler's Thames etchings. It can be safely concluded that by October, 1859, Whistler was capable of any type of linear expression, whether crude or refined, which he chose to employ, and that he matched the character of his line to his subject. Low-life subjects were treated with *naïveté*; bourgeois subjects with refinement.

The most impressive of these plates are the male portrait drypoints of *Becquet*, K.52, *Drouet*, K.55, (pl. 125), and *Astruc, a Literary Man*, K.53 (pl. 126). Becquet was a musician who lived in his studio among "disorder and his cello."[6] Drouet, who sat for Whistler for four hours,[7] was a sculptor and a close personal friend. Astruc was a painter, sculptor, man of letters, and editor of the journal *L'Artiste*,[8] which encouraged original printmaking and was sympathetic to the realist cause. These penetrating studies of notable individuals of Whistler's acquaintance were executed in a highly original style. As in the Thames etchings, Whistler omitted much of the peripheral detail, focussing on the face while barely indicating the costume and setting. They not only demonstrate his continuing interest in focus; they also reveal his interest in seventeenth-century Dutch portrait etching, particularly the work of Van Dyck and Rembrandt.

Whistler would have been familiar with Van Dyck's famous series of etchings of friends and fellow artists published under the title *Iconographia*, and of the distinction to be made between the trial proofs and published states of these etchings. After drawing the heads of his sitters in detail, and indicating the torso area with a few lines, Van Dyck turned his plates over to professional engravers who "finished" the torsos for publication. Collectors have long lamented the fact, and Seymour Haden was no exception. He wrote of how "apparently without a pang, in the prospect of commercial gain," Van Dyck watched "his own inimitable etchings ruined by the so-called "finish" of hireling hands."[9] Haden put together an outstanding group of early states which Whistler would have known well. Whistler also had the opportunity to study fine early impressions at the Manchester Art Treasures exhibition where a group of twelve were on view which were considered by Charles Blanc to be well worth the trip in their own right.

In the portraits, Whistler not only employed the same approach as Van Dyck, focussing on the head while barely suggesting the torso; he also adopted a similar aesthetic refinement. In his review of the Manchester exhibition, Thoré-Bürger saw in Van Dyck all the admirable qualities of the painters of the northern schools, conditioned by the exquisite taste learnt from his sojourn among the English aristocracy. He described his work as "very delicate, very distinguished, seeped in the perfume of aristocracy, above all, elegant."[10] In his opinion, such taste was not to be found in the work of Rembrandt or Velasquez.[11] It is Van Dyck's baroque vigour and dash, combined with his sense of refinement, which characterizes the heavy slashing strokes and hairline hatching of Whistler's male portraits. In *Drouet*, the most dramatic portrait in the group, Whistler adopted a three-quarter pose and sidelong look which recalls Van Dyck's *Lucas Vorsterman*, D.13

(pl. 127) and *Jan Van den Wouver*, D.23 (pl. 124), hailed by Blanc as the rarest of the Van Dyck etchings on view at Manchester.[12]

Whistler's drypoint portraits of women, made on the trip to Paris, include *Fumette Standing*, K.56, *Fumette's Bent Head*, K.57, and *Finette*, K.58 (pl. 128). In them, Whistler began to explore the decorative possibilities of the full-length portrait, drawing on the tradition of sartorial splendour which he saw in Van Dyck, Hollar and Velasquez.

The adaptation of the grand manner of portrait painting to the depiction of a *grisette* and a can-can dancer was very much in keeping with the spirit of Courbet's realism. Whistler gave his subjects monumentality by selecting a low vantage point and emphasizing the richness of their costume. Of the two plates, he preferred *Finette*, and "guarded his proofs jealously."[13] The dark figure which dominates the picture space recalls Hollar's etching *The Winter Habit of ane English Gentlewoman*, P. 1999 (pl. 129), which was in the Haden collection. The mask which Whistler included among the items in the prop-box to the right of Finette may have been intended for use during the forthcoming carnival season; it recalls the facial masks worn with winter costume in Hollar's prints, and the miscellaneous accoutrements found in British aristocratic portraiture.

Despite their historical associations, Whistler's portraits remain portraits of modern women in contemporary dress. Their melancholy

126. Whistler, *Astruc, A Literary Man*, K. 53, 1859. Drypoint, 22.7 × 15.2 cm. Courtesy of the Freer Gallery of Art, Smithsonian Institution, Washington, D.C.

127. Van Dyck, *Lucas Vorsterman*, D. 13. Etching, 24.5 × 15.6 cm. National Gallery of Canada, Ottawa.

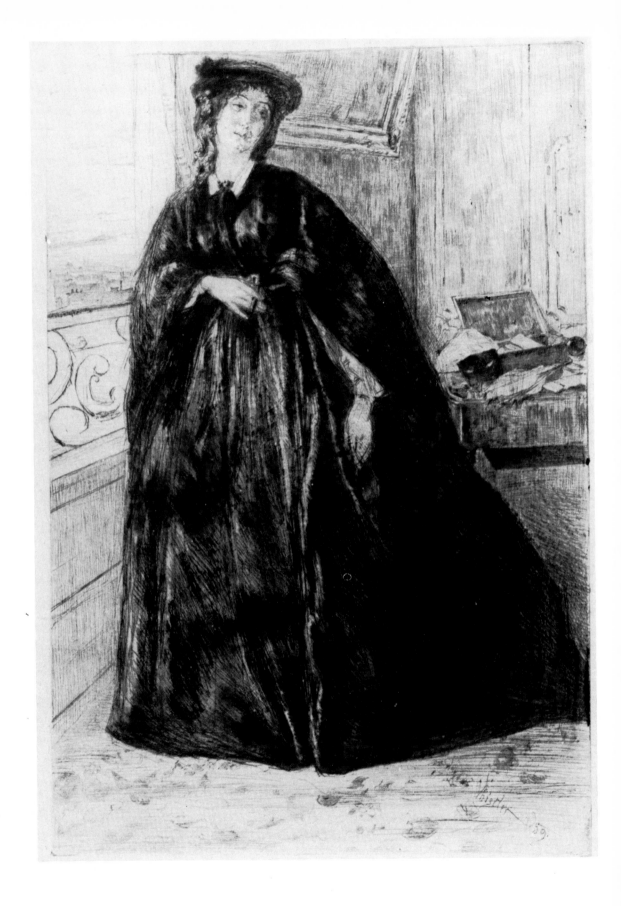

The Winter habit
of ane English Gentlewoman.

129. Hollar, *The Winter Habit of ane English Gentlewoman*, P. 1999. Etching, 20.4 × 9.8 cm. Sidney Fisher Collection, Thomas Fisher Rare Book Library, University of Toronto.

128 (left). Whistler, *Finette*, K. 58, 1859. Drypoint, 28.8 × 20.1 cm. Courtesy of the Art Institute of Chicago.

130. Millais, *A Lost Love*, from *Once a Week*, November 16, 1859. Wood engraving, 11.9 × 8.9 cm. Reproduced by permission of the Trustees of the British Museum.

expressions recall the paintings and wood-engraved illustrations of Millais, whose work Whistler and Fantin had greatly admired that summer at the Royal Academy. The sentiment, narrative element, and even the long fibrous lines of the drypoint, may owe something to Millais's poignant wood-engraved illustrations such as *A Lost Love* (pl. 130), which appeared in *Once A Week* on November 16, 1859.

While the portraits of *Finette* and *Fumette* anticipate Whistler's break with realism and his subsequent alliance with Aestheticism, the etching *Venus*, K.59 (pl. 131), could not be more closely related to the realist tradition. This Venus, perhaps Fumette, in no way conforms to the classical ideal; her ample form and scandalous pose recall Courbet's painting *Woman Resting* of 1858 and Rembrandt's realistic female nudes such as Antiope in *Jupiter and Antiope*, B.285 (pl. 132). Had Whistler painted rather than etched this subject it might well have occasioned a public outcry.

Before leaving Paris he executed a plate which was probably intended as a tribute to Meryon. Entitled *Isle de la Cité, Paris*, K.60 (pl. 133), it was made from a window in the Galerie d'Opéra in the Louvre. The aerial view, showing the Île de la Cité with the towers of Nôtre Dame and the Conciergerie, recalls such views by Meryon as *L'Abside de Notre Dame, Paris*, L.D.38 (pl. 134), and Charles Nègre's photograph *Paris: Construction of the New Pont d'Arcole Seen from Rue de Lobau*, 1855 (pl. 135). Intending to capture the flavour of Paris in the winter rather than create an accurate topographical rendition, Whistler did not bother to reverse the plate. The subject with its sharp focus recalls the Thames etchings. In this plate Whistler first explored the decorative possibilities of bridges which would feature prominently in his later Thames etchings.

After a farewell visit on December 20 to Fantin, who was working in bed fully dressed as protection against the bitter cold,[14] Whistler must have left at once for the comfort of 62 Sloane Street. The proofs from his drypoint plates were probably pulled on Haden's press over Christmas. Haden made a drypoint profile portrait of his wife, entitled *Dasha* (not in Harrington), which exists in a unique impression in the British Museum inscribed by Haden, "sketched on copper and printed in London on Christmas Day, 1859" (pl. 139). At the same time, Whistler made a profile portrait of her from the other side entitled *Portrait of a Lady*, 1859, K. App. II (pl. 138), which also appears to exist in a unique impression. The two etchings are almost mirror images of each other.

Whistler then set to work to make drypoint portraits of the elder Haden children, completing *Arthur Haden*, K.61 (pl. 136), before the New Year, and *Annie Haden*, K.62 (pl. 137), early in 1860. These portraits, which appear to have been intended as pendants, demonstrate Whistler's growing interest in describing the texture of fine fabrics. The portrait of Arthur Haden recalls Van Dyck's double portrait at Windsor of richly attired children, *George Villiers, Second Duke of Buckingham and his Brother Francis Villiers* (pl. 140), and shares with them the slightly pouting and superior expression, richly textured clothing, and curtained backdrop.

Whistler was especially pleased with his portrait of Annie, and said in later life that if he was to be remembered by only one plate, he would like it to be this one. The delicate, hair-like drypoint lines anticipate

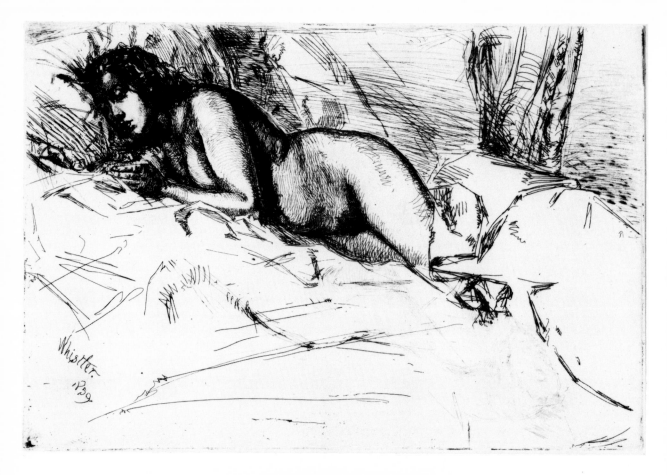

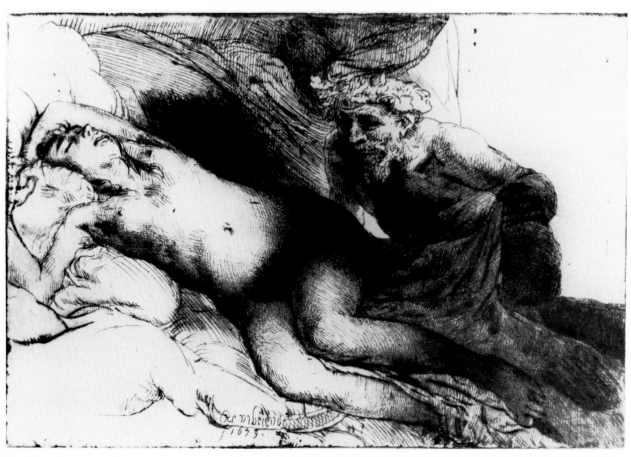

131 (left). Whistler, *Venus*, K. 59. Etching, 15.2 × 22.9 cm. Courtesy of the Freer Gallery of Art, Smithsonian Institution, Washington, D.C.

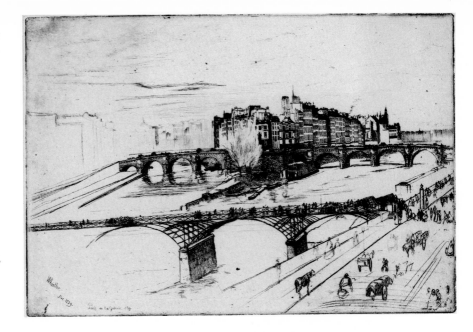

133. Whistler, *Isle de la Cité, Paris,* K. 60, 1859. Etching, 20.0 × 28.8 cm. Reproduced by permission of the Trustees of the British Museum.

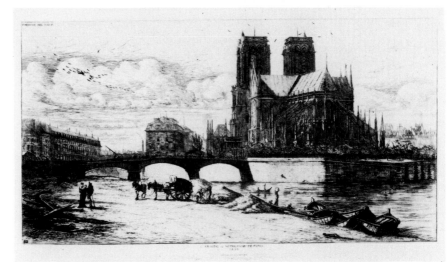

134. Meryon, *L'Abside de Notre-Dame, Paris,* L.D. 38, 1854. Etching, 28.9 × 15.0 cm. Reproduced by permission of the Trustees of the British Museum.

132 (left). Rembrandt, *Jupiter and Antiope*, B. 285, 1647. Etching, 24.5 × 19.1 cm. Reproduced by permission of the Trustees of the British Museum.

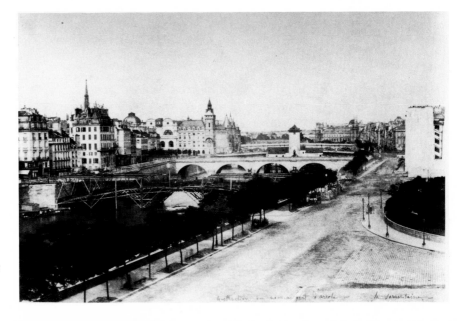

135. Nègre, *Paris : Construction of the New Pont d'Arcole seen from the rue du Lobau.* Salted paper print, 23.1 × 32.3 cm., André James, Paris.

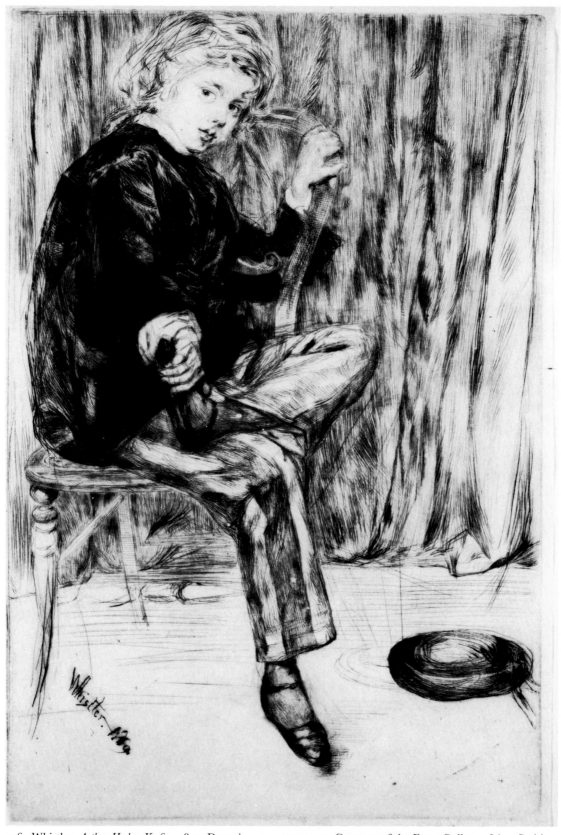

136. Whistler, *Arthur Haden*, K. 61, 1859. Drypoint, 22.7 × 15.2 cm. Courtesy of the Freer Gallery of Art, Smithsonian Institution, Washington, D.C.

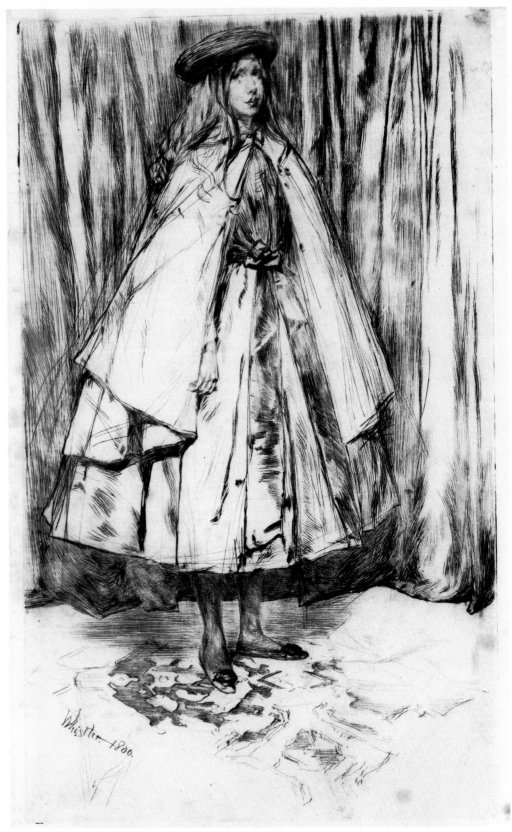

137. Whistler, *Annie Haden*, K. 62, 1860. Drypoint, 34.8 × 21.4 cm. Courtesy of the Freer Gallery of Art, Smithsonian Institution, Washington, D.C.

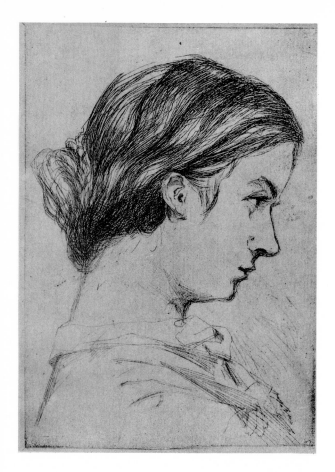

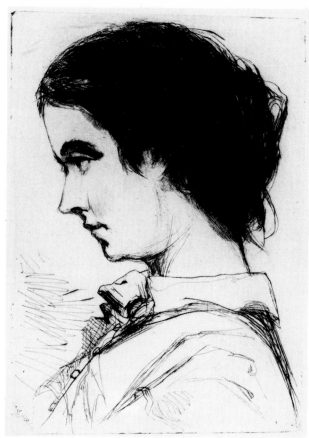

138. Whistler, *Portrait of a Lady*, K. App. II, 1859. Drypoint, 13 × 9 cm. Present whereabouts unknown.

139. Haden, *Dasha*, 1859 (not in Harrington). Drypoint, 13.2 × 9.7 cm. Reproduced by permission of the Trustees of the British Museum.

140 (facing page, below). Van Dyck, *George Villiers, Second Duke of Buckingham and His Brother Francis Villiers*. Oil on canvas, 150 × 125 cm. Reproduced by gracious permission of Her Majesty Queen Elizabeth II, from the Royal Library at Windsor Castle.

Whistler's elegant portraits of the 1870s and demonstrate his complete control over the drypoint medium. The subject played a secondary role; Whistler's interest in the decorative qualities of costume and the way in which light glances off different planes and textures soon began to supersede his interest in the personality of the sitter.

Prior to his return to Paris in the New Year, he turned again to the series of male portrait drypoints, and chose as his subject an amateur photographer called Henry Newnham Davis, who lived at Silchester House, Hants.[15] The Pennells maintained that in Whistler's drypoint portraits he was "consciously competing with the Dutchman."[16] This is nowhere more evident than in the portrait of *Mr. Davis*, K.63 (pl. 141), which recalls Rembrandt's etching of *Clement de Jonghe* B.272 (pl. 142); there are overt references in the high hat and Inverness cape worn by Mr. Davis, as well as in the seated pose and penetrating gaze of the sitter. On an impression of *Clement de Jonghe*, now in the Art Institute of Chicago, Whistler paid his highest tribute to a single work of art, inscribing on the mount, "Without a flaw! Beautiful as a Greek marble or a canvas by Tintoret. A masterpiece in all its elements, beyond which there is nothing."

It was probably at about this time that Drouet recalled how they

. . . were looking over Rembrandt's etchings together once in Drouet's rooms, and Drouet told Whistler he was the first etcher since Rem-

112

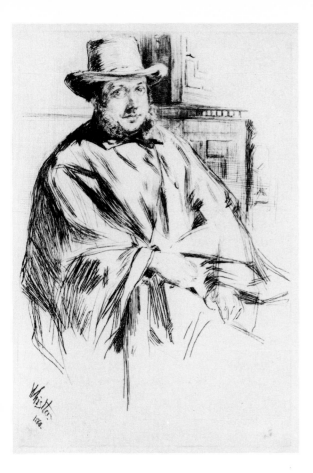

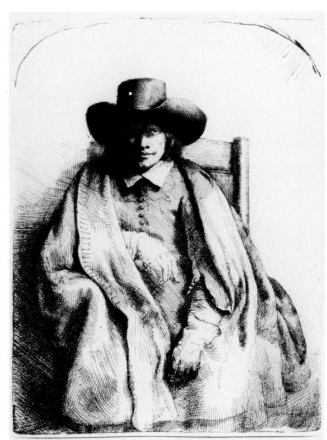

141. Whistler, *Mr. Davis* (Mr. Mann), K. 63, 1859–60. Drypoint, 22.8 × 21.4 cm. Courtesy of the Freer Gallery of Art, Smithsonian Institution, Washington, D.C.

142. Rembrandt, *Clement de Jonghe*, B. 272, 1651. Etching, 20.9 × 16.5 cm. Courtesy of The Art Institute of Chicago, Clarence Buckingham Collection.

brandt and pointed out where their work was the same. And Whistler was deeply moved—"si vous le pensez, mon cher", he said, "ça me donne grand plaisir."[17]

Following his return to Paris Whistler made two more portraits, *Axenfeld*, K.64 (pl. 143), and *Riault, the Engraver*, K.65. Axenfeld was probably identified when exhibited in the Royal Academy in the summer of 1860 as "Mons. Oxenfeld, Litterateur, Paris." Riault was a wood engraver, and was shown at work on a block. These were the final additions to the group of six portraits of notable men in the arts, music, and letters. Together with the *Portrait of Whistler*, K.54, made in the autumn, they commemorate the artist and his friends in much the same way as the *Iconographia*.

Because of the wearing of the drypoint lines, few impressions could be taken from these plates. They were printed for the most part in black ink on old Dutch laid paper or on thin Japanese paper with a silky surface and a translucence that suited the more delicate studies. In a unique experiment, Whistler pulled an impression of *Bibi Lalouette*, now in the collection of the Art Gallery of Ontario, on white silk satin (pl. 144). Looked at in raking light, a disembodied network of black lines appears to float on a silver ground. This was undoubtedly inspired by Rembrandt's occasional and very rare use of silk for trial proofs. Whistler guarded impressions from his drypoint plates carefully, and

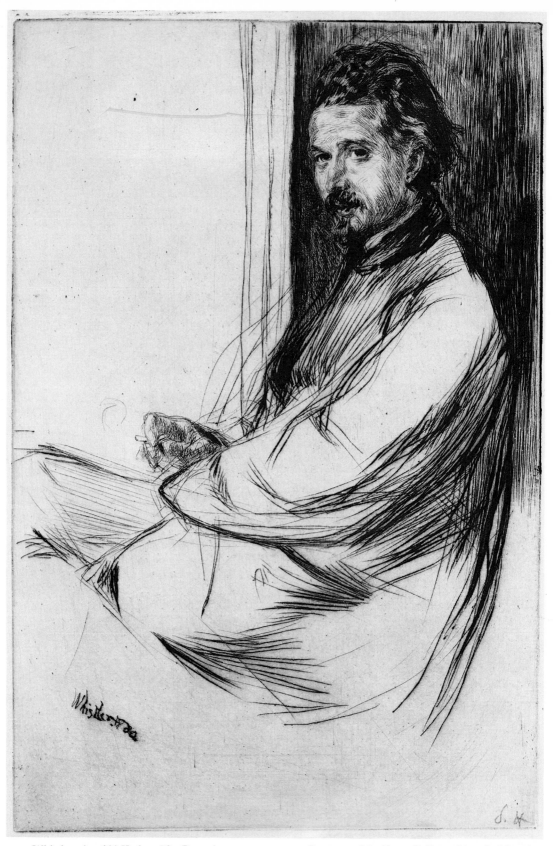

143. Whistler, *Axenfeld*, K. 64, 1860. Drypoint, 22.5 × 15.2 cm. Courtesy of the Freer Gallery of Art, Smithsonian Institution, Washington, D.C.

144 (facing page). Whistler, *Bibi Lalouette*, K. 51, 1859. Etching and drypoint on silk satin, 22.6 × 15.3 cm. Art Gallery of Ontario, Gift of the Dorothy Isabella Webb Trust in memory of Sir Edmund Walker, first President of the Art Gallery of Ontario, 1982.

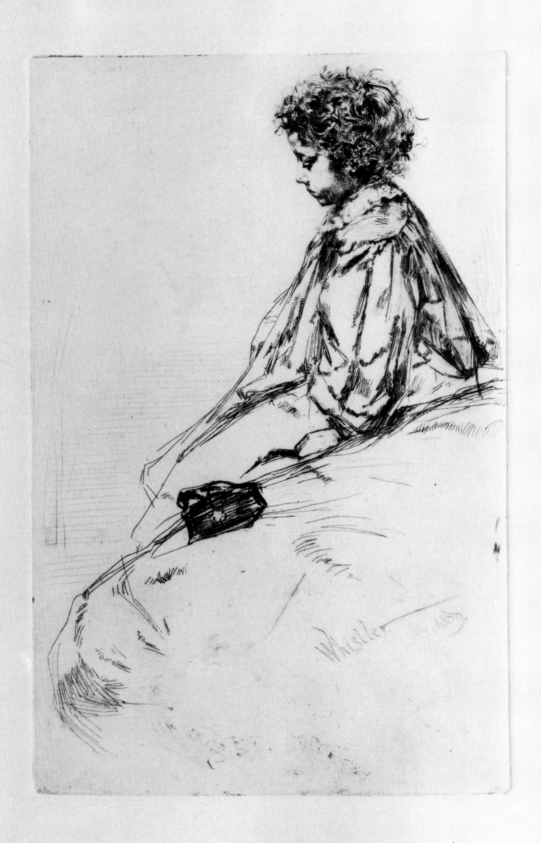

appears to have circulated them privately among his family and
friends.[18]

The drypoint portraits of 1859–60 constitute an important stage in
the evolution of Whistler's etching style. In discovering his love of tex-
ture and refinement, Whistler began to explore the possibilities of the
beautiful which were ultimately to lead him away from realism. In
executing portraits of attractive men and women he was to find a subject
which would preoccupy him for the rest of his life.

## 6. Whistler's Thames Etchings of 1860–61

Whistler returned to London in the spring of 1860 in time for the open-
ing of the Royal Academy in May, and rented a studio at 70 Newman
Street. His initial success may have influenced his decision to settle there.
Not only were two of his drypoint portraits and three of his Thames
etchings on display;[1] his painting *At the Piano* was shown and was greatly
admired by the President of the Royal Academy, Sir Charles Eastlake,
and by the English painter Whistler most admired, John Everett
Millais.

Whistler had lost no time making friends in London. Through Luke
and Alecco Ionides he met the wealthy and philanthropic Ionides
family, and become "pet of the set"[2] at their home at Tulse Hill. The
members of the English group gradually reassembled in London, and
"Ye Societie of our Ladye in the Fieldes" was complete with the arrival
of Du Maurier on May 27. Du Maurier, who was in awe of Whistler's
success, agreed to share his studio in the hope of sharing his companion-
ship and social prestige.

Instead, the hapless Du Maurier lived in extreme discomfort in
Whistler's "blasted apartment"[3] until November, while Whistler spent
extended periods working on the Thames in an inn near the Wapping
steamboat pier. Occasionally he returned to spend a night in London
and regale Du Maurier with amusing stories. Alphonse Legros and the
members of the "English Group," Poynter, Ionides and Du Maurier,
overcame their initial trepidation and went to visit Whistler at Wap-
ping. There are several accounts of jolly evenings spent drinking and
singing at pubs in Wapping and Rotherhithe. The other side of the
river was easily accessible through the Thames Tunnel.

In his memoirs Armstrong recalled how "on the Thames Whistler
worked tremendously . . . not caring to have people about or let any
one see too much of his methods."[4] From June to November he was
engaged in the planning and execution of a painting which he kept
secret, for fear that Courbet might steal his subject.[5] He began with
a preliminary etching, *Rotherhithe*, K.66 (pl. 147), which is by far the
most ambitious and "finished" of the etchings of 1860–1. It was made

on the balcony of the Angel Inn at Rotherhithe, looking northwest
toward the City, with the dome of St. Paul's visible on the horizon at
the far left (pl. 146). Whistler made no attempt to reverse the composi-
tion so that the plate would be topographically accurate, and it can
be safely assumed that his primary interest lay not in recording the view
from the Angel but in constructing the composition.

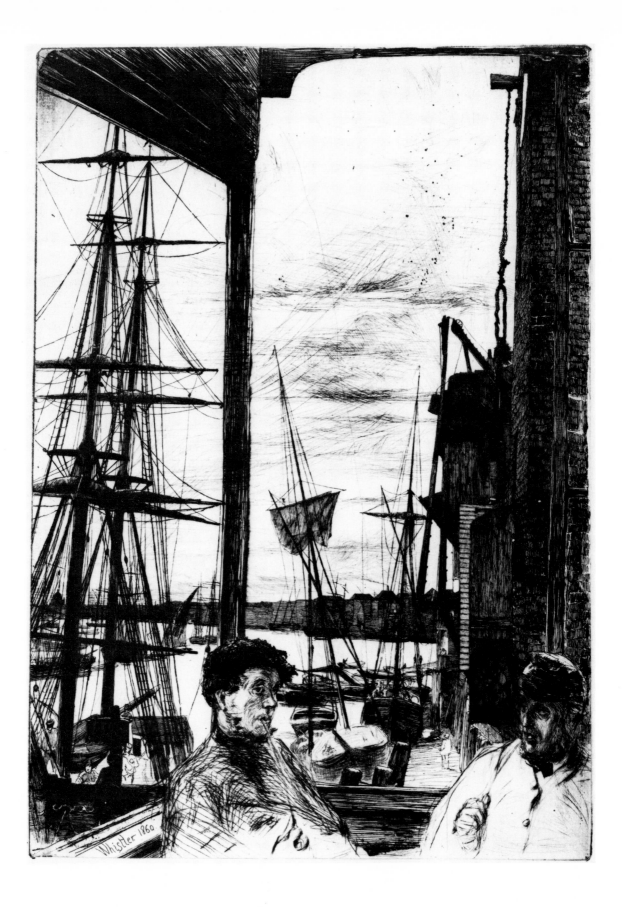

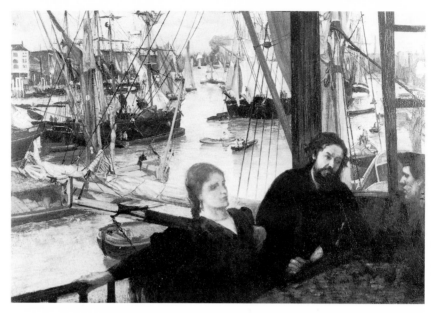

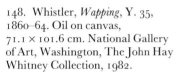

148. Whistler, *Wapping*, Y. 35, 1860–64. Oil on canvas, 71.1 × 101.6 cm. National Gallery of Art, Washington, The John Hay Whitney Collection, 1982.

The painting entitled *Wapping*, Y.35 (pl. 148), clearly builds on the composition worked out in *Rotherhithe*. Like the etching, it is characterized by large foreground figures, a conspicuous post supporting the balcony roof, and a view of shipping on the Thames with Wapping in the background. In a letter to Fantin Whistler described the background of the painting as being "like an etching", no doubt referring to *Rotherhithe* and the Thames etchings of 1859.

Here the comparison between painting and etching end, for the differences are as marked as the similarities. The etching is vertical in format, the painting horizontal, and the division of space and structure of the composition are quite different. In the etching, the upper two-thirds of the picture space is occupied by sky which is scarcely visible in the painting, and the composition is divided vertically into two unequal parts by the radical and asymmetrical placement of the large post just left of centre which runs almost the full height of the composition. This method of bisecting the picture space is extremely awkward to eyes conditioned by Western pictorial composition, but is not at all unusual in the Orient, where it is a characteristic feature of the Japanese *ukiyo-e* woodcut.

Even if Whistler's interest in flattening his compositions in the Thames etchings of 1859 could be explained by the influence of Millais, Meryon, Bracquemond and photography, and if the *naïveté* were ascribed solely to the influence of Courbet and Legros, it is very difficult to explain the eccentric compositional devices found in Whistler's etchings of 1860–1 without looking further. By 1860, Whistler's compositions appear to owe a good deal to Japanese prints, and he seems to have been trying to grasp the basic elements of their spatial organization and to adapt them to his own work.

The reduction of the balcony of the Angel to a geometric box has more in common with Japanese stylization than with French realism. The shallow and unconvincing construction, together with the asymmetrical placement of the post, recalls such prints as Kiyonaga's *Snowy*

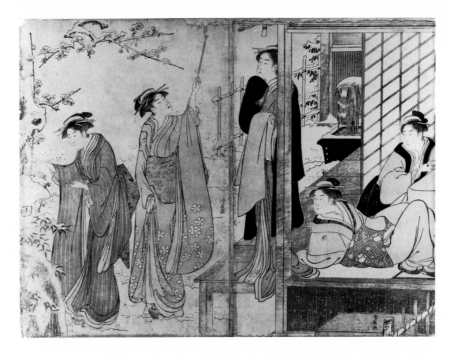

*Morning in the Yoshiwara* (pl. 149), which Whistler owned at the time of his death. He would later use a similar construction in his overtly Japanese painting *The Balcony*, Y.56, in 1867–8. Had he employed such an unconventional idea in the painting *Wapping* he might well have courted rejection at the Royal Academy.

In November, while working at Wapping, Whistler received a visit from Serjeant Thomas, an elderly lawyer who enjoyed patronizing young artists and had at one time assisted Millais financially.[6] According to Du Maurier, Thomas, impressed by Whistler's "French Set" etchings, had "got to know Whistler and arranged for their further publication."[7] A note in Whistler's passport with the address of "R. Thomas, 1 Powis Place, Queen's Square, WC," followed by a list of plates made in 1859 and the spring of 1860, may well constitute Thomas's first order.[8] During the visit to Wapping, Thomas and Whistler entered into a contractual agreement recorded by Du Maurier in a letter. "Serjeant Thomas has bought Jimmy's etchings for 7 years and is exhibiting them—does all the printing (Delattre) and advertising, and gives Jimmy half [sic]."[9] They also began to plan for Whistler's first one-man exhibition of etchings which was scheduled to take place the following April at Thomas's premises at 39 Old Bond Street.

The winter of 1860 was extremely cold, and Whistler probably moved back to Newman Street in November while spending a good deal of time at 62 Sloane Street. On Christmas Day he worked on a new painting, *The Thames in Ice*, Y.36, which shows a ship moored in the frozen river, and employs the thick impasto and broken brushwork of Courbet. He undoubtedly joined the Hadens and George du Maurier for dinner, for the latter reported to his mother "I spent Christmas Day at Mrs. Haden's—very jolly."[10]

At this time Whistler began work on his second painted interior at 62 Sloane Street, *The Music Room*, Y.34 (pl. 150), which may have been

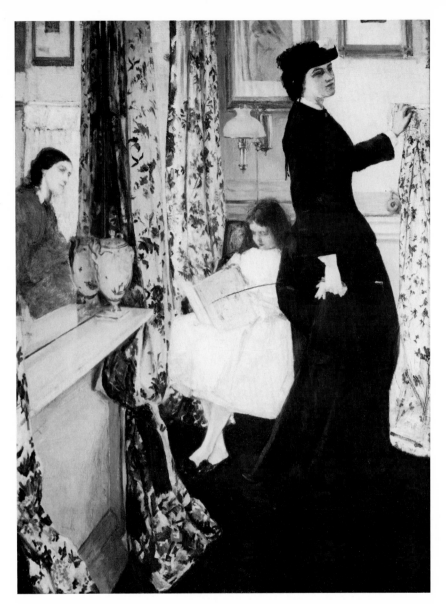

150. Whistler, *The Music Room, Harmony in Green and Rose*, Y. 34, 1860–1. Oil on canvas, 95.5 × 70.8 cm. Courtesy of the Freer Gallery of Art, Smithsonian Institution, Washington, D.C.

intended for submission to the Royal Academy in 1861. The figure of the woman in black, silhouetted against the raking floor and walls which meet at strange angles, once again recalls the relationship of figure and ground found in the *ukiyo-e* woodcut.

After attending a meeting of the Junior Etching Club on January 2, of which he was a recent member,[11] Whistler returned to the Thames and began to etch additional views in preparation for his forthcoming exhibition. Introducing a new theme into his work, he made several studies of bridges, which included *Westminster Bridge in Progress*, K.72 pl. 153), *Vauxhall Bridge*, K.70 (pl. 151), and *Old Hungerford Bridge*, K.76 (pl. 152). His appreciation of bridges probably began at his father's side, but he was much more interested in the old bridges which spanned the Thames than in the wonders of Victorian technology with which they were being systematically replaced during the 1860s, 1870s and 1880s.

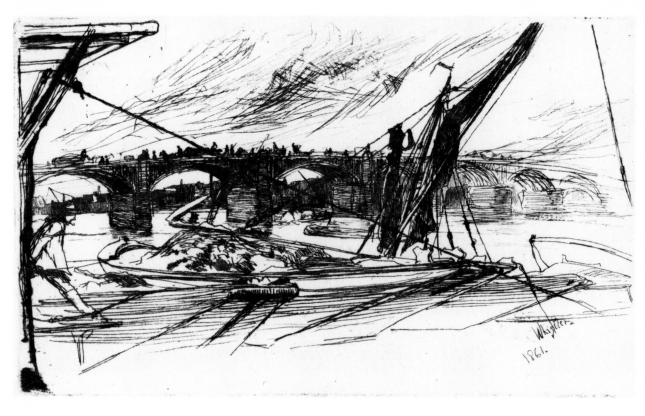

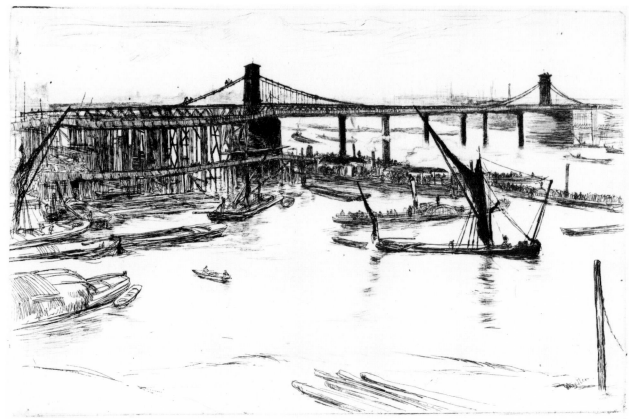

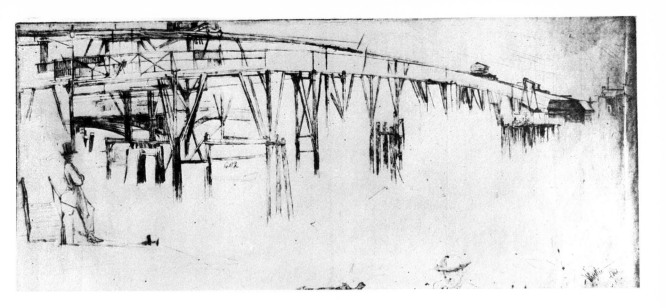

153. Whistler, *Westminster Bridge in Progress*, K. 72, 1861. Etching, 15 × 35.3 cm. S. P. Avery Collection, The New York Public Library, Astor, Lennox and Tilden Foundations.

151 (facing page, above). Whistler, *Vauxhall Bridge*, K. 70, 1861. Etching, 6.8 × 11.4 cm. Courtesy of the Freer Gallery of Art, Smithsonian Institution, Washington, D.C.

152 (facing page, below). Whistler, *Old Hungerford Bridge*, K. 76, 1861. Etching, 13.8 × 21.4 cm. Reproduced by permission of the Trustees of the British Museum.

154. Shuntosai, *Fireworks over Bridge* from Cinsen, 1857. Woodcut, 12.8 × 8.5 cm. Formerly in Whistler's collection. Hunterian Art Gallery, University of Glasgow, Birnie Philip Bequest.

The first of the six plates made on the Thames between January and the end of March was *Westminster Bridge in Progress*, K.72, which shows the beginning of the new bridge which was constructed in 1862 in place of the eighteenth-century stone bridge. The attenuated horizontal shape of the etching, which is more than twice as long as it is high, recalls the *oban* format of Japanese prints. The bridge seems to be viewed from multiple vantage points like bridges in Japanese prints. With its slightly arched shape and decorative struts it recalls the wooden bridges of Hokusai and Hiroshige, as well as a woodcut by Shuntosai in one of Whistler's Japanese books entitled *Fireworks over Bridge from Cinsen*, 1857 (pl. 154). *Westminster Bridge in Progress* exists in only one known impression, and may well have been intended as an experiment in adapting the Japanese method to the drawing of bridges.

Whistler had become increasingly interested in portraying atmospheric effects in etching, having successfully captured the appearance of fog in the painting *The Thames in Ice*. In *Vauxhall Bridge,* K.70, and *Old Hungerford Bridge*, K.76, he was not as concerned with describing the bridges as he was with showing the structures transformed by wind and rain. The careful delineation of contour which characterized the Thames etchings of 1859 was replaced in the spring of 1861 by a system of tonal etching in which lines were laid side by side. The character of the line, which can at times be sharp and slashing, shows the influence on etching of his work in drypoint.

It is possible that Whistler's more summary approach to nature was influenced by ideas then circulating on the subject of artistic photography. In 1853 Sir William Newton, in his celebrated address to the newly formed Photographic Society, said that those who wished to capture artistic effects in photography should not try "to represent or aim at, the attainment of every minute detail, but to endeavour at producing a broad and general effect." Regarding focus he said, "I do not consider that the whole of the subject should be what is called in focus; on the contrary. I have found in many instances that the object is better obtained by the whole subject being a little out of focus."[12]

155. Whistler, *Ratcliffe Highway*,
K. 80, 1861. Etching,
15.1 × 22.4 cm. Reproduced by
permission of the Trustees of the
British Museum.

156. Hokusai, *Samurai in the Rain*
from the *Manga*, vol. 1. Ukiyo-e
woodcut, 22.9 × 15.9 cm. The Art
Department, Newark (N.J.) Public
Library.

In addition to bridge subjects, Whistler began to experiment with fragmented images in *The Penny Boat*, K.67, and *Ratcliffe Highway*, K.80 (pl. 155). They were both made at Limehouse, the former at one of the many steamboat piers, the latter in a sailors' dance hall on the Ratcliffe Highway. The Highway, notorious for a series of murders, contained shops and boarding houses catering to sailors, and other colourful establishments such as Charles Jamrach's wild beast depot. Whistler's *Ratcliffe Highway* could have been made at the East London Music Hall which was crowded with men and women "smoking, drinking, laughing and quarelling."

In both these plates the crowd is represented by scattered, seemingly disembodied heads, randomly arranged in somewhat the same way that Hokusai distributed sketches on the sheets of the *Manga* (pl. 156). They constitute Whistler's first experiments with the placing of compositional fragments to create a harmonious whole in the Japanese manner. His sense of placement which later became so refined, was still in its initial stages and the results appear rather disjointed.

*Early Morning, Battersea*, K.75 (pl. 157), is perhaps the most "oriental" of the etchings of 1861. This is the first work in which Whistler tried to capture the effects of dawn found in Hiroshige or Hokusai. The result was a tonal work in which ambiguous geometric forms loom up and appear as black patches in the morning mist. The flatness which forms

124

assume when visibility is limited provided Whistler with the inspiration which led to his poetic nocturnes in the mid 1860s and early 1870s. The asymmetrical, rather mysterious geometry of the wharf at the left and the fragile little bridge in the background have a subtle if distinctly oriental flavour.

While continuing to add to his Thames etchings, Whistler also set out to make a plate which could be used as an announcement for the exhibition. He made two: the first of these was *Millbank*, K.71 (pl. 158), and the second, *The Little Pool*, K.74 (pl. 159). It is unlikely that both were intended to fulfill the same function, although both were inscribed "The Works of James Whistler: Etchings and Drypoints are on view at E. Thomas, 39 Old Bond Street." It is possible that Thomas disliked the first plate and asked Whistler to make a second. Perhaps the dramatically unconventional composition in which the river and its bank rise vertically in the picture space, framed on the right by a row of upright posts, displeased him. While these elements were unusual in Western art, they could be found in nineteenth-century Japanese landscape prints. Dramatic and highly decorative rows of posts used for mooring boats are frequently found in the river views of Hiroshige and Hokusai. The second plate, *The Little Pool*, was made in late March, and shows Whistler at work on a pier overlooking the Pool accompanied by Serjeant Thomas and his son Ralph.

Whistler must have pulled his proofs on the press which Thomas installed in one of the small rooms at 39 Old Bond Street. Pennell recounted how Whistler

... would come in the evening, when he happened to be in town, to bite and try his plates. Sometimes he would not get to work until half-past ten or eleven. In those days, he always put his plate in a deep bath of acid, still keeping to the technical methods of the Coast

157. Whistler, *Early Morning, Battersea*, K. 75, 1861. Drypoint, 11.3 × 15.2 cm. Courtesy of the Freer Gallery of Art, Smithsonian Institution, Washington, D.C.

158. Whistler, *Millbank*, K. 71, 1861. Etching, 10.1 × 12.6 cm. Reproduced by permission of the Trustees of the British Museum.

159. Whistler, *The Little Pool*, K. 74, 1861. Etching, 10.3 × 12.5 cm. Reproduced by permission of the Trustees of the British Museum.

Survey. Serjeant Thomas, in his son's words, was "great for port wine", and he would fill a glass for Whistler, and Whistler would put the glass by the bath, and then work a little on the plate.[13]

It was probably in preparation for the exhibition that Whistler made new states of some of his earlier plates, for it was in 1861, at the suggestion of Serjeant Thomas, that he added two figures in the interior of *The Rag Gatherers*, K.23, 1858.[14] Delâtre may have come over from Paris to print impressions for the exhibition, fulfilling the terms of the agreement which Whistler had made with Thomas.

The exhibition was financially successful for Whistler. The envious Du Maurier recorded the details:

> Fancy Jimmy's first set of etchings, a dozen (the whole set sold for two guineas), brought him in £200, and he has just sold the 12 plates for another £100, that makes each etching 25 guineas, and I for a drawing on wood, more elaborate, only get 3. And he does anything he likes, while my subjects are cut out for me . . . Jimmy's latter etchings, those of the Thames, which are most *magnificent*, have not sold so well, but because he asks most exorbitant prices for them, 1 and 2 guineas a proof—but all will turn out well in the end I suppose.[15]

Whistler apparently made £200 from the sale of the first hundred "French Set" portfolios printed in Paris and London in 1858, and a further £100 by selling the plates to Thomas. He placed a much higher value on his Thames etchings, asking as much for individual prints as he had for the entire "French Set." The income which he realized provided tangible proof of the financial merits of pursuing this particular avenue of artistic creativity.

It is doubtful whether fewer impressions of the Thames etchings were sold because of the higher price. In 1862, Mrs. Whistler, who marketed the etchings in America, wrote to Whistler asking for "the printed lists you have to complete the Thames etchings." She reported that collectors in America were divided over whether the "French Set" or the Thames etchings were preferable.[16] This debate, which continued for many years, arose out of Whistler's marked change in style and subject. Such controversy was to follow him throughout life as one radical style replaced another.

In the etchings of 1860–1 Whistler began to move away from a linear and toward a tonal depiction of nature, away from a meticulous delineation of reality and toward a more suggestive description of its less tangible aspects. This was a most creative period, in which the etchings lack the resolution found in the works of 1859 but anticipate the revolution in depicting nature which was to point the way to Impressionism.

## 7. Atmosphere and Poetry

As soon as the exhibition at Thomas's had opened, Whistler returned to his work on the painting *Wapping*, and sent an earlier painting *La Mère Gérard*, Y.26, to the Royal Academy, along with three etchings.[1]

161 (facing page). Fantin, *A Piece by Schumann*, 1864. Etching, 18.7 × 27.7 cm. Reproduced by permission of the Trustees of the British Museum.

160. Legros, *Portrait of Mr. Edwin Edwards*, M&T 13, 1861. Etching, 27.9 × 19.8 cm. Courtesy Wiggin Collection, Boston Public Library.

162. Legros, *Le Salon de M. Edwin Edwards*, M&T 130, 1861. Etching, 17.1 × 23.6 cm. Courtesy Wiggin Collection, Boston Public Library.

He was not represented at the Paris Salon, perhaps because he did not have a new work ready for submission by the end of March. During the summer of 1861 he made several *plein-air* landscape etchings and drypoints during visits to the home of Mr. and Mrs. Edwin Edwards at Sunbury near Hampton Court.

Edwards was a lawyer who, when his field of jurisprudence became obsolete, decided to devote himself to his avocations of art and music. To this end he went to a drawing class where he met a young artist, Matthew White Ridley, who had been a fellow student of Whistler in Paris in 1856–7. Through Ridley, Edwards was introduced to Whistler, Legros, Fantin and Haden.[2] During the 1860s and 1870s the Edwards home became a meeting place for *avant-garde* French and English painters and etchers, including Bracquemond, Bonvin, Manet and Charles Keene.

128

Sunbury · Oct · 1864
chez Edward
Un morceau de Schumann

163. Whistler, *Encamping*, K. 82,
1861. Etching, 28.5 × 15.7 cm.
Reproduced by permission of the
Trustees of the British Museum.

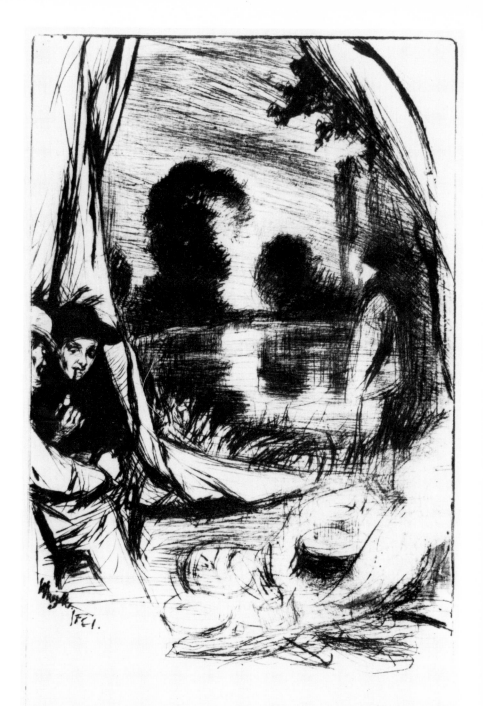

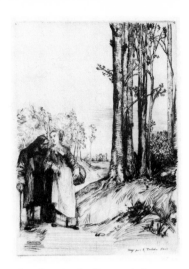

164. Legros, *La Promenade du convalescent*, M. and T. 68, 1861. Etching, 27.9 × 19.8 cm. Courtesy Wiggin Collection, Boston Public Library.

165. Edwards, *Under the Willows, Maple Durham*, 1861. Etching, 16.2 × 23.9 cm. Reproduced by permission of the Trustees of the British Museum.

166. Edwards, *Our Camp at Maple Durham*, 1861. Etching, 10 × 22.3 cm. Reproduced by permission of the Trustees of the British Museum.

Legros taught Edwin Edwards how to etch during a visit which he made with Ridley over Christmas and New Year 1860–1. Edwards was so enamoured of the process that he sent at once to London for an etching press. It was installed by January 4 when Mrs. Edwards pulled an impression of Legros's etching *Faust et Marguerite*, M. & T.13, which was inscribed "Our first proof, A. Legros, M. W. Ridley, Edwin Edwards vue et apprové Ruth Edwards 4 January. 1861."[3] Delâtre printed most of Edwards's early plates, and both Edwards and his wife claimed to have learnt a great deal from "the artistic feeling and manipulatory adroitness" of the printer.[4] Charles Keene, whose plates were proved by Ruth Edwards, claimed that there was "hardly a better printer than this lady to be found in London."[5]

Summer excursions to the Edwards's home at Sunbury must have been delightful occasions. The house was elegant and comfortable, and situated among lawns near the banks of the Thames in a pretty rural reach. The Edwardses were talented musicians, and entertained their guests to musical evenings, playing Schumann and Beethoven on the flute and piano.

Edwards had a covered boat which he used for etching expeditions on the river, no doubt inspired by "Le Botin," the covered boat from which the Barbizon artist Charles Daubigny etched the Seine in 1857–61. Ruth Edwards told the Pennells how "In coming to Sunbury (three miles from Hampton Court) Whistler would sometimes send a line to be met there. We had a large boat with a waterproof cover, my husband and friends several times went up the river and slept in the boat."[6] In June, 1861, despite persistent rain, Edwards invited Ridley and Whistler to take the boat on a camping trip to Maple Durham. On the voyage Whistler appears to have made the drypoints *Encamping*, K.82 (pl. 163), and *The Storm*, K.81 (pl. 167), while Edwards worked on his plates *Under the Willows, Maple Durham* (pl. 165) and *Our Camp at Maple Durham* (pl. 166), inscribed "June 18, 1861."[7]

Whistler must not have considered *Encamping* a great success, for he cancelled the plate after taking only one impression, probably on the press at Sunbury. Stylistically it is a strange *pastiche* of Legros's naïve manner, and Corot's more poetic style. The flatness of the foreground figures and the willows which frame the landscape give the whole the appearance of a stage set. The handling recalls Legros's etching *La Promenade du convalescente*, M. & T.68 (pl. 164), of the same year.

*The Storm*, K.81, shows Ridley battling against driving wind and rain

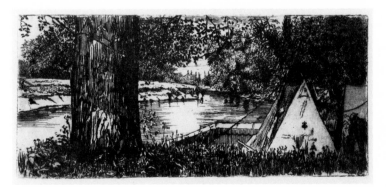

167. Whistler, *The Storm*, K. 81,
1861. Etching, 15.5 × 28.4 cm.
Reproduced by permission of the
Trustees of the British Museum.

169 (right). Daubigny, *Le Lever de
soleil*, L.D. 67, 1850. Etching,
23.2 × 13.2 cm. Reproduced by
permission of the Trustees of the
British Museum.

168. Hiroshige, *The Fifty-Three
Stages of the Tokaido: Shono, A
Shower*, 1833–4. Ukiyo-e woodcut,
34.8 × 22.6 cm. Sir Edmund
Walker Collection, Courtesy of the
Royal Ontario Museum, Toronto.

with the river foaming in the background. Great bundles of drypoint
lines driven through the copper recall Rembrandt's use of line to create
stormy effects in the late states of *Christ Crucified between the two Thieves*,
B.78 (pls. 68–8). Although Bracquemond had also shown rain in etching,
both artists appear to have taken their idea from such Japanese prints
as Hiroshige's *Shono: A Shower* from *The Fifty-Three Stages of the Tokaido*
(pl. 168).

According to Du Maurier the weather in June was wretched for
several weeks.[8] Whistler's exposure to the elements on the camping trip
brought on a serious bout of rheumatic fever.

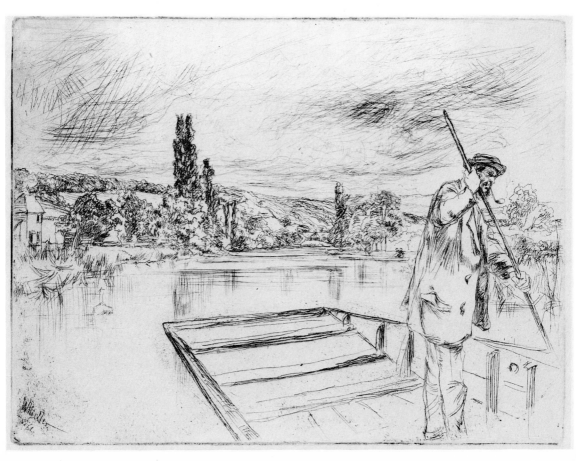

By July 4, when Fantin arrived for a visit, Whistler was too ill to put him up,[9] and the situation had become so serious that Du Maurier received a message that Whistler was dying, and rushed to visit him. He found him "dreadfully ill with Rheumatic fever."[10] While Whistler stayed with the Hadens under the care of Traer,[11] Haden made arrangements for Fantin to stay at Hook's home in Surrey for a couple of weeks, then to go with Ridley to stay with the Edwards on July 20. This was the beginning of the long and close relationship which developed between Fantin and the Edwards. Fantin wrote to his family describing his surroundings, saying "in this house, where I am so comfortable, working, dining, sleeping, music, everything is charming; I regret only one thing: that you can not be as happy as I."[12] He began a portrait of Ruth Edwards who, together with her husband, was to assume the role of Fantin's agent in England.

Whistler appears to have recovered in August, and to have gone to visit Fantin at Sunbury, probably accompanied by Haden. Here they spent a day in the open air etching and enjoying the fine weather. Edwards made etchings in which both Whistler and Fantin were seen seated in the landscape.[13] Whistler made two *plein-air* etchings, *Sketching No. 1*, K.86 (pl. 170), and *Sketching No. 2*, K.87; the latter apparently shows Haden drawing on a copper plate.[14] In addition, Whistler appears to have made *Landscape with a Fisherman*, K.83 and *The Punt*, K.85 (pl. 171), at Sunbury, possibly on the same visit.[15]

Whistler had agreed at the January meeting of the Junior Etching Club to contribute two plates "to replace those promised by the late Mr. Luard in the Collection of Miscellaneous Etchings to be published by Day and Son."[16] The title of the publication was changed to *Passages from Modern English Poets*, and appeared in 1862. To it Whistler contributed *Sketching No. 1*, which was retitled "The Angler," and *The Punt*, retitled "A River Scene." His plates were proved by Frederick Goulding, an apprentice at Day and Son. Goulding, who first met Whistler in 1859, had the "honour" of being Whistler's "devil" and grinding his ink.[17] He was later to become the foremost printer of etchings in England.

The loose, improvisational style of the etchings made during the summer of 1861 demonstrates Whistler's interest in Corot and Daubigny (pl. 169), and his closeness to Haden. The etchings have an animation, freshness and ability to capture light, air and water which is unprecedented in his earlier work.

During Whistler's visit to Sunbury in August, he and Fantin must have made their plans to leave for France during the first few days of September. After arriving in Paris, Whistler continued on to Brittany to recuperate fully from the attack of rheumatic fever.

He remained at the seaside from the beginning of September to the end of the first week in November. During this period he made one drypoint, entitled *The Forge*, K.68 (pl. 172), at Perros-Guirec, which recalls Bonvin's Brittany painting *Les Forgerons: Souvenir du Tréport* (Pl. 173), exhibited at the Salon of 1857. Whistler treated the subject, which was a favourite with Romantics and Realists, in a new way. Gone were the straining, Vulcan-like muscles found in the work of his predecessors; Whistler's smith stands like an alchemist before the forge, observing the glowing metal, while apprentices stand by watching the

170 (preceding page, above). Whistler, *Sketching No. 1*, K. 86, 1861. Etching, 12.0 × 16.5 cm. Courtesy of the Freer Gallery of Art, Smithsonian Institution, Washington, D.C.

171 (preceding page, below). Whistler, *The Punt*, K. 85, 1861. Etching, 11.8 × 16.2 cm. Courtesy of the Freer Gallery of Art, Smithsonian Institution, Washington, D.C.

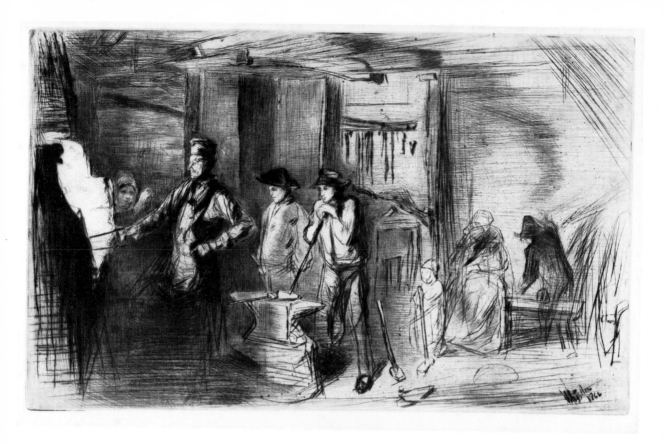

172. Whistler, *The Forge*, K. 68, 1861. Drypoint, 19.5 × 31.5 cm. Art Gallery of Ontario, Gift of Mr. and Mrs. Ralph Presgrave, 1976.

173. Bonvin, *Les Forgerons, Souvenir du Tréport*, 1857. Oil on canvas, 93 × 74 cm. Toulouse, Musée des Augustins.

transformation take place. Whistler was not concerned with a social message; he was interested in the dramatic and shifting illumination inside the dusky room, and the way in which forms were rendered ambiguous and insubstantial by the blaze. In this plate, he returned to the theme of lighting from within which he had explored in *The Music Room* pls. 83–85), three years earlier. In the earlier plate, the forms emerge solidly from the darkness; in *The Forge*, nature is rendered alternately substantial and insubstantial as the glowing metal goes through its metamorphosis. Whistler was very pleased with the drypoint, and printed all the early impressions himself, often on thin, silky *japon mince*.[18]

Whistler's new model and mistress, a red-haired Irish beauty named Joanna Hiffernan, sat for several drypoints in 1861, as well as the painting *Symphony in White, No. 1: The White Girl*, Y.38 (pl. 174), painted in Paris in December. In the drypoint *Jo's Bent Head*, K.78 (pl. 175), Whistler carried the tendency toward radical elimination of detail found in the portrait drypoints of 1859–60 to extremes. While drawing Jo's head in profile he scarcely indicated the contour of her seated form, leaving a great deal to the viewer's imagination. The plate was printed leaving a film of surface tone to suggest atmosphere.

In *The White Girl*, with its symbolic overtones, and in the etchings of 1861, Whistler demonstrated an approach to nature which was becoming increasingly subjective. He appears to have been moving away from the position which Baudelaire condemned as "positivist," and toward the one which he called "imaginative," while continuing to search for subjects from everyday life.

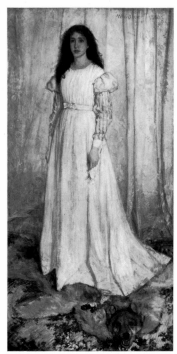

174. Whistler, *Symphony in White,
No. 1: The White Girl*, Y. 38, 1862.
Oil on canvas, 214.6 × 108.0 cm.
National Gallery of Art,
Washington, Harris Whittemore
Collection, 1943.

175. Whistler, *Jo's Bent Head*,
K. 78, 1861. Drypoint,
22.7 × 15.2 cm. Reproduced by
permission of the Trustees of the
British Museum.

He was becoming increasingly interested in the intangible and
changeable aspects of nature which transformed physical reality, and
sought to describe nature in a variety of moods and atmospheric condi-
tions. Wind and rain, overcast skies, bright sunlight, twilight, and the
invasion of dark space by bright light were all sketched with needle
on copper. The more subjective approach, in which nature was viewed
through the artist's own temperament, led Whistler inexorably toward
a break with Realism.

# 8. The Politics of Publication and the Growth of Personal and Professional Rivalries

Just as the Etching Revival began to gather momentum in the early 1860s and etching became "all the rage," Whistler abandoned the medium for seven years. It was characteristic of the artist to run against the pack; he never wanted to be seen to do what everyone else was doing. By 1863 he had begun a radical shift away from realism and toward aestheticism, which led to colour experiments and great strides forward in painting. While this is probably the most important single factor in his neglect of etching, there is reason to believe that his temporary loss of interest may have been due in part to his professional rivalry with Haden.

As interest in etching developed during the early 1860s the relatively uncomplicated life of the pioneer etchers of the 1850s, who had at best a limited market for their work, grew more complex. Casual arrangements for the circulation and sale of work among friends and patrons were supplanted by the formation in Paris of the Société des Aquafortistes in 1862. Amateur etching societies in Britain were soon undermined by this aggressive body which solicited the membership of leading etchers on both sides of the Channel. While it did not completely replace private ventures, the Société provided a model for publishing and marketing which transformed the quiet amateur activity into a competitive industry. It had a great deal to do with stimulating the full-fledged etching revival of the 1860s in France and England, and drew most of the painter–etchers of significance into its sphere.

Whistler would have followed the early development of the Société from close quarters, for it was Legros and Bracquemond who had first raised the idea with the publisher Alfred Cadart early in 1861. Cadart was known to be sympathetic toward realist printmakers, and worked closely with Delâtre who was appointed printer to the Société.

As plans for the Société took shape, Whistler may have begun to regret his contract with Thomas, which was binding until 1867. It came to a convenient and abrupt halt, however, with the death of the publisher in February, 1862. Whistler said to Du Maurier: "I wrote to the old scoundrel, and he died in answer by return post—the very best thing he could do!" Whistler considered himself "well out of that business, the Thomasses [sic] junior being easy to manage."[1] Meanwhile, he began to consider alternative schemes for publishing the Thames etchings, and planned to join the Société des Aquafortistes.

The Société was officially founded three months later on May 31, 1862. It had as its goals the publication of the best work of the new group of painter–etchers, the encouragement and spread of interest in etching among painters of note, and the provision of etching facilities and an exhibition gallery at Cadart's shop at 66 rue de Richelieu near the Bibliothèque Nationale. Membership was by invitation only: a list of proposed artists was drawn up by Cadart, each of whom was invited to submit a reception piece to the five-member jury. By controlling access, it set out to avoid one of the pitfalls of the English Etching Society, making it impossible for "fair ladies" who "prided themselves

on their ability to run an inexperienced needle over the copper plate" from joining.[2]

Whistler may have hoped that the Junior Etching Club could become the English counterpart to the Société des Aquafortistes. At the meeting of June 4, 1862, four days after the Société was founded in Paris, Whistler proposed a similar publishing venture to the Club. The minutes read: "Whistler raised the possibility of starting a periodical which should contain illustrations by the Etching Club. It was proposed that members should ascertain whether any publisher would undertake such a thing."[3] Nothing appears to have been done about Whistler's proposal, and he never attended another meeting. He undoubtedly realized that the days of amateur etching societies were numbered unless they were prepared to publish and market the work of serious etchers. He approached the printsellers Colnaghi's later in the month, and made them an unacceptable offer of ten of his plates which he hoped would bring him "a pot of gold."[4]

The Junior Etching Club finally folded on April 24, 1864. It appears that there was strong resistance from the membership against professionalizing the marketing operation, for the group which was born out of its ashes, the Etchers and Sketchers, decided that their works "were not to be produced with a view to sale but for interchange among members."[5]

The critics Philippe Burty and Charles Baudelaire watched the growth of interest in etching closely. Baudelaire was the more perceptive of the two, and came at once to the support of the young realists and the Société. On April 2, 1862, he wrote an article "L'eau-forte est à la mode," which he expanded after the first portfolio appeared in September. He said that he was delighted by the resurgence of interest in etching although he thought it too personal and "aristocratic" to have wide popular appeal. He saw etching as an excellent medium for the expression of an artist's individuality and his "most intimate personality."[6]

Baudelaire drew attention to a number of etchers, not all of them members of the Société, whose work he had seen and admired; they included Legros, Manet, Haden, Bracquemond, Meryon, Millet, Daubigny and Whistler. He pointed out that most of them had in common their youth and exposure to Courbet's "re-establishment of a taste for simplicity and honesty, and of a disinterested, absolute love of painting."[7] He recalled seeing Whistler's etchings on view at Martinet's gallery in January, and wrote in words which echoed his earlier praise of Meryon:

Just the other day a young American artist, Mr. Whistler, was showing at the Galerie Martinet, a set of etchings, subtle, lively as to their improvisation and inspiration, representing the banks of the Thames; wonderful tangles of rigging, yardarms and rope, a hotchpotch of fog, furnaces and corkscrews of smoke; the profound and intricate poetry of a vast capital.[8]

Fantin sent the article to Whistler, who was staying at Guéthary in the Pyrenees when it appeared. Whistler affected annoyance because "Baudelaire said many poetic things about the Thames and nothing

about the etchings themselves!"[9] At this time he had every intention of joining the Société, and asked Fantin to tell Cadart that he would give him "a plate upon his return to Paris, and that I apply to become a member of the society." In the meantime, he asked Fantin to bring him up to date regarding "the politics of the etchers," as if aware of the conflicts which were already beginning to brew.

This request elicited a lengthy and complicated reply from Fantin, in which he indicated that public criticism of the first portfolio had led Cadart and the jury to search for etchings which were more "finished" and attractive.[10] The work of Seymour Haden was ideally suited, and Cadart had made a special trip to London to pick up Haden's plate. Meanwhile, Bracquemond, Manet and Legros, whose work was contentious, were considering a "coup d'état," to wrest control of the Société away from Cadart. In order to aid their friends, Fantin suggested that Whistler submit a plate only on condition that Cadart allow it to bypass the jury process. Fantin planned to court rejection by submitting an etching made from a pen drawing, whereupon he would leave the Société "with haughtiness and disdain."[11]

Because he was told that the jury process could not be bypassed, Whistler never submitted a plate. He probably lost interest in the Société as the work which it published became increasingly "banal, uniform, and mediocre."[12] Whistler remained on friendly terms with Cadart, who continued as late as the summer of 1863, to hope that he would submit a plate.[13] In 1864, Fantin, whose plate was accepted, walked out of a Société dinner in disgust, finding the company of fellow members "bad, expensive, stupid."[14] Meanwhile, Seymour Haden became more and more involved in the Société, and his star began to rise.

Burty did not understand the *avant-garde* etchers: he had misunderstood Whistler's foregrounds and Bracquemond's tonal method, and in a review of the Société's fifth portfolio in February, 1863, he criticized Legros and Bracquemond, the "pontiffs of the new church," for their crude, dark line, which he associated with gothic woodcuts. He accused them of forgetting that each printmaking process has its own distinctive character, and that one should not be used to imitate another. He criticized Legros's etching for "careless drawing" and "puerile *naïveté* of composition."[15] However, if there was one etcher whom Burty admired unconditionally, it was Seymour Haden. In his article he called Haden "one of the most brilliant etchers in England," and singled out *Vue des bords de la Tamise* for special praise.

By the spring of 1863, Whistler and Haden had grown apart. The close cooperation which had marked their early work had given way to an uneasy truce. Whistler found his brother-in-law overbearing and arrogant. After Haden's initial experiments with the needle, he discovered his exceptional gift for landscape, and made a sequence of extraordinary plates of the rural Thames which were considered by some the finest landscape etchings since Rembrandt. Whistler, who thought of himself as the true artist in the family, must have found it intolerable to see Haden's work receive more attention than his own, and to watch Haden use his own friends as a means of *entrée* into the Paris etching circle. Although Haden worked from nature, and was an important and influential etcher, he was not involved with the *avant-garde* etching

movement. Because he was exceptionally talented, and his subjects pleasing, he was lionized while more important etchers were overlooked. Cadart and Burty both acknowledged him as the leader of the English etching school.

Whistler began to lose confidence in his etched work at this time. In February, when Burty's review appeared, Du Maurier wrote to Armstrong saying that Whistler's "tone is rather changed lately—he has become more modest about his own performances. He was here the other night, and was peculiarly modest about his etchings."[16] This was out of character, and his friends, who greatly admired his etchings, were clearly puzzled.

In March Whistler moved to 7 Lindsay Row in Chelsea, to a house which overlooked the Thames at Battersea. Haden came for a visit and etched *Battersea Reach*, H.52 (pl. 176), inscribed in the first state "Out of Whistler's window . . . Old Chelsea," in a style which recalls the compositional structure of Whistler's Thames etchings of 1859. Haden also etched a view from the Greaves' boat yard which he called *Whistler's House Old Chelsea*, H.54 (pl. 177).

In April Whistler and Legros went to Holland together, no doubt to see twelve of Whistler's etchings which were on view in the Hague, and to see Rembrandt's *Night Watch* in Amsterdam. Here they were joined by Haden, and Whistler and his brother-in-law etched together for the last time. They selected views which recall Rembrandt's *View of Amsterdam*, B.210 (pl. 179), and which were probably intended as homage to the Dutch master. While Haden worked on *Amstelodamum*, H.43 (Pl. 178), with its banner in the sky reading "Hic Terminus Haeret," Whistler worked on *Amsterdam from the Tolhuis*, K.91 (pl. 180). Unlike the products of their earlier etching ventures, these two etchings were very different in style: Haden worked in a restrained manner which recalls Hollar and Meryon, while Whistler used a much freer line to capture wind and atmosphere. He was delighted to learn later that he had been awarded one of three gold medals for the etchings on view at the Hague.

By midsummer Whistler was in good spirits, buoyed by the sensation which his painting *Symphony in White, No. 1: The White Girl*, Y.38, was creating in Paris at the Salon des Réfusés. Fantin had written to say that Courbet, Legros, Manet, Bracquemond and Baudelaire had all admired it. Whistler was delighted to hear of Baudelaire's praise, and forgetting his earlier annoyance, asked Fantin to thank him and tell him that on his next visit to Paris he hoped "to have the pleasure of finally meeting him, at which time I hope he will accept a few of the best proofs of the etchings of which he once spoke so well."[17]

Haden invited Fantin to visit London at his expense, and asked him to stop at Delâtre's on the way to collect some copper plates. He wrote to Delâtre and asked him to package up all the copper plates which he had in his possession by Whistler and himself, and to give them to Fantin when he stopped by. Haden may well have done this to prevent Delâtre from taking impressions to sell without permission. Haden also told Delâtre that he and Whistler were planning a joint publication: "Whistler works well. Among other things we are planning four portfolios of twelve plates: each one of views made on the Thames from its source to the sea. That will make 48 plates altogether, interesting

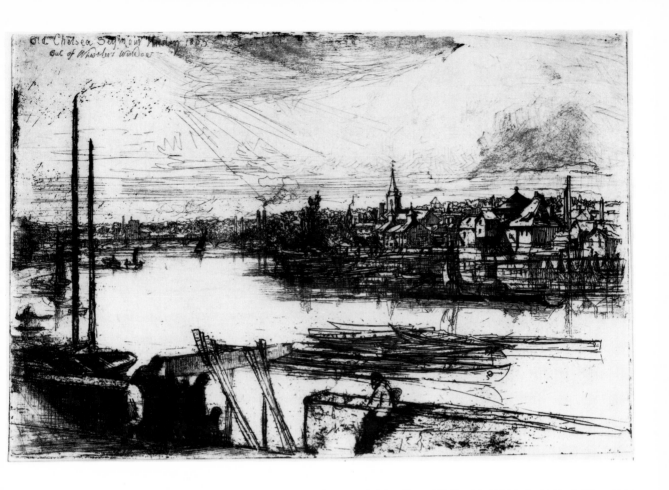

Old Chelsea Seymour Haden 1863
Out of Whistler's Window

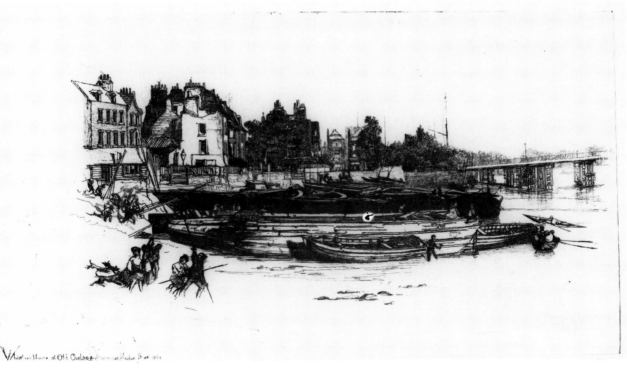

Whistler's House at Old Chelsea Seymour Haden 1863

178. Haden, *Amstelodamum*, H. 43, 1863. Etching, 11.7 × 10.2 cm. Reproduced by permission of the Trustees of the British Museum.

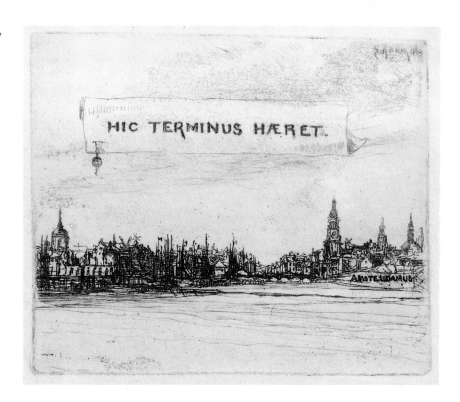

179. Rembrandt, *View of Amsterdam*, B. 210. Etching, 11.2 × 15.3 cm. Reproduced by permission of the Trustees of the British Museum.

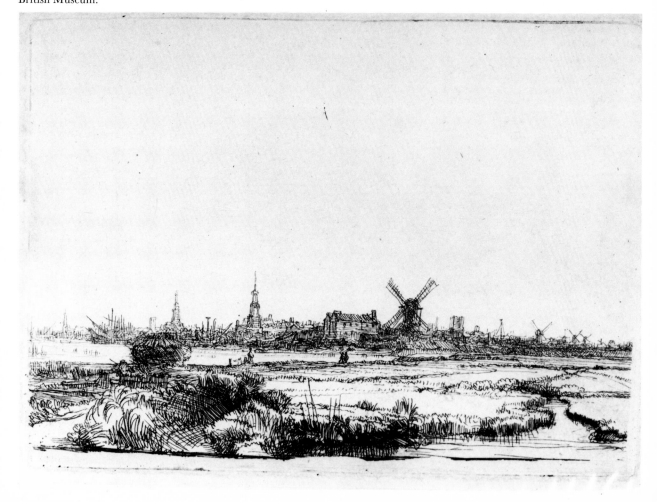

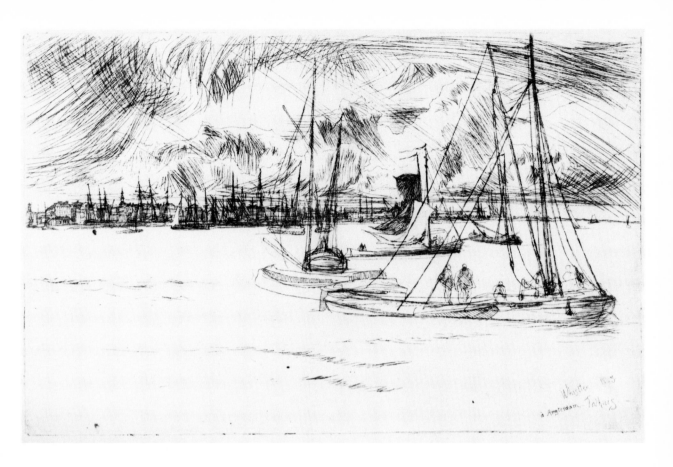

180. Whistler, *Amsterdam from the Tolhuis*, K. 91, 1863. Etching, 13.3 × 20.9 cm. Courtesy of the Freer Gallery of Art, Smithsonian Institution, Washington, D.C.

for our river is very droll.[18] Had this extraordinary project seen the light of day, it would have constituted one of the most important publishing ventures of the etching revival. It would no doubt have included Whistler's etchings of the river as it passed through London and Haden's rural views, many of which were etched at notable points along the river. The abandonment of the project, probably resulted from the growing estrangement of the two men early in 1864, and the new publishing options presented to Haden by Burty.

A series of quarrels of growing intensity took place between Whistler and Haden in 1864, which led to the termination of their relationship. In January, while visiting 62 Sloane Street, Whistler and Legros noticed that Haden had altered the deliberately *naïve* perspective in Legros's painting *L'Angelus*. They took it off the wall and carried it to 7 Lindsay Row to remove the overpainting. Having replaced the picture, they waited gleefully for Haden to notice. In a long letter to Fantin describing the mounting drama and suspense, Whistler reported that "the feeling of hostility grew from day to day between Haden and his devoted brother-in-law." After several days, Haden finally turned to Legros and said "Oh! You have removed all that! Very well. Do it better!"[19]

Haden, so ready to consider himself a superior judge of a work of art, was not above passing judgement on Whistler's lifestyle at Lindsay Row. He was outraged by Whistler's lack of concern for respectability, which was exemplified by his living openly with a woman to whom he was not married. In January, after a terrible row with Whistler over

Jo, Haden forbade his wife to visit her half brother under his own roof, saying that they might only meet at the home of mutual friends. This was cruel punishment indeed, for as Whistler wrote to Fantin, "you know how devoted we are to each other."[20] Suddenly, with only a week of warning, Mrs. Whistler announced that she was leaving America and coming to live with him. Whistler had to find a *"buen retiro"* for Jo, and "purify" his house "from the cellar to the eaves" in preparation for his mother's arrival.

Haden, meanwhile, was looking forward with pleasure to the appearance of a two-part article by Philippe Burty in the September and October issues of the *Gazette des Beaux Arts* entitled "L'Oeuvre de M. Francis Seymour Haden," accompanied by a *catalogue raisonné* of his etchings. Whistler, with more than a touch of malice, wrote to Fantin that Haden "has his head turned with his publication." It was this article which launched Haden's international reputation as the leader of the English school of etching in Britain, France and America. He never looked back.[21]

Given the damning criticism which Burty had levelled at the structure of Whistler's Thames etchings the year before, Whistler must have been incensed at the following passage:

It was neither the Thames below London, as large as an arm of the sea and bearing two-thirds of the world's trade, nor again the Thames in London whose fetid waves bathe the feet of the docks or foam against the arch of the bridges. It was the Thames a few leagues above the city: a modest river with sloping banks scattered with thickets of trees, responding with a bend to the slightest changes in the terrain.[22]

While Burty allowed that Haden had begun etching under the stimulus of "a series of very interesting etchings" by "his brother-in-law Mr. Whisler [sic]," he recounted how Haden, "from the first stroke found himself master of all its secrets."[23] Not only did Burty elevate Haden at Whistler's expense, dismissing his work as a mere stepping-stone in Haden's development; for the second time in a year he misspelled his name.

The joint etching venture had foundered by this time. In 1865, Burty arranged with Haden for the separate publication of his Thames etchings under the title *Etudes à l'eau forte* to appear in 1866 accompanied by a preface by Burty, "associate" of the "Press" and of the *G.B.A.* Following their publication, the etchings were to be exhibited in Paris and London.

Early in 1866, after drawing up a Will on January 31, Whistler left on a mysterious and unexplained journey to Valparaiso. He gave power of attorney to his executors Dante Gabriel Rossetti and Anderson Rose, and made Jo his sole beneficiary. He instructed them

on his behalf to negotiate for the sale and to sell fifteen etched copper plates and to receive the money and give receipts in the name of the said James Abbott McNeill Whistler for the same. And as part of the conditions of such sale to undertake and agree in his name that he will not publish any other etchings in England or elsewhere within

two years of the date of such sale and also that he will give up all proofs taken from the said fifteen etched copper plates except six sets of impressions to be kept or given by the said JAM to his relatives or friends. [24]

Rose went first to Colnaghi's on Old Bond Street where Haden's etchings were to be exhibited, but the price asked was too high. On February 2 the print dealers wrote to say, "We have turned this matter over and over again, but cannot, with every disposition to buy the plates, make you any further offer for them." [25] By April, Jo was very anxious to know whether Rose had had any success in his negotiations with the publishers Day and Hague, and Rossetti wrote to Rose on her behalf. [26] She was clearly in difficult financial straits, and went to Paris to pose for a provocative painting by Courbet entitled *Le Sommeil*. After Whistler returned in September, he and Jo parted amicably.

After the extraordinary success which attended the exhibition of Haden's etchings in Paris and London, Haden assumed the role which was to preoccupy him increasingly: that of apologist for the etching revival. In June, 1866, he made his first pronouncements in an article entitled "About Etching" which appeared in the *Fine Art Quarterly*. Here he outlined the theoretical approach which he and Whistler had evolved during their early years together. He made no mention of his brother-in-law.

By 1867, Whistler's jealousy of Haden was transparent. He had fallen out with Legros, who had become too friendly with Haden, and was convinced that Philippe Burty disliked him, calling him "Haden's little dog" in a letter to Fantin. [27] Fantin, like the Edwardses, had become increasingly aware of the extent to which Whistler's animosity clouded his judgement, and wrote back, "you pay too much attention to Burty, I believe to the contrary that he is well disposed toward you." [28]

Whistler's longstanding antipathy came to the fore in an ugly incident which took place in Paris on April 23, 1867. [29] During a medical conference, attended by Haden, Traer, and Whistler's brother William, Traer died unexpectedly while visiting a brothel. He had apparently been an unhappy and unwilling partner in Haden's medical practice for some time, and had taken to drinking heavily. Without autopsy or funeral, without notifying Traer's family, or mentioning the incident to the two Whistlers, Haden signed the death certificate and had Traer buried in Père Lachaise cemetery. Whistler was outraged by this treatment of the man who had been his personal friend and physician. A fight broke out between the Whistler brothers and Haden in a café, and Whistler pushed Haden through a plate glass window. The relationship between Whistler and his "beaufrère" ended on the spot.

Upon his return to England, Whistler broke the news to Traer's family and raised a subscription to have the body disinterred and returned to England for a Protestant burial. In retaliation, Haden sat down and penned a letter to the Burlington Fine Arts Club, insisting that Whistler be expelled for his ungentlemanly behaviour. Whistler maintained confidentiality around the incident, not wishing to cause Traer's family further grief. When compelled to justify his actions in a letter to the Burlington Fine Arts Club, he received a sympathetic but firm reply: members of the Club were not permitted to strike each

other, regardless of the degree of provocation. This did not stop Whistler from striking Legros who had taken Haden's side in the matter, thereby terminating their relationship. From this time on, Whistler and his mother never set foot in Haden's house again, and were forced to see Deborah only in the homes of mutual friends. Mrs. Whistler, who took her son's side in the quarrel, observed that Major Whistler had disliked Haden from the start. She rewrote her will on June 14 leaving her entire estate to James and William.[30]

It was left to Philip Gilbert Hamerton, author of *Etching and Etchers*, the handbook of the English etching revival, to complete Haden's apotheosis. The dedication page of the first edition of 1868 reads as follows:

> Francis Seymour Haden ... You have the satisfaction of knowing that a great art, hitherto grievously and ignorantly neglected, has, by your labour, received an appreciable increase of consideration; and that, as a consequence of the celebrity of your works, many have become interested in etching, who before their appearance were scarcely aware of its existence ... of all modern etchers you seem to be the most completely in unison with the natural tendencies of the art.[31]

Whatever Whistler's other reasons for ceasing to etch in 1863, the relationship with Haden clearly had a role to play. Whistler could not bear to compete and lose in the same lists as Haden, and the quarrel which erupted between them, while appearing on the surface to be unrelated to professional rivalry, was inextricably combined with it. For the rest of his life, Whistler delighted in taunting Haden and speaking out against him whenever an opportunity presented itself. Haden became increasingly arrogant as he grew older, but never ceased to admire Whistler's etchings, whatever he thought of the man himself.

# CHAPTER THREE

# *Whistler and Aestheticism, 1867–81*

## 1. Whistler's Transition from Realism to Aestheticism

During the seven-year break in Whistler's etching activity from 1863 to 1870, the artist underwent a personal aesthetic revolution of considerable complexity. He found himself torn between antithetical ideas current on either side of the Channel, and spent several years trying unsuccessfully to reconcile them into a unified aesthetic approach.

Whistler was never closer to Courbet or realist art theory than in the aftermath of the exhibition at Bonvin's studio in April 1859. Fantin, who may have been more reserved in his admiration, observed in a letter to Whistler a few months later that Courbet was wasting his talents in drinking and gambling.[1] During the winter of 1859–60, Whistler and Fantin went to Bonvin's studio to work after the model under Courbet's direction.[2] From 1860 to 1864, Whistler worked on his realist *chef d'oeuvre Wapping*, and swore Fantin to secrecy for fear that Courbet might "steal" his subject.[3] Although Fantin participated in the short-lived experiment of Courbet's "atelier" from December 1861 to March 1862, he was soon disillusioned with "its slovenliness and degeneration into a 'club for pointless political arguments'."[4]

In Trouville, where Courbet and Whistler worked together in 1865, Courbet regarded Whistler as his "pupil."[5] Whistler painted *The Sea*, Y.69, using the thick impasto and palette knife technique of Courbet, while Courbet executed a thinly painted *Seascape* in Whistler's new style. Whistler also made a series of four sea pieces, the first of which, *Harmony in Blue and Silver: Trouville*, Y.64, may have been intended as a homage and farewell to Courbet. It shows the painter standing on the sea shore gazing out to sea just as Courbet had depicted himself in 1854 in *The Artist Saluting the Mediterranean at Palevas*. In his four sea pieces, Whistler worked in the thin, translucent layers which had come to characterize his work, and constructed the space according to proportions learnt from Hiroshige and Hokusai. Courbet could not understand this, and said "he always makes the sky too low, or the horizon too high."[6]

Whistler continued to identify with the Société des Trois until 1865, although the association gradually changed character as each of its members developed in different and increasingly incompatible directions. Hoping to create an artistic community around him, Whistler tried to persuade Fantin and Legros to move to England, which the latter did in 1863. In the spring of that year, Whistler and Fantin defined the Société in an exchange of letters as being united against "the stupid masses" while pursuing truth, "la vérité." They saw themselves developing independently, in keeping with their unique artistic temperaments, and providing support and *entrée* for each other.[7] By 1863 their work had grown far apart. Legros's preoccupations interested them less and less; Legros and Whistler quarrelled, and soon lost contact. Despite Whistler's evident desire to retain his friendship with Fantin, they too had little left in common. By 1865 Whistler referred to the Société as "we two" and dismissed the work of Legros, who had "fallen behind," as being of no further consequence.[8]

As the French connection began to weaken, Whistler became increasingly involved with the British *avant-garde*, and fell in with Dante Gabriel Rossetti and his circle. It is not surprising that Whistler, having decided to settle in London, should have identified with the Pre-Raphaelites. The group was viewed in France as the English counterpart to the realist movement. It was admired by Baudelaire who had first seen the work of several of the members of the Pre-Raphaelite Brotherhood at the Exposition Universelle in Paris in 1855.

There were certain basic similarities in the artistic outlook of the Pre-Raphaelites and the realists, despite the gulf which separated the end product. Like the French naturalists and realists, the P.R.B. had, in its early years, rejected the Italian High Renaissance tradition. The members of the Brotherhood dissociated themselves from concepts of classical beauty, and chose models from among their personal acquaintances, making no effort to idealize them; as a result, they were accused, like Courbet, of deliberately choosing ugly models. Some of their paintings dealt with subjects from modern life, although they were also interested in religious, historical and literary themes. The controversy which attended the first appearance of their work would have been sufficient in itself to attract Whistler's attention, and their anti-academic stance, his allegiance. By 1862, however, when Whistler first met Rossetti, the great and purposeful days of the Brotherhood were over; its members, like those of the Société des Trois, were each going their separate ways.

Rossetti and Whistler met on July 28, 1862, and were immediately attracted to each other. They saw each other regularly after Whistler had moved into a house on Lindsay Row in 1863, only a short distance away from Rossetti's house on Cheyne Walk in Chelsea. Whistler tried to graft Rossetti onto the Société des Trois, and asked Fantin to save him a place in his ambitious painting *Hommage à Delacroix*. However, Rossetti never found time to go to Paris for the sitting, and when he finally went in 1864, he criticized Fantin's work for lack of "finish" and saw the contemporary French school as "a great slovenly scrawl."[9] Whistler's attempts to cement relations extended to a joint exhibition of the works of Rossetti and the members of the Société. Du Maurier's description of this venture in a letter of October 11, 1863, recalls Ferlet's description of the Société des vrais bons:

Jimmy . . . Legros, Fantin and Rossetti are going to open an exhibition together. Jimmy and the Rossetti lot, i.e. Swinburne, George Meredith, and Sandys are as thick as thieves . . . Their noble contempt for everybody but themselves envelopes me I know. Je ne dis pas qu'ils ont tort, but I think they are best left to themselves like all Societies for mutual admiration of which one is not a member.[10]

Rossetti's influence may be detected in one of the last drypoints which Whistler made before he stopped etching in 1863. Entitled *Weary*, K.92 (pl. 181), it shows Jo as a beautiful, melancholy, Pre-Raphaelite woman and recalls Rossetti's drawings of Fanny Cornforth. Begun at the time when Whistler had first met Rossetti in July, 1862, several of these drawings, such as *Fanny Cornforth*, S.291, *c.* 1862 (pl. 182), show Rossetti's voluptuous mistress in a semi-recumbent pose.

There is a tradition which links Whistler's etching to Rossetti's poem *Jenny* about a prostitute "fond of a kiss and fond of a guinea."[11] In the poem, Jenny, dressed in silk, reclines and dozes, her hair radiating like an aureole around her head. Whistler's etching appears to correspond to the lines

Why, Jenny, as I watch you there
For all your wealth of golden hair
Your silk ungirdled and unlaced . . .[12]

The poem, written in 1858, was circulated in manuscript among Rossetti's friends while undergoing revision between 1859 and 1869. Whistler could well have heard it read over the dinner table at Tudor House where he was a regular guest. It is not unreasonable to suppose that in the first flush of his enthusiasm for Rossetti, he might have taken the poem as his starting point.

This romantic and poetic image is unprecedented in Whistler's etched work, and was executed using very fine drypoint lines. Few impressions were taken, largely because of the speed with which the burr would have worn. They are printed for the most part in black ink on very thin, silky *japon mince* which enchances the aesthetic beauty and delicacy of the subject.

While their work was very different, Whistler and Rossetti shared one great enthusiasm: a love of Japanese woodcuts and of blue and white oriental porcelain. Although the Japanese material on display at the Second International Exhibition in London in 1862 led to a general enthusiasm in England for the arts and crafts of Japan, it appears that the Rossetti brothers first encountered Japanese objects early in 1863 when Whistler brought Japanese prints, Chinese porcelain, and other oriental *objets d'art* back from Paris.[13] He was one of Mme. Desoye's first customers after she opened her oriental shop on the rue de Rivoli in 1862. The collecting mania soon caught on in the Rossetti circle, and Whistler and Dante Gabriel competed furiously for the best pieces of blue and white at Murray Mark's shop during the 1860s. Whistler regularly dispatched Fantin to look for kimonos and blue and white china on the Paris market. His house on Lindsay Row was soon filled with oriental furniture, fans and paintings which profoundly affected his ideas about interior decoration, as well as the subject matter and structure of his paintings and etchings.

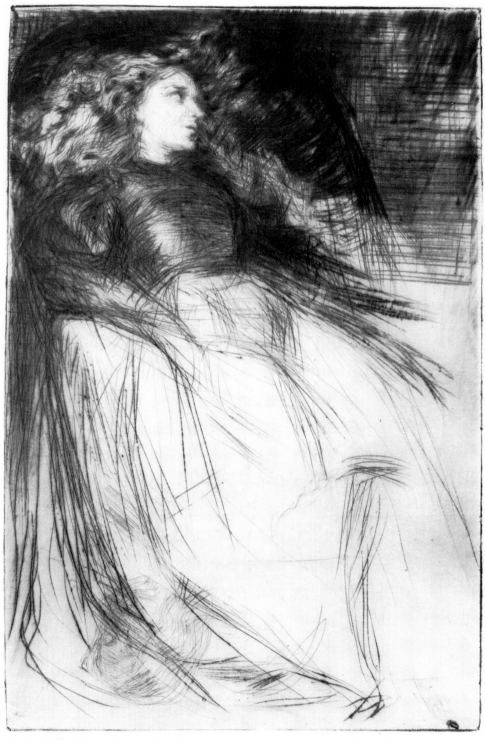

181. Whistler, *Weary*, K. 92, 1863. Drypoint, 19.5 × 13.2 cm. Courtesy of the Freer Gallery of Art, Smithsonian Institution, Washington, D.C.

182. Rossetti, *Fanny Cornforth*,
S. 291, *c.* 1862. Pencil,
25.1 × 28.6 cm. Sir Brinsley Ford,
CBE, FSA.

By 1864 he had begun to incorporate Japanese *objets d'art* into paintings which derived their exotic quality and vivid palette largely from Rossetti. In *The Princess in The Land of Porcelaine*, Y.50, *Purple and Rose : the Lange Leizen of the Six Marks*, Y.47, and *Arrangement in Flesh Colour and Grey: The Chinese Screen*, Y.51, Whistler brought together beautiful modern women and oriental objects, placing them in settings constructed according to design principles learnt from Japanese prints. These paintings are allegorical statements about beauty seen as an end in itself. The admiration with which the women view the objects can be seen as an oriental variation on the theme of John Keats's *Ode to a Grecian Urn*. Like Keats, Whistler had come to believe that "Beauty is truth, truth beauty," and was beginning to demonstrate his allegiance to the art for art's sake philosophy formulated by Rossetti's permanent house guest, the poet Algernon Swinburne.

In the long run Swinburne was to prove the most influential member of the group for Whistler's aesthetic development. In 1864, Whistler asked Swinburne to write some lines of poetry to accompany his

183. Moore, *Lady with a Fan*. Black and white chalk on brown paper, 27.3 × 11.4 cm. Art Gallery of Ontario. Purchased with assistance from the Volunteer Committee Fund, 1978.

painting *Symphony in White, No. 2: The Little White Girl, 1864*, Y.52, which was exhibited at the Royal Academy in 1865. The literal association which existed between painting and poetry in the Rossetti circle initially influenced Whistler, but he was soon to forsake literary association for painting which was both poetic and complete in itself, and required no further explanation. It was during his years in the circle of Rossetti and Swinburne that Whistler abandoned his search for realist themes and devoted himself to pure painting and the pursuit of an art based on beauty.

Whistler's admiration for Rossetti's paintings did not last long; he even suggested that the artist would do better to frame his sonnets. In 1865, he noticed a painting at the Royal Academy by Albert Moore entitled *The Marble Seat* and went in search of the artist. It was Moore's static, classically draped studies of women, beautiful and devoid of narrative content, which exercised a dominant influence on Whistler until the end of the decade. Moore, who shared Whistler's interest in Swinburne's philosophy, led Whistler back to classical beauty and an academic approach to building up his compositions. Whistler attempted to graft Moore onto the Société des Trois in 1865 in place of Legros,[14] and under Moore's tutelage began a two-year period of intense self-education in an attempt to make up for lost time. He gave line priority over colour, worked within a subtle range of colour harmonies, and developed a new iconography.[15]

Thus Whistler came full circle, beginning again where he had left off, at Gleyre's Academy. He looked at ancient Greek sculpture with the same enthusiasm that he had felt for the Venus de Milo upon arriving in Paris in 1855. He would have been familiar with the large marbles on display in the British Museum,[16] as well as with the recently installed Elgin Marbles which influenced the draperies and the disposition of the figures in his painting *Symphony in White No. 3*, Y.61, 1865–7.

Whistler was fascinated by the small terracotta Tanagra figurines which Alexander Ionides began to collect in the late 1850s and early 1860s after they began to appear in excavations along the main road from Athens to Chalkis.[17] Marcus Huish, a collector of Japanese prints and Tanagra figurines, said that the sudden reappearance of these sculptures was for artists "as startling an irruption as that of Japanese art."[18] Whistler considered Japanese prints and Greek sculpture the epitome of two very different types of ideal of beauty: he was later to say that "the story of the beautiful is already complete—hewn in the marbles of the Parthenon—and broidered, with the birds, upon the fan of Hokusai—at the foot of Fujiyama."[19]

In the late 1860s, Whistler and Moore created a unique synthesis of Greece and Japan, painting classically draped women holding Japanese fans. Because their works were at times almost indistinguishable, Whistler decided in 1870 to leave this subject to Moore.

Among the first prints which Whistler made following his seven-year absence from etching were two drypoints in which the influence of Moore, Tanagra and Japan may be clearly seen. *The Model Resting*, K.100, 1870 (pl. 184), shows the classically draped figure of a woman standing in a contraposto pose, and closely resembles the characteristic standing Tanagra figurines. The model has short hair pulled back neatly from her forehead in imitation of the "melon" hairstyle of the

184. Whistler, *The Model Resting*, K. 100, 1870. Drypoint, 20.8 × 13.2 cm. Courtesy of the Freer Gallery of Art, Smithsonian Institution, Washington, D.C.

185. Tanagra Figurine, *c.* 1671. Reproduced by permission of the Trustees of the British Museum.

Tanagras, and wears an undergarment called a "chiton" and a mantle resembling the "himation," seen in the terracottas (pl. 185).[20] Like the sculptors of the late third century, Whistler experimented with the translucent quality of the draperies which partly conceal and partly reveal the form beneath.

In the second drypoint, *The Model Lying Down*, K.121, *c.* 1873 (pl. 186), Whistler combined a pose and costume found in Tanagra terracottas with a whimsical "flight" of Japanese fans across the wall like those at 7 Lindsay Row. The recumbent pose is found in one of the most important Tanagras in the Ionides collection, *An Interesting Group* (pl. 188). In both the drypoint and the terracotta, the woman reclines on a draped couch, her head supported on one arm, and her hip thrown up to create a dramatic diagonal from hip to foot. This figure was repeated in reverse in another drypoint made at this time entitled *Nude Girl Reclining*, K.126 (pl. 187).

The first of these plates, *The Model Resting*, exists in a number of states and a handful of impressions, all of which appear to be printed in black ink on old laid paper or *japon mince*. *The Model Lying Down* is known in a unique impression, while *Nude Girl Reclining* exists in at least two

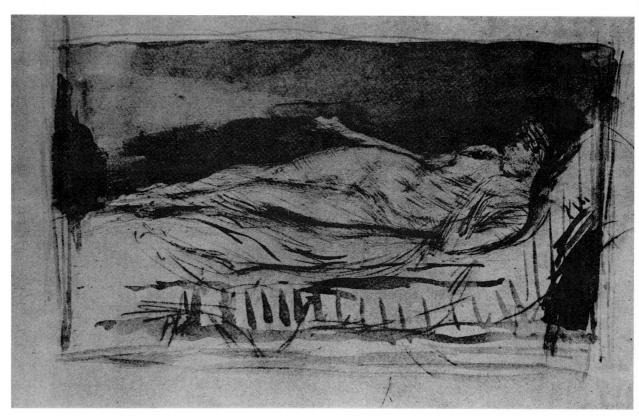

188. *An Interesting Group* from *The Album of Photographs of Tanagra Figurines in the Ionides Collection.* 14.0 × 20 cm. Photograph from the Hunterian Art Gallery, University of Glasgow.

186. Whistler, *The Model Lying Down*, K. 121, *c.* 1873. Drypoint, 18.8 × 22.7 cm. Courtesy of the Freer Gallery of Art, Smithsonian Institution, Washington, D.C.

187. Whistler, *Nude Girl Reclining*, K. 126, *c.* 1873. Drypoint and India ink, 13.8 × 21.5 cm. Courtesy of the Freer Gallery of Art, Smithsonian Institution, Washington, D.C.

impressions. These were probably viewed as experimental works made with no intention to publish, like the majority of the drypoints and etchings which Whistler was to make during the 1870s.

Albert Moore may have been influenced by Jean-Dominique Ingres, who, until his death in 1867, represented the last link in the old master tradition. In April of that year Whistler went to Paris where he may have seen the Ingres retrospective. He wrote to Fantin saying that he found many of Ingres's paintings "not at all Greek as some people like to say—but rather, perversely French."[21] At the same time he greatly regretted not having been a pupil of Ingres, who would have taught him drawing, "dessin." Whistler maintained that if he had studied under Ingres, "with the beautiful quality of my innate talents, what a painter I would be now." He concluded that there was "still much further to go, more beautiful things to make."

In the same letter Whistler lashed out at realism which he saw as having had a negative impact on his development. In an impassioned passage he wrote that it was neither Courbet nor his work that he rejected, but the concept that "one had only to open one's eyes and paint whatever one found in front of one! beautiful nature and the whole caboodle!" In words which echo Baudelaire he wrote, "It's just that this damn Realism appealed at once to my painter's vanity! and mocking all traditions, cried at the top of its lungs, with the confidence of ignorance 'Long live nature!' Nature! My dear, this cry caused me great misfortune." Whistler now categorically rejected realism for an art which, while based in nature, was governed by beauty, the imagination, and artistic temperament. He had begun to formulate his compositions and colour harmonies in his mind. The days of impulsive youth were over.

Whistler's rejection of Courbet followed upon a decade of decline on the part of the master Realist. Whistler had met him in his prime; throughout the 1860s he was criticized by his supporters, including Fantin, for such works as *The Return from the Conference,* an anti-clerical satire considered too tasteless for inclusion even in the Salon des Réfusés. When he submitted *Woman with a Parrot* to the Salon of 1866, there was a sarcastic outcry; Thoré-Bürger wrote of the titillating nude, "Well, my dear Courbet, you are done for now; your palmy days are over! Here you are accepted, bemedalled, decorated glorified, embalmed."[22] Zola, who accused him of producing nothing but a crowd pleaser, said that Courbet's Realism had been superseded by a new movement led by Manet and his circle which believed in the primacy of artistic temperament. It was with this group that Fantin had became identified.

The spring of 1867 marked a major turning point for Whistler on several fronts. In April he fought with Haden, and severed his ties with him for life, and in May he rejected Courbet's Realism for art for art's sake. Having little in common with Fantin, his correspondence came to an abrupt halt after the passionate diatribe of May, 1867. He had tried to reconcile the diverse artistic tendencies to which he had been drawn in France and England, but they were incompatible. Three years later, in 1870, he turned away from the Graeco-Japanese synthesis which he had evolved with Moore, and began to work on a group of paintings which brought his early realist interest in the Thames together

with his new oriental aesthetic. In the Thames nocturnes of the 1870s Whistler was to create some of the most poetic views of nature in the whole history of art.

## 2. The Leyland Years

In 1864, Whistler was introduced by Rossetti to his new patron, the Liverpool shipping magnate Frederick R. Leyland, who was to provide him with important commissions for the next thirteen years. It was during visits to Speke Hall, the Leylands' Tudor country house near Liverpool, that Whistler took up the needle once again, ending his seven-year absence from the medium. During a five-year period, from 1870 to 1875, he made eighteen etchings and drypoints of members of the Leyland family and subjects in the vicinity of Speke Hall.

Frederick Leyland (1831–92) was an aggressive, self-made man, only three years older than Whistler. His origins were somewhat obscure, as Whistler liked to point out, but after joining the Liverpool shipping firm of Bibby, Sons and Co. as an apprentice, he rose rapidly through the ranks. In 1872, at the age of thirty-seven, he purchased the firm from the Bibby family and changed its name to the Leyland Line. During the first half of the 1870s Leyland was preoccupied with taking over and expanding the business. Whistler, in search of "golden guineas," hoped to benefit substantially from his meteoric rise.

Leyland was an intense, highly strung, insular individual, whose real ambition was to be a pianist. With the first money he saved at Bibby's he bought a piano on which he spent long hours practising every evening. According to his guests he

> would come home from his office, go upstairs to his room without speaking to anyone, shut himself in and play on the piano, practising and practising. Then, perhaps, he would go downstairs to the drawing-room where Mrs. Leyland was with [friends] and he would make a scene with her, so that when he was away she was always having little parties and supper parties, and he would come home and catch her in the middle of supper sometimes.[1]

Leyland did not fraternize with Liverpool acquaintances, preferring to alleviate his social isolation by entertaining a growing circle of artists from London. His relationship with his wife, Frances Dawson, began to deteriorate by degrees, as Whistler observed at first hand.

The *nouveau riche* shipping magnate sought to exchange his commercial image for the more socially acceptable one of connoisseur. In the course of assembling a collection of fashionable "finished" genre studies at the Royal Academy, he developed the desire to own a painting by Rossetti. After commissioning a first painting, *Lilith*, in 1864, he became one of Rossetti's two leading patrons. Rossetti deflected Leyland's taste toward the early Italians and the first collection was soon replaced with paintings by Signorelli, Giovanni Bellini, Giorgione, Botticelli and Crivelli, each one chosen with impeccable taste.

Rossetti introduced Whistler to Leyland soon after they first met in

189. Whistler, *Arrangement in Black, Portrait of F. R. Leyland*, Y. 97, 1870–73. Oil on canvas, 192.8 × 91.9 cm. Courtesy of the Freer Gallery of Art, Smithsonian Institution, Washington, D.C.

190. Whistler, *Shipping at Liverpool*, K. 94, 1867. Etching, 22.9 × 15.2 cm. Courtesy of the Freer Gallery of Art, Smithsonian Institution, Washington, D.C.

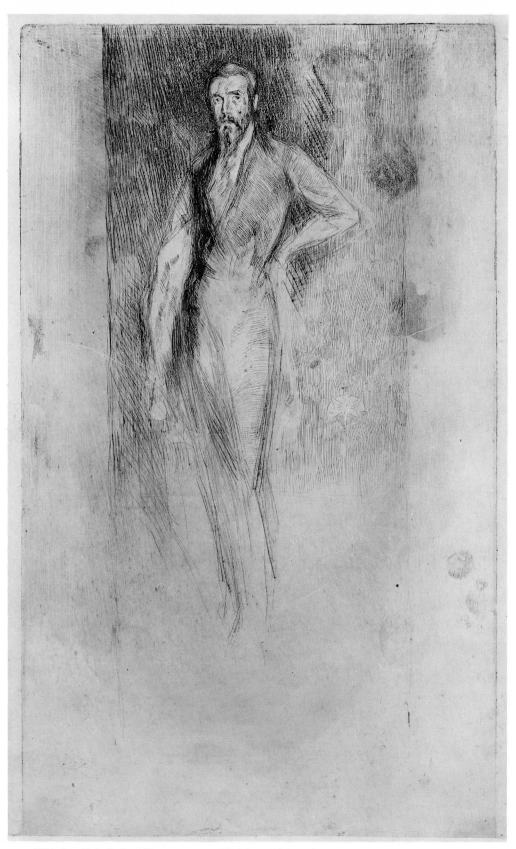

191. Whistler, *F. R. Leyland*, K. 102, *c.* 1870. Etching and drypoint, 29.4 × 17.6 cm. Courtesy of the Freer Gallery of Art, Smithsonian Institution, Washington, D.C.

1864. Leyland was an exceptionally trusting patron, and willingly advanced funds against commissioned work while keeping careful records. Whistler took full advantage of his generosity which fuelled an increasingly extravagant life-style in Chelsea. He received his first advance in 1864 for a series of paintings known as the "Six Projects" which, like so many of Leyland's commissioned works, were never to be completed.

In the summer of 1867 Whistler took his mother to embark at Liverpool for a holiday in America, and may have stopped *en route* at Speke Hall. The only etching made between 1863 and 1870, *Shipping at Liverpool*, K.94 (pl. 190), was made on this journey. In it, Whistler returned to the theme of shipping, but employed a much looser line and more casual structure than he had in the early 1860s. The plate troubled him, and he hammered out parts of it in an attempt to resolve the composition to his satisfaction. He did not attempt another etching for three years.

Following his first extended visit to Speke Hall in 1869, Whistler became a close family friend of the Leylands, and returned with regularity for long visits until 1875. He was a great favourite with Mrs. Leyland and her daughters, and apparently entered into a brief engagement with Frances Leyland's younger sister Elizabeth Dawson.

Whistler temporarily diverted Leyland's collecting interests away from the early Italians, and in August 1870 was consulted about a painting by Velasquez which Leyland was considering for Princes' Gate.[2] It was during the same month that Leyland commissioned him to paint his portrait, *Arrangement in Black, Portrait of F. R. Leyland*, Y.97 (pl. 189), in the style of the Spanish master. In it, Whistler employed the distinctive black and grey tones which he had so greatly admired in the paintings of Philip IV, and his family at the Manchester Exhibition.[3] The portrait represented a happy marriage of Leyland's social ambitions with Whistler's artistic inclinations. It could sit comfortably on the walls of a Tudor country house or hold its own in the grand rooms at Princes' Gate. By 1872, Leyland had purchased two paintings attributed to Velasquez to decorate the "Valasquez room" of his London house,[4] which was in the process of being transformed by a number of leading designers to resemble the palace of a Venetian merchant prince.

There is an undated drypoint portrait, *F. R. Leyland*, K.102 (pl. 191), which may have been made as a *première pensée* for the painting, in 1870. The figure of Leyland is elongated, tubular, streamlined and flattened, and assumes an aristocratic pose with one hand on its hip. The figure is detached from its surroundings in a dramatic way, and stands "on its legs," "well within the frame," in the manner which Whistler considered characteristic of the Spanish master.[5]

It was during the visit to Speke in 1870 that Whistler began to etch seriously once again, although his etchings of this period are more modest than those of 1858–63. The first, entitled *Speke Hall*, K.96 (pl. 192), shows Mrs. Leyland standing at the end of the drive, looking back toward the house. In it, Whistler employed with reasonable success the compositional structure which he had learnt from Japanese prints, selecting a high viewpoint, "tilting up" the background, and constructing a shallow picture space. The long, lean vertical format of the etching, which emphasizes the distance between the figure and the house,

192. Whistler, *Speke Hall*, K.96, 1870. Etching and drypoint, 22.5 × 15.0 cm. Courtesy of the Freer Gallery of Art, Smithsonian Institution, Washington, D.C.

158

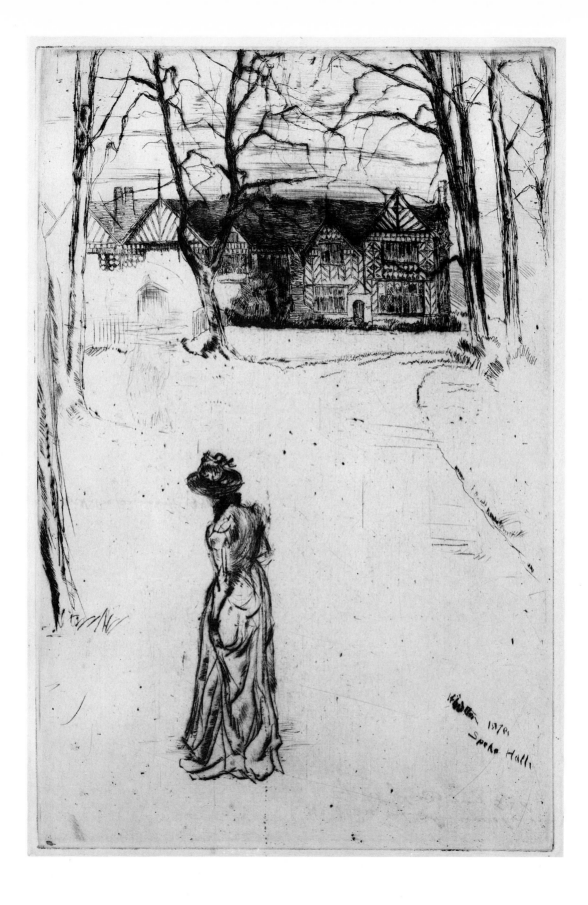

193. Whistler, *The Velvet Dress*, K. 105, 1873. Drypoint, 23.2 × 15.8 cm. Courtesy of the Freer Gallery of Art, Smithsonian Institution, Washington, D.C.

194 (facing page, left). Whistler, *The Little Velvet Dress*, K. 106, 1873. Drypoint, 16.4 × 12.1 cm. Courtesy of the Freer Gallery of Art, Smithsonian Institution, Washington, D.C.

195 (facing page, right). Whistler, *Study for the Portrait of Mrs. Huth.* Pastel, 23.0 × 12.0 cm. Courtesy of The Art Institute of Chicago, Gift of Walter S. Brewster.

196 (facing page, below). Whistler, *Symphony in Flesh Colour and Pink: Portrait of Mrs. Frances Leyland*, Y. 106, 1871–4. Oil on canvas, 195.9 × 102.2 cm. Copyright, The Frick Collection, New York.

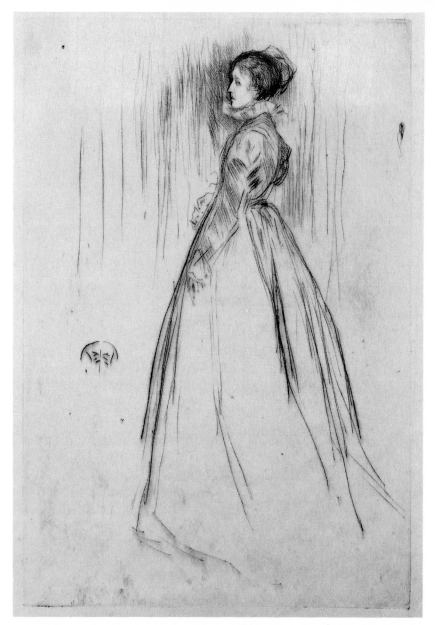

resembles that of the Japanese *oban* print. Whistler changed his mind about the placement of the figure, and redrew it several times, causing it to interact in the second state of the plate with another figure placed to the left of the fork in the path. In the end, he burnished out the second figure and isolated the foreground figure, silhouetting it against a white ground in the Japanese manner, and creating an uneasy tension between the figure and the house which may have been intentional.

The position of the figure, seen from the rear in a three-quarter pose, appears to have been adopted from Japanese prints. In the *ukiyo-e* woodcut, a rear view of this kind is often used to show off the beauty of a kimono. At this time, Whistler became increasingly interested in dresses with trains or ruffles up the back which could provide the cascading effect and visual interest found in the kimono.

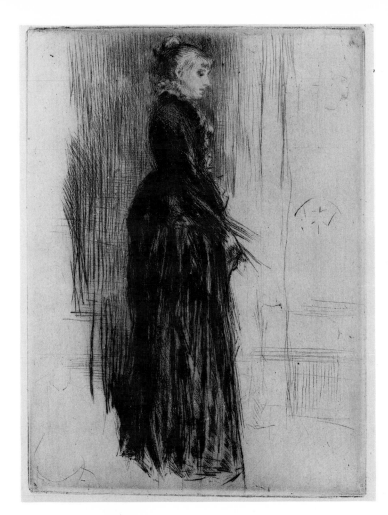

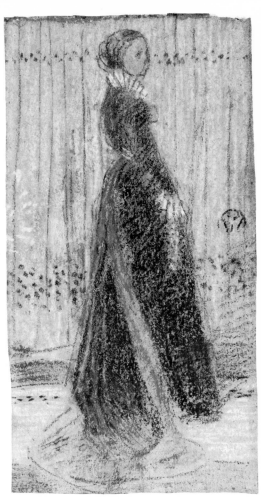

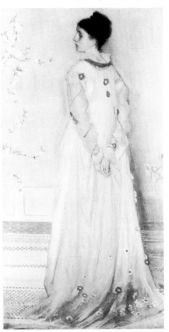

By October, 1871, the portrait of F. R. Leyland, while not completely finished, was hanging on the wall at Speke, where its commanding size and presence would have made it appear very much at home. In October, Leyland commissioned a pendant portrait of his wife and portraits of the children. Whistler began work in October and November, spending Christmas and New Year at Speke. In March, 1872, he returned to London taking the unfinished portraits of Leyland and his wife to Lindsay Row where he continued his work on them.

Leyland demonstrated his enthusiasm for Whistler's etchings in the new year of 1873, when he purchased twenty-three from the group of twenty-nine sent to Speke by Delâtre, who now lived in London. It was probably at this time that Leyland commissioned Whistler to make a series of drypoint portraits of his wife and daughters. Whistler wrote to Delâtre asking him to forward eight copper plates and the recipe for Dutch mordant.[6] He then set to work on a series of etchings and drypoints which are among his finest productions of the 1870s.

He portrayed Mrs. Leyland in three of her favourite dresses, perhaps to help resolve the debate over what she should wear in the painted portrait. Like Hollar and Van Dyck, Whistler tried to describe the texture of the fabrics. The costumes which gave rise to the titles of the

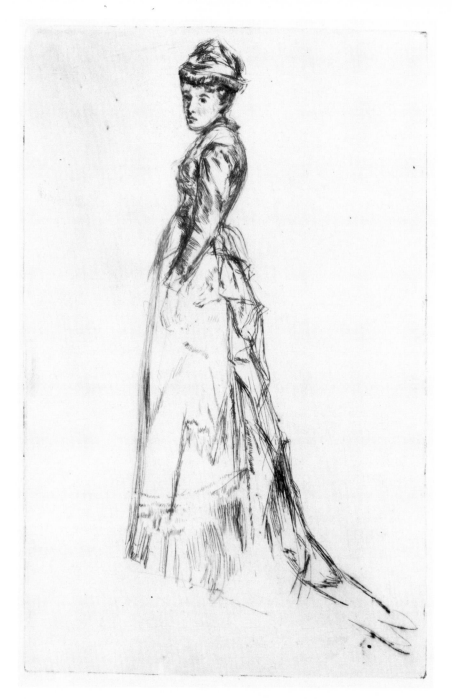

197. Whistler, *The Silk Dress*,
K. 107, 1873. Drypoint,
20.8 × 13.2 cm. Courtesy of the
Freer Gallery of Art, Smithsonian
Institution, Washington, D.C.

etchings were clearly the focus of the exercise: the works were entitled
*The Velvet Dress*, K.105 (pl. 193), *The Little Velvet Dress*, K.106 (194),
and *The Silk Dress*, K.107 (pl. 197). They evoke an earlier historical
period, and *The Silk Dress* reflects the fashion of the day for seventeenth-
century revivals. Mrs. Leyland favoured a black dress like the one worn
by Mrs. Huth, whose portrait *Arrangement in Black No. 2: Portrait of Mrs.
Huth*, Y.125 was then in progress. The costume portrayed in *The Little Velvet
Dress*, K.106, is not unlike the one worn by Mrs. Huth (pl. 195), and
may have been modelled by Whistler's new model and mistress, Maud

198. Millais, *The Baby House*, 1872. Etching, 13.8 × 17.8 cm. Art Gallery of Ontario, Gift of Ascolectric Ltd., 1979.

199. Whistler, *Fanny Leyland*, K. 108, 1873. Drypoint, 19.6 × 13.2 cm. Courtesy of The Art Institute of Chicago, Charles Deering Collection.

Franklin, since the female profile in this etching more closely resembles that of Maud than the dark and delicate Frances Leyland. Whistler rejected them all in the end, and designed a dress with the fineness of gossamer which reflects the influence of Japan on the Aesthetic Movement. With a train at the back, it recalls a kimono, and is shown to advantage in a three-quarter rear view in the Japanese manner. The portrait *Symphony in Flesh Colour and Pink: Portrait of Mrs. Leyland*, Y.106 (pl. 196) is as beautiful and sensuous as the one of Leyland is dark and forbidding.

The drypoint portraits of the Leyland children made in 1873 may have been intended as *premières pensées* for painted portraits or as

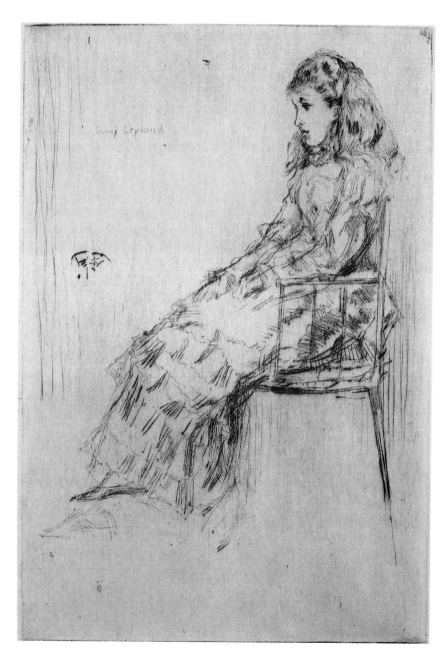

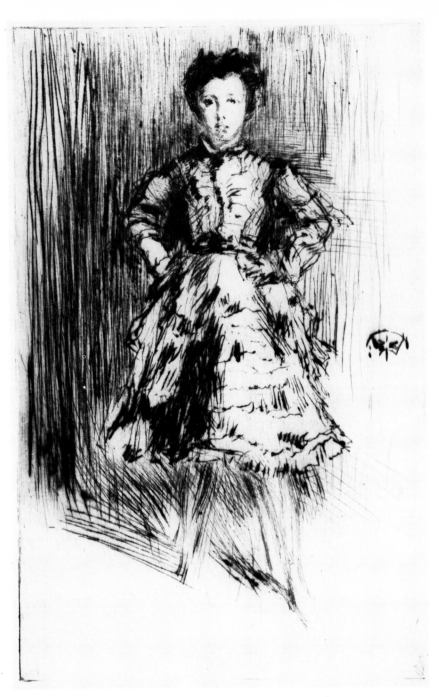

200. Whistler, *Elinor Leyland*,
K. 109, 1873. Drypoint,
21.4 × 14.0 cm. Reproduced by
permission of the Trustees of the
British Museum.

substitutes for them, for the children could not bear the long sittings
which Whistler required, and rebelled. In them, he tried to capture the
personalities of the girls while exploiting the decorative possibilities of
their costume. *Fanny Leyland*, K.108 (pl. 199), a delicate, introspective
girl, is shown seated on a spindly Aesthetic chair in the profile pose which
Whistler had first used in the painting *Arrangement in Grey and Black:
Portrait of the Artist's Mother*, Y.101, 1871. With her brooding quality,
she recalls Millais's adolescents (pl. 198). The other two girls are shown
in frontal standing poses, and appear almost to leap out of the shadows.

Whistler's principal interest in the drypoints of *Elinor Leyland*, K.109 (pl. 200), and *Florence Leyland*, K.110, was to explore chiaroscuro effects by drawing the shadows rather than the contours. The girls are attenuated and mannered, and are not at all true to nature like Whistler's earlier portrait of *Annie Haden*. In them Whistler created *bravura* images of the kind which Boldini and Sargent were soon to adopt.

In each of the plates made at Speke Hall in 1873, Whistler employed his new signature for the first time. His rectilinear monogram which resembles a butterfly was composed, like that of Millais, of his interlocking initials, and was given an oriental shape which recalls the seals on Japanese prints. This heraldic device, which evolved in the late 1870s into a small and sprightly butterfly, was placed with infinite care in different areas of the composition, its location dictated by Whistler's sense of oriental balance and placement.

It was probably in January, 1875, on one of his last visits to Speke, that Whistler made five plates of the house and its vicinity: *Speke Hall*, *No. 2*, K.143, *Shipbuilder's Yard*, K.146 (pl. 201), *The Little Forge*, K.147, *Speke Shore*, K.144 (pl. 202), and *The Dam Wood*, K.145. Whistler's enthusiasm for etching was whetted once again: he wrote to W. C. Alexander on 1 February, 1875, to say "the etchings and drypoints are getting on famously—I have quite got back my old delight with the work and I think I shall have some pretty things to show you soon."[7]

Despite his enthusiasm, the majority of the plates made during the 1870s do not display the same degree of innovation or resolution as the plates of the late 1850s and early 1860s. They can be seen as more modest "variations" on earlier "themes," to use the musical terminology suggested by Leyland with which Whistler began to describe his work in the early 1870s. *Speke Hall* (No. 2), a portrait of the half-timbered house, recalls *The Unsafe Tenement*, but lacks the presence and monumentality of the earlier work; *Speke Shore*, while successfully conveying the mood of a wet and windy day, repeats the theme explored more dramatically in *The Storm* of 1861; *The Little Forge*, in which the figures are swallowed up in shadow, recalls *The Forge* of 1861, and *Shipbuilder's Yard*, K.146, bisected by a mast running the entire height of the composition, recalls *Rotherhithe* of 1860. On the whole, the work of this period is uneven.

Between visits to Speke, Whistler occasionally etched in Chelsea. For the most part the London works show Maud quietly absorbed in genteel occupations around the house, and reflect Whistler's perennial love of the seventeenth-century Dutch interior, blended with his more recent interest in such eighteenth-century Japanese prints as Utamaro's *Ten Typical Feminine Skills*. Whistler's *intimiste* subjects of the 1870s, showing Maud reading, tatting, and having her hair combed, anticipate the work of Bonnard and Vuillard in the 1890s.

To judge from the very high number of figure subjects abandoned or cancelled during the 1870s, sixteen of which are reproduced by Kennedy, Whistler was having trouble drawing the human form. It is not at all clear just what he was after, or why so many of his figures seem unresolved or clumsy at this time. He appears to have been trying to translate into etching the two-dimensional figure type found in Japanese prints. This he could do with the help of colour, but not with pure line. One of his more successful attempts, *A Lady at a Window*, K.138 (pl. 203), shows Maud examining an etching with the wheel of the press visible

201. Whistler, *Shipbuilders Yard*, K. 146, 1875. Drypoint, 27.6 × 15.1 cm. Courtesy of the Freer Gallery of Art, Smithsonian Institution, Washington, D.C.

in the background. She is given a distinctly oriental profile, and is "flattened" using the long diagonal lines which were characteristic of his studies in the mid 1870s. Bracquemond had concluded many years earlier that it was impossible to etch the figure in the Japanese manner, since Japanese art was opposed to modelling in three dimensions.[8] Whistler continued to struggle to give his figures the appearance of being both two- and three-dimensional at the same time. It simply did not work.

Few impressions were taken of the drypoints of the Leyland family, or of the studies of Maud. The Leyland plates were probably intended initially for private circulation, and exist in small editions for the most part printed in black ink on Japanese or old laid paper. According to Walter Greaves, Whistler wiped his plates with three rags and his palm at this time, then pulled the ink out of the lines with a bit of muslin, "really the retroussage he later objected to."[9] Some were printed in the 1880s using artistic printing methods to give them more substance.

In August, 1876, with Leyland's approval, Whistler made some minor modifications to the decoration of the dining room at Princes' Gate, which had just been finished by Thomas Jeckyll. He touched up the red flowers on the priceless sixteenth-century Spanish leather wall coverings with blue so that they would harmonize with his painting, *The Princess in the Land of Porcelain*, 1864, which hung in the room. Enamoured of the colour, he became carried away, and having painted all the antique leather blue, began to decorate the shutters and ceiling with golden peacocks and peacock feathers. He worked frantically throughout the winter, gilding the leather, and holding open house for the press and society without Leyland's knowledge or permission. When he had finished he sent Leyland a bill for 2,000 guineas.

Mrs. Leyland was by this time both a conspirator and an intimate companion. Leyland, having undoubtedly heard the rumours which Rossetti was spreading to the effect that Whistler and Mrs. Leyland were planning to elope, was outraged by Whistler's liberties with both

202. Whistler, *Speke Shore*, K. 144, *c.* 1875. Drypoint, 15.2 × 22.7 cm. Courtesy of the Freer Gallery of Art, Smithsonian Institution, Washington, D.C.

203. Whistler, *A Lady At a Window*,
K. 138. Drypoint, 23.2 × 15.8 cm.
Courtesy of the Freer Gallery of
Art, Smithsonian Institution,
Washington, D.C.

his house and his wife. On July 17, 1877, he wrote to Whistler threatening to "publicly horsewhip"[10] him if he ever caught him in her company again. He refused to pay Whistler's bill, staunchly maintaining that Whistler had greatly exceeded the terms of the original agreement.

The battle between Whistler and Leyland dragged on with growing intensity for two years during which Leyland punished Whistler by systematically destroying him financially. In 1879, Whistler was forced to declare bankruptcy. Frances Leyland left her husband, who lived alone at Princess Gate until his death in 1892. He always enjoyed Whistler's stunning "Peacock Room," which, as the artist correctly prophesied, is the reason why Leyland is remembered today.

# 3. The Publication of the "Thames Set" and the Late Thames Etchings

Whistler's revived interest in etching coincided with the publication of the "Thames Set" in 1871, and with the positive reviews which greeted its appearance. In the early 1870s he returned to the Thames and devoted himself to painting his splendid and poetic "nocturnes." It was not until 1875, after he had made his last etching at Speke Hall, that he turned to the river in search for subjects for etching.

Anderson Rose had been unsuccessful in his initial attempts to sell Whistler's copper plates, and it was not until 1868–9 that a purchaser appeared, in the form of Alexander Ionides. Ionides had entered into a business agreement with Murray Marks, Dante Gabriel Rossetti, Edward Burne-Jones and William Morris to start a Fine Art Company which would deal in blue and white china and the decorative arts, and would have exclusive rights to the sale of Whistler's etchings.

Ionides purchased the copper plates, together with all the impressions taken from them, for £300, and planned to publish an edition in the spring of 1869 following receipt of a shipment of Japanese paper.[1] However, the company as planned never got off the ground, and Ionides was left with the copper plates.[2] In the autumn of 1870 he handed them over to the Covent Garden publishing house of Ellis and Green who planned to have them steel faced and to bring out an edition of one hundred sets in the spring of 1871.

Whistler disliked one of the sixteen plates, and in the autumn of 1870 wrote to Ellis suggesting that either he only print fifteen of them or that he allow Whistler to replace the offending drypoint, *Chelsea Bridge and Church*, K.95 (pl. 204). Not wishing to delay publication, Ellis turned down Whistler's offer to replace "the faulty plate in question" with "an entirely new one and consequently infinitely better,"[3] but did allow him to take the plate back to work on the passages he disliked.

Whistler set to work modifying the plate in the spring of 1871, and according to Frederick Keppel, "much added work is seen in this plate as Ellis published it in the Thames Set."[4] The first state could have been made in the early 1860s, for it is closely related in style and subject to *Early Morning, Battersea*, K.75, 1861 (pl. 157), and seems to be one of the sixteen plates mentioned in Whistler's will of 1866. In these two plates, Whistler worked in the half light of dawn when forms coalesce and appear to become two-dimensional. In subject and approach they anticipate the Thames nocturnes of the early 1870s. *Chelsea Bridge and Church* looks quite "flat" in the first state, in which the forms are bounded by strong black lines which recall the dark contours of the key block in Japanese woodcuts. There is very little recession in depth, and the right side of the composition appears somewhat empty and tilted forward. In retouching the plate, Whistler tried to create a convincing recession while retaining the two-dimensional decorative patterning of the surface by adding a few oriental touches. He incorporated a *repoussoir* element into the space at the right, using a small oriental flowering tree of the kind which he had used in painting as early as 1866.[5] He must not have liked the tree, for he burnished it out and replaced it with a boat of rather oriental shape to balance the lumpy forms of the large

boats on the left which recall the square ships found in his impression of Hiroshige's *Clearing Weather at Shibaura* from *Eight Views of the Suburbs of Edo*, 1837–8 (pl. 205). Satisfied with his *repoussoir* element, he strengthened and darkened the forms on land, the waterfront buildings and the boats, and gave the bridge in the distance a more pronounced oriental shape. By adding reflections in the water and a dark band in the sky, he finally created the illusion he wanted. The first proof of the published state was pulled for Ellis on May 6, on the eve of publication.[6]

The "Thames Set" appeared between May 6 and 26, when a copy was presented to the Print Room at the Victoria and Albert Museum, probably by Ionides. Of the one hundred sets printed, he gave one to each of his children, and left the rest with Thomas Agnew in Old Bond Street, where they were offered for sale at two guineas.

The published title, *A Series of Sixteen Etchings of Scenes on the Thames and Other Subjects*, was even more vague than the published title to the "French Set" had been. The contents, which included fourteen etchings of Thames subjects, also included *Becquet* ("The Fiddler") and *The Forge*. The printed prospectus which accompanied the set read as follows.

*A Series of Sixteen Etchings of Scenes on the Thames and Other Subjects:*

| | |
|---|---|
| 1. Black Lion Wharf | 9. The Limeburner |
| 2. Wapping Wharf | 10. The Little Pool |
| 3. The Forge | 11. Eagle Wharf |
| 4. Old Westminster Bridge | 12. Limehouse |
| 5. Wapping | 13. Thames Warehouses |
| 6. Old Hungerford Bridge | 14. Millbank |
| 7. The Pool | 15. Early Morning Battersea |
| 8. The Fiddler | 16. Chelsea Bridge and Church[7] |

As in the "French Set" portfolio, Whistler must have deliberately arranged the plates at random to preclude any attempt at narrative interpretation. The "Thames Set" plates are not "about" their subjects, but about different ways of seeing and approaching nature. While the series is best known for the group of realist etchings of 1859 which lie at its core, it documents Whistler's changing approach to his subject as he moved away from realism toward aestheticism, and became increasingly concerned with capturing fleeting impressions of nature rather than documenting concrete realities.

The appearance of the set was greeted in *Punch* on June 17 by an anonymous review entitled "A Whistle for Whistler," which must have delighted the artist.[8] Not only did the reviewer attempt to rectify the imbalance which existed between Whistler and Haden by saying "before Seymour Haden was Whistler, his brother-in-law and etching master," it pointed out that in art circles it was felt that the portfolio "beat everything of the kind that has been turned out since Rembrandt." The etchings were perceived as documenting the "vanishing beauties" of "the tumble-down, bank-side buildings of the Thames, from Wapping and Limehouse to Lambeth and Chelsea, above-bridge—great gaunt warehouses, and rickety sheds, and balconies and gazebos hanging all askew and rotting piles and green weeded quays . . . where . . . all is pitchy and tarry and corny and coally, and ancient and fish-like."

209. Whistler, *A Sketch from Billingsgate*, K. 168, 1878. Drypoint, 14.7 × 22.4 cm. Courtesy of the Freer Gallery of Art, Smithsonian Institution, Washington, D.C.

210. Hollar, *Dutch West Indiaman*, from the *Set of Dutch Ships*, P. 1262. Etching, 14 × 23.0 cm. Sidney Fisher Collection, Thomas Fisher Rare Book Library, University of Toronto.

211. Whistler, *Price's Candle Works*, K. 154, *c.* 1877. Drypoint, 15.1 × 22.6 cm. Courtesy of the Freer Gallery of Art, Smithsonian Institution, Washington, D.C.

212. Hollar, *Lambeth Palace from the River*, one of the *Views of Westminster*, P. 1038. Etching, 14.3 × 32.3 cm. Sidney Fisher Collection, Thomas Fisher Rare Book Library, University of Toronto.

It may well have been the pleasure of seeing his hitherto unpublished work of the 1850s and early 1860s appear to a receptive audience which encouraged Whistler to take up etching once again, albeit sporadically. Mrs. Whistler reported to her sister in November, 1871, that "the renewal of etching" had given "zest to the studio at intervals."[9] It is possible that Whistler confined his etching in the early 1870s to commissioned work for Leyland in order to fulfill the terms proposed in his will of 1866 in which he had undertaken not to "publish any other etchings in England or elsewhere within two years of the date" of the sale of the sixteen plates. It is not known whether Ionides or Ellis held him to this offer.

It was not until the mid 1870s, after making his last plates at Speke Hall, that Whistler turned to the Thames again as a source for subjects for printmaking. The etchings and drypoints of the river made between 1875 and 1879 are difficult to date accurately, and may simply have been intended as experiments without any notion of publication in mind.

Whistler continued to try to create the same misty effects in line which he created in paint using thin glazes, by employing a line which became increasingly selective and fibrous. He does not appear to have experimented with aquatint, and only once tried mezzotint,[10] which would have enabled him to create tonal etchings; nor does he appear to have used artistic printing during the 1870s. Like Haden and other purists he probably rejected the use of plate tone out of hand, seeing it as the common refuge of the amateur etcher who wanted to cover up poor line work.

In the drypoints *Battersea: Dawn*, K.155, 1875 (pl. 207), and *Steamboat Fleet*, K.156, *c.* 1875 (pl. 208), Whistler reduced his line to the thinnest, most suggestive ever employed in the history of the medium. The images were drawn with faint, hair-like lines, probably using a diamond-tipped needle. The entire composition was divided into two abstract zones of sky and water demarcated by a faint band of barely discernible forms along the horizon, which were picked up by a series of "boats" in the foreground. The ghostly images, swallowed up in the early morning mist, are restatements in etching of ideas already expressed in such paintings as *Nocturne: Blue and Silver—Cremorne Lights*, Y.115, 1872 (pl. 206).

Whistler's increasing interest in shipping and river traffic during the late 1870s recalls once again the engravings of Hollar and seventeenth-century Dutch marine etchers who were represented in the Haden Collection. Certain motifs, such as the large ship which projects into the composition of *A Sketch from Billingsgate*, K.168, 1878 (pl. 209), recalls Hollar's *Dutch West Indiaman*, P. 1262 (pl. 210), and the grain boat moving parallel to the shore in *Prices' Candle Works*, K.154, *c.* 1877 (pl. 211), the timber boat in Hollar's *Lambeth Palace from the River*, P. 1038 (pl. 212). The work of the Dutch marine etchers Reinier Nooms called Zeeman (*c.* 1623–67), and Ludolph Backhuysen (1631–1708, pl. 213) also appears to have been an influence at this time.

Most of the other Thames etchings of this period return to and reinterpret themes first used in the 1850s and 1860s. The composition of *Free Trade Wharf*, K.163, recalls that of *The Pool*, K.43, 1859; *The Large Pool*, K.174, *c.* 1877, that of *The Little Pool*, K.74, 1861, and *Lindsey*

Houses, K.166, 1878, that of *Amsterdam from the Tolhuis*, K.91, 1863. This play on "themes" and "variations" anticipates Whistler's work in Venice, and his increasing interest in the more abstract elements of composition.

Whistler's fortunes took a turn for the worse in July, 1877. It was during this month that Leyland terminated his business dealings with Whistler, and refused to pay him the 2,000 guineas which he had asked for the "Peacock Room". In addition, he refused to pay the bills for materials used, and forwarded them to Whistler. During the same month a second, perhaps not unrelated, crisis took place. John Ruskin, by then the most influential art critic in the history of the English-speaking world, attacked Whistler's painting *Nocturne in Black and Gold: The Falling Rocket*, Y.170, 1875, in *Fors Clavigera* saying, "I have seen and heard much of cockney impudence before now; but never expected to hear a coxcomb ask two hundred guineas for flinging a pot of paint in the public's face."[11]

Whistler tried to ignore Ruskin's comment, for it was well known in artistic circles that the critic, irritating and irresponsible though he was, was suffering from repeated bouts of mental illness. In September, however, Whistler was to sign a contract with the architect E. W. Godwin, the foremost architect of the Aesthetic Movement, who was to design and build him a house on Tite Street in Chelsea to be called "The White House." Following Ruskin's stinging attack, Whistler was unable to sell his paintings, and Leyland refused to change his stand

213. Backhuysen, *The Arrival in Amsterdam* from the *Marine Set*, B. 12. Etching, 17.6 × 23.4 cm. The Minneapolis Institute of Arts, Gift of Herschel V. Jones, 1916.

regarding payment for the "Peacock Room". His debts began to pile up, and the cost of the house to soar. Whistler had no choice but to launch a libel suit in self defence against Ruskin, and to live on credit until he could reach a favourable settlement with Leyland.

Meanwhile, he was in desperate need of cash to keep smaller creditors, such as the local greengrocer, at bay. One day while meditating upon the wretched state of his affairs and looking out the window of the house on Lindsay Row, Whistler saw Charles Augustus Howell walking by and hailed him. Howell was a charming but dishonest hanger-on of the Rossetti circle, and had once been Ruskin's personal secretary. After hearing of Whistler's plight, Howell, the eternal opportunist, came up with the following solution which was recounted by Whistler to the Pennells as follows:

"Why, you have etched many plates, haven't you? You must get them out, you must print them, you must let me see to them—there's gold waiting. And you have a press!" And so I had, in a room upstairs, only it was rusty, it hadn't been used for so long. But Howell wouldn't listen to an objection. He said he would fix up the press, he would pull it. And there was no escape . . . In the afternoon Howell would go and see Mr. Graves the printseller, and there were orders flying about, and cheques—it was all amazing, you know.[12]

Goulding was engaged to come and help with the printing.[13] Orders certainly did come in, and etchings which were probably never intended for publication were sold to individuals, small printsellers, and Howell himself, who had no scruples about helping himself on the side. Had it not been for Whistler's financial plight and Howell's intervention, it is questionable whether the majority of the plates executed during the mid to late 1870s would have been circulated at all. Given the small number which were printed, Whistler's situation could not have been greatly aided.

It was at about this time that a man called Ernest Brown came to see Whistler about the possibility of publishing one of his etchings in an issue of the *Portfolio* magazine.[14] Whistler let him have *Billingsgate*, K.47, 1859, which had not appeared as part of the "Thames Set." Its publication in January 1878 may have given Whistler ideas. By the autumn of 1878 he had conceived a scheme of producing etchings for the marketplace, no doubt catering to the taste of those who had admired the "Thames Set." On September 26 he wrote to tell his sister-in-law saying:

You know from Willie that I have taken up etching again and have found that people still prefer Whistlers to all others—but the stock is not yet in absolute working order so that I must have a while longer stick hard at it—A printing press has been lent to me and soon I trust I shall turn some of my copper into gold.

Ultimately I hope to get together sufficient to go to Venice with, and then I might come back in about six weeks with a sum large enough to pay off nearly everything and find myself quite out of difficulty at last![15]

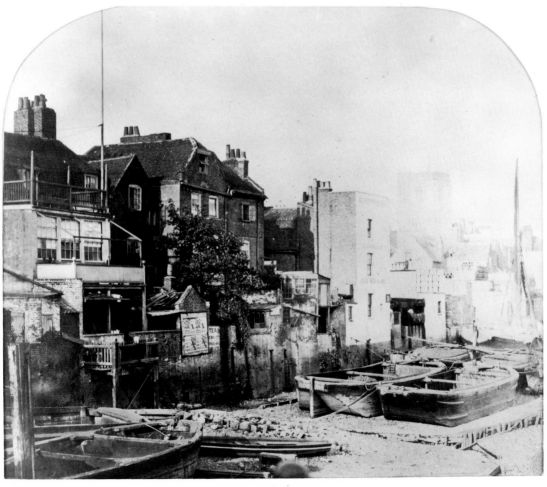

By the end of the year it was imperative that Whistler "turn his copper into gold." Although he had won the court case with Ruskin on November 25, and with it the important right for the artist to decide when his work is "finished," he was awarded only a farthing in damages. The cost of the court case was added to a mounting pile of debts, and his hope that Leyland would relent had come to nought. Whistler suspended the farthing from his watch fob and returned to his copper plates.

Early in the New Year of 1879 the first of the new etchings *"The Adam and Eve", Old Chelsea,* K.175 (pl. 214), was published by Messrs. Hogarth and Son. The old waterfront tavern had already been demolished to make way for the Chelsea embankment, and Whistler appears to have used a photograph *Duke Street House Backing on the River* by James Hedderly (*c.* 1815–1885) (pl. 215) to reconstruct it.[16] He was later to see it as a transitional work in the evolution from the realist style of the Thames etchings of 1859 to the "impressionist" style of the Venice etchings of 1879–80. In the early works, as he pointed out to the Pennells, he drew every plank, every brick, and every roofing tile, with a firm, unbroken contour. In *"the Adam and Eve", Old Chelsea* he suggested light by means of shadow, and the whole by drawing a part. The Pennells summarized his conversation, saying that:

> As he grew older and practised more, he gave up his literal, definite, firm method of work. Instead of drawing the panes of a window in firm outline, for instance, he suggested them by drawing the shadows and the reflected light with short crisp strokes and scarcely any outline at all.[17]

In *"The Adam and Eve", Old Chelsea,* Whistler's concern was not so much to express the physical nature of the structure but to create a feeling of air and atmosphere, and a composition based on oriental principles of balance and placement. In this work the eye is no longer drawn to a specific area of the composition; instead it is drawn to different areas wherever details congregate. By drawing only the shadow and the light within the shadow, Whistler created a new sense of aerial perspective which is not found in the etchings of 1859.

It was probably early in 1879 that Ernest Brown, who had joined the staff of the Fine Art Society, came to see Whistler about handling his etchings. Brown may well have been responsible for persuading the directors of the Society to purchase the "Thames Set" plates from Ellis and Green and to bring out a second edition. Sensitively printed by Frederick Goulding, who was by then a master printer, this edition is generally considered more desirable than the one printed by Ellis. It sold intact for fourteen guineas. Some of the impressions were printed on vellum, a surface which Rembrandt had occasionally used for experimental proofs.[18]

During the early months of 1879, Whistler etched and Goulding helped to print.[19] He lived in constant fear that his creditors would hear of the assets he was creating and seize them. He wrote to Anderson Rose on January 23, saying:

I am afraid that they may come down upon me in the course of the

day—and if I can get over into next week I believe it will be all right—for I have been getting on with some etching plates to-day that I am sure McLean will take directly they are finished—(keep it dark, though—or they might seize the plates before I can get them out of my hands)—but the Levy seemed tolerably decent—and I really can get about 40 or perhaps 50 for next week—and possibly more—only keep them off.[20]

Within a short time the facade of the White House was plastered with bills, and the house occupied by bailiffs. Ingeniously, Whistler pressed them into service at dinner parties as liveried waiters, and managed to conceal his copper plates when they began to inventory his possessions.

Whistler sold impressions of *The Little Putney, No. 1*, K.179, and *Fulham*, K.182, to the Fine Art Society in January, *Old Putney Bridge*, K.178 (pl. 216), in April, and *Old Battersea Bridge*, K.177 (pl. 217), in August. He continued to supply impressions as the editions sold out, and finally sold the copper plates of the last two etchings to the Fine Art Society in the course of the summer. In the midst of all of these pressures, which included additional personal ones which have only come to light recently,[21] it is extraordinary that Whistler should have produced such outstanding plates.

In the etchings of 1879, all the tentative uncertainty found in the plates of the mid 1870s disappeared. By reverting to a style and scale which more closely resembled that of the Thames etchings of 1859, and by creating plates with a greater degree of "finish," Whistler may well have been trying to give the public what he thought it wanted.[22] Nevertheless, in these large and accomplished studies he finally managed to synthesize the lessons learnt from the Western tradition with those from Japan.

His interest in the wooden bridge as a subject for etching may have sprung from the same preservationist instinct which led him to record vanishing parts of dockland. Putney Bridge was demolished in 1884–6, soon after the completion of the new bridge; and Battersea Bridge was closed to traffic in 1883 and demolished in 1890. Whistler expended considerable energy capturing the appearance and mood of vanishing Chelsea as the embankment crept ever closer and the character of the riverside community began to change irrevocably.

But it is also apparent from the structure of his compositions that his interest in the shape and decorative possibilities of wooden bridges was stimulated by his contact with the woodcuts of Hokusai and Hiroshige. He would undoubtedly have known Hokusai's *Unusual Views of Famous Bridges Throughout the Country*, and owned an impression of Hiroshige's famous *Fireworks, Ryogoku* from *One Hundred Views of Famous Places in Edo*, 1858.[23]

In each of the bridge etchings, Whistler borrowed a number of ideas from the Japanese, as he had in his lithographs *The Broad Bridge W.8* and *The Tall Bridge, W.9* of 1878. He chose certain sections of the bridges for representation, abruptly cutting them off at the edge of the plate in the Japanese manner. He employed a low vantage point, and used an arch of the bridge to frame a distant view, just as Hokusai had done in *Mannenbashi Bridge at Fukagawa* (pl. 218). Like Hokusai and

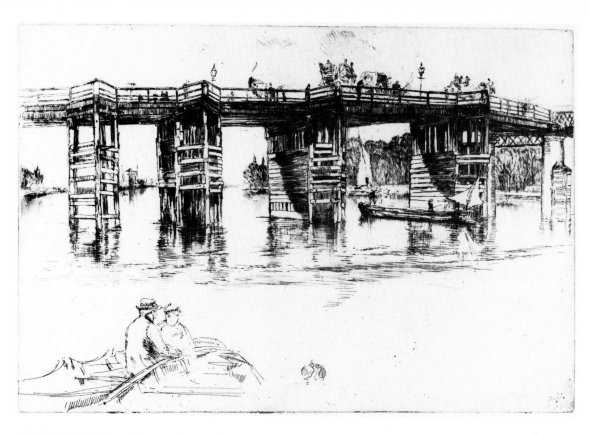

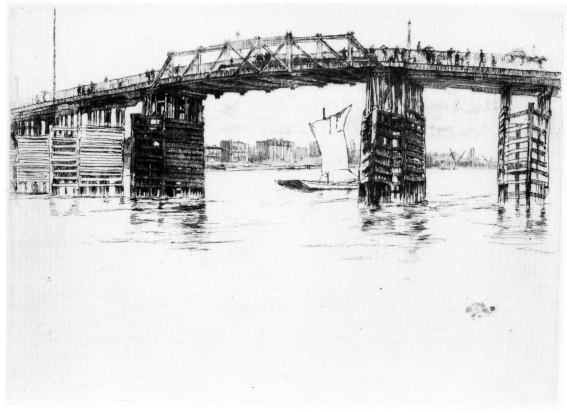

218. Hokusai, *Mannenbashi Bridge at Fukagawa*, from the series *Thirty-Six Views of Mount Fuji*, early 1830s. Ukiyo-e woodcut, 38.1 × 25.7 cm. Courtesy of the Sir Edmund Walker Collection, Royal Ontario Museum, Toronto, Canada.

216. Whistler, *Old Putney Bridge*, K. 178, 1879. Etching, 20.1 × 29.5 cm. Reproduced by permission of the Trustees of the British Museum.

217. Whistler, *Old Battersea Bridge*, K. 177, 1879. Etching, 20.1 × 29.5 cm. Courtesy of the Freer Gallery of Art, Smithsonian Institution, Washington, D.C.

Hiroshige, he frequently placed a boat in the foreground, either approaching the bridge or passing beneath it, to lead the eye into the composition. Pedestrian traffic regularly enlivened the otherwise static view of the Japanese bridge as it does in Whistler's two etchings. The basic division of space, with the horizon just above centre, reflects the Japanese construction of space which Whistler had adopted years earlier from his study of Japanese landscape woodcuts.

Despite all his last-minute efforts, Whistler was declared bankrupt in May 1879, with Leyland as his chief creditor. The contents of the White House including his copper plates, were catalogued by the bailiffs in preparation for the first liquidation sale by Sotheby's on May 7. Whistler was desperately in need of diversion and an income, and was delighted when the Fine Art Society decided to commission him to go to Venice to make a set of etchings. He wasted no time, leaving at the beginning of September and remaining in Venice until the humiliating sale of his effects was over and the horrors of bankruptcy behind him.

## 4. Whistler in Venice

Whistler's desire to go to Venice must have begun with his childhood enthusiasm for the paintings of Turner and with Seymour Haden's reminiscences of his visit in 1844. He probably read John Ruskin's popular book *The Stones of Venice*, 1851–3, which did so much to spread an appreciation of the gothic and Byzantine beauties of the crumbling city. By the late 1870s, Venice had become a mecca for artists, writers and tourists from Britain and America.

Whistler's original plan to visit Italy during the period 1855–58 was postponed indefinitely as changed artistic interests drew him instead to Holland and Spain. However, Venetian art, particularly the work of Tintoretto and Veronese, which had to be seen *in situ*, was greatly admired by his naturalist and realist contemporaries, and may well have fuelled his longstanding desire to go to Venice.

Whistler began to plan a trip while working on the Peacock Room at Princes' Gate, which was being decorated on a Venetian theme. In July 1876, he recorded the first orders in his ledger book for a series of etchings of Venice which he planned to make that autumn.[1] Leyland wrote in August to say that he did not expect to be in London again before Whistler left for Venice,[2] and by September, prospectuses for the series "Venice—by Whistler"[3] had been sent out, and an announcement had appeared in *The Academy* saying that Whistler was about to leave.[4]

He was planning to travel with the money received from Leyland for the finishing touches to the dining room. As his enthusiasm began to mount, his departure date began to fade. Within a month of starting work, Whistler had wildly exceeded his mandate, and the die was cast.

Following his battle with Leyland over the "Peacock Room", he had to give up all thought of going to Venice for the time being. Nonetheless, the trip remained foremost in his mind after his bankruptcy two years later. On July 18, 1879, an announcement appeared in *The Academy*

once again saying that, with the assistance of friends, Whistler was planning a trip to Venice to make a set of twenty etchings.[5]

Soon after it appeared, Whistler must have been approached by Ernest Brown on behalf of the directors of the Fine Art Society, who had agreed to commission Whistler to make a series of twelve etchings to be published in December. Whistler was busily planning his route[6] when the directors met on September 9 and recorded in their minute book "an agreement with Mr. Whistler whereby he agreed forthwith to proceed to Venice and etch 12 plates . . . Cheque for £150 for him drawn."[7] He agreed to return with the plates by December 20.[8]

Whistler wasted no time, and wrote to George Lucas to say that he would be leaving at once for Paris with Maud.[9] They arrived on September 16, and after staying two days, Whistler caught the night train for Venice.[10] Maud remained for a month with Lucas in Paris giving Whistler time to find lodgings and start on his work. Lucas put Maud on the train on October 18; six days later she wrote to thank him and report her safe arrival in Venice.[11]

Whistler found rooms at the Palazzo Rezzonico on the Grand Canal near the Accademia, where he lived with Maud during the autumn and winter of 1879–80. Using the sixteen copper plates marked "Hughes and Kimber"[12] which he had brought from London, he set to work to etch the required dozen for the Fine Art Society. Between the time of his arrival in September and the time of his anticipated return to London in December, he appears to have etched the following compositions from which he planned to select twelve:

| | |
|---|---|
| *The Doorway*, K.188 | *Ponte del Piovan*, K.209 |
| *The Riva*, K.192 | *The Rialto*, K.211 |
| *Two Doorways*, K.193 | *Quiet Canal*, K.214 |
| *Bead Stringers* K.198 | *La Salute: Dawn*, K.215 |
| *Nocturne: Palaces* K.202 | *Lagoon: Noon*, K.216 |
| *Long Lagoon*, K.203 | *Islands*, K.222 |
| *The Bridge*, K.204 | *Old Women*, K.224 |
| *The Balcony*, K.207 | *Nocturne: Salute*, K.226 |

On December 8, anticipating Whistler's return, the directors of the Fine Art Society met to decide how much they would offer Whistler for his plates. The minutes read "Whistler plates of Venice—it was determined to purchase these plates for the sum of £700."[13] Whistler, however, had no intention of returning. He was possessed by extraordinary creative impulses, and could not resist playing truant in order to take maximum advantage of the opportunity to produce not only additional copper plates which he could sell to his advantage, but a series of pastels as well. Moreover, the thought of returning on the eve of the mortifying sale of the contents of the White House on February 12 must have appalled him. Of his intentions, however, the Fine Art Society knew nothing.

On New Year's Day, 1880, Whistler wrote to his sister to explain his delay:

Of course, if things were as they ought to be all would fit in well and I should be resting happily in the only city in the world fit to

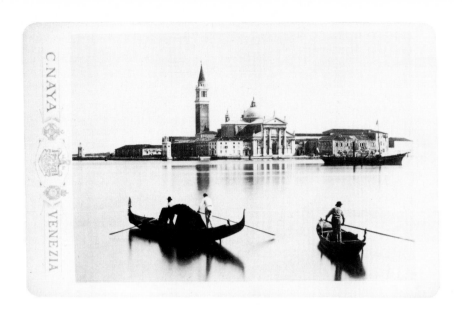

219. Naya, C., *Isola di S. Giorgio*, c. 1880. Albumen (cabinet card), 9.5 × 14 cm. Collection Steven Evans, Toronto.

live, instead of struggling on in a sort of Opera Comique country when the audience is absent and the season is over.[14]

Rumour of his intentions probably reached the Fine Art Society through Howell who also spread word that Whistler was engaged in making a series of "huge" plates. On January 14, Marcus Huish of the Fine Art Society wrote an angry letter saying that the directors had been expecting his plates for weeks, and that those who had originally expressed interest were now tired of waiting. As a result they had been forced to postpone publication until the following autumn.[15]

Whistler, whose literary abilities ran a close second to his artistic talents, fired off a reply blaming the weather for his tardiness:

> I can't fight against the gods—with whom I am generally a favorite—and not come to grief—so that now—at this very moment—I am an invalid and a prisoner—because I rashly thought I might hasten matters by standing in the snow with a plate in my hand and an icicle at the end of my nose. I was ridiculous—the gods saw it and sent me to my room in disgrace . . . I have not written to you for I hate writing—and couldn't tell you anything that you didn't already well know . . . How Mount Vesivius is frozen inside—and nothing but icicles come out? How here in Venice there has been a steady hardening of every faculty belonging to the painter for the last two months and a half at least—during which time you might as well have proposed to etch on a block of Wenham Lake as to have done anything with a copper plate that involves holding it![16]

He tried to console Huish for his recent loss of business by promising still more. He wrote winningly, as if drafting a press release, of the importance of his recent work and the novelty of his approach to his surroundings:

> Venice, my dear Mr. Huish, will be superb—and you may double

your bets all round . . . the mine of wealth for both you and me in this place . . . I have learned to know a Venice in Venice that the others never seem to have perceived, and which, if I bring back with me as I propose will far more than compensate for all annoyances delays and vexation of spirit . . . The etchings themselves are far more delicate in execution, more beautiful in subject, and more important in interest than any of the old set.

While it was true that Whistler was using rather larger plates in Venice than he normally used, the largest was $9\frac{7}{8} \times 14\frac{1}{8}$in. and did not begin to compare with the overblown and empty productions which had become commonplace in Britain and France during the 1860s and 1870s. In mock heroic fashion he wrote that he was "shocked" out of all his "usual impassiveness" by the suggestion that he was neglecting his work in order to

. . . trifle with plates, whose exaggerated size, not only partook of the character so generally accorded to all Howellian assertion, but would have been proof enough in itself—were any needed—of the unlikelihood of the story! Little Mr. Brown would have told you how Mr. Whistler holds in contempt and derision the "big plate"—the advertisement of the ignorant—the inevitable pitfall of the amateur. I am even astonished that Howell himself—in his desire to make statements—should have missed this tip—as he has often heard me scoff at the vulgarity, of the pretence, and point out the gross condition of brain that could tolerate the offensive disproportion between the delicate needle of the etcher and the Monster Plate to be covered! Perceive how inartistic is the undertaking—based as it is on the dulness which distinguishes not between mastery of manner, and "muchness" of matter! From this [pente ridicule] the painter's science saves him—he knows that the dimensions of the work *must* be always in relation to the means used—and reaching the limit, unerringly lays aside the needle for the brush, that he may not find himself worming his weary way across a waste of copper—all quality lost—all joy of execution gone—nothing remaining but the doleful task for the dreary industry of the foolish—the virtue of the duffer . . . and so we have heads the size of soup plates—and landscapes like luncheon trays—while lines are bitten furiously until in the impression they stand out like the knotted veins on his own unthinking brow—Poor meek Rembrandt!—with his mild miniatures—beside such colossal duds how dwarfed he becomes! how uninteresting his puny portraits of diminutive Burgomaster Six and Clement de Young [sic]—how weak his little windmills . . . Ah well! nous avons changé tout cela!—But this is not a letter—I shall find myself in the midst of another pamphlet so by the way you had better carefully keep this—for who knows—I may borrow it for an extract.

Marcus Huish did not pursue the matter further at this time. Instead, he attended the sale of Whistler's effects in February and purchased some of his oriental china and his Japanese picture books. No doubt he added some of these items to his growing collection of oriental art, and returned others to Whistler. He also purchased lot 78, "About 100

copper plates of etchings, mostly erased,"[17] probably as a means of protecting the Fine Art Society's investment.

Whistler, delighted at the prospect of extending his stay, wrote to Howell saying that he was "bound to turn everything into gold—I can't help it—the work I do is lovely and these other fellows have no idea! no distant idea! of what I see with certainty."[18] Secure in the knowledge that the Fine Art Society would not now publish the plates until the autumn of 1880, Whistler's major concern became the replenishment of his etching supplies. Although he was able to procure locally the heavy, soft Venetian eighteenth-century paper on which he pulled his rudimentary trial proofs, he was dependent on friends in London to supply him with the Japanese and old Dutch papers which he preferred to use. In response to his pleas, T. R. Way, his lithographic printer, sent Japanese paper rolled up in a large illustrated periodical, and Ernest Brown procured twenty to thirty sheets of old Dutch from Goulding. Whistler also asked Brown to send him three balls of varnish for making etching ground from Hughes and Kimber, together with a small bottle of stopping out varnish.[19]

He did not, however, request a shipment of copper plates, and it may be safely assumed that by the beginning of 1880 he had begun to order them from a Venetian coppersmith who later supplied plates for Frank Duveneck and Otto Bacher. A careful examination of all the plates made in Venice led Getscher to divide them into four groups: the sixteen which were bought from Hughes and Kimber, seven with milled backs (which may have been sent from London), and thirty-seven which were hand-made and bear hammer marks on the back in two distinct patterns. It was on these last three groups of plates, forty-four in number, that Whistler appears to have worked from January to October.[20]

Whistler threw himself into the social and artistic life of Venice, going back and forth between Florian's and Quadri's, the two cafés which flank the Piazza San Marco, whenever he ran out of credit on one side or the other. When summer came, he met a group of students who had recently spent the winter in Florence studying under Frank Duveneck, an American painter of German descent. It was not long before Duveneck and his "boys" ran into Whistler who was delighted to meet a group of young admirers.

Chief among them was Otto Bacher who was also an etcher and who had brought with him a portable press from Munich. Bacher persuaded Whistler and Maud to move into the room next to his in the Casa Jancovitz at the end of the Riva degli Schiavoni near the Via Garibaldi. The move may have been occasioned partly by financial necessity, but brought with it the advantages of an excellent view of the Doge's Palace, San Giorgio and the Salute, as well as the congenial company of Bacher and his friends and easy access to Bacher's etching press.[21]

Bacher was delighted to have an opportunity to observe Whistler at work; he not only recorded his etching technique in considerable detail, but set to work to assist him. He took over the grounding of Whistler's plates, an activity which Whistler was all too ready to leave to others. Instead of applying the old-fashioned ground composed of white wax, bitumen, pitch and resin heated over an alcohol flame, Bacher covered the plates with the ground known as "Rembrandt's" ground, which Whistler apparently came to prefer.[22]

Although Whistler also disliked biting his plates, this activity could not be entrusted to anyone else. He set a day aside for the task, and as it approached he became more and more depressed. Whistler's method of biting was both skilful and dangerous. Instead of immersing the plate in a bath of Dutch mordant as he had done in his early days, he used a feather to move a mixture of nitric acid and water around on the surface of the plate, and it could inflict serious burns.[23] Although Whistler's method was not unlike that which he had learnt at the Coast Survey Office, he neglected to place a wax reservoir around the plate; when he considered the plate sufficiently well bitten, he simply drained the acid from the surface back into the bottle.[24] He then scrutinized the plate with a magnifying glass to make sure that there was no false biting. This continuous process of biting enabled him to produce the infinitely subtle gradations of tone which characterize the Venice etchings, and which could not have been produced through the process of multiple biting used for the "French" and "Thames Set" plates.

Whistler inked his plates carefully, using a dabber to squash black or brown ink into the shallow lines, moving the hot copper plate over the heater, and "rough-wiping it neatly with muslin." When the plate had cooled, he used his hand with its "palm of a duchess" to wipe the residue away "in the daintiest manner imaginable." In this way, despite the minimal line work, Whistler could pull "a proof so rich and full that it would surprise most etchers to see how much ink he got from those tiny weblike scratches."[25]

Although he took progress proofs in Venice, he waited to print editions until after his return to London. Before Bacher's arrival he used the old Venetian press on which Canaletto was said to have printed his plates,[26] but finding it primitive, he wished that he had brought his own press from London.[27] Bacher's press was much more convenient but it had one disadvantage: it could not accommodate large sheets of paper. Some of Whistler's plates were sufficiently large that the paper had to be folded; if he wanted to make an edition without folding the paper, he "had to carry the plates to the old Venetian printer who had two wooden presses well equipped for this purpose."[28]

It is possible to identify a number of proofs made in Venice, some of which were "touched" as guides for further work on the plate. Unlike the impressions printed in London, the margins are intact, and they are often printed on thick, soft, eighteenth-century paper with widely spaced laid lines. Whistler does not appear to have played with artistic printing effects in Venice, but to have taken rather dry impressions in order to check his line work. Some of these were given to Otto Bacher, no doubt in return for the use of his press, and bear his red stamp (Lugt 2002). Very few impressions were taken of the early states, which often exist in unique trial proofs, and which do not appear to have been considered "states" in themselves by Whistler.

———————

Views of Venice had always enjoyed a healthy market in Britain, one which Canaletto had supplied in the eighteenth century. The current popularity of Venice with English tourists would have assured Whistler and the Fine Art Society of a good market for etched views.

Whistler's approach to his subject must have been conditioned by a desire to capture the special beauty of the modern city, so eloquently described by Ruskin in *The Stones of Venice*:

> Her successor, like her in perfection of beauty, though less in endurance of dominion, is still left for our beholding in the final period of her decline: a ghost upon the sands of the sea, so weak—so quiet— so bereft of all but her loveliness, that we might well doubt, as we watched her faint reflections in the mirage of the lagoon, which was the City, and which the Shadow.[29]

There can be no doubt that in choosing to depict a city which already enjoyed immortality through the paintings of Canaletto, Guardi and Turner, that Whistler was heir to a rich visual tradition which he could not possibly ignore, and it would be extremely important to him to find an approach to the subject which would be identified with him alone. Since his predecessors had focussed on popular tourist views of San Marco, the Salute and the Grand Canal, Whistler strategically avoided them. This tendency was nonetheless perfectly consistent with his approach to Paris and London. He did not want to create a series of *vedute* for the tourist trade; instead he wanted to capture and record the essence of the crumbling city: its texture, its light, its distinctive enclosed *calli* and *piazze,* and its unique "floating" quality. Although he did consent to etch a few recognizable views, he did not bother to reverse his plates, and for the most part sought out picturesque nooks and crannies on the smaller canals to which the old masters had not penetrated. His delight in the picturesque nature of the city was expressed in a letter to his mother:

> this evening the weather softened slightly and perhaps to-morrow may be fine—and then Venice will be simply glorious, as now and then I have seen it—after the wet, the colours upon the walls and their reflections in the canals are more gorgeous than ever—and with sun shining upon the polished marble mingled with rich toned bricks and plaster, amazing city of palaces becomes really a fairy land— created one would think especially for the painter. The people with their gay gowns and handkerchiefs—and the many tinted buildings for them to lounge against or pose before, seem to exist especially for one's pictures and to have no other reason for being! One could certainly spend years here and never lose the freshness that pervades the place![30]

In Venice, he worked, as he had always done, directly from nature, carrying grounded copper plates wrapped in paper and an etching needle embedded in cork in his pocket. Each day he set out by foot or by gondola, in search of new subjects.

Although his immediate inspiration came from nature, Whistler created in Venice the perfect synthesis for which he had been searching, combining the love of picturesque form and spatial geometry learnt from Rembrandt and the Dutch, with atmospheric effects learnt from Turner and Corot, and two-dimensional decorative patterns learnt from Japanese prints. Although many of his contemporaries, struck by

187

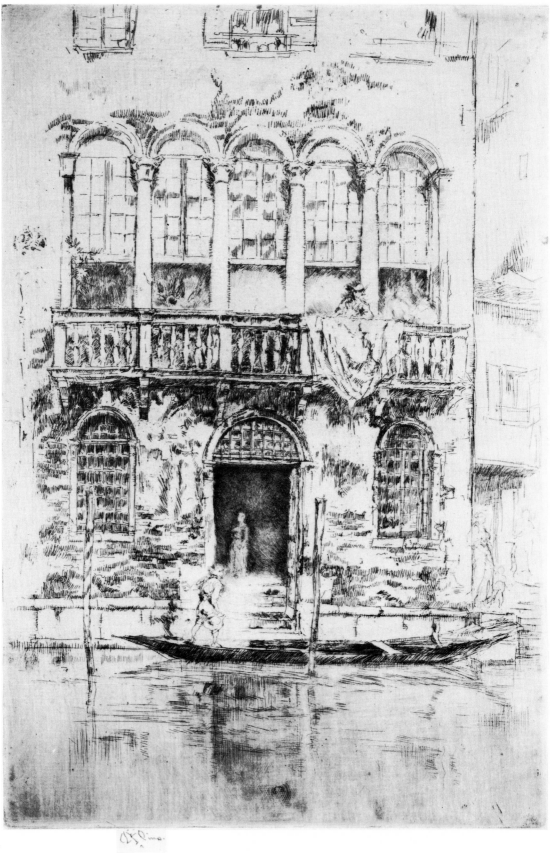

221. Canaletto, *Grand Canal: The Palazzo Foscari and the Campo S. Sofia*, C. 596. Pen and brown ink, 17.4 × 25.8 cm. T. Moatti, Udine.

220. Whistler, *The Balcony*, K. 207, 1879–80. Etching, 29.3 × 19.8 cm. Courtesy of the Freer Gallery of Art, Smithsonian Institution, Washington, D.C.

the novelty of his Venice style, were unable to see the etchings as a logical outgrowth of his earlier work, Whistler correctly maintained that "the whole thing with me will be just a continuation of my own art work, some portions of which complete themselves in Venice."[31] In the Venice etchings, his poetic impressions were suspended like a veil before the viewer, and nature was transformed into delicate compositional arrangements of pattern and void which were flattened until they hung midway between two and three dimensions.

This was facilitated by the discovery of what he called his "secret of drawing," which was also used by his Japanese contemporary Kyosai. It is not known whether Whistler knew of Kyosai at the time, or whether he developed his method directly from the study of oriental art.[32] It involved working from the centre of the composition toward the periphery, keeping the plate in a state of "completion" at all times. Harper Penington, who was in Venice at the time, saw Whistler standing in a sandolo, making great sweeping gestures with his hand over a plate. He later wrote to him saying, "You stood poised, with a plate lying on your left arm while your right hand made sweeps and curves above it, in the air. How well I remember seeing you look up and then down again, up and down, up and down, several times, and then draw the contemplated line."[33] When Pennell asked Whistler to explain his method of drawing, Whistler explained that he sought to fix on the copper plate the spot or subject of greatest interest first. Then he sometimes bit the plate, and took a proof impression before continuing to develop peripheral detail. By degrees he enlarged the composition, which, he maintained, was "finished from the beginning."[34] In these works the spatial structure is quite different from that of the "French Set" or "Thames Set." The subject is approached frontally, but rather than receding from the picture plane in successive stages, it appears to move out from the centre of interest in a series of concentric circles, parallel and close to the picture plane. Whistler managed to give these plates a two-dimensional decorative quality while preserving an illusion of depth in the third dimension.

In Venice, under the brilliant sun, Whistler's calligraphic line broke down, becoming at times little more than a staccato shorthand of dots and dashes. He strove for ever greater selectivity of detail, only suggesting, never describing, those elements which played a vital role in his compositional arrangements. The placement of the compositional fragments became increasingly more refined, and the subtle sense of balance more exact. He continued to draw shadows rather than contours, using infinite numbers of hairlike lines, sometimes drawn with dentist's tools, running roughly parallel to each other, and sandwiching the shimmering light between them. In this way he achieved effects in etching which he later described as "painting with exquisite line."[35]

Whistler's line may have been influenced by the great Venetian draughtsmen, Giovanni Battista Tiepolo, Canaletto and Guardi. The little figures which animate many of the plates, and which were often added later, have a rococo quality which recalls the agitated staffage of Tiepolo and Guardi. Whistler's shorthand representation of architecture using little calligraphic touches, which may be seen in *The Balcony*, K.207 (pl. 220), is anticipated in the numerous quick sketches which Canaletto made of Venetian buildings in which he sought only to

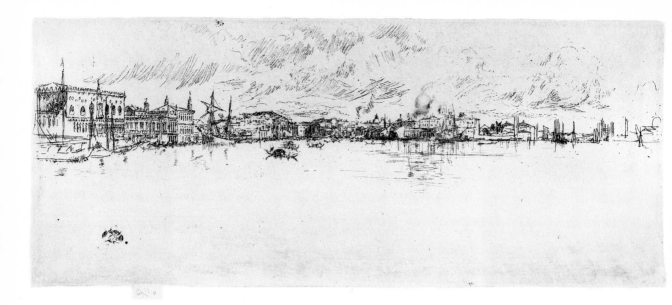

222. Whistler, *Long Venice*, K. 212, 1879–80. Etching, 12.7 × 31.0 cm. Reproduced by permission of the Trustees of the British Museum.

capture the rhythm of the fenestration and the overall distribution of elements on the facade (pl. 221). Even the way in which Whistler sandwiched light between series of diagonal lines in areas of shadow can be found in the drawings and, to some extent, the etchings of Canaletto.

Whistler's Venice etchings come closer perhaps to the painterly and picturesque drawings of Francesco Guardi. He could well have seen Guardi drawings at stalls and shops in the vicinity of S. Marco, where they had a ready tourist market.[36] Whistler's long horizontal compositions showing Venice stretched along the lagoon, as in *Long Venice*, K.212 (pl. 222), recall such Guardi drawings as *The Entrance to the Grand Canal*, S.24 (pl. 223); and the ghostly gondoliers in *Upright Venice*, K.205, which look like water insects, resemble similar figures in Guardi's *Santa Maria della Salute*, S.21. Whistler's admiration for the work of Canaletto and Guardi may have been stimulated by his visit to Venice, for during the 1880s he apparently admired their work even more than that of Rembrandt,[37] and went "dozens of times" to look at their paintings in the National Gallery in London.[38]

In Venice Whistler continued to explore themes and variations which

223. Guardi, *Entrance to the Grand Canal*, S. 24. Pen and light wash, 14.3 × 20.7 cm. National Gallery of Canada, Ottawa.

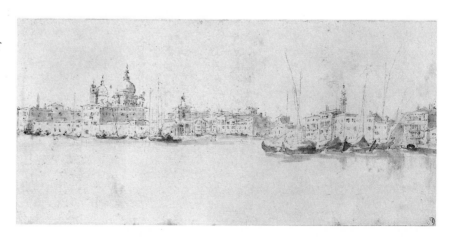

had preoccupied him for years, demonstrating the consistency of his formal concerns. While his subjects are attractive and capture the feeling of the city, he was not interested in subject as an end in itself, and never reversed the plates. Upon close examination it appears that his interest lay in the more purely abstract elements of the composition, and that the subject played an increasingly incidental role. This was anticipated in the portrait "arrangements" of the 1870s, and in the decoration for the "Peacock Room." In his pamphlet *Harmony in Blue and Gold: The Peacock Room* of 1877, Whistler maintained that the peacock motif was only a "means" of carrying out a formal arrangement in gold on blue and blue on gold, and he stressed the significance of the pattern/ground reversal which can be seen to anticipate the optical experiments of twentieth-century art.[39]

Looked at in this context, the Venice etchings can be divided into groups each of which explores a similar theme with formal variations, and can be seen as the logical outgrowth of Whistler's early work in the medium.

Whistler continued to develop the decorative and spatial possibilities of figures in doorways which he had first explored in 1858 in *La Vieille aux loques* (pl. 61), and *La Marchande de moutarde* (pl. 55). This idea had been extended the following year in *The Limeburner* (pl. 108), to include a succession of doorways and courtyards. In Venice he used the magnificent arched doorways with their cast iron grillwork and mysterious inner spaces to great advantage, as well as the narrow covered passageways which link the *calli* and often open onto canals.

While the picturesque qualities of the walls and door surrounds were fully exploited, Whistler's real interest lay in chiaroscuro experiments using dark on light and light on dark. He silhouetted light figures against dark doorways set in turn into light walls in *Two Doorways*, K.193, *The Beggars*, K.194, *The Balcony*, K.207, *Garden*, K.210, *The Dyer*, K.219, *Stables*, K.225, and *Bead Stringers*, K.198. In *Doorway and Vine*, K.196 (pl. 224), he reversed the order, placing a dark figure against a light ground. He incorporated all of the possible variations on this theme into *The Beggars*, K.194, silhouetting a light figure against the entrance to a dark passageway, a dark figure against the light at the far end, and a ghostly figure in transition in the middle.

At times the compositions are almost reduced to geometrical elements and can be "read" as abstract. In *Nocturne: Furnace*, K.213 (pl. 225), Whistler created a night effect outside, thereby providing a foil to the brilliantly lit interior which reads as a white "square" in a dark "rectangle." This effect was reversed in *The Dyer*, which is essentially composed of a dark "rectangle" within a light one. All the possible changes on this theme were rung in *Doorway and Vine*, K.196, in which a white "square" is placed within a black "rectangle" which is placed in turn within a white "rectangle." This tendency toward geometric abstraction not only lends monumentality to Whistler's compositions, it creates an illusion of recession while at the same time reducing the subject to an essentially two-dimensional pattern.

Whistler continued to develop the bridge theme, focussing on the small bridges which span the canals. Some, such as *The Bridge*, K.204, were approached from above, and employ the high viewpoint, steeply raked composition, and motif of the small boat approaching the arch

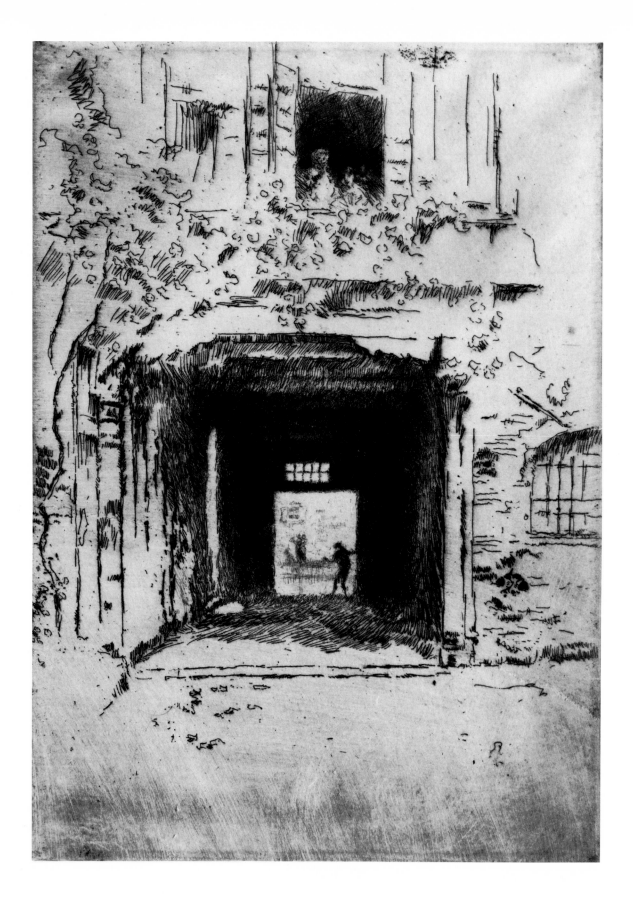

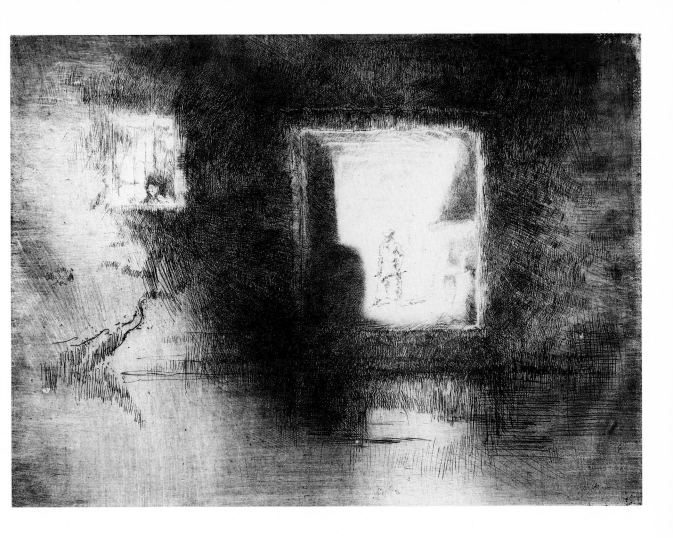

225. Whistler, *Nocturne, Furnace*, K. 213, 1879–80. Etching, 16.8 × 23.2 cm. Reproduced by permission of the Trustees of the British Museum.

224. Whistler, *Doorway and Vine*, K. 196, 1879–80. Etching, 23.4 × 17.0 cm. Reproduced by permission of the Trustees of the British Museum.

which are found in Hokusai and Hiroshige. Sometimes he approached the bridge from below in a gondola and use the arch as a device for framing the landscape beneath, as in *Ponte del Piovan*, K.209 (pl. 226). In this plate, the bridge and the view beneath it are flattened to achieve a two-dimensional curtain-like decorative effect which owes a great deal to Japanese prints and anticipates the Amsterdam etchings of 1889.

A rather eccentric theme which Whistler continued to employ in his Venice etchings is that of the vertical object placed asymmetrically in the composition, bisecting the picture space. This motif, which was first used in *Rotherhithe* in 1860 (pl. 147) and in *Shipbuilders Yard* (pl. 201), in 1875, appears to have its origin in the Japanese print. In Venice, Whistler explored this idea further in *The Little Mast*, K.185 (pl. 227), and *The Mast*, K.195.

The theme which is perhaps most effectively developed and closely identified with the Venice etchings is the view of the city by day and by night "floating" on the water. This idea, which originated in the painted nocturnes of the early 1870s, first entered Whistler's etched work in *Battersea: Dawn*, K.155 (pl. 207) and *Steamboat Fleet*, K.156 (pl. 208). The formal arrangement consists of a string of architectural elements stretched across the horizon where sky meets water. Among

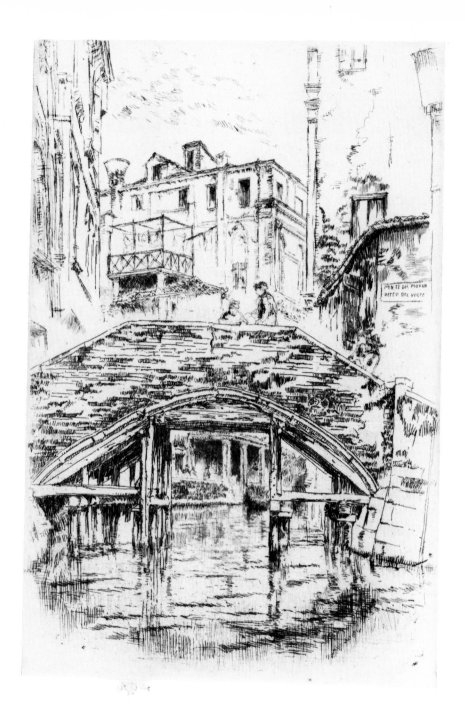

226. Whistler, *Ponte del Piovan*,
K. 209, 1879–80. Etching,
22.6 × 15.2 cm. Reproduced by
permission of the Trustees of the
British Museum.

227. Whistler, *The Little Mast*,
K. 185, 1879–80. Etching,
26.6 × 18.7 cm. Reproduced by
permission of the Trustees of the
British Museum.

the daytime variations are *Little Venice*, K.183, *Little Lagoon*, K.186, *San Giorgio*, K.201, *Long Lagoon*, K.203, *Upright Venice*, K.205, *Long Venice*, K.212 (pl. 222), *La Salute: Dawn*, K.215, *Little Salute*, K.220, *Islands*, K.222, *Shipping Venice*, K.229, and *Venice*, K.231.

The greatest of these are Whistler's poetic nocturnes, *Nocturne*, K.184 (pls. 228–232), and *Nocturne: Palaces*, K.202 (pls. 233–8). They were made using the memory method of Lecoq de Boisbaudran, which Whistler had discussed with Alan Cole on the eve of his departure for Venice, saying that he considered a painter's retention of memory

194

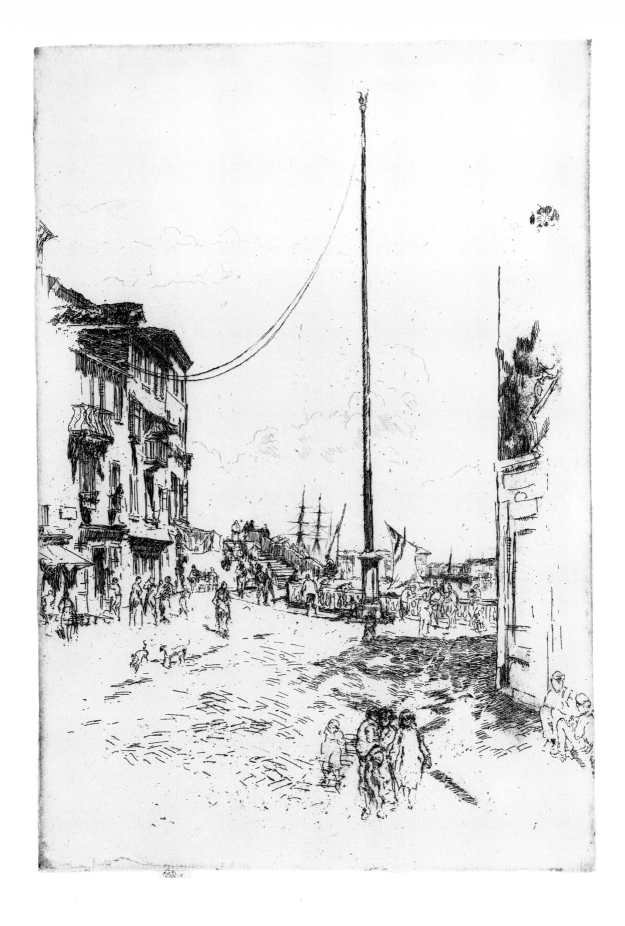

"whereby he seizes the effect and paints it" of vital importance.[40] He had used this method on the Thames while collecting data for the painted nocturnes in the 1870s, carefully memorizing the details of light and colour as he was rowed on the river at night by his pupil and boat-man, Walter Greaves.

A major difference in creating etched nocturnes lay in the versatility of the printing process. The painted nocturne was static and could seize but one effect; the etched nocturne, simply by varying the amount of ink left on the surface, could be used to create any number of effects. In Venice, Whistler picked up artistic printing where he had left off twenty years earlier after printing *Street at Severne* (pl. 53) and *The Music Room* (pls. 83–85), under Delâtre's tutelage.

While employing the same etched matrix, virtually every impression printed from the plates of *Nocturne*, K.184 (pl. 228), and *Nocturne: Palaces*, K.202 is unique, and has the appearance of a monotype. By varying the colour and the amount of ink on the surface of the plate, Whistler could change the temperature, mood, and time of day from pearly morning to hot night. Simply by wiping the surplus ink more or less vigorously with his palm, he replicated effects of dawn, evening or night. *Nocturne* was printed in brown or black ink, and wiped from the horizon line toward the lower margin and corners, creating a sense of recession and translucency. Most impressions capture a twilight effect, and have a "clearing" on the horizon against which San Giorgio and the large ship are silhouetted as the last rays of sun slowly fade (pl. 230). In successive impressions they dissolve and become insubstantial. As impressions become darker, they blend and flow into each other until they are swallowed up by the darkness. In the blackest impression (Rosenwald Collection, National Gallery in Washington) only the last glint of light is visible along the horizon, as night descends (pl. 232). Whistler may have pulled this proof for his own amusement.

In *Nocturne: Palaces*, the etched line once again provided only the most elementary grid for the effects to be achieved by manipulative printing (pl. 233). The time of day and temperature varied with the inking: black ink gave the plate a cool feeling, while brown ink gave it a warm one. By leaving progressively more brown ink on the plate, Whistler could suggest an early summer evening, a soft warm night, and a hot dark night (cover illustrations). He used a lamp to light the composition from within, a device which he had borrowed from Rembrandt and first used in *Street at Saverne* (pl. 53). In some impressions, by varying the inking, the lamp is made to appear very bright, while in others it can scarcely be seen. The brighter the rays which emanate from it, the less visible the bridge becomes, thrust into shadow. The intensity of the reflections cast by the door and boat on the canal also vary from one impression to another, the most dramatic having the strongest reflections. The evening mist descends from above in vertical striations which at times look almost like rain.

Although Whistler did not experiment extensively with artistic printing methods in Venice, saving this until he could work under better physical conditions in London, he clearly conceived of the nocturnes prior to his departure. There has been much discussion over where he got the idea for manipulating weather effects and changing the time of day using plate tone. A variety of sources had a role to play.

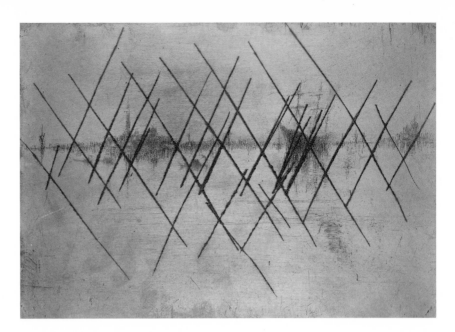

228. Whistler, *Nocturne*, K. 184, 1879–80. Copper plate, 20.1 × 29.5 cm. Metropolitan Museum of Art, Museum Accession.

The first and most important of these was Rembrandt himself, who experimented with the plate *Christ Crucified Between the Two Thieves* (pls. 68–9), changing the mood, time of day and weather effects by continuing to work on the plate and applying veils of ink over the etched matrix. It was Rembrandt's example that led to Delâtre's experiments, which the printer pursued vigorously after becoming assistant to R. J. Lane at the Victoria and Albert Museum in 1864.[41] He developed his art of "retroussage," as he called it, to the point where he used so much plate tone that it was referred to scathingly as his "sauce abondante"[42] or, because of its original association with Rembrandt, his "sauce hollandaise."[43]

With the spread of etching in the 1860s, artistic printing became epidemic, earning a bad name for itself and also the opposition of purists, including Haden, who had no desire to see his line work disguised by Delâtre's "mania for making all his proofs dark and heavy.[44] Young Frederick Goulding delighted in "treacly" impressions, as his etching *On The Seine near Elboef*, 1877 (pl. 239), reveals. The debate over the merits of *retroussage* divided the etching community into those who liked to exploit its *chiaroscuro* effects, and those who believed that etching should depend on line alone. This distinction soon turned into a crisis of principle: Haden, with Hamerton close at his heels, led the campaign against, and said that if Delâtre ever used plate tone on his works, it would be "the signal for his immediate dismissal.[45]

Delâtre pursued his experiments undaunted, and brought out two portfolios of modest drypoints in which he demonstrated the possibilities of *retroussage*. In *Souvenirs: Six pointes sèches* of 1871, he included a stormy landscape in which the plate was wiped clean at the horizon to create an effect of light in the midst of dark. He continued his explorations in *Six pointes-sèches* of 1873 which he dedicated to Edwin Edwards. In one plate, a landscape with reindeer, Delâtre used tone to create a night effect in the sky, heavier tone to suggest shadow on the land, and wiped the "moon" clean. In an etching entitled *La Nuit, C.* 1880 (pl. 240),

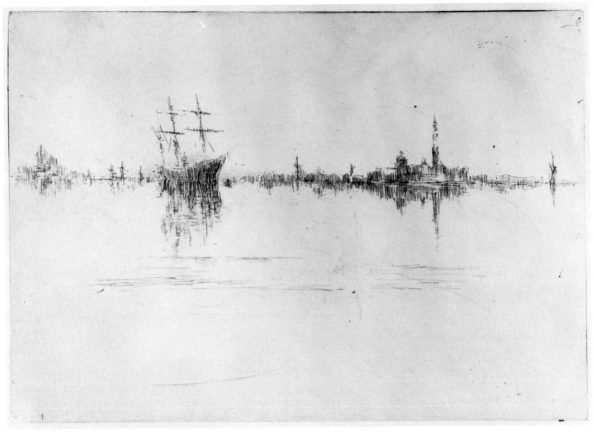

229. Whistler, *Nocturne*, K. 184, I/V, 1879–80. Trial proof, Etching and drypoint, 20.1 × 29.5 cm. Hunterian Art Gallery, University of Glasgow, Birnie Philip Bequest.

230. Whistler, *Nocturne*, K. 184, IV/V, 1879–80. Etching, 20.0 × 29.5 cm. Art Gallery of Ontario, Gift of Touche Ross, 1978.

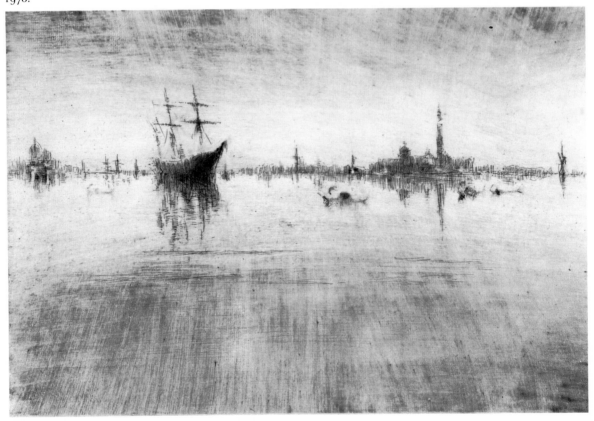

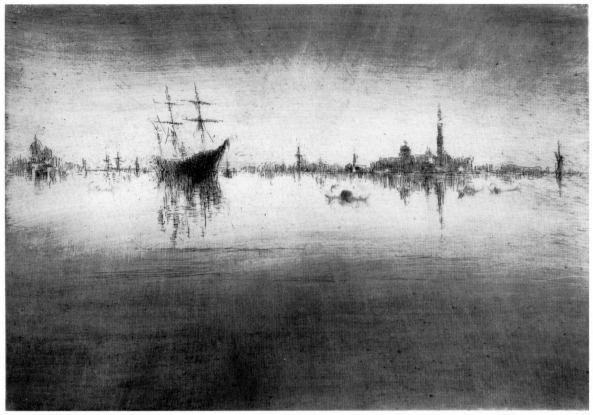

231. Whistler, *Nocturne*, K. 184, IV/V, 1879–80. Etching, 20.1 × 29.3 cm. National Gallery of Art, Washington, Lessing G. Rosenwald Collection.

232. Whistler, *Nocturne*, K. 184, IV/V, 1879–80. Etching, 20.1 × 29.3 cm. National Gallery of Art, Washington, Lessing G. Rosenwald Collection.

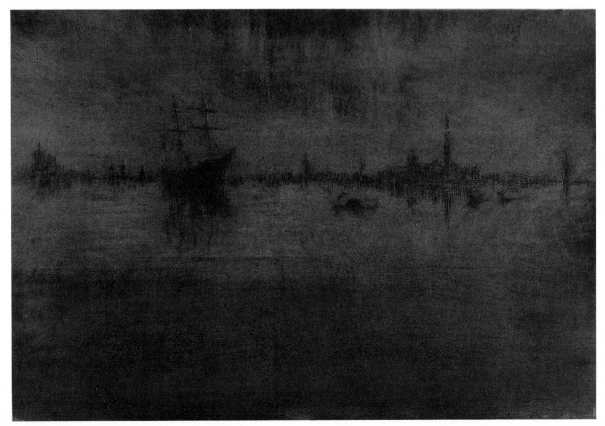

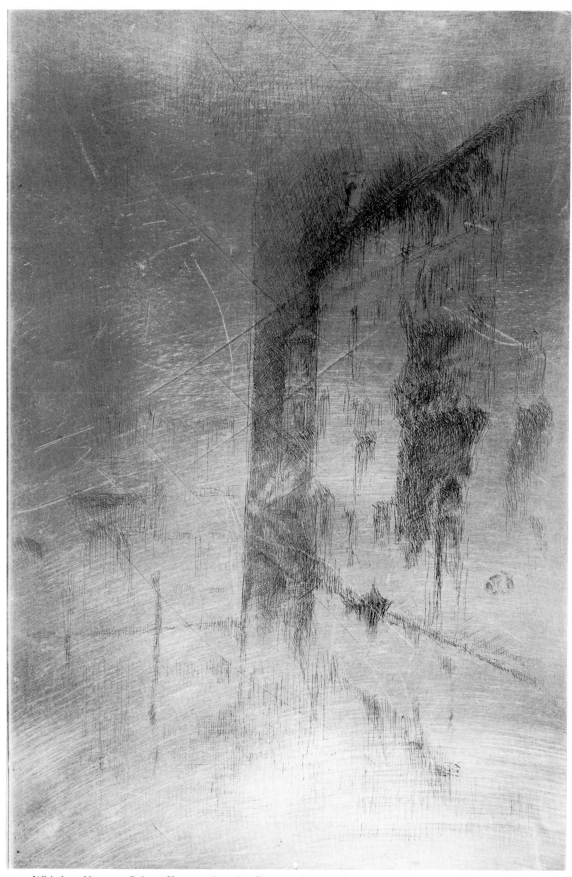

233. Whistler, *Nocturne: Palaces*, K. 202, 1879–80. Copper plate, 29.6 × 20.1 cm. Courtesy of the Art Institute of Chicago.

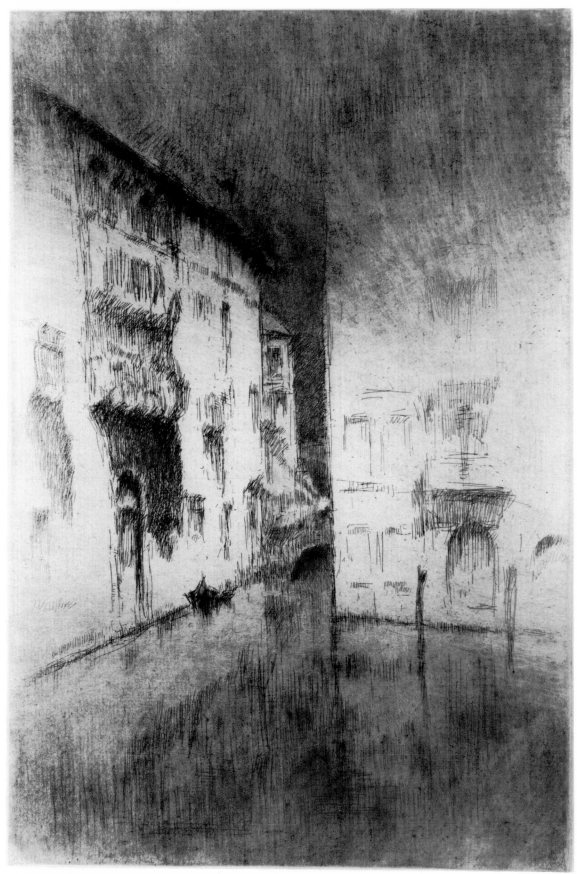

234. Whistler, *Nocturne: Palaces*, K. 202, VII/IX, 1879–80. Etching and drypoint, 29.6 × 20.1 cm. Art Gallery of Ontario, Gift of Arthur and Esther Gelber, 1982.

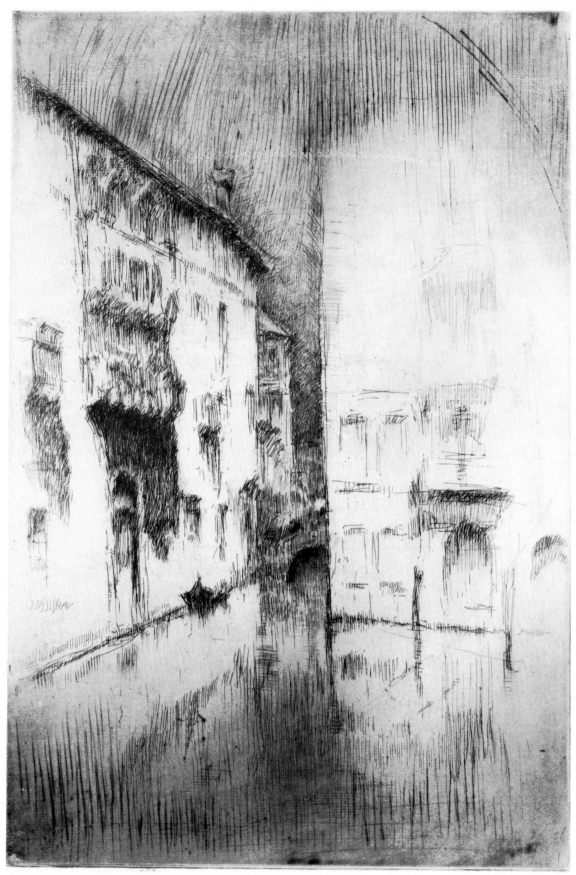

235. Whistler, *Nocturne: Palaces*, K. 202, II/IX 1879–80. Etching and drypoint, 29.6 × 20.1 cm. Metropolitan Museum of Art, Gift of Miss G. Louise Robinson, 1940.

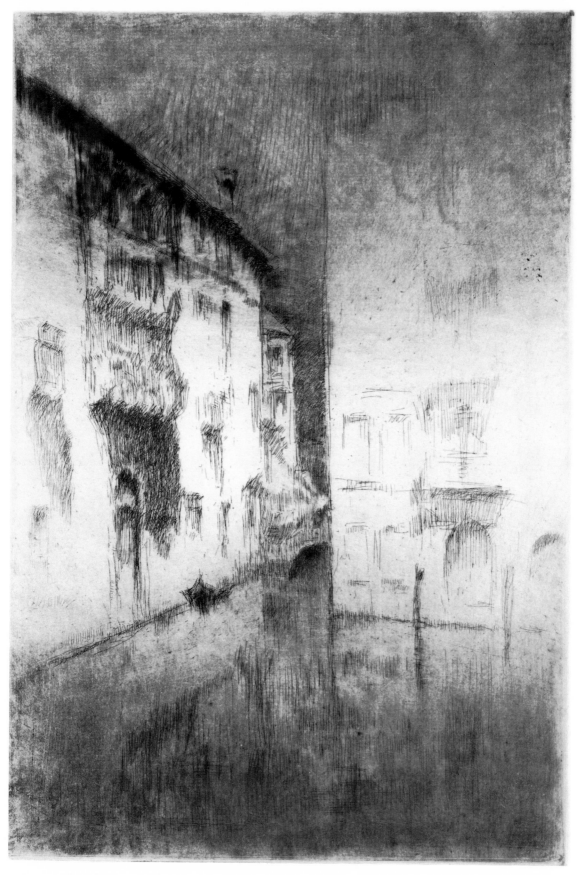

236. Whistler, *Nocturne: Palaces*, K. 202, VII/IX, 1879–80. Etching and drypoint, 29.6 × 20.1 cm. Metropolitan Museum of Art, Bequest of Susan Dwight Bliss, 1967.

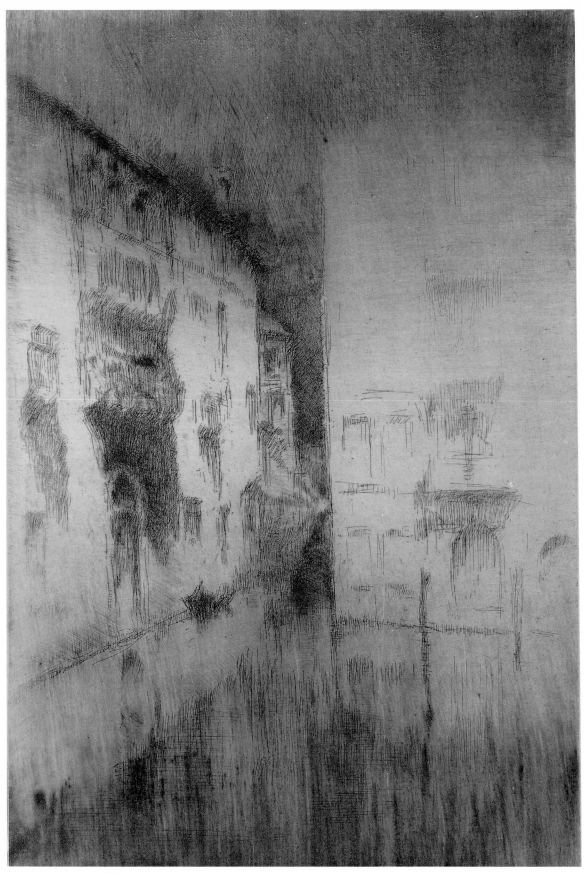

237. Whistler, *Nocturne: Palaces*, K.202, VIII/IX, 1879–80. Etching and drypoint, 29.6 × 20.1 cm. Metropolitan Museum of Art, Harris Brisbane Dick Fund, 1917.

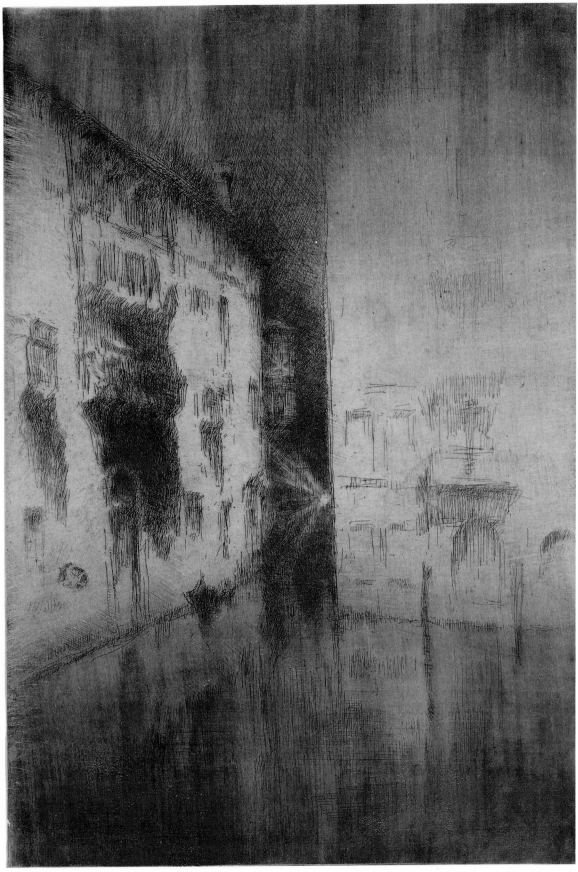

238.  Whistler, *Nocturne : Palaces*, K. 202, IX/IX, 1879–80. Etching and drypoint, 29.6 × 20.1 cm. Metropolitan Museum of Art, Gift of Harold K. Hochschild, 1940.

he used heavy films of black and brown ink to create nocturnal effects in the land and sky which were not unlike those used by Whistler in the Venice nocturnes.

Delâtre had a host of followers, the most inventive of whom was Vicomte Lodovic Napoléon Lepic (1839–89).[46] Lepic, who began to etch under the influence of the newly formed Société des Aquafortistes, experimented with a single etched matrix and plate tone to create as many variations as he possibly could, calling his process "mobile etching." His most astonishing experiment consisted of a sequence of eighty-five different manipulations of the etching *Vue des Bords de l'Escaut*, 1875 (pls. 241–242), in which he created "time after time from the same plate a daytime effect and a nighttime effect, a sunset, a moonrise, a full moon etc."[47] By painting on the plate with the ink he changed the time of day, the season, the focal point, and the perspective.

Whistler could hardly have admired this freakish work, but he may have heard of these experiments from Degas who was taught the monotype technique by Lepic in 1874.[48] "Mobile etching" was in itself a hybrid of the etching and monotype processes. For those who were interested, Lepic's experiments were described in great detail in his book *Comment je devins graver à l'eau-forte*, which was published by Cadart in 1876. If his artistry did not endow him with immortality, the novelty of his experiments would have ensured him of publicity in etching circles. Lucas, whom Whistler visited *en route* to Venice, acquired no fewer than nineteen of Lepic's manipulations.[49]

There was, however, a more immediate source of inspiration in Venice itself. Otto Bacher, with whom Whistler spent many an evening, amused his friends by making monotypes dubbed "Bachertypes." He recorded how "As a means of amusement we often painted a face or a landscape upon a plate with some pointed instrument of thumb, using burnt sienna or ivory black and a medium. This would be run through my press—hence the term Bachertype. One print only would be made."[50] Whistler was himself the subject of the "Bachertype" *Portrait of Whistler* made by Charles Corwin in 1880 (pl. 245). Bacher believed that Whistler "saw in their beauty the possibilities of their further use as a tonal form in the printing of etchings, for the Venetian etchings

which were printed at this time reveal a more definite use of this form in printing."[51]

A not dissimilar method of manipulation was used by Japanese print-makers, who were able to extract the most subtle gradations of tone in the printing of woodblocks. In Japan no press was used. A sheet of paper was simply laid face down over a series of wood blocks, one for each colour, and rubbed from the back with a pad or buren. By varying the pressure, a master printer could create a wide range of special effects, known as *betsu Zuri*, and "by omitting, adding, or substituting a few blocks, and by printing the blocks differently, with different colours," morning, afternoon, mist, evening and night effects could be produced."[52] Numerous examples of this may be found in the work of Hiroshige. In the British Museum there are two quite different impressions of *Yeitai Bridge and Tsukuda Island* from *One Hundred Views of Edo* (pls. 243–244), in which the printer created nocturnal effects of varying intensity by increasing or reducing the pressure on the block.

Whistler's interest in changing the time of day and capturing the

241 (above). Lepic, *Vue des bords de l'Escaut*, 1870–75. Etching, 34.3 × 74.4 cm. Reproduced by permission of the Maryland Museum of art.

242 (below). Lepic, *Vue des Bords de L'Escaut*, 1870–75. Etching, 34.3 × 74.4 cm. Reproduced by permission of the Maryland Museum of Art.

243. Hiroshige, *Yeitai Bridge and Tsukuda Island* from *One Hundred Views of Edo*, 1858–9. Ukiyo-e woodcut, 38.8 × 21.8 cm. Reproduced by permission of the Trustees of the British Museum.

244. Hiroshige, *Yeitai Bridge and Tsukuda Island* from *One Hundred Views of Edo*, 1858–9. Ukiyo-e woodcut, 38.8 × 21.8 cm. Reproduced by permission of the Trustees of the British Museum.

245. Corwin, *Portrait of Whistler*, 1880. Monotype, 22.4 × 15.4 cm. Metropolitan Museum of Art, the Elisha Whittelsey Collection, The Elisha Whittelsey Fund, 1960.

magic of the floating city, inevitably recalls the work of Joseph Mallord William Turner. Although his name does not appear in Whistler's letters or recorded conversations after the early 1860s, there can be little doubt that Whistler was thinking of Turner in Venice. His early love of Turner's painting appears to have resurfaced in the early 1870s along with his interest in capturing the poetry of nature and atmospheric effect. Venice had been a great spur to Turner's imagination, and Whistler would have known of the sublime views which he had made of the city in oil and watercolour. Among the great Venetian oils left to the nation in the Turner Bequest in 1856 were views of the city seen at different times of day, including *Venice, Evening, going to the Ball*, B. & J.416, 1845, *Morning, returning from the ball, St. Martino*, B. & J.417, 1845, and views of the city "floating" in the lagoon, such as *Venice,— Sunset, a Fisher*, B. & J.419, 1845, and *Venice with the Salute*, B. & J.502, *c.* 1840–5. The fluid way in which Whistler applied plate tone to give his etched nocturnes translucency recalls Turner's magnificent watercolour "notes" of Venice, especially the evening views of the entrance to the Grand Canal (pl. 246). What Turner said with watercolour, Whistler said with etching; Venice was never more poetically portrayed.

Whistler had begun to search for tonal effects in printmaking in 1878 when he first experimented with lithotint under the tutelage of T. R.

208

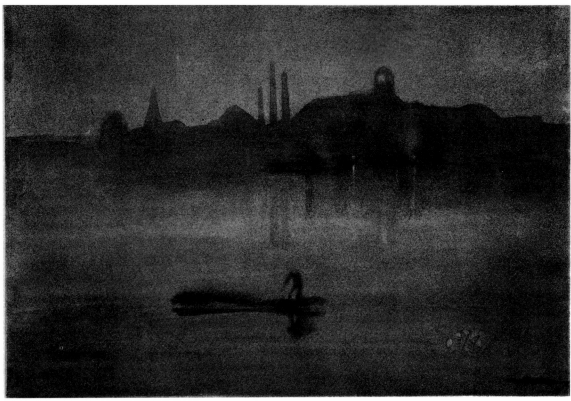

Way. By brushing thin washes of lithographic ink onto stone, Whistler was able to create morning and evening effects in *Nocturne: The River at Battersea*, W.5, 1876 (pl. 247), and *Early Morning*, W.7A, 1878. The soft atmospheric effects which the technique made possible closely resemble the effects achieved with plate tone in the Venice nocturnes.

The summer finally drew to a close, and the Duveneck boys left Whistler and Maud alone in Venice once again. Brown, under pressure from the directors of the Fine Art Society, wrote on October 1 saying that he was "utterly frustrated" not to have heard from Whistler, and that interest in the Venice etchings which had been promoted the previous year had all but died out. The directors were not only threatening to cut Whistler off financially, they were planning to seize his plates as security if he did not return at once.[53] Whistler wrote on October 25 asking Brown to keep the Board from seizing his plates for one month, at which time he promised to repay the £200 he owed them.[54]

Meanwhile Huish, who understood Whistler very well, sent him the money he needed out of his own pocket "since the Board are united against more aid," and added that unless he returned at once, he would not be represented in the forthcoming exhibition of the greatest living etchers. Huish pointed out that it "will be sadly incomplete if the head of the etching revival is not represented." Knowing of Whistler's rivalry with Haden, Huish could not resist adding "The medical profession are very much perturbed at the thought of your being represented by a set of new plates, while it will only be, by some old stagers."[55] Needless to say, Whistler, in a state of great excitement, made plans to leave as soon as possible. He wrote to his brother William saying that he intended to have "the centre of the whole thing for himself," and saw it as a "capital rentrée for me!"[56]

## 5. The "First Venice Set" and the Founding of the Painter–Etchers

Whistler arrived back in London in the second week of November, and went into hiding while proving the Venice plates and choosing the twelve etchings for inclusion in the "First Venice Set." He slipped into the city unnoticed, for as he had told the Doctor, "I don't want anybody to know until I am in full blaze."[1] He stayed first with the William Whistlers in Wimpole Street, then moved to lodgings at 76 Alderney Street in Pimlico. It is likely that he went first to prove his plates at Ridley's studio, for he had written to the Doctor to tell Ridley to have everything "in perfect working order—having oils for ink and boards for the primary proofs all nicely prepared for me for I shan't have a day to lose."[2]

He must have notified the Fine Art Society of his return, for they soon installed a press in a room above their galleries where he could print and they could keep an eye on him. But he found the space far from ideal, and the workshop was moved to the first floor of a house in Air Street with a bow window which looked out under the Regent Street colonnade.

The printing of the Venice etchings was a formidable task, but

Whistler refused to turn his plates over to a commercial printer. For the rest of his life he printed his plates with the help of studio assistants, and as Goulding observed, "put into the printing his own individuality as much as into all the other work he did. No two proofs were ever alike, nor do I expect he wished them to be."[3] The first of his assistants was T. R. Way, the printer who had taught him lithography in the late 1870s. Way recalled an exciting moment in Air Street when Whistler placed a bottle of nitric acid on a heater: "the stopper blew out, steaming acid fumes filled the room and they had to run for their lives into a bedroom where Whistler never seems to have slept."[4] On another occasion, corrosive sublimate was spilt on the floor; according to Way there was not much left of the carpet.

It was after Whistler's return from Venice, when his fortunes were at their lowest ebb and the public held him in greatest contempt, that enthusiasm for his work began to spread among young students in the art schools and studios.[5] The first to be drawn into his orbit was an Australian named Mortimer Menpes (1855–1938), a student of Poynter's at South Kensington Schools. Menpes met Whistler in November in the little room over the Fine Art Society and offered to help with the printing. His offer was accepted, and he became the first of Whistler's "followers." Menpes watched Whistler with great interest as he modified the plates, "adding drypoint and scraping . . . caressing the plates into form."[6] He described Whistler's methods of biting, inking and printing in his book *Whistler as I Knew Him*, which is a valuable source of information about this period.

Menpes was the first to witness one of the novelties which entered Whistler's etched work at this time: the trimming of the margin. There were several reasons for trimming, both aesthetic and practical. Although Whistler had never left a wide margin on the impressions which he had printed himself, he had never before eliminated the margin altogether in order to enhance the aesthetic merit of the work itself. He was probably influenced by the irrational way in which collectors prized the wide margin and were prepared to pay considerably more for a Rembrandt with a few extra millimetres, regardless of the quality of the impression. Moreover, most old master prints were trimmed and mounted into albums until the vogue for framing and hanging them began in the nineteenth century. Whistler was undoubtedly right to point to the senselessness of valuing a print for its margin and to maintain that the margin was an integral part of the work of art and as such should be kept in proportion to it.

His new aesthetic position was also influenced by practical considerations. Old paper was becoming increasingly rare and expensive, and Whistler was initially dependent on a supply which Goulding made available to him through the Fine Art Society for the printing of the exhibition proofs.[7] While "no price was too high" to pay for it, Whistler "did not waste it, cutting it near to the size of the plate."[8] Moreover, old paper was soft, and while Delâtre could handle it with impunity, Whistler would occasionally slice it along the plate line in the press. Pennell wrote:

In some matters of printing he was like all of us—who are not professional printers—not quite sure of himself, and at times, as this old

paper is often brittle or soft, the edge of the plate when going through the press, cut the paper in places right through. The edges then have to be trimmed, or the paper patched up, a vile practise which leaves marks.[9]

Making a virtue of necessity, Whistler trimmed the margins off of all his etchings after his return to London. According to Menpes, he

> took a long time to trim it, used no ruler, just a knife on a piece of glass. He followed the plate mark. "I use no ruler because I wish the knife to follow sympathetically the edge of the proof. Even the cutting of this paper, although you may not know it, is vibrated and full of colour".[10]

He left a projecting tab for his butterfly signature which was placed in such a way that it performed an active role in balancing the composition and extending it beyond the plate mark. This simple device transformed the etching into an *objet d'art* in its own right, not unlike a paper sculpture. The simple and elegant result had a distinctly oriental feel to it, and had to be "floated" in a mat showing the edges all around. The placement of the pencilled butterfly and the abbreviation "imp." to indicate that Whistler had printed it inaugurated the tradition of signing impressions by hand which became common practice by the end of the nineteenth century.

The Venice etchings were printed for the most part on eighteenth-century Dutch laid paper. Menpes was probably dispatched on paper hunts, for he recalled how in his years with Whistler he "ransacked the slums and alleys of Paris, Antwerp, Amsterdam, Brussels and London," generally finding a few sheets torn from old books, and occasionally being rewarded with a major find. He understood the characteristics which Whistler liked in old paper, and described them in the following passage:

> Proof-paper must be old; age alone can give the quality required for fine work. The real thing is recognizable, first by its colour—a beautiful indescribable tint of gold—and secondly by the odour left in it by the decay of the size used in its manufacture. The more completely the size has decayed the better the paper; but the size must have been there, just as sugar must have been in Chablis.[11]

This golden tone was intensified by the sheen which Whistler left on the surface. The late Hyatt Mayor wrote:

> William Ivins told me years ago that Whistler put the satiny sheen on his prints by heating the copper plate hot enough to calendar the damp paper. I seem to remember his telling me that he had been told this by a friend of Whistler's. As I remember, Whistler was very proud of this effect.[12]

The sheen gave the surface of the laid paper, a luxurious, silky finish, not unlike that of Japanese paper.

Once he had created a set of proofs, Whistler was in a position to

make the final selection for inclusion in the "First Venice Set." Although
he had begun this process in Venice, he continued to change his mind
right up until the time that the works were on the walls of the Fine
Art Society. Bacher recalled how "As Whistler progressed with his con-
tract, he would change an etching from the Fine Arts' Set, as he called
it, to his own replacing it with a more recent plate. Thus he continued
rearranging the two classes until his departure."[13]

The twelve etchings which were ultimately included were selected
with an eye to creating a balanced hanging in the Fine Art Society
gallery.[14] Nonetheless, the plates which were published under the title
*Venice, Whistler. Twelve Etchings*, represent a well-balanced selection of
the themes explored in Venice, and included a number of the finest
etchings made during 1879–80. They were:

1. *The Little Venice*, K.183
2. *The Two Doorways*, K.193
3. *The Beggars*, K.194
4. *Nocturne*, K.184
5. *The Doorway*, K.188
6. *The Riva*, K.192
7. *The Bridge*, K.204
8. *The Little Lagoon*, K.186
9. *The Palaces*, K. 187
10. *The Venetian Mast*, K.195
11. *The Traghetto*, K.190
12. *The Piazzetta*, K.189

At the end of November, Whistler came out of hiding, and made a
public visit to the Fine Art Society where the exhibition of the "greatest
living etchers" was already in progress, and Frederick Goulding was
giving printing demonstrations:

> Well, you know, I was just home, nobody had seen me and I drove
> in a hansom. Nobody expected me. In one hand I held my long cane;
> with the other, I led by a ribbon a beautiful little white Pomeranian
> dog—it too had turned up quite suddenly. As I walked in, I spoke
> to no one, but putting up my glass I looked at the prints on the walls:
> Dear me! Dear me! I said. Still the same old sad work! Dear me!
> And Haden was there talking hard to Brown and laying down the
> law, as he said Rembrandt, I said Ha! Ha! and he vanished.[15]

Whistler was incensed by Goulding's presence, and wrote to Huish to
say that he would not hang his etchings that night or the next morning
unless he received assurances that the two presses would be removed
and the engagement of Goulding cancelled for his private view: "Look
here my dear Huish, I have not taken all this trouble for you to order
that the people should 'be amused' by either any printing tricks or spun
glass or the Meerschaum pipe making in the place."[16]

Clearly Whistler's request was met, for he hung the etchings "on the
line" and rather high in the Middle Room of the Fine Art Society on
November 28 or 29. He later told the Pennells how

> when I was hanging my etchings, the consternation was great. On
> the ladder, I could hear whispers below me—no one would be able
> to see the etchings. Of course, I said, that's all right. In an exhibition
> of etchings, the etchings are the last things people come to see.[17]

But the public came and the critics came. For the most part they came

f. Seymour Haden

to mock at what one called "another crop of Mr. Whistler's little jokes." Reviewers took opposite sides in the debate. The majority agreed with the opinion that "this new manner of Mr. Whistler's is no improvement upon that which helped him to win his fame in this field of art," and pointed out that his etchings "used to be remarkable for the clearness, decision, and unerring precision of their drawing, as well as for the power which they displayed."[18] They felt that Whistler had "attempted to convey impressions by lines far too few for his purpose," and complained that the nocturnes did not depend wholly for their effect on etched line, but on the "processes of printing."[19] A very few agreed with the opposite position that the etchings constituted a "perfect balance of light and shade," and that the architectural features were "admirably designed, not with a laborious minuteness, but with a perfect understanding of their especial character."[20] Whistler saved all the news clippings carefully for future reference. Only eight sets of etchings sold, and the exhibition was a financial disaster.

This must have been a terrible disappointment to the artist, one which he hid behind his customary wall of bravado. He must have been touched by the note which Millais left for him at the Fine Art Society saying "I was so charmed by your Venice work that I cannot resist writing you a little note to say so. They gave me real pleasure."[21] In March he gaily wrote to Otto Bacher saying "you have no idea of the success of the etchings and pastels—but better still, you have no idea of their real beauty—especially the etchings—if you could see the lovely proofs I have pulled."[22]

Fortunately, the exhibition of Whistler's Venice pastels which opened on January 29 fared much better. But while it was being installed, Whistler was suddenly called to Hastings where his mother was dying. He spent a week there with his sister-in-law, Mrs. William Whistler, and there was

> a particularly melancholy afternoon, windy and wet, when they were up on the cliffs together, and Jimmie was taking himself to task for not having been kind and considerate enough—he had not written as often as he should from Venice—he fairly cried with remorse.[23]

Anna Mathilda Whistler, to whom he had always been a devoted, if not model, son, died on January 31.

It is difficult to say whether Whistler's subsequent erratic behaviour can be interpreted as a means of alleviating his grief.[24] The unsuspecting Seymour Haden, more capable than anyone of arousing Whistler's ire, became the target of his first attack. Haden was outraged by the fact that reproductive engravers could become full Royal Academicians, while etchers could not. Having resigned in frustration from the Etching Club in 1878, he decided to found his own Society of Painter–Etchers, in 1880. Modelled on the Société des Aquafortistes, with Goulding as its printer, it sought official recognition for the practice of etching as a branch of the fine arts. Haden maintained that

> it was because of the endless rejection of recognizing the importance of original etching over reproductive engraving by the R.A. that the

Royal Society was founded. When a vacancy occurred among the members [of the R.A.], it was supplied by the election of the copyist engraver, never by the original engraver; so that at last, worn out by the unequal struggle, we abandoned further effort and formed the present society.[25]

Whistler, while he must have been sympathetic to the cause, would have nothing to do with the Painter–Etchers, and resented the position which Haden assumed as the spokesman for etching in England. He campaigned vigorously to keep his friends from joining or from submitting work to the first annual exhibition which was due to open in April at the Hanover Gallery. He maintained that for his "followers" to belong to a Society "calling itself the Society of Painter–Etchers of which Whistler is not the head, is to occupy publicly a foolish and ridiculous position."[26] Among the Americans invited to submit work was Otto Bacher. Whistler wrote to him demanding unflinching loyalty, and saying "Don't dream of it my dear Bacher!—The Society of Painter Etchers is already ridiculous and I intend that it shall die the death of the absurd. So just wait a bit—and send nothing to this Seymour Haden game."[27]

On March 17 Whistler launched a "Storm in an Aesthetic Teapot." Haden, whose vision may already have begun to fail, and whose line was becoming thicker and heavier, apparently mistook etchings of Venice submitted by Frank Duveneck for those of Whistler. Not having heard of Duveneck, and suspecting that Whistler had adopted a *non de plume*, Haden, accompanied by Legros, paid a visit to the Fine Art Society on March 17 and demanded to see Whistler's Venice etchings. Whistler, who was under contract to the Fine Art Society not to publish any more etchings of Venice for a year, saw Haden's visit as casting aspersions on his integrity. Taking Menpes with him, he strode over to the Hanover Gallery on the evening of March 17 in search of Haden, who had fortunately left. The next day, Whistler demanded that Huish issue a written challenge to Haden. On March 21 Haden wrote to Huish saying that he had never intended to impute that Whistler was in breach of contract, and that he had not mistaken the work of Duveneck for that of Whistler.

Whistler was not about to let his prey off lightly. He put together *The Piker Papers* in which he included the exchange of letters between Huish and Haden and added a long diatribe in which he asked Haden rhetorically whether it was "officially, as the Painter–Etchers' President that you pry about the town?"[28] He drafted a letter to the Committee of the Painter–Etchers on May 10 hoping to embarrass the President, which only serves to reveal his deep-seated bitterness and jealousy of Haden:

> surely I may with indiscretion congratulate the President upon . . . the Pecksniffian whine about the "brother-in-law"—rather telling in its way—but shallow! shallow!—for after all, gentlemen, a brother-in-law is *not* a connection calling for sentiment in the abstract, rather an intruder than a "near relation"—"near relation" is mere swagger.[29]

Following his attack on Seymour Haden, for which the "Piker" incident

only provided a convenient excuse, Whistler staged a protest in the galleries of the Fine Art Society. On Saturday March 21, being short of money and not having received a cash advance for the pastels which were selling well, "just when the crowd was thickest, and everything was going beautifully," he marched into the gallery and said in a loud voice:"Well, the Show's over."

> Huish and Brown rushed up and tried to quiet me . . . But I said again, the Show's over: Ha! ha! they will not give me any money and the Show's over. Finally Huish promised to give me a cheque on Monday—I had asked for two hundred pounds; now I made it three hundred, and so I said, All right, the show can go on.[30]

That the directors kept their word is confirmed by a record in the minute book of the Society which indicates that a cheque for £300 was drawn for Whistler on March 23.[31] But the complexities of acting as Whistler's dealers appear to have worn down their formidable patience. On April 12 the minutes record a decision "to terminate his engagement with the Society at the end of three months . . . with the alternative of remaining until the close of the exhibition."

The printing of the Venice etchings was way behind schedule, despite the assistance provided by Mortimer Menpes and his wife Dorothy. In the spring of 1881 they invited Whistler to print at their house in Fulham and set up a printing room for him. Dorothy recalled how

> I saw that marvellous set of Venice etchings printed: in fact, the bulk of them were printed in my own printing-room, a room which I had especially arranged for the master, and it was in this little printing room of mine that Whistler taught me the art of printing from the copper plate.[32]

One day, when Whistler was having a bad day at the press, he asked Mortimer Menpes to print one of his "palaces." The result was so good that Menpes printed regularly for Whistler after that. Whistler chose to view his "follower" as an extension of himself, just as the Japanese printmaker viewed his apprentices, and said to him: "I have educated and trained you, and have created an atmosphere which enables you to carry out my intentions exactly as I myself should. You are but the medium translating the ideas of the Master."[33] With Menpes willing to print for him, Whistler was free to get on with new work and keep up his round of social engangements. This was a necessary adjunct to the art of self-promotion which was to absorb an increasing amount of his time and energy during the early 1880s.

However, the number of Venice etchings dispatched to the Fine Art Society during the spring and summer of 1881 was still far from adequate. Between March 1881 and February 1882 the directors cajoled and threatened Whistler to try to get him to complete the printing. In response, he maintained that his original agreement to print twenty sets gratuitously was only valid as long as the plates were to be published jointly;[34] since the Society had bought the plates outright, he now required £1 for each impression printed. This additional expense made it very difficult for the Society to make a profit on the

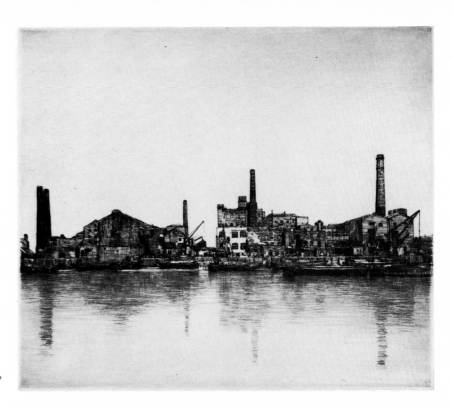

251. Menpes, *Warehouses by the Thames*, mid-1880s. Etching, 27.9 × 34.3 cm. Art Gallery of Ontario, Gift from the Canadian Imperial Bank of Commerce Fund, 1977.

sale of the etchings, and the directors seriously considered handing the plates over to a commercial printer.[35] Whistler said that they might approach Goulding to print "Nocturnes," "Doorways," "Beggars," and "Lagoons,"[36] and at least one plate was handed over. The result was far from satisfactory. Menpes recorded how

> On one occasion Whistler sent a plate to a professional printer, and was so disgusted with the result that he asked Menpes to destroy all the proofs. The plate had been wiped with a metallic hand, in a hard, sweeping movement, until the surface of the plate was cleansed mechanically. Then the ink had been dragged up to procure what the printer called a full rich proof—a proof that Whistler called gummy and treacly.[37]

Whistler subsequently rejected the idea of Goulding printing the Venice plates, on the grounds that he "wasn't running an aquarium or a music hall."[38] He told Huish that while the Fine Art Society had the right to decide, he would refuse to print ever again from any plate which was given to a commercial printer. An *entente cordiale* was finally effected: Huish, who readily admitted that the impressions which Whistler had printed recently were magnificent, decided to leave the plates in Whistler's hands for printing. Whether the impressions which he saw were printed by Whistler or Menpes may never be known. It is apparent from Menpes' etching *Warehouses by the Thames* (pl. 251) that Menpes was perfectly capable of simulating Whistlerian artistic effects.

Late in 1881, a young artist, Walter Richard Sickert (1860–1942), went to see Whistler at his studio at 13 Tite Street. Sickert had first

met Whistler at the time of the latter's bankruptcy in May 1879, and had since been studying etching under Alphonse Legros at the Slade. Whistler cautioned him saying "You've wasted your money, Walter; there's no use wasting your time too!".[39] With this Sickert abandoned the Slade and became a "follower." He was put to work assisting Menpes with the printing of the Venice etchings. Like Menpes, he sought to learn as much as he could of Whistler's method, and was observed by Menpes writing Whistler's "secret of drawing" on his shirt sleeve.

The "First Venice Set" was largely completed in 1891,[40] although Whistler was still finishing the job in 1901. The prospect of printing 1,200 proofs was daunting to the artist who had promoted the concept of the *belle épreuve*, seeing each impression as a rare, precious, and unique object. It was largely due to this that the art of etching gained a new position at the top of the hierarchy of graphic media during the 1880s and 1890s, one which Seymour Haden and his Society of Painter–Etchers could never have achieved by politics alone.

# CHAPTER FOUR

# *The Late Etchings,*
# *1881–1903*

## 1. The London Etchings of the 1880s and the Exhibition of 1883

After etching the Venetian *calli*, it was logical that Whistler should turn his attention to the streetscapes of "the only city in the world fit to live" upon his arrival back in London. His long-standing love of the city, and especially the Georgian buildings of Hogarth's day, led him to explore the visual possibilities posed by rows of shops and picturesque markets in run-down neighbourhoods. In their ability to capture the character and texture of the buildings, the London etchings of the 1880s recall Whistler's early "portraits of places" along the Thames; in their use of the open "impressionist" line and abstract compositional tendencies developed in Venice, they represent a major stylistic advance beyond his earlier portrayals of the city.

Whistler's interest in streetscape probably stemmed from the seventeen-century Dutch cityscape and the etchings of Hollar, Hogarth and Cruikshank. He had already begun to explore this theme in the painted nocturnes of the 1870s, *Nocturne: Grey and Gold—Chelsea Show*, Y.174, 1876, and *Nocturne: Black and Gold—Rag Shop, Chelsea*, Y.204, 1878. In these, visual interest was created by the abstract patterning of lit windows and doorways silhouetted against the dark mass of the buildings. During the 1880s, Whistler painted daytime streetscapes on a very small scale: among his exquisite panels, approximately 12 × 21 inches, are *Blue and Orange: Sweet Shop*, Y.263, 1884, and *Street in Old Chelsea*, Y.249, 1880–5.

It is possible that the Chelsea subjects which predominate among the London etchings were suggested to Whistler by his first "pupil," Walter Greaves (1846–1930). The son of a local boatman, Greaves was a neighbour of Whistler when the artist lived at 7 Lindsay Row in the 1860s and 1870s. He knew Chelsea intimately, and from the time of their first meeting in 1863 showed Whistler the "jumble of old inns, stables, wharves, warehouses and rickety houses"[1] which made up the

252. Greaves, *The Adam and Eve*.
Etching, 12.4 × 19.8 cm.
Reproduced by permission of the
Trustees of the British Museum.

area. Whistler taught Greaves to paint and etch, and sent him in search of subjects in the streets and along the waterfront of Chelsea. A number of Greaves's works bear close resemblance to those of Whistler, but either because they are undated, or because the dates were later altered by Greaves, it is difficult to say with certainty which came first. Greaves's etching *The Adam and Eve* (pl. 252) closely approximates Whistler's *The "Adam and Eve", Old Chelsea* K.175, 1879 (pl. 214), and it is quite possible that Greaves treated the subject first. It is executed in the naïve style to which he always reverted when left to his own devices. His etching of *Duke Street, Old Chelsea* (pl. 253) shows an intimate streetscape which anticipates Whistler's Chelsea views of the 1890s, while employing the more open line which Greaves used when under Whistler's direction. This work, which is variably dated from 1860 to 1873,[2] predates Whistler's streetscapes of the 1880s.

By comparison with the Venice etchings, Whistler's London plates seem excessively modest both in scale and in scope. They are each little vignettes, seldom more than 4–7 inches in size. It is possible that Whistler chose to work on this scale in defiance of the criticism levelled at the Venice plates by those who considered them "slight in execution and unimportant in size," although the scale is consistent with his interest in Rembrandt, whose etched work remains the touchstone for the late etchings. There was, however, a more practical consideration. For Whistler, etching and sketching had by this time become interchangeable. He carried around grounded copper plates and used them as a convenient surface for the jotting down of visual impressions as if they were sheets in a sketchbook. The maximum size of the plates was in large measure determined quite simply by the dimensions of his pocket.

In keeping with his renewed interest in Rembrandt's etchings, Whistler abandoned pure drypoint in favour of etching in his later work. He preferred the clean-wiped plate, and left only the slightest traces of ink in the foreground to suggest aerial perspective. In the tiny London plates with their calligraphic line and shorthand description of architecture and human form, Whistler made quintessential statements about design which give them a unique place among the late etchings. It is perhaps in these that Whistler's most characteristic etching style emerged and was distilled and codified. They inspired endless imitations by the "followers" and by those who mistakenly believed them easy to replicate. However, Whistler's understated late style proved to be remarkably elusive.

It is impossible, given the freshness, lightness and airiness of these plates, not to compare them to the etchings of the French Impressionists by which they were probably influenced. In 1890 Whistler referred to the style of his etchings of the post-Realist period as "inchoate" or "impressionist,"[3] and indeed his concern to capture atmospheric effect and the transient aspects of nature was akin to the Impressionist vision. He was never numbered among the Impressionists, although he was initially invited to exhibit with them. Mary Cassatt wrote to Pennell saying: "long ago M. Degas told me he had once written a very urgent letter to Whistler asking him to join a group of painters who were intending to exhibit together, the same group afterwards nicknamed impressionists, but Whistler never replied to the letter."[4]

While Whistler shared many of the same interests, he was involved

253. Greaves, *Duke Street, Old Chelsea*. Etching, 19.3 × 17.3 cm.
Reproduced by permission of the
Trustees of the British Museum.

with optical experiments of a different order which anticipate Post-Impressionism and follow an independent, though not entirely unrelated, course. During the 1880s he had several friends and admirers among the Impressionists including Pissarro and Monet.

The first of the London streetscapes were made within a few weeks of Whistler's return from Venice. *Alderney Street*, K.238, was probably made when he lived there in lodgings in November or December, 1880, while *Regent's Quadrant*, K.239, was made from the windows of the workshop on Air Street, looking out from under the Nash colonnade. These inaugurated the series of approximately sixty plates on which Whistler worked sporadically from 1880 to 1887, the majority of which appear to date from 1883 to 1885. It is not clear whether Whistler planned to publish them as a set, although he did see them as a coherent group.

The subjects which Whistler selected were intimate and picturesque slices of life. He would sometimes send the "followers" in search of appropriate sites before setting forth with his plate in his pocket and his folding canvas stool. He favoured shop fronts with facades embellished with awnings and signs and punctuated by windows and doors which were filled with bottled sweets or flanked by barrows of fruit and vegetables. The King's Road was rich in subject matter, as were the smaller streets adjacent to the main artery. Whistler made many of the plates from nature, and finished them in his studio the next day.

*The Fish Shop, Busy Chelsea*, K.264 (pl. 254), one of the more ambitious plates of this period, is a characteristic example of the streetscape composition. The view chosen was probably used first in the painting *Street in Old Chelsea*, Y.249, *c.* 1880/85 (pl. 255), where it also takes in Maunder's Fish Shop, one of Whistler's favourite Chelsea shops. The etching shows the composition in reverse and restricts the visual frame of reference horizontally to the three shops, including Maunder's, found left of the centre in the painting. The composition is also restricted vertically: buildings are terminated at the second floor level, and the proportion of road to picture space is reduced from one-half to one-third. Whistler adopted the frontal approach which he had first used in *Black Lion Wharf* in 1859 (pl. 112), and explored extensively in the Venice etchings. The row of buildings parallel to the picture plane occupies the middle ground, while the road, in place of the river or canal, occupies the foreground. The overall effect is one of two-dimensional patterning, and the ultimate aim of the work is to be found in the careful arrangement and balance of the compositional fragments. The facade, which remains essentially two-dimensional, is enlivened by the rhythm of doors and windows, and given a three-dimensional appearance through the inclusion of projecting awnings and bins, and receding doorways and passageways. These etchings demonstrate the successful application of the Whistler's Venetian synthesis of occidental and oriental influences to a London subject.

In addition to portraying the streets of Chelsea, Whistler looked farther afield. His wanderings took him to the East End, into Spitalfields and Houndsditch, the heart of the used clothing district. His interest in rags and ragpickers, which had begun with the realist etchings of 1858, resurfaced at this time. However, it was now inspired by the picturesque nature of the milieu rather than by the people who worked and lived there.

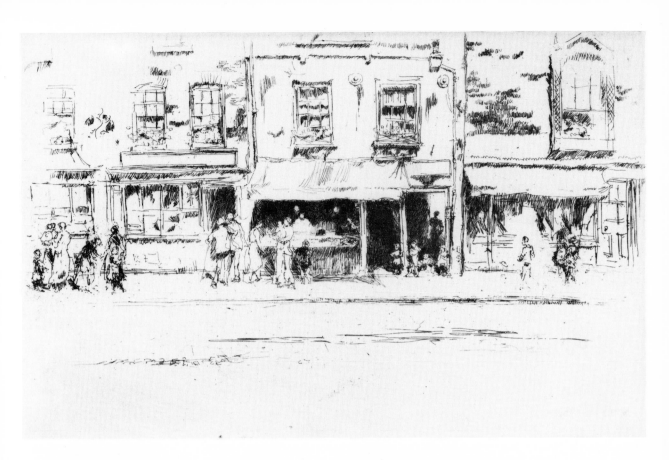

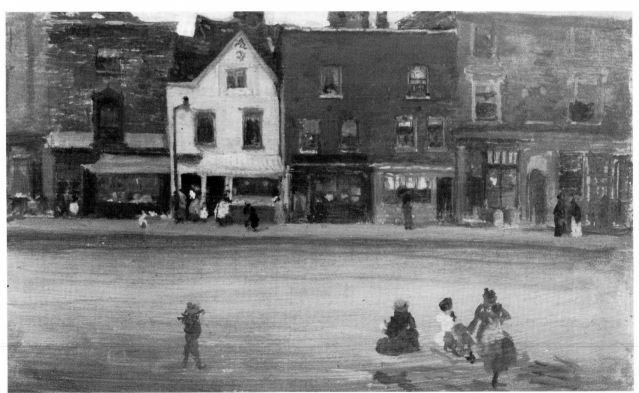

A number of etchings show the buildings in which old garments were bought and sold. *The Clothes Exchange 1*, K.287, and *The Clothes Exchange 2*, K.288, were probably made at Phil's Buildings on the north side of Houndsditch; here, between four and five o'clock each day, there was "small traffic and bustle where hundreds of dealers of cast-off clothing used to assemble after their morning rounds, picking up whatever they could hope to sell for shillings and for pence,"[5] *Fleur de Lys Passage*, K.289, shows the "Entrance to the Exhibition Clothes Exchange," located just south of the junction of Shoreditch High Street and Commercial Road.

The Petticoat Lane market, which was the major weekly event in the area, took place on Sunday in Middlesex Street. It was so rife with pickpockets that it was said that you "could lose your watch at one end of the lane and buy it back at the other end."[6] *Petticoat Lane*, K.285, and *Old Clothes Shop No. 2*, K.258 (pl. 256), were made in the vicinity. In these plates the overriding concern was for abstract compositional elements rather than subject. By focussing on a carefully selected fragment of a building and juggling the picturesque elements on the facade—doors, windows, and suspended rags—Whistler created balanced, asymmetrical compositions which were complete in themselves.

In addition to views of rural Chelsea and the East End, Whistler made charming *plein-air* studies of children in Gray's Inn Place which recall *En plein soleil* of 1858. In them Whistler showed children and their parents enjoying fresh air and sun in this charming precinct of the Inns of Court, perhaps on a quiet summer Sunday. The distribution of the children on the lawn, represented as a neutral ground in *Children : Gray's Inn*, K.301 (pl. 257), provided the artist with the elements for his compositional arrangements.

Whistler made a few related etchings on a trip to the country in 1886, probably on a visit to Sandwich.[7] The etching *The Village Sweet Shop*,

256. Whistler, *Old Clothes Shop, No. 2*, K. 258. Etching, 9.5 × 16.2 cm. Courtesy of the Art Institute of Chicago, Clarence Buckingham Collection.

257. Whistler, *Children, Gray's Inn*, K. 301, 1866–8. Etching, 17.8 × 12.7 cm. Courtesy Wiggin Collection, Boston Public Library.

K.251 (pl. 258), is similar in concept to the painting *An Orange Note: Sweet Shop*, Y.264, 1884 (pl. 259). In both painting and etching, doors and windows create a recession and provide visual interest while the building functions as an abstract ground. Sweets or fruit placed in windows add a decorative touch to the pictorial geometry of the etching, and a colour "note" to the painting. Whistler's developing interest in transparency and translucency was explored in the etching of sweets barely visible through the glass of the shop window. The disarming simplicity of these works, which reflect his current aesthetic of charm and daintiness, could not be successfully imitated. Walter Sickert made perhaps the most successful attempts in his etchings, *The Glovemaker Worcester*, 1884, and *Woman in a Doorway*, 1884 (pl. 260).

Whistler proposed to the Fine Art Society that it hold a second exhibition of Venice etchings to open on February 17, 1883, which would

227

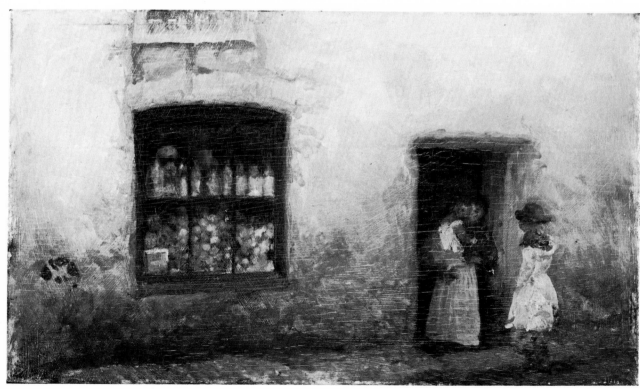

include a few of the London plates. Huish agreed on condition that Whistler show only those works which had not been previously exhibited. The fifty-one etchings to be included consisted of the balance of the Venice plates and a handful of the London ones.

To set the context and attract public attention, Whistler developed an ambitious scheme for "packaging" the exhibition. The gallery itself was to be transformed into a work of art entitled "Arrangement in Yellow." To this end it was decorated in white and yellow: the mouldings, skirting board, carpet, and fireplace were to be yellow; the walls were to be covered with white felt to a height of ten feet; and the etchings were to be hung in white frames. In addition, Whistler began making little yellow butterflies to give to his friends and supporters "to wear defiantly with the brave and beautiful on the great day."[8]

The *pièce de résistance* was to be the exhibition catalogue. This was a labour of love for which Whistler culled and manipulated carefully selected barbed quotes from his collection of press clippings, placing them under the titles of the works listed in the catalogue. His pleasant anticipation at arousing the ire of "the enemy" can be seen in this letter to Waldo Story of February 1, 1883:

> A servant in yellow livery! handing catalogues in brown paper cover same size as Ruskin pamphlet!!! And such a catalogue! ... all that I have collected of the silly drivel of the wise fools who write, and I pepper and salt it about the catalogue ... In short I put their nose to the grindstone and turn the wheel with a whir! ... The whole thing is a joy—and indeed, a masterpiece of mischief.[9]

The catalogue was handed out by a "yellow man" whose canary and white livery led him to be nicknamed "the poached egg." It was so popular that a third edition had been printed by the end of February. The notoriety attached to both colour scheme and catalogue attracted great crowds, including the Prince and Princess of Wales, who went around the gallery looking at everything, "the Prince chuckling at the catalogue."[10] The general response of the critics was to dismiss the exhibition as a huge joke, and to portray Whistler as the "artistic Barnum" Leyland had once accused him of being. But Whistler was elated. He wrote to Storey saying: "The Critics simply slaughtered and lying round in masses! The people divided into opposite bodies, for and against—but all violent!—and the Gallery full!—and above all the catalogue selling like mad! ... In short it is amazing."[11]

The cost to the Fine Art Society continued to escalate. When the day of reckoning finally came there was a great debate over who was responsible for the livery worn by the "yellow man." Whistler refused to pay for it, maintaining that it was part of the decoration. After this escapade there were no more spectacular exhibitions of Whistler etchings in London galleries. By artists, however, the exhibition was perceived quite differently. Camille Pissarro, writing from Paris to his son Lucien who lived in London, said:

> How I regret not to have seen the Whistler show. I would have liked to have been there as much for the fine drypoints as for the setting which for Whistler has so much importance; he is even a bit too

261. Roussel, *The Street, Chelsea Embankment*, 1888. Etching, 14.6 × 20.8 cm. Art Gallery of Ontario, Gift from the Canadian Imperial Bank of Commerce Fund, 1977.

pretentious for me, aside from this I should say that for the room white and yellow is a charming combination.

He strongly recommended that Lucien study Whistler's etchings and drypoints, saying

> Whistler makes drypoints mostly, and sometimes regular etchings, but the suppleness you find in them, the pithiness and delicacy which charm you derive from the inking which is done by Whistler himself; no professional printer could substitute for him, for inking is an art in itself and completes the etched line.[12]

While Whistler was working on the London etchings, Seymour Haden was vigorously pursuing his crusade on behalf of original etching. Encouraged by the New York dealer Frederick Keppel, he set off on a lecture tour of America in November 1882, and spoke in a number of cities including New York, Cincinnati, Boston, Milwaukee, and Philadelphia. His lectures generally ended up as harangues against reproductive engraving and created considerable animosity. According to at least one American contemporary:

> Dr. Haden's reception in this country was not of such a cordial character as to make him enamoured of the people on this side of the Atlantic, and since his return home to England he has made no attempt to conceal his disappointment at the results of his visit here and his disinclination ever to come again.[13]

Whistler must have been galled at the thought of Haden going to his own country of origin to make pronouncements on etching. He promised to undertake a lecture tour of America himself in 1884, no doubt

with the intention of undoing Haden, but in the end this never came about.

During the summer of 1883, a young American etcher who had heard Haden lecture in Philadelphia, and had seen some of Whistler's etchings in the collection of James L. Claghorn, President of the Pennsylvania Academy, called on Whistler in Chelsea. This was the beginning of a friendship with Joseph Pennell and his wife Elizabeth which was to last for the rest of Whistler's life. The Pennells became the most devout of the "followers," which no doubt preserved them from the conflagrations which were to consume his friendships with Menpes and Sickert at the end of the decade. They dedicated years to assembling information for a two-volume biography of Whistler which appeared after his death in 1908, and which remains a standard reference for his work.

Whistler derived a good deal of satisfaction from his "followers," who were complete with the advent in 1885 of Theodore Roussel (1847–1926). A French artist who had moved to England and settled in Chelsea, Roussel painted views of Chelsea which were similar to those of Whistler. After seeing some of them at Dowdeswells, Whistler sought an introduction. Roussel soon joined the charmed inner circle, and was so full of respect for the "master" that he always went bareheaded in his presence. When he began to etch seriously in 1888 it was to make small streetscapes such as *The Street, Chelsea Embankment* (pl. 261) in the manner of Whistler's London etchings. Like Whistler, he trimmed off the margin and left a small projecting tab for his pencilled signature. He claimed that anything he had done in etching he owed "absolutely" to Whistler.

Whistler's London etchings do not appear to have been well received by dealers or the collecting public. Mackay at Colnaghi's, having originally said that he wanted to handle them, ultimately declined Whistler's offer. Whistler sarcastically recorded the event in a conversation with the Pennells:

I took my London etchings to Colnaghi's, and they said they would consider the matter. I left the prints, and, after a little, not hearing, went to ask what they were going to do. We are sorry, but we find we cannot do anything, was the answer. They are not exactly the things for us. In fact, they are not dogs by Landseer. "Ha! ha! I see," said Whistler.[14]

He printed only a handful of impressions in 1887 some of which were handled by Dowdeswells. These etchings are consequently very rare indeed.

It was during the first half of the 1880s that Whistler tried to recover the ground he had lost prior to his trip to Venice. His new public image, that of *poseur* and jester, attracted a lot of attention, and he became the witty public figure for which he is remembered. The Tite Street studio was a second home to the "followers," and was frequented by Oscar Wilde and by Whistler's growing entourage. By 1885 he had "arrived" and was rapidly becoming known as one of the best artists of the day to the younger generation of art students, who looked to him increasingly for advice and guidance.

## 2. The "Second Venice Set" and the Jubilee Etchings

The "Second Venice Set" was not published under the *aegis* of the Fine Art Society, probably because of the antagonism which resulted from the exhibition of 1883, and the fact that Whistler had still not completed the printing of the "First Venice Set." The directors nonetheless commissioned him in 1884 to print an edition of fifty impressions of the third state of his early etching *The Kitchen*, K.24 (pl. 45), from the plate in their possession.

The revival of interest in the "French Set" plate may have arisen from the tonal printing of the Venice nocturnes. Looking at *The Kitchen* with Menpes in the mid 1880s, Whistler observed: "Well, well, well! Not bad, not bad! But I have learnt something since then, I think Menpes. At that time I struggled to get tone in my etchings in a laboured way."[1] The new edition was printed in black or dark brown ink using more plate tone to create painterly artistic effects. As in all the etchings made after his trip to Venice, Whistler trimmed the margins and left a projecting tab for his signature.

This interest in returning to and reinterpreting earlier plates using artistic printing techniques which had been developed while printing the Venice plates appears to have preoccupied Whistler in the 1880s and 1890s. It is difficult to be sure when individual impressions of earlier plates were printed, although the amount of plate tone used and the marginal trimming indicates a date after 1880. Although Whistler declared that he detested the fetish which surrounded the collecting of "states," he was to create a number of new states specifically for the market during the last two decades of his working life, as Rembrandt had reinterpreted *Christ Crucified Between the Two Thieves*.

It was to the firm of Dowdeswell and Dowdeswell that Whistler turned to arrange publication of the balance of the Venice plates. Being desperately in need of money, he offered to sell the plates for £600, and wrote to say "Times are bad—very—but then they make the moment for speculation for those who have the chance."[2] He magnanimously offered to let the firm keep whatever it could make beyond the £600, and offered to sell the proof impressions of the twenty-six plates for another £600. The plates were due to appear on April 1, 1886, under the title *A Set of Twenty-Six Etchings*. The prospectus advertised an edition of thirty sets and twelve additional impressions from fifteen plates. The works included were as follows:

| | |
|---|---|
| *Doorway and Vine*, K.196 | *Lobster Pots*, K.235 |
| *Wheelwright*, K.233 | *Riva, No. 2*, K.206 |
| *San Biagio*, K.197 | *Drury Lane*, K.237 |
| *Bead-Stringers*, K.198 | *The Balcony*, K.207 |
| *Turkeys*, K.199 | *Fishing Boat*, K.208 |
| *Fruit Stall*, K.200 | *Ponte del Piovan*, K.209 |
| *San Giorgio*, K.201 | *Garden*, K.210 |
| *Nocturne: Palaces*, K.202 | *The Rialto*, K.211 |
| *Long Lagoon*, K.203 | *Long Venice*, K.212 |
| *Temple*, K.234 | *Nocturne: Furnace*, K.213 |
| *The Bridge*, K.204 | *Quiet Canal*, K.214 |

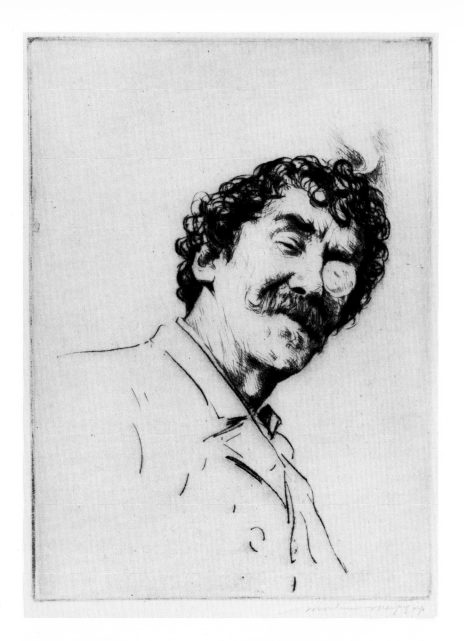

262. Menpes, *Portrait of Whistler with Monocle*, drypoint, 18.4 × 13.2 cm. The Reid Gallery, Guildford, Surrey.

*Upright Venice*, K.205      *La Salute : Dawn*, K.215
*Little Court*, K.236      *Lagoon : Noon*, K.216

Whistler clearly got behind schedule. On the eve of publication when he had undertaken to deliver three complete sets together with the sheet of "Propositions" which was described in the prospectus as "a short resumé of the principles held" by Whistler in etching, he wrote saying "I did not send the proofs today because I have not as yet signed them— indeed I don't well know how I can sign them all for tomorrow."[3] He maintained that he was hard at work on the Propositions, but said that they were being "revised," and promised that they would have them "tomorrow for the printer, or certainly the day after—"I am perfectly wild with work."[4]

233

By the mid 1880s, Whistler had taken to making public pronouncements of a theoretical nature, prompted by a need to defend himself against his critics and a desire to compete with Ruskin and Haden in the public forum. In 1879, while a selection of etchings from his collection was on view at the Burlington Fine Arts Club, Haden delivered a lecture and series of "Propositions" to the Royal Institution which was subsequently published in the *Magazine of Art*.[5] This may have inspired Whistler's "Propositions" of 1886, just as Haden's recent lecture tour of America probably gave rise to Whistler's selection of the lecture format for his *Ten O'Clock* in 1885. While in the lecture Whistler summarized his overall aesthetic approach to art and nature, he devoted the *Propositions* entirely to etching; as such they constitute his most important theoretical statement on the subject.

The origin of the *Propositions* may be found in the letter which Whistler wrote to Marcus Huish from Venice in January 1880, in which he defended himself against the rumour which Howell had been spreading around London that Whistler was engaged in making "huge plates" for the Fine Art Society. Whistler ended the letter with the sentence "But this is not a letter—I shall find myself in the midst of another pamphlet so by the way you had better carefully keep this—for who knows—I may borrow it for an extract."[6] In the "Propositions," he summarized the points raised in the following table:

I.    That in Art, it is criminal to go beyond the means used in its exercise.

II.   That the space to be covered should always be in proper relation to the means used for covering it.

III.  That in etching, the means used, or the instrument employed, being the finest possible point, the space to be covered should be small in proportion.

IV.   That all attempts to overstep the limits insisted upon by such proportion, are inartistic thoroughly, and tend to reveal the paucity of the means used, instead of concealing the same, as required by Art in its refinement.

V.    That the huge plate, therefore, is an offence—its undertaking an unbecoming display of determination and ignorance—its accomplishment a triumph of unthinking earnestness and uncontrolled energy—endowments of the "duffer".

VI.   That the custom of "Remarque" emanates from the amateur, and reflects his foolish facility beyond the border of his picture, thus testifying to his unscientific sense of its dignity.

VII.  That it is odious.

VIII. That, indeed, there should be no margin on the proof to receive such "Remarque".

IX.   That the habit of margin, again, dates from the outsider, and continues with the collector in his unreasoning connoisseurship—taking curious pleasure in the quantity of the paper.

X.    That the picture ending where the frame begins, and, in the case of the etching, the white mount, being inevitably, because of its colour, the frame, the picture thus extends itself irrelevantly through the margin to the mount.

XI.   That wit of this kind should leave six inches of raw canvas between the painting and its gold frame, to delight the purchaser with the quality of the cloth.

Whistler's *Propositions* dealt with a number of key questions: the scale appropriate to etching, the width of the margin, and the foibles of amateurs. These issues were set forth like Haden's in a series of pithy statements, and were numbered, like Ruskin's, using Roman numerals.

Whistler was acutely concerned during the 1880s about matters of proportion. Bacher had recorded how in Venice, "All the theory Whistler hinted at was delicacy of biting, and of drypoint. Delicacy seemed to him the keynote of everything, carrying more fully than anything else his use of the suggestion of tenderness, neatness and nicety."[7] Whistler strove to achieve his aesthetic of delicacy in part by using small plates and by abandoning the old two-ended etching needle in favour of dentist's tools which gave him the finest possible line. The majority of his contemporaries, including Haden and Legros, were engaged in making "oversize" plates for the market. In Whistler's letter to Huish, he attacked the "Monster Plate," with its "heads the size of soup plates—and landscapes like luncheon trays," and called to his defence "Poor meek Rembrandt!" who "with his mild miniatures—beside such colossal duds how dwarfed he becomes!"

Whistler took the opportunity in the *Propositions* of reaffirming his purist stance which resisted amateur innovation and technical cookery of all kinds. In addition to oversize plates and heavy linework, he disliked the contemporary craze for "remarques" or marginal sketches surrounding the etched composition. These were often removed as the plate was put through progressive states, giving impressions with remarques a special *cachet* with collectors. Whistler attributed the existence of this "aberration" to the amateur, seeing in it a lack of understanding of the importance of compositional integrity, and a love of novelty for its own sake. Bacher recorded how in Venice, Whistler held the *remarque* in contempt—never placing it on any of his work."[8]

The etchings did not sell well, and Dowdeswells were so worried about their investment that by July Whistler had offered to buy back the impressions still on their hands and make way for those who might do better business for them.[9] The market appears to have picked up in the second half of the year, for Dowdeswells complained in early 1887 that "the publication and distribution of [the sets] to subscribers has been unduly postponed by Mr. Whistler's fads."[10] Preoccupied with other matters, Whistler had still not delivered the thirty sets by the spring of 1887. Dowdeswells wrote an outraged letter to say that it was "perfectly preposterous that in nearly eleven months" he had not supplied them "especially at the rate agreed to pay him,"[11] and threatened to put the matter into the hands of a lawyer if the balance was not ready by March 23, 1887.

With the assistance of Menpes and Sickert, the impressions were finally printed. From January 15 to July 16, batches of impressions and cancelled plates were sent over to Dowdeswells, and careful track was kept of them in Whistler's ledger book.[12] It would appear that the thirty sets were printed together with twelve extra impressions of fifteen of the plates, and an additional 123 proofs, for on July 16, 1887,

Dowdeswells settled their account with Whistler "for printing one thousand and ninety-three proofs of Venice Second Series, at two and a half guineas per dozen, £238–17–6 less £50 for a total of £188–7–6."[13] This must have placed their business arrangements on a more agreeable and productive footing, for Dowdeswells were to continue to handle Whistler's etchings for another year.

———

Whistler's fame and notoriety peaked in the mid 1880s. In 1886 he was given his first official post by the Society of British Artists. The exhibiting Society, which had been formed to break the monopoly of the Royal Academy, dated back to the beginning of the nineteenth century. By the mid 1880s its fortunes had fallen to their lowest ebb; uncertain of a future competing with newly formed groups, it sought a desperate remedy. Noting the enthusiastic following which Whistler was attracting among young and rising artists, the members felt that he might be able to drag them from the pit of obscurity into which they were afraid of sinking. On June 1, 1886, they elected Whistler President.

As might be imagined, the Society was divided from the start into factions for and against. Opposition grew when Whistler's policy of thinning out Society exhibitions through "the virtue of rejection" left the lesser lights without representation. Whistler refused to allow the kind of overcrowded exhibitions in which paintings were hung above and below "the line" to continue, maintaining that the walls were there to provide a foil to good pictures well spaced and well arranged along the line. The members objected, and held a meeting in which they proposed that "the experiment of hanging pictures in an isolated manner be discontinued," and that in future enough works be accepted to cover the vacant space as before.[14]

The controversy over Whistler's autocratic administration came to a head over the question of an appropriate address to mark Queen Victoria's Jubilee in 1887. Without consulting the members, Whistler decided to prepare an address himself. He described it as follows:

I prepared a most wonderful address. Instead of the illuminated performances for such occasions, I took a dozen folio sheets of my old Dutch etching paper. I had them bound by Zaehnsdorf. First, came the beautiful binding in yellow morocco and the inscription to Her Majesty, every word just in the right place,—most wonderful. You opened it, and on the first page you found a beautiful little drawing of the royal arms that I had made myself; the second page, with an etching of Windsor, as though—"theres's where you live!" On the third page, the address began. I made decorations all round the text in water-colour, at the top the towers of Windsor, down one side a great battleship plunging through the waves, and below, the sun that never sets on the British Empire,—What?—The following pages were not decorated, just the most wonderful address, explaining the age and dignity of the Society, its devotion to Her Glorious, Gracious Majesty, and suggesting the honour it would be if this could be recognised by a title that would show the Society to belong specially

263. Whistler, *Wild West, Buffalo Bill*, K. 313, 1887. Etching, 7.9 × 18.4 cm. Metropolitan Museum of Art, Collection of Paul Walter. Photograph courtesy of the Metropolitan Museum of Art.

to Her. Then, the last page; you turned and there was a little etching of my house at Chelsea—"And now, here's where I live!" And then you closed it, and at the back of the cover was the butterfly.[15]

The address was sent to Her Majesty on June 20, and not a word was said to the Society. When the question was raised in a meeting about preparing an appropriate address to send to the Queen, Whistler proudly revealed that he had already submitted an address on the members' behalf, and that in return, the Queen had commanded that the Society should henceforth be called "Royal." Although, according to Whistler, "they jumped up and rushed toward me with outstretched hands," he waved them all off, and "continued with the ceremonial to which they objected."[16] Needless to say, this *modus operandi* did not endear him to the majority.

In addition to the etchings of *Windsor (Memorial)*, K.329 and *Chelsea (Memorial)*, K.331 made for inclusion in the Jubilee address, Whistler made a number of etchings to mark Jubilee year, these included three plates, *Wild West, Buffalo Bill*, K.313 (pl.263), *Wild West*, K.314, and *The Bucking Horse*, K.315, made at Earl's Court while Buffalo Bill's Wild West Show was in progress, the only etchings Whistler ever made on an American theme. As President of the R.S.B.A., Whistler was invited to the Jubilee ceremonies in Westminster Abbey. He took a grounded copper plate with him and sat on one side of the triforium etching *Abbey Jubilee*, K.316.

But it was during the Naval Review off Spithead on July 27, which he also attended in an official capacity, that Whistler produced the most important group of plates made to celebrate the Jubilee. The *Naval Review Series* consisted of twelve small plates, most of them made from a moving boat. They were begun on July 27, and finished the following day.[17] The Series consisted of the following:

264. Whistler, *Bunting*, K. 324, 1887. Etching, 17.5 × 12.4 cm. Courtesy of the Print Department, Boston Public Library.

These sprightly little plates capture the mood of the day and the feeling of wind and weather with seeming ease: the snapping of the pennants on the stay in *Bunting*, K.324, is almost audible. They are full of air and light, expressed in the open calligraphic line which Whistler now used with the greatest economy, and which only suggested, never fully stated, his selected impressions of nature. The compositions hang delicately and convincingly between two and three dimensions.

The plates represent what Edward G. Kennedy was to call Whistler's "official style." No doubt made with presentation in mind, Whistler wrote to the Rt. Hon. Smith, First Lord of the Treasury on December 1, 1887, saying

> I have accordingly embodied my impressions and observations, on that memorable day, in a set of etchings, notes as I might say of the needle, not the pen, taken at the moment, and from point to point of that imperial, but pacific, and more than Roman, triumph.[18]

In the *Naval Review Series*, Whistler followed to the letter the principles outlined in his Propositions. The largest plate measured $5\frac{3}{16} \times 8\frac{3}{4}$ inches, and the needle used was very fine and wielded sparingly. The phrase "notes of the needle" very aptly describes the etchings of the first half of the 1880s, which never sought to rival the Venetian plates in scale, and are generally regarded as quiet footnotes in Whistler's etching career.

The proofs were printed in black ink on old laid paper with a little residual plate tone to create a sense of aerial perspective. Proofs of the etchings produced in Jubilee year were sent to Dowdeswells in August and September only a few weeks after they were etched. The total number of impressions appears to have been very small.

These are the last etchings Whistler ever made in England. In 1888, as a result of his growing unpopularity, he was forced to resign from the Presidency of the Society of British Artists. His brother-in-law, meanwhile, continued to hold forth as President of the Society of Painter–Etchers, now designated "Royal." In an attempt to cheer Whistler up, Edward G. Kennedy described a visit in Jubilee Year to Haden, that "infernal old toady to rank," who on the way to the station near his country house in Hampshire would "wave his hand and smile in a paternal way, as the little rustics used to bob curtseys as we passed in his Victoria."[19]

Whistler's ability to tolerate Haden and the foibles of the "Islanders" diminished as his fame and recognition grew on the Continent. He began to think seriously of giving up his antagonistic position and of moving to Paris. During the latter half of the 1880s he spent more and more time in France and the Low Countries.

## 3. Etchings of Brussels, Touraine and Amsterdam

Whistler's peregrinations were so frequent in the late 1880s that it is difficult to keep track of the many trips which he made across the Channel to France and the Low Countries. On trips to Brussels in 1887, Touraine in 1888, and Amsterdam in 1889, he carried prepared copper plates with the intention of making etchings for the marketplace.

While there is every reason to believe that he was motivated in part by financial gain, being well aware of public interest in tourist views; as in Paris, London and Venice, Whistler rarely included recognizable landmarks. Although he had left the realist aesthetic far behind, he preferred to take his subject matter from the poorer areas seldom penetrated

by tourists. These areas, which tended to be older and relatively unchanged, had in common their picturesque state of dilapidation and consequent richness of texture. He was certainly not drawn there by affection for the lower orders of society, toward whom he could be peremptory and even vicious.

In the autumn of 1887, Whistler went to Holland and Belgium with Dr. and Mrs. William Whistler, stopping at Ostend, Calais and Bruges on the way. He made nineteen etchings on this trip, thirteen of them in Brussels. The majority of the plates were etched in the Quartier des Marolles, which extended from the Palais de Justice on the north, to the Place de la Chapelle on the west, and the Porte de Hall on the east. This area was described at the turn of the century as "unchanged in its general characteristics, dialect and customs," despite the fact that its main streets, the rue Haute and rue Blaes, were busy thoroughfares leading from one part of the city to the other. The Marollian dialect, a "horrible jumble of the refuse and dregs of the French and Flemish languages," and the Marollian type were clearly distinct. The girls were "thick-set, broad-featured, and rough-mannered, with greasy locks plastered on their temples or covering their foreheads with a bushy 'fringe'," while the boys were characterized by the "pallid unhealthy 'Hooligan' with insults and oaths ever on the tip of his tongue, always ready for rough play and worse." While these types were considered the lowest echelon of the Marollian social order, there was also a superior class which carried on its "daily avocations in small and close-smelling, antiquated shops" of a kind which had an irresistible appeal to Whistler.[1]

For the most part he stationed himself in the little alleys which ran north off the rue Haute, and fended off the local inhabitants with his etching needle. Octave Maus wrote:

He was frequently to be met in the alleys which pour a squalid populace onto the old High Street, engaged in scratching on the copper his impressions of the swarming life around him. When the inquisitive throng pressed him too hard, the artist merely pointed his graver at the arm, or neck, or cheek of one of the intruders. The threatening weapon, with his sharp spiteful laugh, put them at once to flight.[2]

Whistler did not dwell on the inhabitants, who only appear as staffage, but on the picturesque streets of small shops, continuing the same theme begun in London. Whistler approached his subjects with the frontality which had characterized the London streetscapes.

He also worked in the tourist centre of Brussels, the Grand'Place, which was surrounded by seventeenth-century Guild Houses of monumental proportions. The etching *Grand'Place, Brussels*, K.362 (pl. 266), shows the central portion of the Hotel des Ducs de Brabant, designed by Guillaume de Bruyn. The vertical slice of a facade in the etching *Palaces, Brussels*, K.361 (pl. 267), is probably taken from one of the many handsome buildings in the Place des Palais.

In the Brussels etchings, Whistler continued to develop new variations on old themes, some of which took his work farther along the road toward abstraction. While the Marollian streetscapes recall the London

shopfronts of the 1880s, and *Archway, Brussels*, K.366, the Venetian *San Biagio*, K.197; the *Grand'Place, Brussels*, K.362, and *Palaces, Brussels*, K.361, go far beyond their antecedents. Whistler's interest in the arrangement of architectural ornament on the facade began in Venice, where it may be seen to advantage in *The Balcony* K.207 (pl. 220). But it was in 1887–9 that he began to look to ornament as the starting point for compositions which became increasingly abstract.

In *Grand'Place, Brussels*, K.362 and *Palaces, Brussels*, K.361, Whistler was concerned primarily with the play of light and shade over the surface of the buildings, and not with their monumentality. As in Venice, he set out to distill the essence of form dissolved in light. Employing his "secret of drawing," he worked from the centre of the composition toward the periphery, allowing the edges to fall away. By drawing only the "bones, the skeleton, of the architecture,"[3] the buildings were reduced to linear essentials. The insubstantial and delicate images hang like cobwebs in the air, with no real solidity. In their linear daintiness they appear to be trapped between two and three dimensions. The abstract tendencies found in these plates find a logical sequel in the Cubist drypoints of Georges Braque.

Whistler was delighted with these etchings, and wrote to tell Waldo Storey that he had "discovered" Brussels as he had London and the Thames, and that he preferred his recent work to the *Naval Review Series*.[4] It was no doubt his intention to create a market by broadcasting his pleasure in his new work. Whistler's relationship with the Fine Art Society had continued to deteriorate during the autumn of 1887, following a quarrel over the "unauthorized" sale of etchings on consignment, an incident dubbed "the purloined portfolio." Perhaps for this reason, the Brussels etchings were handled by Dowdeswells, to whom Whistler supplied proofs in February 1888.

The demand for Whistler's etchings increased significantly in both Europe and America during the late 1880s. The dealer Edward G. Kennedy wrote in February from Wunderlich's in New York requesting impressions of recent etchings, including those of Buffalo Bill's Wild West Show.[5] During the same month, Whistler showed etchings of the East End of London with the Société des XX in Brussels; in May he showed etchings with Durand-Ruel in Paris; and in June he showed a Brussels etching with the New English Art Club. All this activity stimulated his interest in the medium, and led to the planning of yet another series of views on the Continent.

———

On August 11, 1888, he married Beatrice Godwin, the wealthy widow of E. W. Godwin, who had died two years earlier. The marriage was arranged in great haste. Whistler moved from the "Vale" to the Tower House in Tite Street while Maud was away in Paris. There, with a few friends, sitting amid packing cases, the Whistlers ate the wedding breakfast sent from the Café Royale and the wedding cake from Bruszard's. This event marked the beginning of the happiest phase of Whistler's adult life. His wife, herself a capable artist and amateur etcher, was sympathetic and understanding.

Following the wedding the Whistlers set off on a honeymoon to the

265. Braque, *Pale Ale*, E. 7, 1911. Etching and drypoint, 45.0 × 32.4 cm. Art Gallery of Ontario.

266. Whistler, *Grand'Place, Brussels*, K. 362, 1887. Etching, 21.9 × 13.9 cm. University of Michigan Museum of Art. Bequest of Margaret Watson Parker, through Dr. Walter C. Parker.

267. Whistler, *Palaces, Brussels*, K. 361, 1887. Etching, 21.9 × 13.9 cm. Courtesy of the Print Department, Boston Public Library.

268. Whistler, *Chateau, Verneuil*, K. 380, 1888. Etching, 17.8 × 12.7 cm. Metropolitan Museum of Art, Harris Brisbane Dick Fund, 1917.

chateaux of the Loire and the towns of Touraine. Their itinerary included Vovés (southeast of Chartres), Bourges, Blois, Tours, Amboise, Loches, Bridoré and Verneuil-sur-Indre. Whistler took with him thirty-four grounded copper plates which he used like sheets in a notebook, sketching picturesque vignettes which took his fancy along the way. The largest group of etchings made in any one place was the series of eleven at Loches; he also made six at Tours, five at Bourges, and one or two at each of the other places visited. He once again assiduously avoided tourist views which were well known from travel literature by the 1880s.

Although Whistler's etchings are not unrelated to the nineteenth-century tradition of regional views, he had no desire to contribute to the process of documentation begun by Baron Taylor in *Voyages pittoresques et romantiques dans l'ancien France*, which had started publication

in 1820 and continued until 1878. Whistler's interest in the area appears to have been based on its architectural heritage, for he described this series as his "Renaissance lot." While a logical outgrowth of his enthusiasm for the early Italian Renaissance architecture of Venice, Whistler's interest in French Renaissance architecture coincided with a rash of scholarly interest in the mid 1880s.[6] He approached Touraine in much the same way as he had approached Venice and Brussels, seeking to capture the essence of its architectural forms. He sought once again, to show the whole by means of the part, and by selecting doors, windows, and mouldings as subjects, demonstrated the belief expressed in the "Ten O'Clock" lecture that "the artist is born to pick and choose, and group with science, these elements, that the result may be beautiful."[7]

There were just enough recognizable landmarks in the plates of Touraine to provide local colour and cater to the taste for etched views. Although Whistler tended to turn his back on the chateaux themselves, perhaps because they would have looked particularly odd etched in reverse, he did etch a turret of du Cerceau's *Château Verneuil*, K.380 (pl. 268), and a diminutive view of *Château, Amboise*, K.393, in which the sinister fortress was given the appearance of a fairy-tale castle. However, *From Agnes Sorel's Walk*, K.385, shows a view of the town of Loches seen from the grounds of the chateau where the beautiful mistress of Charles VII had lived and died. Civic monuments fared rather better: Whistler included Renaissance landmarks well known to tourists in the plates *Tour St. Antoine, Loches*, K.392, *Hotel de Ville, Loches*, K.384, and *Clock Tower, Amboise*, K.394. In all of these the image appears in reverse, although towers tend to be symmetrical which helps to disguise the fact.

269. Whistler, *Hangman's House, Tours*, K. 376, 1888. Etching, 13.5 × 9.8 cm. Reproduced by permission of the Trustees of the British Museum.

270. Whistler, *Renaissance Window, Loches*, K. 390, 1888. Etching, 17.8 × 12.8 cm. Courtesy of The Art Institute of Chicago, Bryan Lathrop Collection.

271. Hotel Croix Blanche at Tours. Picture Division, Metropolitan Toronto Public Library.

For the most part the "Renaissance" series consisted of vertical segments of buildings and sections of architectural ornament. French Renaissance architecture is characterized by flat volumetric surfaces embellished with ornament localized in the vicinity of doorways and windows, gables and turrets. Whistler's poor eyesight may help to account for his preference for detail located on the first two storeys. He was interested in such "notes" in the composition of the facade as the flamboyant doorway in *Hangman's House, Tours*, K.376 (pl. 269), and the window surround in *Window, Bourges*, K.400; he was also interested in the "arrangement" or sequence of these details, both vertical, as in *Renaissance Window, Loches*, K.390 (pl. 270), and horizontal, as in *Hôtel Lallemont, Bourges*, K.399. He would delimit the visual frame of

246

272. Whistler, *Hotel Croix Blanche, Tours*, K. 373, 1888. Etching, 17.8 × 12.4 cm. Courtesy of the Freer Gallery of Art, Smithsonian Institution, Washington, D.C.

reference and select from the facade only those details which interested him, creating from architectural fragments a composition complete in itself.

He occasionally omitted or moved details found in nature to suit the needs of his composition. This may be seen by comparing a contemporary photograph of the Hotel de la Croix-Blanche at Tours (pl. 271), with the etching *Hotel Croix-Blanche, Tours*, K.373 (pl. 272). Here Whistler chose to ignore the dramatic turrets and gables of the roofline, and concentrate instead on the more accessible and intimate details of the doors and windows in the first and second storey at the base of the tower. He was for the most part faithful to nature, but he did eliminate a window which can be seen in the photograph on the upper left, and

he moved the projecting lantern down a few feet. While the photographer set out to document the entire facade, Whistler set out to create an "arrangement" from a critical mass of selected detail.

By comparison with the work which was to follow, the etchings made in Touraine are "linear" rather than "painterly," and depend for effect on the "bones" of the buildings, rather than on dramatic chiaroscuro effects. This may have something to do with the quality of light in the region, which is blond, flat, and even, and which does not tend to cast dramatic shadows.[8]

Whistler was pleased with these plates and began to promote them in England through Charles Hanson—his illegitimate son by Louise Hanson, a model and parlour-maid. Hanson acted as Whistler's secretary from the summer of 1888 until the early 1890s. Whistler wrote to Hanson from Loches and asked him not to reveal his whereabouts, saying, "I don't want the people to know that I am here. I also don't want their attention drawn to any one place, so you might say that I had been travelling about making visits in the neighbourhood of Paris and Bordeaux".[9] From Tours, he sent Hanson a few paragraphs for insertion in the *Pall Mall Gazette*:

> Mr. Whistler, we hear, has in his journeying to France, not been idle—He brings back with him some fifty new etchings of the finest quality. Those who have seen them in Paris say that the elegancies of French Renaissance have never been so exquisitely rendered as in these fairy-like plates.[10]

Like the Brussels plates, the Renaissance etchings were never published as a set, and only a few impressions appear to have been pulled. Whistler printed them on the press which had been moved in June from the Vale to a little room on the top floor of the Tower House in Tite Street where it was placed "as snug as possible in the corner by the fireplace."[11] The first impressions were sent to the Fine Art Society on March 27, 1889. The views of Loches appear to have been the most popular, for Whistler sent over additional impressions on May 21.[12]

During the summer, a group of Whistler's etchings were displayed in the British section of the Exposition Universelle in Paris. He had initially submitted twenty-seven to the American section, but when only seventeen were accepted he withdrew his etchings in a fit of pique, and sent them to the British section instead. There, much to his annoyance, he was allowed to hang only nine, and was forced to compete in the same lists with Haden. The final blow came when the Grand Prix was awarded to Haden.

Whistler had made several etchings in Holland on a trip in 1884, when he etched *Dordrecht*, K.242, *Little Dordrecht*, K.243, and *Boats, Dordrecht*, K.244. He had also visited Amsterdam, where he made *The Little Wheelwrights*, K.245. With its feeling of light and wind, its boats in the foreground and cityscape in the background, *Dordrecht* recalls the etching *Amsterdam from the Tolhuis* of 1863 (pl. 180).

For many years, it had been Whistler's "often expressed wish to return

273. Vermeer, *The Little Street*, 1661. Oil on canvas, 54.3 × 44 cm. Amsterdam, Rijksmuseum.

to Holland and portray, with their fascinating reflections, some of the picturesque old houses on the canals of Amsterdam."[13] In August, 1889, Whistler travelled to Amsterdam with Beatrice with the intention of making a series of ten copper plates. Although, like Rembrandt, Whistler "saw picturesque grandeur and noble dignity" in the poor quarter of Amsterdam and "lamented not that its inhabitants were not Greeks,"[14] he did have some unpleasant encounters with the locals who were far from welcoming. According to Pennell:

> In Amsterdam, the women in the houses on one of the canals, where Whistler sat in a boat working, objected, and emptied basins of water out of the windows above him. He only managed to dodge them just in time, and he had to call on the police, when, he told us the next interruption was a big row above him, and "I looked up, dodging the filthy pails to see the women vanishing backward being carried off to wherever they carry people in Holland. After that, I had no more trouble, but I always had a policeman wherever I had a boat."[15]

Despite the unsettling realities of modern life, in Amsterdam, as in London and Venice, Whistler magically transformed the disjointed structures along the back canals with their "old paint and old wood-work"[16] into palaces by capturing their pattern and colour and mirrored reflections. Like his new friend, the symbolist poet Stéphane Mallarmé, Whistler sought to capture the essence of what was otherwise impermanent in nature. As such, the etchings of houses reflected in canals may be seen as a logical outgrowth of the great Venetian nocturnes. In the Amsterdam plates, however, Whistler "painted with exquisite line" rather than films of plate tone, and created multifaceted images which shimmer with light and "colour."

These etchings combine the elaborate and picturesque detail of the "French" and "Thames" Set with the Venetian method of constructing the picture space so that it appears to hang between two and three dimensions. As in Venice, Whistler approached his subjects frontally, selected an area of architectural detail which interested him, and isolated its key elements. In doing so, he must have been thinking of the seventeenth-century Dutch cityscape, and particularly of Johannes Vermeer's *The Little Street c.* 1661 (pl. 273), of which he owned a photograph. Like Vermeer, Whistler was interested in the grid formed by the horizontal and vertical architectural members, and for the first time carried this pattern right to the edge of the plate, working over the entire surface with minute hair-like lines, leaving no space uncovered. It was in the Amsterdam etchings that Whistler came closest to etching in two dimensions. The surface of *The Embroidered Curtain*, K.410 (pl. 274), reads as a two-dimensional pattern which, with its asymmetrical arrangement of doors and windows and juxtaposition of patterns and textures, recalls the compositional structure of Japanese prints. The building was flattened to such an extent that it appears to hang like a veritable curtain in the middle distance. As such, this plate continues the tendency toward abstraction found in *Palaces, Brussels.*

In Amsterdam, Whistler must have been constantly reminded of Rembrandt, and it is not surprising to find unmistakable echoes of the

"Master's" etchings in two of the prints in the series. The compositional structure of *Balcony, Amsterdam*, K.405, in which a three-dimensional space was created through the use of a projecting balcony above and a darkened doorway below, appears to be borrowed from Rembrandt's *Christ Presented to the People*, H.271. The lamp in Whistler's *Nocturne: Dance House*, K.408 (pl.275), has a star-shaped radiance which recalls the lantern in Rembrandt's *The Star of the Kings*, B.113 (pl. 276). The flattened composition of Whistler's etching, which reads as a two-dimensional pattern of light against dark, is a synthesis of the lessons learnt from Rembrandt and Japan.

In addition to frontal views of buildings, Whistler made two views of bridges, *Bridge, Amsterdam*, K.409 (pl. 277), and *Little Drawbridge, Amsterdam*, K.412, which continue the theme found in the "bridge-pieces" of 1879. They recall the truncated views of slightly arched bridges found in Hiroshige and Hokusai, and have a poetic and ethereal aspect as they traverse the shimmering surface of the canal.

The extraordinary chiaroscuro effects, whereby light and dark were carefully modulated to give the overall surface vitality and visual richness, were achieved largely through myriad hair-like lines etched into copper. Their biting proved a problem. According to Pennell, Whistler drew with such minuteness that hardly any of the ground remained on the plates.[17] Although he stopped the biting at just the right moment, some areas of the plates have the appearance of being underbitten. They wore very quickly under the pressure of the press, and of the few impressions printed, only a handful were pulled before the plates began to appear grey and bald in places. These etchings are both Whistler's most splendid and most overblown productions: in them, he pushed the etching technique to the physical limits of the medium. It was probably with the Amsterdam plates in mind that Walter Sickert spoke scathingly of Whistler's "feast of frail and dainty sketching upon copper."[18] They can be seen as the *grand finale* of Whistler's etching career.

He was already well into the series when he wrote to Huish on September 3 extolling the virtues of the new plates, and proposing their purchase and exhibition by the Fine Art Society:

I find myself doing far finer work than anything I have hitherto produced—and the subjects appeal to me most sympathetically—which is all important.

I make my offer first to yourselves, because of the recent entente cordiale which you have brought about.

Now—I have begun etchings here and this already gives me great satisfaction—I shall therefore go on—and I will produce new plates of various sizes—the beauty and importance of these plates, you can only estimate from your knowledge of my care for my own reputation—and from your experience of myself in the Venice transaction.—

Meanwhile I may say that what I have already begun, is of far finer quality than all that has gone before—combining a minuteness of detail, always referred to with sadness by the Critics, who hark back to the Thames etchings (forgetting that they wrote foolishly about those also when they first appeared!) and with greater freedom and more beauty of execution than even the Venice set, or the last Renaissance lot can pretend to.

251

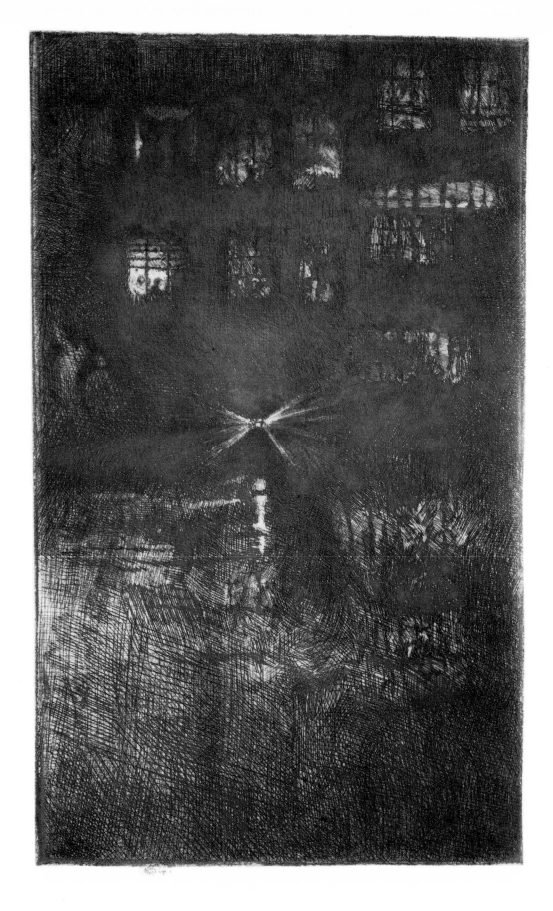

276. Rembrandt, *The Star of the Kings: A Night Piece*, B. 113, 1651. Etching, 9.7 × 14.6 cm. Art Gallery of Ontario, Sir Edmund Walker Collection, 1926.

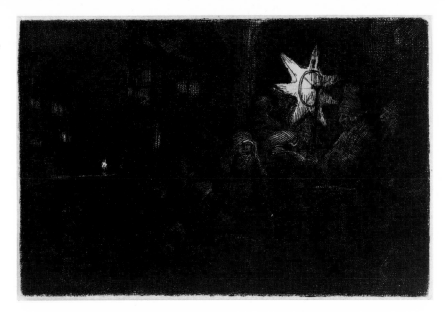

He offered to sell the plates to the Fine Art Society, and drafted a contract agreement which read as follows:

1. Thirty proofs of each plate to be printed for your stock.
2. One proof of each plate for the British Museum.
3. Five proofs of each plate for myself—more of which latter to be parted with for the period of one year from the date of delivery of stock.

The Fine Art Society

4. If there are different states of the plates, two of each state to be printed for yourselves, and two for me.
5. The price for the ten plates to be two thousand guineas.
6. The price of each proof for the public to be from ten guineas up— i.e. the "quality" will be that "preciousness" that will class the proofs among those for which I habitually ask twelve guineas or more.
7. After the above conditions are complied with, the plates to be destroyed, in such a manner as shall prevent the possibility of further printing, but shall leave the surface undefaced—in which condition they shall be exhibited—the method, chemical, or other, producing such result, to be determined between us.
8. The printing to be done by myself without further payment.[19]

In addition to marketing the series in Britain, Whistler was keen to promote it in America. His wife, who assisted with his correspondence, wrote to Kennedy from Amsterdam on September 29 to say that Whistler thought that "these plates will be among the finest he has done as they are very elaborate in character, and as they come from the country of the Knickerbockers they ought to be a great success in New York."[20]

275. Whistler, *Nocturne: Dance House*, K. 408, 1889. Etching, 27 × 16.6 cm. National Gallery of Art, Washington, Rosenwald Collection, 1943.

On March 4 Whistler was interviewed by a critic from the *Pall Mall Gazette*, who found him "printing the most exquisite series of etchings he has ever produced." The proofs of the Amsterdam plates were framed in "dainty frames of white with black bars," and were placed face to the wall on the floor of the studio. One after the other, Whistler placed them on the easel and discussed them. He is then reported to have made the following statement regarding his development as an etcher:

"I divide myself into three periods . . . First you see me at work on the Thames", producing one of the famous series. "Now, there you see the crude and hard detail of the beginner. So far, so good. There, you see, all is sacrificed to exactitude of outline. Presently, and almost unconsciously, I begin to criticise myself, and to feel the craving of the artist for form and colour. The result was the second stage, which my enemies call inchoate, and I call Impressionism. The third stage I have shown you. In that I have endeavored to combine stages one and two. You have the elaboration of the first stage, and the quality of the second."[21]

He saw the Amsterdam etchings as the synthesis of the realist and "impressionist" phases of his development, as tying together the early and middle stages of his career. With them, his last major contribution to the history of etching was complete.

The agreement which Whistler had proposed to the Fine Art Society would have permitted the Society to make only £100 on each plate sold, or £1,000 altogether, while Whistler would have netted £2,000. It is not surprising therefore that nothing came of his proposal. He nonetheless printed several sets, and sent one to the Fine Art Society on March 13. In April, 1890, the etchings were put on view at the Grolier Club in New York and at Dunthorne's Gallery in London. At Dunthorne's they were seen by George Bernard Shaw who called them "The most exquisite renderings by the most independent man of the century . . ." and added that "Had Mr. Whistler never put brush to canvas, he has done enough in these plates to be able to say that he will not altogether die."[22]

During the last decade of his life, Whistler became preoccupied with perfecting his earlier work. In 1890, he began work on new states of the Venice etchings, and wrote to Brown to say that he hoped they would be "even better than before."[23] They must have been finished by February, 1892, when Charles Freer from Detroit put in an order for them. Simultaneously, he set to work creating new states of the Amsterdam etchings which Freer and Kennedy ordered in January, 1892. Whistler staunchly maintained that, despite their marketability, he was not interested in creating the new states for their own sake. He wrote to Robert Deaulliarme, who had asked to see the "intermediate states" of the Venice plates, saying "Why you should wish to bewilder yourself or your clients with what can only be a more puzzling condition of 'rebus' than ever I cannot conceive."[24]

Whistler regretted the fact that the Fine Art Society was not prepared to undertake a major exhibition of "the new states, the old ones (larger than the later ones, more margin)" a set of the destroyed proofs, and the enamel-like treated copper plates. As he said to Brown,

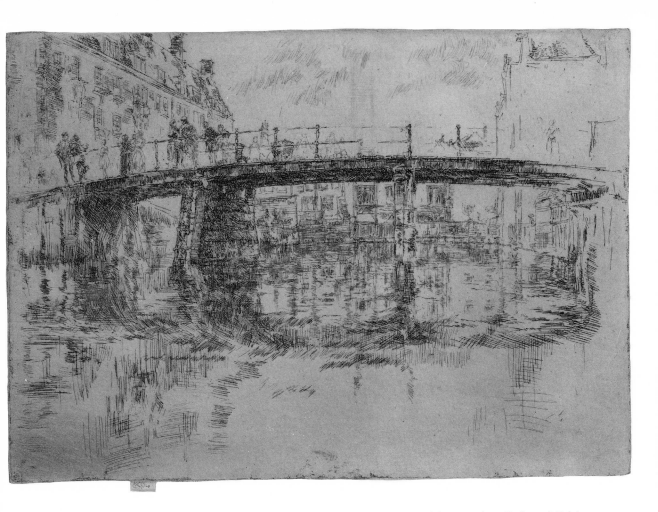

277. Whistler, *Bridge, Amsterdam*, K. 409, 1889. Etching, 16.6 × 24.2 cm. Metropolitan Museum of Art, Collection of Paul Walter. Photograph courtesy of the Metropolitan Museum of Art.

this would have made a peculiar and interesting little exhibition—where all the diletanti and connoisseurs could have wagged their heads to their heart's content—all the wisdom of Wedmore—fancy—and other authorities whose names I forget. You would have had all this, and I think it would have been to the good—The article in the Pall Mall points to the kind of thing I had intended—But to do it at all it should be perfect—and now it had better be only restricted to a collection of these last new states.[25]

He asked that the proofs be placed in his old frames, "the very narrow white ones with the brown lines."

It was with the etchings of Brussels, Touraine and Amsterdam that Whistler's last great surge of etching activity came to an end. The concept of taking architectural detail as the starting point for compositional arrangements which began in Venice found its logical conclusion in these plates which adopted both linear and painterly approaches, and ran the gamut from "notes of the needle" to monumental "finished" works. In them he came as close to abstraction as any etcher before the birth of Cubism, and exploited the full range of technical possibilities inherent in the medium.

# 4. The Paris Etchings

Although Whistler's work had achieved a certain level of public recognition in Britain by 1891, he had never really settled down there following his return from Venice. Despite the growth of his reputation, he was never invited to become a Royal Academician. This insult was compounded when a letter addressed to him at "The Academy, England" was returned by Burlington House bearing the notation "Not known at the R.A." Pretending to be enchanted by the irony, Whistler published the letter and referred to the incident as one of "the droll things of this pleasant life."

In Paris, on the other hand, his new friends Stéphane Mallarmé and Claude Monet joined forces with his old friend Théodore Duret to see that his work was given the public recognition it deserved. In 1888 Mallarmé translated the "Ten O'Clock" lecture into French, and in the same year Duret published the first serious book on Whistler's work, *Whistler et son oeuvre*. In November 1891, Mallarmé and Duret persuaded the Luxembourg to purchase Whistler's *Arrangement in Grey and Black: Portrait of the Painter's Mother*, Y.101. Two months later, in January 1892, thanks to the efforts of Mallarmé and Monet, Whistler was made an Officer of the Legion of Honour.

The final straw in Britain came with the retrospective exhibition organized by Goupil's in London in May 1892, which was entitled *43 Nocturnes, Marines and Chevalet Pieces*. Thanks largely to the official recognition which Whistler's work had recently received, there was finally a healthy market for it, and many of his former patrons wasted no time in selling early paintings for huge profits. Whistler, who regarded this as a form of betrayal, tried to ensure that from this time on his best work left England. He actively assisted American collectors, principally Charles Freer, with the result that the finest collections of etchings are now in America, where the Freer Gallery of Art ranks highest of all.[1]

Whistler spent the summer of 1891 in Paris working on lithographs which were to absorb an increasing amount of his time and attention in the early 1890s. From this time until he abandoned etching in favour of lithography in 1893, his etchings and lithographs were closely related, and he used the two media interchangeably. The Paris lithographs were made using the transfer process which T. R. Way had taught him in 1887. By drawing with chalk on waxy transfer paper he created painterly "charcoal" effects using paper stumps.[2] While Whistler's etchings resemble multiple pen drawings, the lithographs have the appearance of chalk drawings.

Whistler made a group of etchings from the nude or partly draped model at this time, which even Pennell was unable to date.[3] Made *c.* 1890–3 either before leaving London or soon after the move to Paris, they are closely related to a group of transfer lithographs dated 1890 to 1895. They were made from a model who walked around the studio at her leisure, allowing Whistler to capture natural poses and gestures. These works were referred to generically as "tanagras," and the graceful movements of the young model, with her hair bound up in a scarf, wearing loose, transparent drapery, recall the Tanagra terracotta figurines which Whistler had found so appealing during the latter half of the

278. Whistler at his printing press in the rue Notre-Dame-des-Champs, Paris, 1893.

256

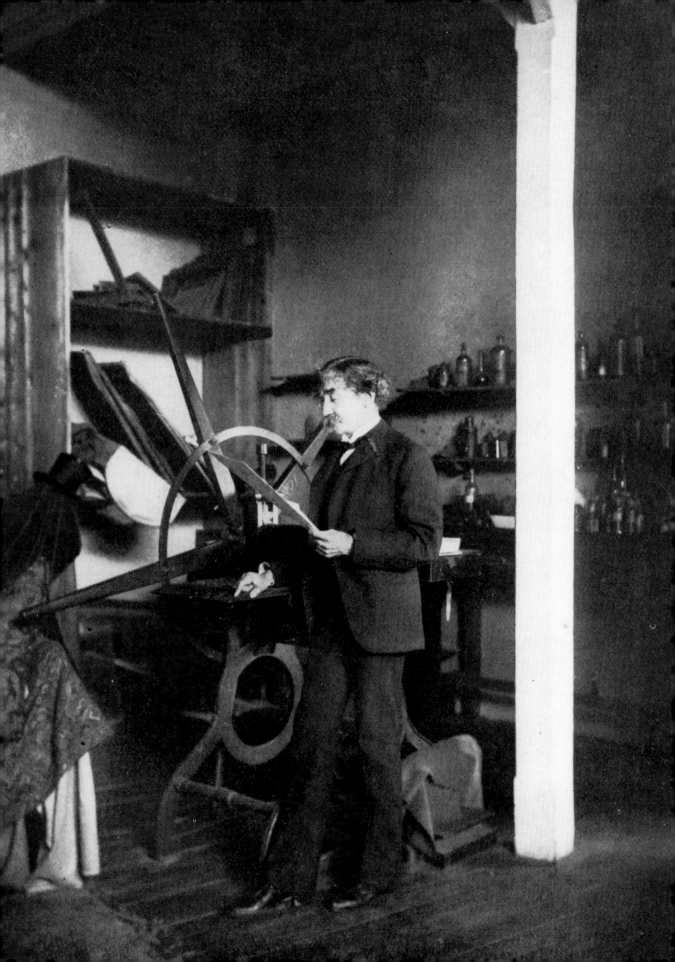

279. Whistler, *Cameo No. 2*,
K. 348. Etching, 17.6 × 12.8 cm.
Courtesy of the Freer Gallery of
Art, Smithsonian Institution,
Washington, D.C.

1860s. Although he abandoned this theme in 1870, afraid that his work
would be confused with that of Albert Moore, he took it up again and
developed it in the 1890s. His renewed interest may have been prompted
by the fact that he was then assisting with the sale of the Ionides
Tanagras. But it is also possible, given the emphasis on partly veiled
dancing figures in the lithographs, that he was inspired by the perform-
ances of the dancer Loïe Fuller, of whom he made a number of sketches.[4]

The more casual studies, *Model Stooping*, K.342, *Binding the Hair*,
K.344, and *The Fan*, K.345, are closely related in subject and pose to
the lithographs *Model Seated on the Floor*, L.57, and *The Dancing Girl*,
L.45, 1890. These impromptu studies capture the grace and elegance
of the model in motion. The more posed studies include *Cameo No. 1*,
K.347, and *Cameo No. 2*, K.348 (pl. 279), which shows a young mother

258

280. Whistler, *Mother and Child, No. 4*, W. 134, 1895. Transfer lithograph, 14.8 × 21 cm. Courtesy of the Freer Gallery of Art, Smithsonian Institution, Washington, D.C.

playing with her child, a subject which appears under the guise of Aphrodite and Eros in Tanagra figurines. These two etchings can be related to a series of lithographs of a young mother and child which were drawn on transfer paper around 1890 and printed about five years later. The enclosed, protective gesture in which the mother leans over the child in *Cameo No. 2* may be compared with a similar pose in the lithograph *Mother and Child No. 4*, W.135 (pl. 280). In both the etching and lithograph, Whistler sought to capture the translucent qualities of the drapery which partly reveals and partly conceals the form beneath, as it does the sculpted Tanagra figurines. The most elaborate etching in the group, *Nude Figure Reclining*, K.343, is closely related to the lithograph *Nude Model Reclining*, W.47, 1893. It has a certain provocative quality which is found in several of Whistler's nude and partially draped figures at this time. The titillating element may owe something to the etchings of Whistler's Belgian contemporary Felicien Rops, or to his interest in the French rococo.

Of this group, Whistler's favourite etching was *Cameo No. 1*. Early in 1893 he selected it for inclusion in a group of etchings which was to represent him at the Chicago World's Fair. Although he was awarded a prize for etching, American collectors found this work too *risqué*: Kennedy wrote to Whistler to say that he could not sell it because of "the thinness of the drapery."[5]

281. Whistler, *Marchande de vin*,
K. 421, 1892–3. Etching,
8.5 × 19.7 cm. Courtesy of the
Freer Gallery of Art, Smithsonian
Institution, Washington, D.C.

Whistler's series of etched views of Paris were begun during the summer of 1892,[6] after he had settled into a studio at 186 rue Notre-Dame-des-Champs not far from the one which the "English Group" had rented thirty-five years earlier. It was at the top of one of the highest buildings on the street, and the concièrge would give directions by saying "You can't go any further than M. Vistlaire!" The walls were painted rose, and the furniture consisted of a lounge, a few chairs, the blue screen which he had painted in the Japanese manner, and a white wood cabinet for prints, drawings and pastels. In the farthest corner was a printing press or rather, "a printing shop, with inks and papers on shelves."[7]

The Paris views, which are twenty-three in number, build on themes and compositional variations found in the Venice etchings of 1879–80, and the London etchings of 1880–7. The same tendency to "flatten" space and approach subjects frontally was applied to Paris streetscapes using the method which Whistler had evolved from his study of Japanese prints. *Marchande de vin*, K.421 (pl. 281), and *Fruit Shop, Paris*, K.424 (pl. 282), show rows of shops or shop fronts which are closely related to such London etchings as *The Fish Shop, Busy Chelsea* (pl. 254). *Bébés, Luxembourg Gardens*, K.428, in which the pattern and distribution of the figures is the subject of the plate, recalls *Children, Gray's Inn*. The preoccupation with doorways, and with women seated in doorways, found in *Carpet Mender's*, K.420, and *Sunflowers, rue des Beaux-Arts*, K.422, continues themes found in the Venice etchings *Bead-Stringers*, K.198 and *Two Doorways*, K.193.

The major development beyond the London and Venice etchings may be found in the application of the more painterly line developed in Amsterdam to create rich, dark shadows vibrant with light and "colour" (pl. 283). In the Paris etchings, Whistler used patches of fibrous lines running parallel to each other and turned on angle. To etch them, he used a light-weight, "perfectly balanced, beautifully designed little needle 3 or 4 inches long," made for him by an instrument maker in

282. Whistler, *Fruit Shop, Paris*, K. 424, 1892–3. Etching, 12.7 × 19.7 cm. Metropolitan Museum of Art, Collection of Paul Walter. Photograph courtesy of the Metropolitan Museum of Art.

Paris, which he carried in his pocket in a little silver case.[8] Whistler had a great deal of difficulty with the biting, partly because of the closeness of the lines, and partly because of the abuse to which he had subjected the grounded copper plates. According to Pennell the ground wore off before the plates were sufficiently bitten:

> Whistler was in everything else the most careful man I ever saw. But in the case of his unbitten plates, he was the most careless. They were never properly packed, they were usually carried in paper which rubbed them, and as if this were not enough, they were left for months, and the result was inevitable. Plates ground in the winter could not be bit in the summer. The ground came off.[9]

The first plates were probably bitten using the "Dutch bath." On September 18, 1892, Frank Short sent Whistler the recipe which he appears to have forgotten after using nitric acid for so long.[10] Whistler also asked Short if he could send him some old paper, but after a fruitless search, the young etcher was only able to turn up one old book.

In the summer of 1893, Whistler began to bite and print in earnest, and went looking for Pennell to ask for help. One morning in June, while Pennell was busy making drawings in one of the towers of Notre Dame Cathedral, he heard Whistler puffing and groaning as he climbed the endless winding staircase. "He told me why he had come. He was working on a series of etchings of Paris. Some were only just begun, others were ready to bite, but a number ought to be printed, and would

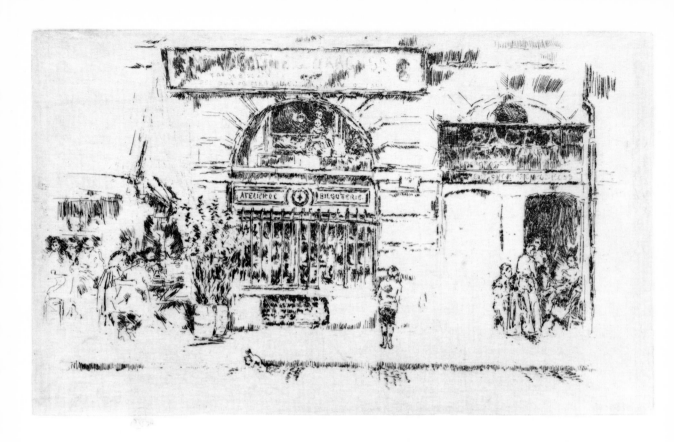

283. Whistler, *Atelier de bijouterie*, K. 433, 1892–3. Etching, 12.7 × 21.6 cm. Metropolitan Museum of Art, Collection of Paul Walter. Photograph courtesy of the Metropolitan Museum of Art.

I come and help him?" This was the first time that Pennell had been asked to help Whistler print; he must have been concerned about his lack of experience, for Whistler reassured him and said that "I could help him, and he could teach me."[11]

The next morning Pennell arrived at the Whistlers' apartment at 110 rue de Bac at nine o'clock, and had a leisurely breakfast followed by coffee and cigarettes in the garden. By this time it was too late to go to the studio, so Whistler "brought out some of the plates which he had been working on—the plates of little shops in the near streets and we looked at them, and that was all." This pattern continued for three or four days at which point Pennell said that they must either start printing or he must return to his drawing. Whistler took him at once to the studio and set to work on the press which had been installed by the printer Belfont. The plates were heated slightly, then inked and wiped, sometimes by hand and sometimes with a rag, until they were nearly clean but still had good surface tone. Pennell positioned the paper on the press and pulled the proofs, Whistler inking and Pennell printing all afternoon.

As each proof came off the press, he looked at it, not satisfied, for they were all weak, and saying, "we'll keep it as the first proof, and it will be worth something some day." Then he put the prints between sheets of blotting paper, and that night, or the next, after dinner, trimmed them with scissors, and put them back between the folded sheets of blotting-paper which were thrown round on the table and

on the floor. Between the sheets, the proofs dried naturally and were not squashed flat.[12]

The printing continued for several days while Whistler became more and more dissatisfied with the weakness of the proofs.

He still had some unbitten plates which he then took out and began to bite using nitric acid and a feather. Pennell carefully observed the process:

> A number of plates had never been bitten, and one hot Sunday afternoon he brought them in the garden at the Rue du Bac. A chair was placed under the trees, and on it a wash-basin, into which each plate was put. Instead of pouring the diluted acid all over the plate in the usual fashion drops were taken up from the bottle on a feather, and the plate practically printed with the acid. The acid was coaxed, or rather, used as one would use water-colour, dragged and washed about. Depth and strength were got by simply leaving a drop of acid on the lines where these effects were needed. There was little stopping-out of passages where greater delicacy was required; when there was any, the stopping-out varnish was thinned with turpentine, and Whistler, with a camel's hair brush, painted over the parts that did not need further biting. To me, it was a revelation. Sometimes he drew on the plate.[13]

But, regardless of how Whistler bit the plates, they were all afflicted by the same problem. As the proofs came off the press, "enthusiasm was endless," but "every plate was a disappointment."[14] Whistler was afraid to reground the plates, or to allow Lamour, the old etching material maker in Paris, to do it, although he had offered to do so and sent regrounding rollers around to the studio for the purpose. Before Whistler finally consented to hand the plates to Lamour he reprinted them, and the impressions "came out exquisite shadows."[15] The number of proofs printed in June and early July must have been very few. They were pulled on old laid paper, probably the paper which Whistler and Pennell found in quantity on a visit to Fontainebleau that summer.

After the proofs came off the press, they were dried between pieces of blotting paper thrown on the floor, then picked up and put in the corner the next day. Here they would often lie for days until after "careful, loving criticism, their edges were cut, and on some the Butterfly appeared, though this was usually done later."[16]

Almost six years went by before Whistler completed the printing of the plates back in London. In July, 1899 he asked Frank Short for permission to use his press.[17] He pulled nineteen prints on his first day, and told the Pennells that "Once I started, all the joy in it came back again, and I got through by lunch time."[18] Whistler appears to have accepted Short's offer to reground the plates and finally decided to leave the printing to him as well. When Short asked how he wanted the plates inked, Whistler replied "Wipe them as clean as you can—what was good enough for Rembrandt is good enough for me."[19]

It is not surprising, given the frustrations involved in printing the Paris plates, that Whistler threw more and more energy into lithography. In 1893 he made twelve lithographs of Paris subjects, and in 1894

the number tripled. His enthusiasm for the effects which he was able to obtain using the transfer process may have diverted his interest from seeking new effects in etching. He clearly enjoyed experimenting with the new and challenging medium. He used both etching and lithography interchangeably in 1893–4, carrying either transfer paper or grounded copper plates on his walks through Paris. The portability of the transfer paper, combined with the fact that it came "prepared," did not require grounding, and could be sent rolled in a large periodical to Tom Way in London for printing, must have greatly added to its appeal. When he went on a trip to Brittany in July 1893, he carried transfer paper instead of grounded copper plates for the first time. His use of lithography greatly increased during the autumn of 1893 after he had found a solution to the one technical problem which made it less attactive. Whistler disliked the mechanical grain of reticulated dots with which the Austrian and German transfer papers were stamped, since they showed up in the image. In the autumn of 1893 he found smooth transfer paper at Lemercier's in Paris which had no grain of its own, and he used it from that time on.

Whistler appears to have been interested initially in comparing the effects which could be obtained in the two media, and made several lithographs and etchings on the same themes in 1893–4. The etching *Bébes, Luxembourg Gardens*, K.428, may be compared to the lithograph *Nursemaids: Les Bonnes du Luxembourg*, W.48; the lithograph *The Pantheon from the Terrace of the Luxembourg Gardens*, W.45 (pl. 284), to the etching *Pantheon, Luxembourg Gardens*, K.429 (pl. 285), and the lithograph *The Terrace, Luxembourg*, W.55 (pl. 286), to the etching, *Terrace, Luxembourg Gardens*, No. 2, K.426 (pl. 287). By January, 1894, Whistler had made the transition. When Kennedy wrote to Whistler early in the New Year to inquire about recent etchings, Whistler replied saying, "I don't know about etchings just now I am greatly interested in lithographs."[20] He was not in fact to make any more etchings for eight years.

In August, 1894, Ernest Brown wrote from the Fine Art Society to

286. Whistler, *The Terrace, Luxembourg*, W. 55, 1894. Transfer lithograph, 8.5 × 20.8 cm. Courtesy of the Freer Gallery of Art, Smithsonian Institution, Washington, D.C.

287. Whistler, *Terrace, Luxembourg Gardens, No. 2*, K. 426, 1892–3. Etching, 12.7 × 17.5 cm. Courtesy of the Freer Gallery of Art, Smithsonian Institution, Washington, D.C.

288. The Ethel Birnie Philip–
Charles Whibley wedding party in
the garden at 110 rue du Bac,
1894. Beatrice Whistler wears the
dark hat and is seated at the centre.
Hunterian Art Gallery, University
of Glasgow, Birnie Philip Bequest.

ask Whistler to make some more proofs of the Venetian etchings *The Doorway* and *The Beggars*. Whistler was annoyed, and wrote back saying

devil of it is that it will doubtless give me endless trouble to get these two plates into working order—you see, as I have told you over and over again, when one stops—it is the very devil to start again . . . all this over refinement and anxiety for the perfection of quality is dead loss and vexation—For my own reputation, the complete beauty of one proof is enough—and the production of scores of the same plate is really a madness.[21]

Nonetheless, he set to work, and on August 7 sent Brown a number of proofs of "Beggars," and promised one or two of the "Doorway" on Japanese paper.[22]

The "intimiste" Paris lithgraphs of 1894–5 reflect the happy domestic

289. Whistler, *By the Balcony*, W. 124, 1896. Transfer lithograph, 21.5 × 14 cm. Courtesy of the Freer Gallery of Art, Smithsonian Institution, Washington, D.C.

life which the Whistlers led at their apartment at 110 rue de Bac from 1892 to 1895. Sadly, these days were soon to be cut short. Here, where Whistler entertained artists from all over the world at his famous Sunday brunches, where Beatrice and her sister played duets on the piano, and where monks sang in the adjacent garden on summer afternoons, Beatrice fell ill with cancer.

Whistler could not bear to face the diagnosis. Dr. William Whistler came to Paris to examine her and broke the news, something Whistler could neither believe nor forgive. In December he took her to London in search of more optimistic medical opinions. But there was no hope. Whistler's last lithographs, made in the Savoy Hotel, show Beatrice slowly fading away (pl. 289). She died on May 10, 1896, at St. Jude's Cottage on Hampstead Heath. Whistler was found wandering blindly on the Heath after her death, in a state of shock.

This was the second crisis of Whistler's life after the Ruskin affair. It completely disoriented him on a personal level, and sapped his will

290. Dr. William Whistler,
Hunterian Art Gallery, University
of Glasgow, Birnie Philip Bequest.

to live. He was sixty-two years of age, and despite an unbroken sequence of common-law relationships had greatly enjoyed the comfortable and happy years of his marriage. Rosalind Birnie-Philip, Beatrice's younger sister, came to live with him and looked after him for the rest of his life. In return, Whistler made her his executrix.

As in the aftermath of his mother's death, Whistler now engaged in a series of conflicts which were viewed by several of his close friends as a means of alleviating grief. He immediately began to do battle with Sir William Eden over the portrait of his wife, and with the Ways over the publication of the catalogue of his lithographs.

He must also have been deeply upset just before Beatrice's death when Haden received a knighthood for his contribution to etching in 1895. Kennedy wrote to tell him of the distinction, and tried to humour him and take his mind off Beatrice's state of health with the following letter:

> Keppel has gone to visit *Sir* Seymour Haden. Poor fellow, he looks ill, but maybe Hampshire air will prove beneficial. Sir Wm. Agnew *Bart*! Poor Sir Seymour Kt!!! Alas, the futility of striving, when talent, genius, etc. etc. can only arrive at Knighthood, and Bil Agnew—picture dealer is made a Baronet with a large B!!! Sigh not therefore, my dear friend, after such empty honours! Remain satisfied to be King of the brush and needle, for what would you do in the company of the Knight of the Shire and of the Baronet with a big, big B.?[23]

On Whistler's first appearance in public after the death of his wife, he had the pleasure of running into Haden at a dinner given by the Society of Illustrators of which both men were vice-presidents. Neither Whistler nor Haden had any idea that the other would be attending. When Pennell realized the situation he contrived to keep them apart, and managed to conceal Haden from Whistler until dinner was announced:

> But both seemed to feel that something was happening, though at first neither saw the other. As Whistler sat down, he produced two or three eye-glasses from his pocket. Still, neither saw the other. The soup came. Some one said something to Whistler and there was a "Ha! ha!" Haden stopped, his spoon in his hand, dropped it in his plate and fled, followed by another "Ha! ha!"[24]

This was Whistler's final act of vengeance on Haden. The two men were never to meet again.

Following the death of Beatrice, Whistler found it very difficult to recover his old enthusiasm for work. She had loved lithography and after her death he never again picked up the chalk. His friends tried to divert him. In April 1897, he was asked to appear as a witness for Pennell in the court case Sickert vs. Pennell. The former "follower" turned "enemy" had attacked the validity of transfer lithography as an original printmaking process. The case was won by Pennell with Whistler's assistance.

That summer the Vanderbilts, no doubt hoping that it would cheer him up, invited Whistler to watch the Queen's Jubilee naval display from their yacht "Sagitta." His frame of mind was quite different from

268

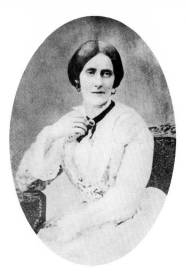

the summer of 1887. He sat on deck writing a mournful letter to his sister, Lady Haden, for whom he never lost his deep affection:

> You see they have taken me off to this naval display—and here on Sunday afternoon, glaring and dreary am I staring at Dover—which looks more depressingly "English" than ever!... The Review was well enough—but after all what is the use!—Then again the weather is, of all kinds, the one I most have in horror—clear and hard and sunny—and with it there is, about me, complete silence—for everyone has gone ashore and I am seated here completely steeped in the saddest thoughts I can muster for company.[25]

## 5. The Corsican Etchings

During the last years of his life Whistler enjoyed some of the acclaim that was his due. In 1898 he was elected President of the International Society of Sculptors, Painters and Gravers, whose object was "the organization in London of Exhibitions of the finest Art of the time ... the non-recognition of nationality in Art, and the hanging and placing of works irrespective of such consideration."[1] This was a goal close to his heart.

At the Second International Exhibition at Knightsbridge in 1899, an exhibition of his etchings was hung in a small room called the White Room specially decorated for the purpose. Since Whistler was in Paris at the time, the selection was left to Pennell who chose a number of etchings not shown before, among them plates from the *Naval Review Series*. Whistler was annoyed and when Pennell pressed for a reason, he said only that these plates were "too very slight for the understanding of the abomination outside."[2]

The following year Whistler expressed a wish that the "most magnificent proofs" of his etchings, "say about thirty of them," be sent from America to represent him at the 1900 Exposition Universelle in Paris. Unfortunately, there was not enough time to comply with his request. As Howard Mansfield pointed out, it did however indicate which of his works Whistler liked best at that time. He asked for "the fine full length of *Annie Haden* (dry point)," *Axenfeld, Chancellerie, Mairie, Loches*; "all my beautiful doorways" in Venice; the Amsterdam etchings, and "a fine proof of *Smithy*—very rich interior—smith filing at window,—beautiful work in roof and background." In addition, he wanted a "rare proof of Jo and her sister doing her hair—*The Toilette*, I think it may be called (dry point)." He also wanted *Cameo No. 1* and *Cameo No. 2*.[3] It was on the occasion of this exhibition that Whistler was awarded the Grand Prix for etching. To mark the event the publisher Heinemann threw a dinner party at which "they crowned him with laurel—or sprays from a plant in the dining-room—and Whistler was delighted."[4]

In the last years of his life Whistler regained contact with several of the friends of his student days in Paris, among them Drouet and Becquet. He was often lonely, and would go to Drouet with his worries. To distract him, Drouet would pull together dinner parties, one of which was given in honour of Becquet:

292. Whistler sketching in Corsica, by William Heinemann, 1901.

A wreath of laurel was prepared. During dinner M. Drouet said he had met many men, but, *pour la morale*, none greater than Becquet, who was moved to tears. Then Whistler said they had wanted to present him with some little souvenir, and the laurel wreath was brought and offered to him by Whistler and Becquet fairly broke down; he would hang it on the walls of his studio, always to have it before him! he said.[5]

By 1897, Whistler's health had begun to break down. The climb to his studio on the sixth floor of the rue Notre-Dame-des-Champs was bad for his heart, and he suffered from colds in the damp apartment at 110 rue de Bac. By November 1900, he was ill in bed at Garlant's Hotel in London, unable to shake off a bad cough. He nonetheless insisted on going to his studio. Afraid of spending the winter in London, he decided to set off in search of the sun, sailing to Tangiers and Algiers via Gibraltar.[6]

On December 12, before leaving, he sent a telegram to Joseph Pennell saying, "You once said you would like to varnish me a plate or two—Do

270

293. Whistler, *The Sleeping Child, Ajaccio*, 1901. Etching, 15 × 18.9 cm. Courtesy of the Print Department, Boston Public Library.

294. Whistler, *Bohemians, Corsica*, K. 422, 1901. Etching, 8.4 × 5.3 cm. Courtesy of the Freer Gallery of Art, Smithsonian Institution, Washington, D.C.

you think you could bring round three little ones with you this evening?—If busy don't dream of it."[7] Although Pennell immediately grounded "ten or a dozen copper plates," he warned Whistler that "the ground would probably come off as it was not properly cooled and fixed."[8] Nonetheless, Whistler peremptorily wrapped the plates in his shirts, and placed them in his steamer trunk.

He set out a few days later accompanied by his brother-in-law Ronald Murray Philip. They were dogged by bad weather all the way. When they arrived in Tangier, the wind was icy; in Algiers it rained; and when they headed for Marseilles, hoping to find sunshine, snow was falling. Whistler spent two weeks in bed and had to call a doctor. Corsica was recommended; drawn by the hope of good weather and the appeal of "Napoleon's Island," Whistler set sail once again. When he arrived, the weather was cold and windy and he was unable to work out of doors.

Fortunately the poor weather and his desperate need of company led to a friendship with the curator of the museum at Ajaccio who had offered Whistler the use of his studio. On fine days Whistler took his copper plates and went out, sitting on his little folding stool etching scenes and individuals in Ajaccio. But when he tried to bite the plates the ground came off, just as Pennell had predicted. Whistler blamed the disaster on Pennell, and wrote to Rosalind Birnie-Philip on March 15, saying, "Fancy that even a couple of etchings that should have been beauties—and might . . . have bettered the situation, went all to the dogs with Pennell's varnishing."[9] Three weeks later he wrote to Elizabeth Pennell saying that her husband's varnishing was "simply *disastrous*, and all my etchings ruined. The plates were simply *burned* into a state of enamel, and the varnish flew away with the whole work."[10]

271

It had been eight years since Whistler had picked up his etching needle, and these works are but quiet postscripts to an illustrious career. Only four of them survive, two of which were printed during Whistler's lifetime, and two after his death. The first of these were *Bohemians, Corsica*, K.442, and *Marchande de vin, Ajaccio*, and the last, *The Sleeping Child, Ajaccio* (pl. 293) and *The Flaming Forge, Ajaccio* (pl. 295)[11].

In these, his last etchings, Whistler returned to the themes and motifs which had entered his work in his earliest years. *Bohemians, Corsica* (pl. 294), a study of women in a doorway, recalls *La Marchande de moutarde* of 1858 (pl. 55) while the *Marchande de vin, Ajaccio*, standing proudly upright in her regional dress, recalls *La Mère Gérard* (pl. 33). *The Flaming Forge* continues the theme which entered his work with *The Forge* in 1861 and builds on the more recent lithographed variations, *The Forge: Passage du Dragon*, L.107, and *The Smith: Passage du Dragon*, L.109 (pl. 296), of 1894.

Whistler's health did not improve. He had great difficulty learning to relax after decades of frenetic activity:

At first, though I got through little, I never went out without a sketch-book or an etching plate. I was always meaning to work, always thinking I must. Then the Curator offered me the use of his studio. The first day I was there, he watched me but said nothing until the afternoon. Then, "But Mr. Whistler, I have been watching. You are all nerves, you do nothing. You try to, but you cannot settle down to it. What you need is rest—to do nothing—not to do anything.[12]

He finally did manage to relax, and it came to him as a revelation that

295. Whistler, *The Flaming Forge, Ajaccio*, 1901. Etching, 15.3 × 19.1 cm. Courtesy of the Print Department, Boston Public Library.

296. Whistler, *The Smith—Passage du Dragon*, W. 73, 1894. Transfer lithograph, 26.8 × 17.4 cm. Courtesy of the Freer Gallery of Art, Smithsonian Institution, Washington, D.C.

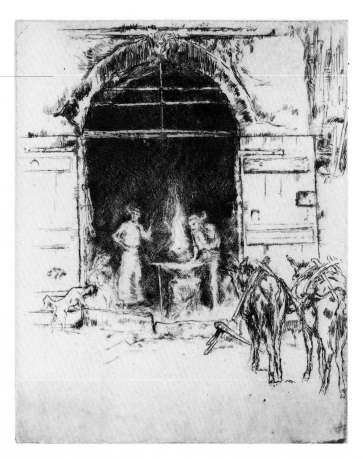

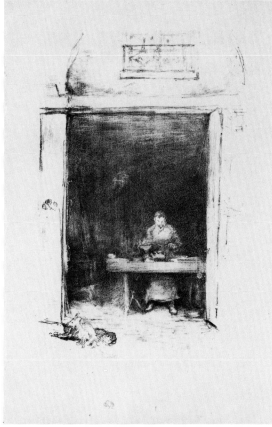

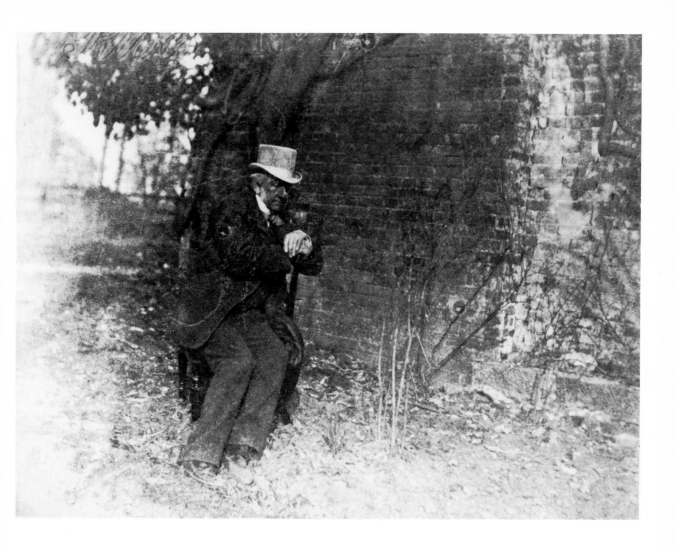

297. Sir Francis Seymour Haden in his last years. Hunterian Art Gallery, University of Glasgow, Birnie Philip Bequest.

for years I have had no play! . . . for years I have made for myself my own treadmill and turned upon it in mad earnestness until I dared not stop! and the marvel is that I lived to be free in this other Island— and to learn, in my exile, that again "Nothing matters!"[13]

By the end of April he was feeling much better. He set sail on May 1 for Marseilles, and finally arrived back in London on May 9. However, from this time until his death two years later he was never to enjoy good health.

Thanks in particular to the enthusiasm of American collectors, Whistler's etchings were by now enjoying a healthy market. This was greatly stimulated by the huge exhibition of 306 etchings shown at Wunderlich's in New York in 1898. Whistler's old friend Mr. Brown of the Fine Art Society kept pleading with him to finish printing the "First Venice Set." In November, 1901, he added a new incentive by saying that he could get Seymour Haden to let him have some old Dutch paper.[14] Haden, by this time almost blind, was disposing of his collection and the contents of his studio.

To the last, Whistler retained his early love of Hogarth. In November

273

1901 he sent a subscription to the fund to save Hogarth's house in Chiswick, and wrote to say that he was upset that nothing official had been done, either by the Government or the Royal Academy, to respect the memory of "her one Master who, outside of England, is still great."[15] He joked about this, as he did many things in which he passionately believed: "Hogarth," he said wryly, "should be rescued from the obscurity of his own country."[16] His pithy statements were repeated endlessly, if seldom understood.

During a visit to the Hague with Charles Freer in August 1902, Whistler suffered a minor heart attack. It was not very serious, although it indicated heart trouble, and he was very much amused to discover that a London paper, the *Morning Post*, had published a premature obituary upon receiving the news. He was soon back on his feet, and was "all alive and bright again" on a visit to the Mauritshuis where he expressed "particular interest in and affection for" Rembrandt's painting *Study of an Old Man*, then thought to be a portrait of his father, saying that it was "a fine example of the mental development of the artist, which should be continuous from work to work up to the end."[17]

His health continued to decline. He spent most of his last year in a modern house at 74 Cheyne Walk leased in April 1902, close to his first house on Lindsay Row. It was built by C. R. Ashbee in a style which Whistler said showed "the disastrous effect of art upon the middle classes."[18] Here he worked in the studio at the back, ate, slept and received visitors. One of his chief delights was the bottle of American cocktails which Edward Kennedy always brought with him. Whistler amused himself and his friends by reading over his old correspondence, especially the "wonderful letters"[19] which he had exchanged with the Fine Art Society while living in Venice.

He died in the studio of a heart attack on Friday, July 17, 1903. Six days later, his coffin was carried along the waterfront to Old Chelsea Church. It was draped with a purple pall on which was placed a golden laurel wreath sent by the International Society. The funeral was simple, the attendance poor, and no other official recognition was awarded him. Among the mourners were his niece, Annie Haden (Mrs. Thynne), his son Charles Hanson, his old "follower" and "enemy" Mortimer Menpes, and his devoted biographers Joseph and Elizabeth Pennell.

After the service the procession set out in carriages for Chiswick. Here, in the little churchyard overlooking the Thames which adjoins St. Nicolas's Church, only a few feet from Hogarth's grave, Whistler was laid to rest beside his wife under a wall covered with clematis.

# APPENDIX A

*The Chronological Order of Whistler's Etchings of 1857–9*

In compiling his *catalogue raisonné* of Whistler's etchings, *A Descriptive Catalogue of the Etchings and Drypoints of James Abbott McNeill Whistler* (Chicago, 1909), Howard Mansfield contacted a number of Whistler's surviving friends and relatives in an effort to establish the exact chronological sequence of his etchings.

A letter survives from Mansfield to Haden in the MS Dept. of the New York Public Library, dated October 16, 1905, (James A. McNeill Whistler Misc. Papers, Rare Books and Manuscripts Division, The New York Public Library, Astor, Linox and Tilden Foundations) in which Mansfield proposed for Haden's consideration a chronological order for the etchings of 1857–9. Although no reply from Haden has yet come to light, it is possible, by comparing the order proposed by Mansfield in the letter with the order adopted in the published catalogue, to determine the nature of the changes suggested by Haden. No one was more intimately involved than Haden with Whistler's early etching production, and it is most unlikely that such changes could have been suggested by anyone else alive at that time. For this reason, Mansfield's order for the etchings of 1857–9 has been adopted in *Appendix B*.

In the table which follows, the sequence which Mansfield proposed to Haden in his letter is listed in the right-hand column, and the final published order in the left. For convenience, the corresponding Kennedy catalogue number has been included in the middle column. Kennedy's order is quite unreliable for the early period.

| Mansfield Cat. Nos. | Kennedy Cat. Nos. | Mansfield's MS Titles and Cat. Nos. Submitted to Haden for Comments |
|---|---|---|
| M. 2 | K. 3 | 1. Au Sixième |
| M. 3 | K. 4 | 2. Man Holding a Glass |
| M. 4 | K. 5 | 3. Youth with German Cap |
| M. 5 | K. 6 | 4. Seymour Standing |
| M. 6 | K. 29 | 5. Seymour Seated |
| M. 8 | K. 10 | 6. Annie |
| M. 9 | K. 7 | 7. Early Portrait of Whistler |
| M. 10 | K. 8 | 8. Annie Haden with Books |
| M. 29 | K. 30 | 9. Annie Seated |
| M. 7 | K. 9 | 10. Little Arthur |
| M. 20 | K. 20 | 11. Gretchen |
| M. 11 | K. 14 | 12. La Rétameuse |
| M. 13 | K. 11 | 13. La Mère Gérard |
| M. 14 | K. 12 | 14. La Mère Gérard Stooping |
| M. 15 | K. 13 | 15. Fumette |
| M. 12 | K. 15 | 16. En plein soleil |
| M. 16 | K. 16 | 17. Liverdun |
| M. 19 | K. 19 | 18. Street at Saverne |
| M. 17 | K. 17 | 19. The Unsafe Tenement |
| M. 18 | K. 18 | 20. The Dog on the Kennel |
| M. 24 | K. 24 | 21. The Kitchen |

| | | |
|---|---|---|
| M. 21 | K. 21 | 22. La Vielle aux loques |
| M. 22 | K. 22 | 23. La Marchande de moutarde |
| M. 23 | K. 23 | 24. The Rag Gatherers |
| M. 25 | K. 25 | 25. Whistler Drawing |
| M. 26 | K. 26 | 26. Auguste Delâtre |
| M. 28 | K. 28 | 27. Reading in Bed |
| M. 27 | K. 27 | 28. The Wine Glass |
| M. 31 | K. 33 | 29. The Music Room |
| M. 30 | K. 32 | 30. Reading by Lamplight |
| M. 32 | K. 31 | 31. Seymour |
| M. 34 | K. 35 | 32. Greenwich Park |
| M. 33 | K. 34 | 33. Greenwich Pensioner |
| M. 35 | K. 36 | 34. Landscape with Horse |
| M. 36 | K. 37 | 35. Nursemaid and Child |
| M. 37 | K. 38 | 36. Thames Warehouses |
| M. 38 | K. 39 | 37. Old Westminster Bridge |
| M. 39 | K. 40 | 38. Limehouse |
| M. 40 | K. 41 | 39. Eagle Wharf |
| M. 41 | K. 42 | 40. Black Lion Wharf |
| M. 42 | K. 43 | 41. The Pool |
| M. 43 | K. 44 | 42. Thames Police |

The information which Mansfield apparently received from Haden relates to several groups of etchings which the latter knew intimately : the early etchings made in Paris between 1857–8; the etchings of the Haden children of 1857–8; the Paris etchings of 1858; the etchings made in Alsace and Germany in 1858; the etchings made at 62 Sloane Street in November and December 1858; the etchings made in Kensington Gardens and at Greenwich in 1859; and the first Thames etchings of 1859.

Mansfield explained that he had "placed those earliest which are signed, at least in the first state, 'J.W.'." Haden did not disagree with Mansfield's proposed order for the early plates *Au Sixième*, *The Dutchman Holding a Glass*, and *A Youth Wearing a German Cap*. Mansfield specifically asked Haden whether *A Youth Wearing a German Cap* was correctly placed, and described it as "a small etching of the earliest period which Mr. Freer found last year in Paris, and which I think must have been an outcome of Whistler's Rhine journey." Either Haden did not know the plate, or else he must have accepted the order proposed by Mansfield.

Haden must have been responsible for the careful reorganization of the etched portraits of his children. *Annie Seated*, originally no. 9 on Mansfield's list, became no. 29 in the published catalogue, and *Little Arthur* was moved from tenth to seventh place.

Perhaps the most important change involves the organization of the etchings made in Paris, Alsace and on the Rhine during summer and autumn of 1858. Mansfield was particularly concerned about the order of these plates, and wrote to Haden "I am somewhat uncertain whether the etchings of the French subjects, La Rétameuse, La Mère Gérard, La Mère Gérard Stooping, Fumette, and En plein soleil should come before or after Liverdun and the other Alsatian subjects."

Haden must have told Mansfield that some of the Paris etchings were made before and some after the trip, and that two of the plates of Alsatian and German subjects were made following Whistler's return to Paris in October. *La Rétameuse, En plein soleil, La Mère Gérard Stooping*, and *Fumette* were listed as having been made prior to Whistler's departure, and *La Vieille aux loques* and *The Rag Gatherers* after his return. *The Kitchen* and *La Marchande de moutarde* were place among the etchings made after Whistler's return to Paris.

In reorganizing the plates made at 62 Sloane Street in November–December, 1858, Haden included among them *The Wine Glass* and *Reading in Bed*. This evidence would tend to negate Whistler's later comment that *The Wine Glass* was made about the same time as the first Thames etchings, and Ralph Thomas's statement that *Reading in Bed* was made in Paris. Thomas later withdrew this remark and said that the etching showed Mrs. Haden in bed.

Haden also changed the order of the plates made in Kensington Gardens and Greenwich in early summer, 1859. He did not, however, adjust the sequence of the Thames etchings of 1859, either because he agreed with Mansfield or because he had lost intimate contact with Whistler after the latter went to stay at Wapping.

# APPENDIX B

*The Chronological Order of Whistler's Etched Work*

The following chronological list of Whistler's etchings is based on evidence or argument put forward in the text and in my thesis "Whistler's Etchings and the Sources of His Etching Style, 1855–80," Ph.D. Thesis, Courtauld Institute, University of London, 1982. By no means all the chronological problems have been resolved. This should be regarded as an interim list pending a revision of the Kennedy catalogue.

The order of the etchings closely follows that used by Howard Mansfield in *A Descriptive Catalogue of the Etchings and Drypoints of James Abbott McNeill Whistler* (1909). The order of the Venice etchings adopted here was established by Robert Getscher in the appendix to "Whistler in Venice" (Diss., Case Western Reserve, 1970).

When dates can be established from documentary evidence they are stated plainly. When works cannot yet be ascribed to a particular year from documentary evidence, they are bracketed. When no date can be established it is omitted altogether.

For the sake of simplicity, the titles used by Edward G. Kennedy in *The Etched Work of Whistler* (1910) have been employed. Mansfield tried whenever possible to use Whistler's original titles, and a revision of the Kennedy catalogue will involve restoring Whistler's titles whenever they can be established with certainty.

| Reference Numbers | M. | K. | Published Titles | Date |
|---|---|---|---|---|
| 1 | 1 | 1 | Sketches on the Coast Survey Plate | 1854–5 |
| 2 | App. I | App. I | View of the Eastern Extremity of Anacapa Island from the Southward (lost) | 1854–5 |
| 3 | — | — | Untitled (Fitzwilliam Museum) | (1855–7) |
| 4 | 2 | 3 | Au Sixième | 1857 |
| 5 | 3 | 4 | The Dutchman Holding a Glass | (1857) |
| 6 | 4 | 5 | A Youth Wearing a German Cap | (1855–7) |
| 7 | 5 | 6 | Seymour Standing | (1857–8) |
| 8 | 6 | 29 | Seymour Seated | (1857–8) |
| 9 | 7 | 9 | ᵃLittle Arthur | (1857–8) |
| 10 | 8 | 10 | ᵃAnnie | (1857–8) |
| 11 | 9 | 7 | Early Portrait of Whistler | (1857–8) |
| 12 | 10 | 8 | Annie Haden with Books | (1857–8) |
| 13 | 11 | 14 | ᵃLa Rétameuse | 1858 |
| 14 | 12 | 15 | ᵃEn plein soleil | 1858 |
| 15 | 13 | 11 | ᵃLa Mère Gérard | 1858 |
| 16 | 14 | 12 | La Mère Gérard Stooping | 1858 |
| 17 | 15 | 13 | ᵃFumette | 1858 |

| Reference Numbers M. | K. | | Published Titles | Date |
|---|---|---|---|---|
| 18 | 16 | 16 | ªLiverdun | 1858 |
| 19 | 17 | 17 | ªThe Unsafe Tenement | 1858 |
| 20 | 18 | 18 | The Dog on the Kennel | 1858 |
| 21 | 19 | 19 | ªStreet at Saverne | 1958 |
| 22 | 20 | 20 | Gretchen at Heidelberg | 1858 |
| 23 | 21 | 21 | ªLa Vieille aux loques | 1858 |
| 24 | 22 | 22 | ªLa Marchande de moutarde | 1858 |
| 25 | 23 | 23 | The Rag Gatherers | 1858 |
| 26 | 24 | 24 | ªThe Kitchen | 1858 |
| 27 | — | — | "Treize eaux-fortes d'après nature" (unpublished title page to the "French Set") | 1858 |
| 28 | 25 | 25 | ªThe Title to the "French Set" | 1858 |
| 29 | 26 | 26 | Auguste Delâtre | 1858 |
| 30 | 27 | 27 | The Wine Glass | 1858 |
| 31 | 28 | 28 | Reading in Bed | 1858 |
| 32 | 29 | 20 | Annie Seated | 1858 |
| 33 | 30 | 32 | Reading by Lamplight | 1858 |
| 34 | 31 | 33 | The Music Room | 1858 |
| 35 | 32 | 31 | Seymour Standing Under a Tree | 1859 |
| 36 | — | 2 | Trees in a Park | 1859 |
| 37 | 33 | 34 | Greenwich Pensioner | 1859 |
| 38 | 34 | 35 | Greenwich Park | 1859 |
| 39 | 35 | 36 | Landscape with the Horse | 1859 |
| 40 | 36 | 37 | Nursemaid and Child | 1859 |
| 41 | 37 | 38 | ᵇThames Warehouses | 1859 |
| 42 | 38 | 39 | ᵇOld Westminster Bridge | 1859 |
| 43 | 39 | 40 | ᵇLimehouse | 1859 |
| 44 | 40 | 41 | ᵇEagle Wharf | 1859 |
| 45 | 41 | 42 | ᵇBlack Lion Wharf | 1859 |
| 46 | 42 | 43 | ᵇThe Pool | 1859 |
| 47 | 43 | 44 | ᵇThames Police | 1859 |
| 48 | 44 | 45 | Longshoremen | 1859 |
| 49 | 45 | 46 | ᵇThe Limeburner | 1859 |
| 50 | 46 | 47 | Billingsgate | 1859 |
| 51 | 47 | 48 | A Wharf | 1859 |
| 52 | 49 | 49 | Soupe à trois sous | 1859 |
| 53 | 50 | 50 | Bibi Valentin | 1859 |
| 54 | 51 | 51 | Bibi Lalouette | 1859 |
| 55 | 52 | 52 | ᵇBecquet | 1859 |
| 56 | 53 | 53 | Astruc, a Literary Man | 1859 |
| 57 | 54 | 54 | Portrait of Whistler | 1859 |
| 58 | 55 | 55 | Drouet | 1859 |
| 59 | 56 | 56 | Fumette Standing | 1859 |
| 60 | 57 | 57 | Fumette's Bent Head | 1859 |
| 61 | 58 | 58 | Finette | 1859 |
| 62 | 59 | 59 | Venus | 1859 |
| 63 | 60 | 60 | Isle de la Cité, Paris | 1859 |
| 64 | 61 | 61 | Arthur Haden | 1859 |
| 65 | App. II | App. II | Portrait of a Lady | 1859 |
| 66 | 62 | 62 | Annie Haden | 1860 |
| 67 | 63 | 63 | Mr. Davis (Mr. Mann) | 1860 |
| 68 | 64 | 64 | Axenfeld | 1860 |
| 69 | 65 | 65 | Riault, The Engraver | 1860 |
| 70 | 66 | 66 | ᵇRotherhithe | 1860 |
| 71 | 67 | 67 | The Penny Boat | 1860 |
| 72 | 70 | 70 | Vauxhall Bridge | 1861 |
| 73 | 71 | 71 | ᵇMillbank | 1861 |
| 74 | 73 | 73 | Little Wapping | 1861 |

| Reference Numbers | M. | K. | Published Titles | Date |
|---|---|---|---|---|
| 133 | 129 | 130 | A Lady Wearing a Hat with a Feather | (1873–75) |
| 134 | 130 | 131 | A Girl with Large Eyes | (1873–75) |
| 135 | 131 | 133 | The Desk | (1873–75) |
| 136 | 132 | 134 | Agnes | (1873–75) |
| 137 | 133 | 135 | The Boy | (1873–75) |
| 138 | 134 | 136 | Swinburne | (1871–7) |
| 139 | 135 | 138 | A Lady at a Window | (1873–5) |
| 140 | 136 | 137 | A Man Reading | (1873–75) |
| 141 | 137 | 139 | Miss Alexander | (1873–75) |
| 142 | 138 | 140 | The Guitar Player | 1875 |
| 143 | 139 | 141 | The Piano | (1875) |
| 144 | 140 | 142 | The Scotch Widow | 1875 |
| 145 | 141 | 143 | Speke Hall No. 2 | 1875 |
| 146 | 142 | 144 | Speke Shore | (1875) |
| 147 | 143 | 145 | The Dam Wood | (1875) |
| 148 | 144 | 146 | Shipbuilder's Yard | 1875 |
| 149 | 145 | 147 | The Little Forge | 1875 |
| 150 | 146 | 148 | Two Ships | 1875 |
| 151 | 147 | 149 | Steamboats off the Tower | 1875 |
| 152 | 148 | 150 | The White Tower | (1875) |
| 153 | 149 | 152 | The Troubled Thames | (1875) |
| 154 | 150 | 153 | London Bridge | (1875) |
| 155 | 151 | 154 | Price's Candle Works | (1875) |
| 156 | 152 | 155 | Battersea : Dawn | 1875 |
| 157 | 153 | 156 | Steamboat Fleet | (1875) |
| 158 | 154 | 157 | The Sail | (1875) |
| 159 | 167 | 170 | Irving as Philip of Spain No. 1 | (1876–7) |
| 160 | 168 | 171 | Irving as Philip of Spain No. 2 | (1876–7) |
| 161 | 155 | 158 | Fishing Boats, Hastings | 1877 |
| 162 | 156 | 159 | Wych Street | 1877 |
| 163 | 157 | 160 | Little Smithfield | (1877) |
| 164 | 158 | 161 | Sketch of Houses | (1877) |
| 165 | 159 | 162 | Temple Bar | (1877) |
| 166 | 160 | 163 | Free Trade Wharf | 1877 |
| 167 | 166 | 164 | Lord Wolseley | (1877) |
| 168 | 161 | 165 | The Thames Toward Erith | (1877) |
| 169 | 162 | 166 | Lindsey Houses | (1878) |
| 170 | 163 | 167 | From Pickle-Herring Stairs | (1878) |
| 171 | 164 | 168 | A Sketch from Billingsgate | 1878 |
| 172 | 165 | 169 | St. James's Street | 1878 |
| 173 | 169 | 172 | Whistler with the White Lock | 1879 |
| 174 | 170 | 173 | The Tiny Pool | (1879) |
| 175 | 171 | 174 | The Large Pool | (1879) |
| 176 | 172 | 175 | The "Adam and Eve", Old Chelsea | 1879 |
| 177 | 177 | 179 | The Little Putney No. 1 | 1879 |
| 178 | 173 | 176 | Under Old Battersea Bridge | 1879 |
| 179 | 179 | 182 | Fulham | 1879 |
| 180 | 175 | 178 | Old Putney Bridge | 1879 |
| 181 | 176 | 180 | The Little Putney No. 2 | 1879 |
| 182 | 174 | 177 | Old Battersea Bridge | 1879 |
| 183 | 178 | 181 | Hurlingham | 1879 |
| 184 | 184 | 187 | ᶜThe Palaces | 1879 |
| 185 | 192 | 195 | ᶜThe Mast | 1879–80 |
| 186 | 209 | 212 | ᵈLong Venice | 1879–80 |
| 187 | 188 | 191 | ᶜThe Traghetto No. 2 | 1879–80 |
| 188 | 187 | 190 | The Traghetto No. 1 | 1879–80 |
| 189 | 207 | 210 | ᵈThe Garden | 1879–80 |
| 190 | 216 | 219 | The Dyer | 1879–80 |

| | | | Published Titles | Date |
|---|---|---|---|---|
| 191 | 218 | 221 | Wool Carders | 1879–80 |
| 192 | 191 | 194 | ᶜThe Beggars | 1879–80 |
| 193 | 194 | 197 | ᵈSan Biagio | 1879–80 |
| 194 | 198 | 201 | ᵈSan Giorgio | 1879–80 |
| 195 | 203 | 206 | ᵈThe Riva, No. 2 | 1879–80 |
| 196 | 226 | 229 | Shipping, Venice | 1879–80 |
| 197 | 181 | 184 | ᶜNocturne | 1879–80 |
| 198 | 224 | 227 | Gondola Under a Bridge | 1879–80 |
| 199 | 201 | 204 | ᵈThe Bridge | 1879–80 |
| 200 | 208 | 211 | ᵈThe Rialto | 1879–80 |
| 201 | 199 | 202 | ᵈNocturne : Palaces | 1879–80 |
| 202 | 204 | 207 | ᵈThe Balcony | 1879–80 |
| 203 | 189 | 192 | ᶜThe Riva, No. 1 | 1879–80 |
| 204 | 190 | 193 | ᶜTwo Doorways | 1879–80 |
| 205 | 185 | 188 | ᶜThe Doorway | 1879–80 |
| 206 | 227 | 230 | Venetian Court | 1879–80 |
| 207 | 228 | 231 | Venice | 1879–80 |
| 208 | 182 | 185 | ᶜThe Little Mast | 1879–80 |
| 209 | 180 | 183 | ᶜLittle Venice | 1879–80 |
| 210 | 225 | 228 | The Steamboat, Venice | 1879–80 |
| 211 | 186 | 189 | ᶜPiazzetta | 1879–80 |
| 212 | 202 | 205 | ᵈUpright Venice | 1879–80 |
| 213 | 193 | 196 | ᵈDoorway and Vine | 1879–80 |
| 214 | 210 | 213 | ᵈNocturne : Furnace | 1879–80 |
| 215 | 214 | 217 | Glass Furnace : Murano | 1879–80 |
| 216 | 205 | 208 | ᵈFishing Boat | 1879–80 |
| 217 | 222 | 225 | Stables | 1879–80 |
| 218 | 223 | 226 | Nocturne : Salute | 1879–80 |
| 219 | 200 | 203 | ᵈLong Lagoon | 1879–80 |
| 220 | 211 | 214 | ᵈQuiet Canal | 1879–80 |
| 221 | 183 | 186 | ᶜThe Little Lagoon | 1879–80 |
| 222 | 206 | 209 | ᵈPonte del Piovan | 1879–80 |
| 223 | 195 | 198 | ᵈBead-Stringers | 1879–80 |
| 224 | 197 | 200 | ᵈFruit-Stall | 1879–80 |
| 225 | 220 | 223 | Nocturne : Shipping | 1879–80 |
| 226 | 215 | 218 | Fish-Shop, Venice | 1879–80 |
| 227 | 196 | 199 | ᵈTurkeys | 1879–80 |
| 228 | 212 | 215 | ᵈLa Salute : Dawn | 1879–80 |
| 229 | 219 | 222 | Islands | 1879–80 |
| 230 | 221 | 224 | Old Women | 1879–80 |
| 231 | 213 | 216 | ᵈLagoon : Noon | 1879–80 |
| 232 | 229 | 232 | Venetian Water-carrier | 1879–80 |
| 233 | 230 | 233 | ᵈWheelwright | 1879–80 |
| 234 | 217 | 220 | Little Salute | 1879–80 |
| 235 | 231 | 234 | ᵈTemple | (1880–81) |
| 236 | 232 | 236 | ᵈLittle Court | (1880–81) |
| 237 | 233 | 235 | ᵈLobster Pots | (1880–81) |
| 238 | 234 | 237 | ᵈDrury Lane | (1880–81) |
| 239 | 235 | 239 | Regent's Quadrant | 1880–81 |
| 240 | 236 | 238 | Alderney Street | (1880–81) |
| 241 | 237 | 240 | The Smithy | |
| 242 | 238 | 241 | Swan and Iris | (1883) |
| 243 | 239 | 242 | Dordrecht | 1884 |
| 244 | 240 | 243 | Little Dordrecht | 1884 |
| 245 | 241 | 244 | Boats, Dordrecht | 1884 |
| 246 | 242 | 245 | The Little Wheelwrights | 1884 |
| 247 | 243 | 248 | A Corner of the Palais Royal | (1883–86) |
| 248 | 245 | 249 | Booth at a Fair | (1884–86) |

| Reference Numbers | | | Published Titles | Date |
|---|---|---|---|---|
| M. | K. | | | |
| 307 | 303 | 308 | Butcher's Shop, Sandwich | (1887) |
| 308 | 304 | 309 | Ramparts, Sandwich | (1887) |
| 309 | 305 | 311 | Sketch of Battersea Bridge | (1887) |
| 310 | 306 | 310 | Charing Cross Railway Bridge | (1887) |
| 311 | 307 | 312 | Black Eagle | (1887) |
| 312 | 308 | 314 | Wild West | 1887 |
| 313 | 309 | 315 | The Bucking Horse | 1887 |
| 314 | 310 | 313 | Wild West, Buffalo Bill | 1887 |
| 315 | 311 | 323 | ᶜPortsmouth Children | 1887 |
| 316 | 312 | 317 | ᶜTilbury | 1887 |
| 317 | 313 | 320 | ᶜVisitor's Boat | 1887 |
| 318 | 314 | 319 | ᶜTroop Ships | 1887 |
| 319 | 315 | 318 | ᶜMonitors | 1887 |
| 320 | 316 | 321 | ᶜThe Turret-Ship | 1887 |
| 321 | 317 | 322 | ᶜDry-Dock, Southampton | 1887 |
| 322 | 318 | 324 | ᶜBunting | 1887 |
| 323 | 319 | 325 | ᶜDipping the Sail | 1887 |
| 324 | 320 | 326 | ᶜThe Fleet : Evening | 1887 |
| 325 | 321 | 327 | ᶜReturn to Tilbury | 1887 |
| 326 | 322 | 328 | ᶜRyde Pier | 1887 |
| 327 | 323 | 331 | Chelsea (Memorial) | 1887 |
| 328 | 324 | 329 | Windsor (Memorial) | 1887 |
| 329 | 325 | 330 | Windsor, No. 2 | 1887 |
| 330 | 326 | 316 | Abbey Jubilee | 1887 |
| 331 | 327 | 274 | Jubilee Place, Chelsea | 1887 |
| 332 | 328 | 332 | The Fur Coat | |
| 333 | 329 | 333 | Nora Quinn | |
| 334 | 330 | 334 | Miss Lenoir | (1885–8) |
| 335 | 331 | 335 | The Little Hat | |
| 336 | 332 | 336 | The Mantle | |
| 337 | 333 | 347 | Cameo, No. 1 | |
| 338 | 334 | 348 | Cameo, No. 2 | |
| 339 | 335 | 337 | The Japanese Dress | |
| 340 | 336 | 341 | Baby Pettigrew | |
| 341 | 337 | 339 | Gypsy Baby | |
| 342 | 338 | 338 | Resting by the Stove | |
| 343 | 339 | 340 | Little Nude Figure | |
| 344 | 340 | 342 | Model Stooping | |
| 345 | 341 | 343 | Nude Figure Reclining | |
| 346 | 342 | 344 | Binding the Hair | |
| 347 | 343 | 345 | The Fan (Model No. 3) | |
| 348 | 344 | 346 | Little Model Seated | |
| 349 | 345 | 132 | Young Woman Standing | |
| 350 | 346 | 123 | Nude Woman Standing | |
| 351 | 347 | 354 | The Beach, Ostend | 1887 |
| 352 | 348 | 352 | Quay, Ostend | 1887 |
| 353 | 349 | 349 | Fish Market, Ostend | 1887 |
| 354 | 350 | 353 | Canal, Ostend | 1887 |
| 355 | 351 | 351 | Market-Place, Bruges | 1887 |
| 356 | 352 | 356 | Church, Brussels | 1887 |
| 357 | 353 | 355 | Courtyard, Brussels | 1887 |
| 358 | 354 | 362 | Grand'Place, Brussels | 1887 |
| 359 | 355 | 361 | Palaces, Brussels | 1887 |
| 360 | 356 | 357 | The Barrow, Brussels | 1887 |
| 361 | 357 | 358 | High Street, Brussels | 1887 |
| 362 | 358 | 359 | Flower Market, Brussels | 1887 |
| 363 | 359 | 360 | Gold-House, Brussels | 1887 |
| 364 | 360 | 363 | House of the Swan, Brussels | 1887 |

| Reference Numbers | | | Published Titles | Date |
|---|---|---|---|---|
| M. | K. | | | |
| 365 | 361 | 366 | Archway, Brussels | 1887 |
| 366 | 362 | 365 | Brussels Children | 1887 |
| 367 | 363 | 364 | Butter Street, Brussels | 1887 |
| 368 | 364 | 367 | Little Butter Street, Brussels | 1887 |
| 369 | 368 | 369 | Place Daumont | 1888 |
| 370 | 369 | 368 | Courtyard, Rue P. L. Courier | 1888 |
| 371 | 370 | 370 | The Wine-Shop | 1888 |
| 372 | 371 | 371 | Railway-Station, Vovés | 1888 |
| 373 | 372 | 372 | Rue des Bons Enfants, Tours | 1888 |
| 374 | 373 | 373 | Hôtel Croix-Blanche, Tours | 1888 |
| 375 | 374 | 374 | Market-Place, Tours | 1888 |
| 376 | 375 | 375 | Little Market-Place, Tours | 1888 |
| 377 | 376 | 376 | Hangman's House, Tours | 1888 |
| 378 | 377 | 377 | Cellar-Door, Tours | 1888 |
| 379 | 378 | 378 | Château Bridorez | 1888 |
| 380 | 379 | 379 | Château, Touraine | 1888 |
| 381 | 380 | 381 | Doorway, Touraine | 1888 |
| 382 | 381 | 380 | Château Verneuil | 1888 |
| 383 | 382 | 382 | Mairie, Loches | 1888 |
| 384 | 383 | 383 | Chancellerie, Loches | 1888 |
| 385 | 384 | 384 | Hôtel de Ville, Loches | 1888 |
| 386 | 385 | 385 | From Agnes Sorel's Walk | 1888 |
| 387 | 386 | 386 | Market-Women, Loches | 1888 |
| 388 | 387 | 391 | Hôtel de la Promenade, Loches | 1888 |
| 389 | 388 | 387 | Theatre, Loches | 1888 |
| 390 | 389 | 392 | Tour St. Antoine, Loches | 1888 |
| 391 | 390 | 388 | Market-Place, Loches | 1888 |
| 392 | 391 | 390 | Renaissance Window, Loches | 1888 |
| 393 | — | 389 | Poultry Market, Loches | 1888 |
| 394 | 392 | 395 | Chapel Doorway, Montresor | 1888 |
| 395 | 393 | 393 | Château Amboise | 1888 |
| 396 | 394 | 394 | Clock-Tower, Amboise | 1888 |
| 397 | 395 | 396 | Gateway, Chartreux | 1888 |
| 398 | 396 | 397 | Under the Cathedral, Blois | 1888 |
| 399 | 397 | 398 | Court of the Monastery of St. Augustine, Bourges | 1888 |
| 400 | 398 | 399 | Hôtel Lallemont, Bourges | 1888 |
| 401 | 399 | 400 | Windows, Bourges | 1888 |
| 402 | 400 | 401 | Windows Opposite Hotel, Bourges | 1888 |
| 403 | 401 | 402 | Notre Dame, Bourges | 1888 |
| 404 | 402 | 403 | Steps, Amsterdam | 1889 |
| 405 | 403 | 404 | Square House, Amsterdam | 1889 |
| 406 | 404 | 405 | Balcony, Amsterdam | 1889 |
| 407 | 405 | 412 | Little Drawbridge, Amsterdam | 1889 |
| 408 | 406 | 407 | Pierrot | 1889 |
| 409 | 407 | 408 | Nocturne : Dance House | 1889 |
| 410 | 408 | 406 | Long House—Dyer's—Amsterdam | 1889 |
| 411 | 409 | 409 | Bridge, Amsterdam | 1889 |
| 412 | 410 | 411 | Church, Amsterdam | 1889 |
| 413 | 411 | 410 | The Embroidered Curtain | 1889 |
| 414 | 412 | 415 | Jews' Quarter, Amsterdam | 1889 |
| 415 | 413 | 414 | Little Nocturne, Amsterdam | 1889 |
| 416 | 414 | 416 | Zaandam | 1889 |
| 417 | 415 | 413 | The Mill | 1889 |
| 418 | 416 | 420 | Carpet Menders | (1892–3) |
| 419 | 417 | 422 | Sunflowers, Rue des Beaux-Arts | (1892–3) |
| 420 | 365 | 419 | Rue de la Rochefoucault | 1893 |
| 421 | 366 | 417 | Quai de Montebello | 1893 |

aPlates published as part of the "French Set," 1858.
bPlates published as part of the "Thames Set," 1871.
cPlates published as part of the "First Venice Set," 1881.
dPlates published as part of the "Second Venice Set," 1886.
ePlates published as part of The Naval Review or Jubilee Series.

# ABBREVIATIONS

| | |
|---|---|
| B | Bartsch, Adam. *Le Peintre-graveur.* 21 vols. 1803–21; rpt. Leipzig: Joh. Ambr. Barth, Editeur, 1876 |
| Bér | Béraldi, Henri. *Les Graveurs du XIXᵉ siècle.* 12 vols. Paris: L. Conquet, 1885–92 |
| B & J | Butlin, Martin, and Evelyn Joll. *The Paintings of J. M. W. Turner.* 2 vols. London: Yale University Press, 1977 |
| BP | Birnie Philip Collection, Glasgow University Library |
| BPL | Boston Public Library, Dept. of Prints and Drawings |
| D | Dutuit, Eugène. *Manuel de l'amateur d'estampes.* Paris, 1884 |
| Freer | Freer Gallery of Art, Smithsonian Institution, Washington, D.C. |
| GUL | Glasgow University Library |
| G | Guiffrey, J. J. *L'Oeuvre de Ch. Jacque: Catalogue de ses eaux-fortes et pointes sèches.* Paris: Lemaire, 1868 |
| H | Harrington, H. Nazeby. *The Engraved Work of Sir Francis Seymour Haden.* Liverpool: Henry Young and Sons, 1910 |
| K | Kennedy, Edward G. *The Etched Work of Whistler.* 5 vols. New York: The Grolier Club, 1910 |
| L | Levy, Mervyn. *Whistler Lithographs: A Catalogue Raisonné.* London: Jupiter Books, 1975 |
| LC | Library of Congress |
| L D | Delteil, Loys. *Le Peintre-graveur illustré, XIXᵉ siècle.* 32 vols. Paris: l'auteur, 1906–30 |
| Levy | Levy, Mervyn. *Whistler Lithographs: A Catalogue Raisonné.* London: Jupiter Books, 1975 |
| Lugt | Lugt, Fritz. *Les Marques de collections de dessins et d'estampes.* Amsterdam: Vereenigde Drukkerijen, 1921. *Supplément.* La Haye: Martinus Nijhoff, 1956 |
| Lugt (Ventes) | Lugt, Fritz. *Repertoire des catalogues de ventes publiques.* 3 vols. La Haye: Marinus Nijhoff, 1938 |
| M | Mansfield, Howard. *A Descriptive Catalogue of the Etchings and Drypoints of James Abbot McNeill Whistler.* Chicago: Caxton Club, 1909 |

| | |
|---|---|
| M & T | Malassis, A. P. and A. W. Thibaudeau. *Catalogue Raisonné de L'oeuvre gravé et lithographié de M. Alphonse Legros*. Paris: Chez L. Baur, 1877 |
| NYPL | New York Public Library |
| P | Parthey, Gustav. *Wenzel Hollar*. Berlin: 1853 |
| P | Paulson, Ronald. *Hogarth's Graphic Works: First Complete Edition*. 2 vols. New Haven: Yale University Press, 1965 |
| PC | Pennell Collection, Library of Congress |
| S | Surtees, Virginia. *The Paintings and Drawings of D. G. Rossetti (1828–1888)*. Oxford: Clarendon Press, 1971 |
| S | Shaw, J. Byam. *The Drawings of Francesco Guardi*. London: Faber and Faber, n.d. |
| T | Thomas, Ralph. *A Catalogue of the Etchings and Drypoints of J. A. M. Whistler*. London: J. R. Smith, 1874 |
| TB | Turner Bequest |
| W | Way, Thomas R. *Mr. Whistler's Lithographs. The Catalogue, compiled by T. R. Way*. London: G. Bell and Sons, 1896 |
| W | Wedmore, Sir Frederick. *Whistler's Etchings, a study and catalogue*. London: 1886 |
| Y | Young, Andrew McLaren and Margaret MacDonald, Robin Spencer and Hamish Miles. *The Paintings of James McNeill Whistler*. 2 vols. London: Yale University Press, 1980 |

# NOTES

## CHAPTER ONE

### The Early Years: London, Washington and Paris, 1834–58

1. WHISTLER'S EARLY YEARS

1. Arthur H. Frazier, "Whistler's Father—Topographer Extraordinary," TS, Freer Gallery of Art, Washington, D.C. I am grateful to Martin Amp for bringing this to my attention.
2. For information about the Whistler family, see Kate Donnelly and Nigel Thorp, *Whistlers and Further Family*, exh. cat. (Glasgow: Glasgow University Library, 1980).
3. For a description of these towns and the life of the Whistler family at this time see Gordon Fleming, *The Young Whistler, 1834–66* (London: Allen and Unwin, 1978).
4. These are for the most part to be found in the Pennell Collection at the Library of Congress and in the Birnie Philip collection at Glasgow University Library.
5. Anna Mathilda Whistler, *Diary*, Feb. 27, 1847, LC PC.
6. Whistler later helped to raise money for the restoration of Hogarth's house, and is buried only a few yards from him in Chiswick Cemetery.
7. Elizabeth Robins and Joseph Pennell, *The Whistler Journal* (Philadelphia: J. B. Lippincott Company, 1921), p. 180.
8. Anna Mathilda Whistler, *Diary*, July 1, 1844, LC PC.
9. Pennell, *Journal*, p. 182.
10. Anna Mathilda Whistler, *Diary*, Oct. 10, 1847, LC PC.
11. Anna Mathilda Whistler, *Diary*, July 10, 1848, LC PC.
12. Seymour Haden's father, Charles Thomas Haden (1786–1824), was the author of *Practical Observations on the Management of Children*, which appeared posthumously in 1827. He had practised out of the house at 62 Sloane Street, and left his son both the house and practice. See Victor G. Plarr, *Plarr's Lives of the Fellows of the Royal College of Surgeons of England* (London: J. Wright and Sons Ltd., 1930), p. 486.
13. James McNeill Whistler, Letter to Mrs. Whistler, March 17, 1849, GUL BP 11 Res 1/52.
14. His travel notebooks are now in Special Collections, Glasgow University Library. Among the miscellaneous Haden papers at GUL is Haden's passport issued on Feb. 9, 1844, by the British Consul at Boulogne-sur-Mer. It is possible, from the stamps on the passport, to reconstruct Haden's itinerary. I am indebted to Dr. Nigel Thorp for bringing this material to my attention.
15. Francis Seymour Haden, Journal, July 22, 1844, GUL.

On July 22, echoing the opening lines of Byron's *Fourth Canto* of *Childe Harold's Pilgrimage* (1812–18), "I stood in Venice, on the 'Bridge of Sighs'; A Palace and a prison on each hand," Haden wrote:

Bridge of Sighs by moonlight—as black singular and gloomy as one could desire to see it. . . . There is perhaps no city in chrystendom [sic] which has preserved its originality of character so entirely as Venice—everything but the countenance of the inhabitants has remained unchanged . . .

And just as Byron had described the gondola gliding along "the water looking blackly,/Just like a coffin clapt in a canoe," Haden described:

. . . the singular and elegant gondola—its quaint prow and black, coffin-like cabin—all is so [old]—so very solemn—so perfect—that there is nothing to rouse the enchained intellect . . .

The notebooks are peppered with references to Byron, and it may be safely concluded that, like so many other English travellers in Italy, Haden was following deliberately in the poet's footsteps.

It was not until the following year, in 1845, that a young English contemporary of Seymour Haden, John Ruskin (1819–1900), made his second and most important visit to Venice to begin the detailed recording of architecture which would lead to the publication of *The Stones of Venice* in 1851–3. It is apparent that the two men shared a similar interest in applying scientific observation to the study of art and architecture, and that they shared a common love of the romantic poets and painters, particularly of Byron and Turner, who had captured the contemporary British imagination with their vivid descriptions of Venice.

Continuing in the steps of Byron and Turner, Haden left the north of Italy and travelled on to Switzerland where he stopped at Lake Lucerne, stayed at Fluellen, and visited Tell's Chapel and the Righi. Turner spent part of the summer of 1844 there engaged in making his series of sublime watercolours of Lake Lucerne. It is possible that Haden knew Turner, although it is unlikely that they could have met on this journey, as there is no mention of Turner in the journals. Haden's granddaughter claimed that she had in her possession "sheets of delightful pencil studies he made, and charcoals and an early Turner drawing done when they were sketching in Wales." (Davia Seymour-Haden,

Letter to Walter Stanton Brewster, April 18, 1947. Walter Stanton Brewster Collection, Art Institute of Chicago.)

16. It is possible from the journals to date some of the drawings from which Haden made etchings. Among these are the *Tomb of Porsena* (June 13), the *Castle of Ischia* (June 23), *Houses on the Tiber* (April 1), and the *Villa of Maecenus* (April 16; May 18).

17. Francis Seymour Haden, *The Etched Work of Rembrandt True and False* (London: Macmillan and Co., 1895), p. 6 (hereafter referred to as *Rembrandt* (1895).

18. Haden, Letter to S. P. Avery, Jan. 29, 1889, Sir Francis S. Haden Letters, 1864–1902, Rare Books and Manuscripts Division, The New York Public Library, Astor, Lenox, and Tilden Foundation.

19. Unfortunately a single buyer could not be found, and the collection was ultimately broken up and sold in sections. The old master prints were sold in June, 1891, and the miscellaneous modern etchings and Meryon etchings in 1911 following Haden's death.

In attempting to reconstruct Haden's collection the three sales catalogues provide a point of departure. The old master prints, which were sold together with Haden's collection of master drawings and part of his library, were included in the *Catalogue of the Collection of Prints and Drawings Formed by Francis Seymour Haden* auctioned by Sotheby, Wilkinson and Hodge, June 15–19, 1891. They were divided into 605 lots, many of which consisted of more than one work, or more than one state. The *Catalogue of the Miscellaneous Etchings Formerly Belonging to Sir Francis Seymour Haden*, published by Kennedy and Co. in New York in 1911, contained 321 entries, and the *Catalogue of Meryon's Etchings*, by Wunderlich in New York in 1911 contained 87 entries, each including several states or proofs. In addition, Haden had an extensive collection of modern etchings which does not appear to have been catalogued, and which must have rivalled his old master collection in extent. It included his important collection of Whistler etchings and his collection of Alphonse Legros which Beraldi said was one of the most comprehensive ever formed.

20. *Sotheby*, 1891. The Rembrandt entries appear under Lots 329–472.

21. Joseph Maberley, *The Print Collector* (London, 1844), p. 53. See John R. Klein, "The Prints and Writings of Francis Seymour Haden," (M.A. Report Courtauld Institute, University of London, 1977), pp. 13–14 and f.n. 7.

22. Francis Seymour Haden, *Catalogue of the Etched Work of Rembrandt*, exh. cat. (London: Burlington Fine Arts Club, 1877), p. 5. (hereafter referred to as *Rembrandt* (1877). In this exhibition, Haden applied his "subversive theory" by hanging Rembrandt's *oeuvre* chronologically, whereupon the less competent works of Rembrandt's pupils and followers became apparent. Next to etchings by Rembrandt he hung Rembrandt School etchings made in the same year, and challenged his public to discern the difference between the line of master and pupil. Moreover, he advised his viewers "while their eye is full of what they have seen," to go to the British Museum and other public and private collections, and compare the impressions which they had seen with others (p. 8).

23. Francis Seymour Haden, *About Etching*, exh. cat. (London: The Fine Art Society, 1879), p. 56.

24. Whistler, Letter to Major Whistler, Jan. 26, 1849, GUL BP 11 Res 1/46.

25. Major Whistler, Letter to Whistler, Jan. 18, 1849, GUL BP 11 Res 1/43.

26. Mrs. Whistler, Letter to Whistler, Jan. 20, 1849, GUL BP 11 Res 1/43.

27. Whistler, Letter to Major Whistler, Jan. 26, 1849, GUL BP 11 Res 1/43. Whistler's tastes appear to have leaned toward the grand manner and romantic subject painting at this time. In March, no doubt as a result of Whistler's interest in Fuseli who Charles Robert Leslie (see p. 221) called in his second lecture "a great genius—a genius of whom the age was not worthy," Haden

gave Whistler a print which would not have been to his own taste, but which Whistler described enthusiastically in a letter to his mother, saying: "Seymour has given me such a nice present: a 10s Print from one of Fuseli's works called 'The Lazar House,' it is taken from Milton and is really a fine thing tho' much exaggerated." (Whistler, Letter to Mrs. Whistler, March 17, 1849, GUL BP 11 Res 1/52).

28. Paul Mantz, "Artistes Anglais: Charles Leslie," *Gazette des Beaux-Arts*, Sér. 1, 4, No. 3 (1859), p. 81.

29. Paul Mantz wrote that Leslie's lectures were "très suivi", in his obituary on Leslie, 182.

30. Whistler would have been able to study these lectures in advance. They appeared as Charles Robert Leslie, "Professor Leslie's Lectures on Painting," *The Athenaeum*, No. 1060 (1848), 191–4; No. 1061 (1848), 220–3; No. 1062 (1848), 247–51, and No. 1063 (1848), 270–4.

31. Leslie, "Lectures," 193.

32. Leslie, "Lectures," 249.

33. Leslie, "Lectures," 192.

34. Leslie, "Lectures," 248.

35. Sir Joshua Reynolds, *Discourses on Art*, ed. Robert Wark (New Haven: Yale University Press, 1981), *Discourse IV*, p. 63.

36. Reynolds, *Discourses, Discourse IV*, p. 69. "The painters of the Dutch school have still more locality. With them, a history-piece is properly a portrait of themselves; whether they describe the inside or outside of their houses, we have their own people engaged in their own peculiar occupations; working, or drinking, playing, or fighting. The circumstances that enter into a picture of this kind, are so far from giving a general view of human life, that they exhibit all the minute particularities of a nation differing in several respects from the rest of mankind. Yet, let them have their share of more humble praise. The painters of this school are excellent in their own way; they are only ridiculous when they attempt general history on their own narrow principles, and debase great events by the meanness of their characters."

37. Major Whistler, Letter to Whistler, Oct. 29, 1848, GUL BP 11 Res 1/24.

38. Reynolds, *Discourses, Discourse XI*, p. 199.

39. Leslie, "Lectures," 192.

40. John Ruskin, *Modern Painters*, 6th ed. (London: Smith, Elder and Co., 1857–88), I, 36. Haden owned a set of *Modern Painters*, the 1st volume of which bore the publication date 1848. It is not known when he acquired it, but given his interest in Turner, it could well have been during that year. See *Sotheby*, 1891, Lot 648.

41. Reynolds, *Discourses, Discourse II*, p. 31.

2. WHISTLER IN AMERICA

1. Mrs. Whistler, Letter to Mrs. Harrison, Friday, 20th 1849, LC PC.

2. For an account of Whistler's days at West Point, see Fleming, *Young Whistler*, pp. 80–108.

3. H. M. Lazelle, "Whistler at West Point," *Century Magazine*, Vol. 90 (1915), p. 710. Lazelle was Whistler's room-mate.

4. Day Allen Willey, "Whistler's West Point Drawings," *Book News Monthly*, v. 30 (1912), 637.

5. Deborah Whistler, Letter to Whistler. Nov. 9, 1851, GUL BP 11 Res 1/71. Deborah writes to her young half-brothers, "We have some books lent to us just now which I am sure you would like to see—magnificent engravings from the Florence Gallery. There are some of Titian's heads which Seymour is constantly saying 'now that's just what Jemmie would like'."

6. Mrs. Whistler, Letter to Margaret Harrison, Feb. 21, 1853. LC PC.

7. Fleming convincingly proposes this in *Young Whistler*, pp. 103–5.

8. Morris Schaff, *The Spirit of Old West Point* (Boston; Houghton Mifflin, 1907), p. 22.

9. Sd. Henry S. Pritchett, Note to Howard Mansfield, May 8, 1900, The Pierpont Morgan Library.

10. John Ross Key, "Recollections of Whistler," *Century Magazine*, 75 (1908), 931.

11. The history of the Coast Survey Plate was given to the Pennells by Fitzroy Carrington of Keppels on Sept. 5, 1906. It had been given, together with some drawings, to a Chicago man who Whistler had known from West Point days, whose name Carrington could not remember. He had sold it after having it for more than 30 years to Mr. Keppel, who sold it to William Heinemann, from whom it was passed to George S. Hellman, a dealer in the New York Cooperative Society at 34th St. and 5th Ave. He wrote a second letter on Sept. 7, 1906, saying "the man from whom the Coast Survey plate was bought in Chicago was Mr. John R. Key—an artist (obscure)." LC PC.

All of the impressions were made on modern laid paper or thin Japanese papers. The first impression, taken at the Coast Survey, was printed on heavy paper resembling card.

12. This sketchbook and its contents is carefully analysed by Nancy Pressly in "Whistler in America: An Album of Early Drawings," *Metropolitan Museum Journal*, 5 (1972), pp. 125–54. I am especially grateful to Mrs. Pressly for lending me her collection of photographs of Whistler's early drawings.

13. Miscellaneous notes made on Dec. 17, 1907 by Howard Mansfield concerning Whistler's plate of Anacapa Island, The Pierpont Morgan Library. The etching would have been transferred to the stone using transfer paper.

14. Elizabeth Robins and Joseph Pennell, *The Life of James McNeill Whistler* (London: William Heinemann, 1909), I, 46.

15. Mrs. Whistler, Letter to Whistler 13 Feb., 1854, GUL W.447. Quoted by Fleming, *Young Whistler*, p. 114. She writes "persevere till your year on the U.S.C.S. is fulfilled. It will be impossible without ruin to our little stock that you go to Europe (as you seem to cherish hopes) and that Willie return to College which he is preparing by daily hard study to do." She may have suggested that he wait until his inheritance arrived to alleviate his dependence on her.

16. Pritchett, Note to Mansfield, The Pierpont Morgan Library.

17. Key, "Recollections," p. 929.

18. Mrs. Whistler, Letter to Whistler, July 11, 1855, GUL BP 11 Res 1/127 W.458.

19. Mrs. Whistler, Letter to Whistler, July 25, 1855, GUL BP 11 Res 1/128 W.459.

20. A most important document for tracing Whistler's movements in 1855–8. GUL.

3. NATURALISM AND "THE ROAD TO HOLLAND"

1. Entry cards, GUL BP 11 36/33 and 36/35.

2. See Albert Boime, "The Instruction of Charles Gleyre and the Evolution of Painting in the Nineteenth Century," in *Charles Gleyre ou les illusions perdues*, exh. cat. (Winterthur: Kunstmuseum, 1974), p. 103.

3. Leonée Ormond, *George du Maurier* (London: Routledge and Kegan Paul, 1969), p. 46.

4. Charles Gleyre, Letter to Count de Nieuwenkerke, n.d. (June, 1856), Archives du Louvre. The card was issued on June 17, 1856, GUL BP 11 36/35.

5. Luke Ionides, *Memories* (Paris: Herbert Clarke, 1925), p. 10.

6. Pennell, *Journal*, p. 165.

7. Pennell, *Journal*, p. 87.

8. Mrs. Whistler, Letter to Whistler, [no month] 30, 1856, GUL BP 11 Res 1/124.

9. Charles Baudelaire, "The Salon of 1845," in *Art in Paris, 1845–1852*, trans. Jonathan Mayne (London: Phaidon, 1970), p. 16.

10. Charles Baudelaire, "Some French Caricaturists," in *The Painter of Modern Life*, trans. Jonathan Mayne (London: Phaidon, 1964), p. 183.

11. Baudelaire had written a searing review of Gleyre's submission to the Salon of 1845. See Mayne, *Art in Paris*, p. 16.

12. For information regarding the English Group, see Ormond, *Du Maurier*, pp. 34–63.

13. Ormond, *Du Maurier*, p. 46.

14. Ormond, *Du Maurier*, p. 54.

15. The episode appears to have taken place between Jan. 1, 1857, when the English Group moved into the studio and early summer when Du Maurier moved to Antwerp. See Ormond, *Du Maurier*, pp. 60–5.

16. L. M. Lamont, ed., *Thomas Armstrong, C.B. A Memoir* (London: Martin Secker, 1912), p. 146.

17. Ormond, *Du Maurier*, p. 60. Léonée Ormond has never managed to find an impression of this plate. Letter to the author 3 August, 1983.

18. At the end of the Salon it became part of the Luxembourg collection, where it "proved so popular with collectors and art critics" that four copies were commissioned. The picture is vertical in format, with a dramatically sloping ceiling. Light falls on the two unfortunate figures in the dim interior through a small dormer window. I would like to thank Alan Bowness for drawing the painting to my attention. See Gabriel P. Weisburg, *The Realist Tradition: French Painting and Drawing, 1830–1900*, exh. cat. (Cleveland: Cleveland Museum of Art, 1981), p. 44, no. 5.

19. Mayne, *Art in Paris*, p. 70.

20. This is the address given in the Salon listing for Tassaert in 1857. See H. W. Janson, ed., "Paris Salon de 1857," in *Catalogues of the Paris Salon*, 1673–1881, 60 vols (New York: Garland Publishing, 1977), p. 318.

21. Pennell, *Journal*, pp. 88–9. Oulevey told the Pennells that "In the Rue Campagne-Première, Whistler had a little hand press and pulled his own prints, sometimes before the people who bought them."

22. The two impressions are in Glasgow in the Birnie Philip Estate and in the Freer Gallery. The latter belonged to Haden and bears the inscription.

23. Jules Castagnary, "Philosophie du Salon de 1857," in *Salons 1857–70* (Paris: Bibliothèque Charpentier, 1892), pp. 1–65.

24. Anne Coffin Hanson, "Manet's Subject Matter and a Source of Popular Imagery," in *Museum Studies*, Art Institute of Chicago, 3(1968), pp. 64–5.

25. Castagnary, "Salon de 1857," p. 15.

26. Castagnary, "Salon de 1857," p. 47.

27. Charles Blanc, *Les Trésors de l'art à Manchester* (Paris: Pagnaire, Librairie-Editeur, 1857), p. 15.

28. Living in exile, following his political activity during the 1848 Revolution, Théophile Thoré adopted the pseudonym William Bürger, and devoted himself to the study of art history. For an analysis of Thoré-Bürger's contribution, see Frances Suzman Jowell, *Thoré-Bürger and the Art of the Past* (New York: Garland Publishing, 1977).

29. William Bürger, *Trésors d'art exposés à Manchester en 1857 et provenant des collections royales, des collections publiques, et des collections particulières de la Grande Bretagne* (Paris: Jules Renouard, 1857), p. 238.

30. Bürger, *Trésors*, p. 321.

31. Anon., *Catalogue of the Art Treasures of the United Kingdom Collected at Manchester in 1857* (London: Bradbury and Evans, 1857), p. 23. Introduction by George Scharf.

32. Blanc, *Manchester*, p. 212.

33. Blanc, *Manchester*, p. 234.

34. Blanc, *Manchester*, p. 236.

35. Paul Poujaud, Letter to Marcel Guérin, July 11, 1936. Quoted in Theodore Reff, "Le Papillon et le vieux boeuf," in *From Realism to Symbolism: Whistler and His World*, ed. Allen Staley, exh. cat. (New York: Columbia University, 1971), p. 28.

36. George Lucas, *The Diary of George A. Lucas: An American Art Agent in Paris, 1857–1909*, ed. Lilian M. C. Randall (Princeton: Princeton University Press, 1979), p. 73.

37. See Appendix A, p. 276.
38. The first of these may be seen in the Avery Collection at the New York Public Library. The second was purchased at Sotheby's by M. Thibaudeau, see GUL BP 11 6A–47.
39. Mrs. Whistler, Letter to Whistler, May 7, 1858, GUL BP 11 Res 1/141.

4. REALISM AND URBAN WORKING WOMEN

1. Champfleury, "Du Réalisme: Lettre à Madame Sand," *L'Artiste*, 16, No. 5 (1855).
2. Castagnary, "Salon de 1857," p. 29.
3. Achille Fould, *Le Moniteur universel*, Sunday, Aug. 16 and Monday, Aug. 17, 1857, p. 898, in *Realism and Tradition in Art, 1848–1900*, trans. Linda Nochlin (London: Prentice-Hall, 1966), pp. 3–4.
4. Andrew McLaren Young, Margaret MacDonald, Robin Spencer and Hamish Miles, *The Paintings of James McNeill Whistler* (London: Yale University Press, 1980), I, no. 26. The arguments for dating this painting are summarized here.
5. This painting is said to have been inspired by Rembrandt's self-portrait in the Louvre. See Young, *Whistler*, I, No. 23.
6. For a description of this theme, see Gabriel P. Weisberg, *The Realist Tradition: French Painting and Drawing, 1830–1900*, exh. cat. (Cleveland: The Cleveland Museum of Art, 1981), pp. 42–63.
7. Théodore Duret, *Histoire de J. McN. Whistler et de son oeuvre* (Paris: H. Floury, Editeur, 1914), p. 8. Duret described their relationship as follows: "Cette mère Gérard venait de la bourgeoisie, elle était instruite, elle faisait des vers; de chute en chute, après avoir tenu un cabinet de lecture, elle s'était vue réduite à vendre des fleurs à la porte du bal Bullier. Whistler, attiré par son aspect pittoresque, avait voulu l'utiliser comme modèle et, pour en mieux disposer, l'avait tenue longtemps auprès de lui, la promenant par la ville et l'emmenant à la campagne, à l'étonnement des spectateurs."
8. Joseph C. Sloane, *French Painting Between the Past and the Present: Artists, Critics and Traditions from 1848–1900* (Princeton: Princeton University Press), p. 74.
9. Pressley, "Album," p. 139, f.n. 74.
10. Weisberg, *The Realist Tradition*, p. 45.
11. Anne Coffin Hanson, *Manet and the Modern Tradition* (New Haven and London: Yale University Press, 1977), p. 72.
12. Pennell, *Journal*, p. 89. This episode was set in Paris in the rue Campagne-Première.
13. Faucheux, "Musées de la Hollande," *Revue Universelle des Arts*, 8 (Oct. 1858–Mars 1859), p. 179. He wrote:

Je viens, un peu tard, parler d'un excellent petit livre, que tout le monde artistique connaît aujourd'hui, que chacun a lu, qui se trouve dans toutes les bibliothèques d'amateurs; je veux parler du livre de M. W. Burger sur les musées d'Amsterdam et de la Haye.

14. *Sotheby*, 1891, lot 613.
15. William Bürger, "Rembrandt au Musée d'Amsterdam," *L'Artiste*, 7, No. 4 (1858), 182.

chose étonnante, que cette peinture, la plus fantastique qui existe au monde, sans aucune comparaison, sont en même temps le plus réel.

16. Mrs. Whistler, Letter to Whistler, Aug. 1, 1858, GUL BP 11 Res 1/142.

5. WHISTLER'S RHINE JOURNEY

1. Pennell, *Journal*, p. 43.
2. The sketches referred to in this chapter are all in the Freer Gallery of Art.
3. The itinerary can be reconstructed by pooling the information found in the passport with that found on the titles of etchings, inscriptions on drawings in the Freer mentioned later in this chapter, and in Whistler's reminiscences to the Pennells. For the correct order of the plates, see Haden's letter to Mansfield, Appendix A.
4. There can be no doubt that Whistler was familiar with the etched work of Jacque at this time. While there does not appear to be a list of Jacque etchings in the Haden collection, it is unthinkable that he would not have represented the most prolific naturalist etcher, and the leader of the nineteenth-century French etching revival. Whistler's friend George Lucas was beginning to assemble his outstanding collection of Jacque etchings at this time (now in the Print and Drawing Dept. of the Baltimore Museum of Art), and Thomas Armstrong of the "English Group" spent time painting at Barbizon and had even met Millet (Lamont, *Armstrong*, p. 39). Charles Blanc pointed out in "De la gravure à l'eau-forte et des eaux-fortes de Jacque," *Gazette des Beaux-Arts* Sér. 1, 9, No. 4 (1861), 204, that Jacque was "un artiste qui est plein de vie a vue ses oeuvres devenir aussi rares que celles d'Ostade, de Corneille Dusart, ou de Thomas Wyck".
5. This plate was given the title *La Maison délabrée, Alsace* by Henry Béraldi, *Les Graveurs du XIXe siècle* (Paris: L. Conquet, 1885–92), XII, 280.
6. There can be no doubt that the drawings mentioned in this chapter, which are all in the Freer Gallery of Art, are preliminary to the etchings. The Pennells created some confusion, no doubt abetted by Whistler, when they wrote: "The statement has been made that these plates were done from sketches, most of the so-called sketches were made after the plates were finished to show his friends and relations what they were like; they were drawn, he told me, straight on the copper . . . So far as we know he never made a preliminary sketch." (Pennell, *Life*, I. 72.) Whistler did not believe in making preliminary sketches once his pattern of working directly from nature was established, and he looked askance at his early etchings. However, the consistent reversal of the image, together with the careful annotations on the drawings, makes the possibility of their having been made afterwards to show his friends what his etchings looked like quite unthinkable. The corroboration between the etchings and drawings is so exact that he could never have reconstructed the detail from memory.
7. When Whistler did finally use this composition as the basis for the etching *The Miser*, he brought a level of imagination to his interpretation which is not found in the etchings of 1858. In the plate, the figure by the window was darkened to dramatize his isolation, and the tunnel-like perspective of the room with its long trestle table was exaggerated. It is out of place among the straightforward and picturesque etchings from nature published in the "French Set". It is not clear where the title came from; the plate was originally entitled *A Room* in the Thomas catalogue. It is executed in drypoint which Whistler began to use in the autumn of 1859. It is not included among the etchings made in 1857–9 in Haden's letter to Mansfield (see Appendix A.)
8. A good example of the genre is Bonvin, *Porte de Chaumière*, 1855. Pen and ink, watercolour, and gouache, on grey paper, 25.9 × 21.2 cm. Art Market, London, 1981.
9. Gabriel P. Weisberg, *Bonvin* (Paris: Editions Geoffroy-Dechaume, 1979), p. 174.
10. Leslie, "Lectures," p. 249.
11. In 1857, Thoré-Bürger mentioned de Hooch in the catalogue of the Manchester Art Treasures exhibition, saying: "Pieter de Hooch clora bien cette longue suite de Hollandais, inaugurée par Rembrandt, à qui il ressemble, comme perfection du clair-obscur et justesse de la lumière dans ses éclats. On ne connât point son maître, mais c'est Rembrandt qui l'est." Pointing to the four paintings included in the exhibition, he noted that de Hooch was "très-rare", and that the Louvre had "un chef-d'oeuvre, *La Partie de cartes*." (Thoré-Bürger, *Trésors*, p. 317.)
In his article "Révision du Catalogue des Tableaux du Musée

de Paris" which appeared in *L'Artiste* on "*desiderata* de l'histoire de l'art hollandais" ("Revision du catalogue des tableaux de musée de Paris," *L'Artiste*, 7, No. 4 (1858), 173), he said that the Dutch had neglected to patronize him as he deserved, unlike the English, and that the English "ont exalté de Hooch comme il le mérite."

12. Haden put together a remarkable Meryon collection, subsequently described in the *Catalogue of Meryon's Etchings Formerly Owned by Sir Francis Seymour Haden* (Wunderlich: New York, 1901). His first recorded visit to Meryon took place in 1860 after the artist's release from Charenton, when Haden went to buy on behalf of the South Kensington Museum (subsequently the Victoria and Albert Museum). Haden clearly admired Meryon's work and had no doubt secured fine impressions for himself before this time. (See Martin Hardie, 'The Technique and Etching of Charles Meryon and James Abbott McNeill Whistler," *Proceedings of the National Picture Print Society*, 3 (1937–8), p. 36.)

13. It was ceded to Germany after the Franco-Prussian War in 1870.

14. An article by Jules Janin extolling the pleasures of Baden appeared in *L'Artiste* on August 1, 1858. *L'Artiste* 7, No. 4 (1858).

15. Pennell, *Journal*, pp. 43–4.

16. E. S. Lumsden, *The Art of Etching* (1924; rpt. New York: Dover, 1962), p. 295.

17. Weisberg, *Bonvin*, pp. 247, 250.

18. Pennell, *Journal*, pp. 43–4.

19. Pennell, *Journal*, pp. 43–4.

20. Whistler, Letter to Deborah Haden, 1858, GUL Rev. 1955 H/1.

21. Despite the fact that Whistler never got to Amsterdam, there are some cryptic notes in his passport which make it possible to reconstruct some of his destinations in that city, no doubt made *en route*. They are: "Musée des Estampes Directeurs Kleinhamer et Engelberts/Japon-Herenlogement Amsterdam/Ferdinand Bol Leprozenhuis." Whistler clearly intended to go to see Ferdinand Bol's painting of the *Four Regents of the Lepers' Asylum in Amsterdam,* 1649, which was hanging at that time in the Regent's Chamber of the Leper's Asylum (Leprozenhuis). This painting has been on loan to the Rikjsmuseum since 1926.

The reference to the "Musée des Estampes" refers to the extraordinary print collection then under the curatorship of H. A. Klinkhamer, which was famous for its Rembrandt etchings as well as other Dutch prints. It became part of the Rijkmuseum in 1885. (See *Gids Voor Het Rikjsprentenkabinet* (Amsterdam: Rijksmuseum, 1964), p. 18.)

The Japon-Herenlogement probably refers to the place where Whistler and Ernest were hoping to stay. Whistler arranged a forwarding address in Amsterdam to which he wrote to check for letters while waiting in Cologne.

22. Lucas, *Diary*, p. 82.

23. Pennell, *Life* 1, 68.

## 6. THE "FRENCH SET"

1. Mrs. Whistler, Letter to Mr. Gamble, Dec. 5, 1858, GUL AM 1963 W/22.

2. See Appendix A.

3. This was brought to my attention by Martin Amp, Assistant to the Director, Freer Gallery of Art.

4. Whistler wrote to Delâtre for the recipe years later, when he began to etch again at Speke Hall on 22 Jan. (1873):

> . . . comment mêlez-vous votre acide pour mordre. J'ai oublié—en quantiés égales n'est-ce pas—C'est-à-dire moitié eau et moitié acide nitrique. (LC PC)

While Delâtre's reply has not been located, it would seem from Whistler's subsequent missive that Delâtre sent him the recipe for

the "Dutch bath," and ascribed its invention to Haden. Whistler wrote back in defence of Rembrandt: "Notez bien que la formule n'est pas seulement à Haden—L'acide en question—appelée le "Mordant Hollandais"—ou bien Bain Hollandais est parfaitement connu lá-bas—un artiste à Amsterdam me l'a donné il y a bien longtemps. On dit que Rembrandt s'en servait. Maintenant quant à l'autre, Acide Chromique—qu'est-ce que c'est?—et quel sont les proportions d'eau avec laquelle il faut les mêler? Cela me parait bien—et je voudrais bien m'en servir." (LC PC)

5. The etcher E. S. Lumsden pointed out that the "French Set" and the "Thames Set" plates were bitten in the bath, writing: ". . . no plates worked thus solidly up to their platemarks (e.g. *Black Lion Wharf* and *La Vieille aux loques*) could have been done in any other manner. In the last mentioned, if the margin be examined, foul biting will be found running right up to the edge (including several finger marks) where all the ground was weakened during the plate's manipulation." (Lumsden, *The Art of Etching*, p. 67.)

6. Haden went so far as to advocate false biting saying "it is always to be welcomed and the results of it never to be removed." (S. R. Koehler. Letter "Mr. Seymour Haden's Lectures," *Boston Daily Advertiser*, Dec. 9, 1882. Haden Clippings File, Dept. of Prints and Drawings, Boston Museum of Fine Arts).

7. Pennell, *Life*, 1, 71.

8. In 1859, during its first year of publication, the *Gazette des Beaux Arts* carried a two-part article in May and August by Vallet-Viriville, entitled "Notes Pour Servir à l'Histoire du Papier." Different types of old paper and watermarks were described in some detail. Whistler and Haden must have seen the articles, for Haden had a subscription to the *G.B.A.*

9. In 1726 a hundred thousand reams of this paper were sold in Amsterdam in a single day. It was the whitest of papers made prior to the invention of bleaches, perhaps because of the whiteness of the puritan linen which went into making it. It had the finest texture of any hand-made antique paper, and is characterized by its thin, well-drawn lines, its translucency, and its smooth surface. The invention in the late seventeenth century of the Hollander beater, which tore the rags into shreds finer than any used before in papermaking, and the careful hand polishing given to the surface of the sheet at the end of the paper-making process were largely responsible. Dard Hunter, *Papermaking: The History and Technique of an Ancient Craft* (1943; rpt. New York: Dover Publications, 1978), p. 243.

10. Vallet-Viriville (see f.n. 8, p. 223 above) had praised this paper highly in his article, calling it "papier de chine":

> Le papier de la Chine, comme on sait, affecte diverses nuances, dans la gamme du blond. Il est fin à merveille, ondoyant et soyeux; il prépare, à tout empreinte en noir, un fond doux, suffisamment clair, qui plaît à l'oeil et repose la vue. Ce papier boit, avec une finesse et une sensibilité sans pareilles, le moindre trait quelconque qu'on y imprime.

11. As Christopher White has pointed out in *Rembrandt as an Etcher* (London: A. Zwemmer, 1969), I, pp. 14–15, "Rembrandt experimented with a wide variety of papers. He would sometimes buy empty books at auction in order to break them up for their old paper. He made proof impressions from the same plate on different types of paper to see what effect a particular tone and texture would have on the mood of the finished work. Early in his life he preferred to print on ordinary white paper, the fine white laid which at that time came from France and Germany. As he became interested in richer tonal effects in the 1640s, he began to vary the kind and colour of paper used. He made a number of impressions on heavy grey "oatmeal" paper, which was softer, rugged in feel, and contrasted less with the tone of the ink than impressions taken on white paper. Inspired by his admiration for the curious etchings of Hercules Seghers, Rembrandt experimented with coloured washes, occasionally adding pale yel-

low, pale pink, and an opaque green-grey to the paper before printing the plate. Since Rembrandt, unlike Seghers did not like to use coloured inks, he soon abandoned his experiments for the black ink did not look well on the tinted paper."

12. Mrs. Whistler, Letter to Mr. Gamble, Dec. 5, 1858, LC AM 1962.

13. Whistler, Letter, *New York Tribune*, Aug. 16, 1880, GUL BP 11 6A/40.

14. Mrs. Whistler, Letter to Mr. Gamble, Dec. 5, 1858, LC AM 1962.

15. Fantin, Letter to Whistler, June 29, 1859. GUL BP II L/25.

16. Delannoy, Letter to Whistler, Nov. 9, 1858, GUL BP 11 D/43.

17. Mrs. Whistler, Letter to Mr. Gamble, Dec. 5, 1858, LC PC.

## 7. DOMESTIC GENRE ETCHINGS

1. "Etching Club Minutes and Accounts," MS, Library, Victoria and Albert Museum. Minutes for Tuesday, 16 Nov., 1858.

2. Fantin Latour in a letter to his parents. July 17, 1859, wrote to say that Haden's "atelier" contained "tous les outils, les presses, la où il y a du monde qui vient voir imprimer." Grenoble.

3. The dating of this plate was somewhat confused by a note written by Whistler, probably in the 1880s, to Walker G. Chambers, now in the Art Institute of Chicago, Brewster Collection. It reads "The Wine Glass was done in England at the time of the first Thames etchings." If taken literally, this would push the date of the etching forward to the early summer of 1859. It fits logically in subject and style with the etchings made at Christmas, 1858, and was placed among them by Haden when he revised Mansfield's list. The date of Haden's drawing, *The Wine Glass*, in the Albright–Knox Art Gallery in Buffalo, New York, tends to confirm this likelihood.

4. Although Ralph Thomas, Whistler's first dealer and the author of the first catalogue of his etched work, initially believed that this plate was made in Paris in 1859, and was retouched in England in 1861 (Ralph Thomas, *A Catalogue of the Etchings and Drypoints of J.A.M. Whistler* (London: J. R. Smith, 1874, no. 29)), he later noted in the margin of his copy of Wedmore's catalogue next to the relevant entry, "Mrs. Haden." This copy of Frederick Wedmore, *Whistler's Etchings: A Study and Catalogue* (London: A. W. Thibaudeau, 1886), is in the collection of Mr. Paul Marks which was brought to my attention by Margaret Macdonald. Haden placed it among the etchings done at Christmas 1858.

5. In his "Salon of 1857", p. 39, Castagnary wrote:

Au-dessus du niveau des foules s'élève un petit nombre d'hommes d'élite, que les inquiétudes de la pensée ou les agitations du coeur ont marqués comme d'un signe. Ce sont des penseurs, des poètes, des savants, des magiciens, des prophètes.

6. The title "The Slipper" is annotated on an impression in the Avery Collection, NYPL.

7. Leslie, "Lectures," p. 250.

8. T. R. Way wrote on an impression now in the Rosenwald Collection in the National Gallery, Washington, "may be compared to Rembrandt's shell."

9. This impression is currently on the art market in New York. It passed through Sotheby's in a sale of prints "from the collection of the late Sr. F. Haden's brother," Nov. 18, 1931. The portrait is merely the outline of a head.

10. Lumsden, *The Art of Etching*, p. 296.

11. This drawing is also in the Albright–Knox Art Gallery, Buffalo, N.Y.

12. This impression is now in the Metropolitan Museum of Art, New York. The inscription was first noted in Allen Staley, ed., *From Realism to Symbolism: Whistler and His World*, exh. cat. (New York: Columbia University, 1971), p. 81, by Marion Spears Grayson.

13. *Sotheby*, 1891, Lot 458.

14. As Eleanor Sayre and Felice Stampfle pointed out in *Rembrandt, Experimental Etcher*, exh. cat. (Boston Museum of Fine Arts, 1969), p. 11, Rembrandt, in experimenting with this plate, ". . . made even more beautiful and impressive prints by leaving carefully wiped surface tone on the plate. In a number of impressions this produces a dramatic darkness which intensifies the harshness of the tragedy. It is this masterly and imaginative use of tone which makes many of the impressions printed by Rembrandt himself unique and precious."

15. Douglas Druick believes that Whistler could have discussed this with Fantin between October 7 and November 6. For drawings by Fantin on this theme, see Douglas Druick and Michael Hoog, *Fantin Latour*, exh. cat., (Ottawa: The National Gallery of Canada, 1981) pp. 89–91.

16. This impression is in the Museum of Fine Arts, Boston.

17. This impression, inscribed "my friend Traer", is in the New York Public Library.

18. When the painting was X-rayed it was discovered that "a thin preparatory stage of the design was first made to include the figure at the piano, the picture frames, but perhaps not the listening girl." Young, *Whistler*, I, 8, No. 24.

## CHAPTER TWO

## Whistler and Realism, 1859–67

### 1. ENGLISH LANDSCAPE ETCHINGS

1. M. Ferlet, Letter to Ludovic Barrie, Jan. 6, 1859, Bibliothèque d'Art et d'Archéologie, Paris. Quoted by Louise d'Argencourt Douglas Druick in *The Other Nineteenth Century: Paintings and Sculpture in the Collection of Mr. and Mrs. Joseph Tanenbaum*, exh. cat. (Ottawa: National Gallery of Canada, 1978), p. 92.

2. Pennell, *Life*, 1, 75.

3. Pennell, *Journal*, p. 40.

4. Janson, *Catalogues of the Paris Salon, 1673–1881*. "Salon de 1859", p. 475, nos. 3673 and 3674.

5. Algernon Graves, *The Royal Academy Exhibitors: A Complete Dictionary of Contributors and their Work from its Foundation in 1769 to 1904*, 8 vols. (London: George Bell and Sons, 1905), VIII, p. 249, no. 1197.

6. Castagnary, "Salon de 1857", p. 39.

7. Fantin, Letter to Whistler, June 26, 1859, GUL BP 11 L/25.

8. Fantin, Letter to his parents, July 14, 1859, Grenoble.

9. Fantin, Letter to his parents, July 15, 1859, Grenoble.

10. Mayne, *Art in Paris*, p. 164.

11. Mayne, *Art in Paris*, p. 159.

12. Mayne, *Art in Paris*, p. 162.

13. Mayne, *Art in Paris*, p. 157.

14. Mayne, *Art in Paris*, p. 197.

15. Mayne, *Art in Paris*, p. 164.

16. Whistler, Letter to Fantin, Jan. 5, 1864 (mfm. 797–802), LC PC.

17. Castagnary, "Salon de 1857," p. 59. He wrote: ". . . un paysage ferme et vigoureux, qui ne mérite qu'un reproche, mais capital. *Pourquoi ce télégraphe électrique?* Que signifie-t-il, je ne dis pas dans cette toile, mais dans toute toile? Qu'y-a-t'il de commun entre ce fil d'archal, ce produit industriel, utile, et le paysage, recherche et expression du beau dans la nature? Evidemment c'est un non-sens."

18. Fantin, Letter to Whistler, Aug. 5, 1859, GUL BP 11 L/26.

### 2. THE THAMES ETCHINGS OF 1859

1. Gerstle Mack, *Gustave Courbet* (London: Hart-Davies, 1951), p. 162.

2. Fantin, Letter to his parents, July 24, 1859, Grenoble.

3. Mayne, *Art in Paris*, pp. 200–1.

4. Léonce Bénédite, "Artistes Contemporains: Whistler," *Gazette des Beaux Arts*, Pér. 3, 33, No. 575 (1905), 410.

5. Haden, *About Etching* (1879), quoted in Richard Pennington "The Etched Work of W. Hollar—A descriptive Catalogue," 15 vols. T. S., 1, Foreward, n.p. Thomas Fisher Rare Book Library, University of Toronto.

6. Leslie, "Lectures," p. 233.

7. *Old Battersea Bridge*, Y.33.

8. Fantin, Letter to his parents, July 15, 1859, Grenoble.

9. This is described in length in Fantin, Letter to his parents, July 24, 1859, Grenoble.

10. Harold P. Clunn, *The Face of London*, rev. ed. (London: Spring Books, 1950–60) p. 321. Fantin describes this viaduct as follows: "Au dessus de la rue, un viaduc immense, qui la traverse obliquement, tout en fer." The viaduct in question was composed of one thousand arches, which ran in a straight line from London Bridge to Deptford. It is clearly visible in *A Balloon View of London as Seen from the North* (pl. 146) with a train on it in the upper right hand quadrant.

11. Clunn, *Face of London*, p. 314.

12. Clunn, *Face of London*, p. 114.

13. Charles Dickens, *Our Mutual Friend* repr. (New York: Signet, 1980), p. 34.

14. J. Pennell, Letter to Mansfield, Feb 22, 1895, LC PC.

15. "A Whistle for Whistler," *Punch*, June 17, 1871. Clippings file LC PC.

16. Philippe Burty, "L'Oeuvre de M. Charles Meryon," *Gazette des Beaux Arts*, Sér. 1, 14, No. 6 (1863), 523.

## 3. THE RADICAL RECONSTRUCTION OF THE PICTURE SPACE

1. Fantin, Letter to his parents, July 15, 1859, Grenoble.

2. This was pointed out by Jeremy Maas in *Victorian Painters* (London: Barrie and Rockliff, The Cresset Press, 1969), p. 194.

3. James D. Burke, *Charles Meryon: Prints and Drawings*, exh. cat. (New Haven, Conn.: Yale University Art Gallery, 1974), p. 3.

4. Philippe Burty, "La Photographie en 1861," *Gazette des Beaux Arts*, Sér. 1, 11, No. 13 (1861), 242. As Weston J. Naef has written in "The Beginnings of Photography as Art in France," "The 1859 exhibition represented a triumphant moment for those who wished to see photography become a legitimate companion of the fine arts." *After Daguerre: Masterworks from the Bibliothèque Nationale*, exh. cat. (New York: Metropolitan Museum of Art, 1980–1), p. 38.

5. Mayne, *Art in Paris*, p. 152.

6. Philippe Burty, "Salon de 1863: La Gravure et La Lithographie", *Gazette des Beaux Arts*, 15, No. 2 (1863), 153: "Les eaux-fortes de M. Whistler parlent l'anglais le plus pur. L'originalité de la conception est sans conteste. Malheureusement M. Whistler s'est fait une "théorie des premiers plans" qui imprime à ses dessins je ne sais quelle apparence photographique vraiment regrettable: il pose sur ces maudits premiers plans des personnages ou des objects qu'il traduit, sans les modeler, avec leur exagération relative de masse. Cela nuit beaucoup à l'intérêt de la pièce, qui ne commence jamais qu'au second ou au troisième plan. Il suffit d'étudier un instant les admirables paysages de Rembrandt pour sentir la fausseté du système de M. Whistler, si remarquablement doué à tous autres égards."

7. Philippe Burty, "La Photographie", 246: "Les artistes reprochent avec raison à la photographie de ne point donner aux premiers plans l'importance qu'ils ont dans la nature. Condamnés par les lois de l'optique, à se placer très-loin des objects, lorsqu'ils veulent des épreuves de quelque étendue, les photographes ne peuvent en quelque sorte obtenir que des rideaux de fond."

8. James Borcoman, *Charles Nègre, 1820–1880*, exh. cat. (Ottawa: The National Gallery of Canada, 1976), p. 27.

9. Jean-Paul Bouillon, "Remarques sur le Japonisme de Bracquemond," in *Japonisme, An International Symposium* (Tokyo: Committee for the Year 2001 and Kodansha International Ltd., 1981), p. 88.

10. The date of this event has been confirmed by Martin Eidelberg in "Bracquemond, Delâtre and the Discovery of Japanese Prints", *Burlington Magazine*, 123, No. 937 (1981), 221–7.

11. Léonce Bénédite, "Artistes Contemporains: Whistler," *Gazette des Beaux Arts*, Pér. 3, No. 579 (1905), 142.

12. Bracquemond, Letter to Pennell, LC PC.

13. Bouillon, "Bracquemond," p. 94.

14. Bouillon, "Bracquemond," p. 95.

"la tendance du paysage à se disposer dans la verticalité de la feuille, par la composition asymètrique et fort peu classique du motif, et bien sur par le découpage et l'emboitement des surfaces en "aplats".

15. A group of Japanese prints were on view in the Manchester Exhibition of 1857. They were listed in the *Catalogue of the Art Treasures of the United Kingdom Collected at Manchester*, in 1857, No. 1348, as "Old Japanese . . . sixteen woodcuts printed in colours, of early but uncertain date. Supposed to be illustrations of a Romance or Novel; two represent a Dance of Death. W. Russell, esq. (No. 1348)." These were probably early nineteenth century illustrations of *tableaux* from the Kabuki theatre, and the prints representing the "Dance of Death" could well have been by Kuniyoshi or a contemporary.

16. Captain Osborne, who travelled with Lord Elgin, referred to "the great bridge of Yedo" as "the London Bridge of Eastern Land." Captain Sherard Osborne, "Japanese Fragments," *Once A Week*, 3 (1860), p. 313. The series of articles was illustrated with woodcut reproductions of *ukiyo-e* woodcuts by Hiroshige and Hokusai, including sheets from the *Manga*.

17. Philippe Burty, "La Société des Aqua-fortistes," *Gazette des Beaux Arts*, Sér. 1, 14, No. 2 (1863), 190.

"dont l'idèal est d'arriver à ne mettre sur une planche que des valeurs de tons".

## 4. THE SCIENCE OF OPTICS AND THE THAMES ETCHINGS OF 1859

1. See p. 113.

2. Bernhard Sickert, *Whistler* (London: Duckworth, 1908), p. 117.

3. Haden, in "About Etching," *Fine Art Quarterly*, NS 1, (1866), 149, pointed out how the dead body in the etching *The Death of the Virgin*, B.99, slid toward the end of the bed, "just as dead bodies do."

4. According to Andrew Wilton, Whistler and his contemporaries would not have known the contents of Turner's perspective lectures at the Royal Academy given between 1811 and 1828, which reflected his knowledge of the function of the human eye gleaned in part at Sir Anthony Carlisle's lectures on anatomy at the Academy around 1809. Turner spoke in his fourth lecture, "On Light, Shade and Perception," in 1818, about the importance of applying the scientific knowledge of vision to the creation of works of art: "Vision, therefore whether natural or educated, becomes the judge and arbiter of imitation, whether it is of the greater or lesser truth, by or through lines, the appearance or occupation of space, of any known form, whereas the Science becomes the corrector upon the union of theoretical inductions, which vision, that is the power of seeing with nature'[s] pictorial means, creates for itself a power of capacity of so doing." John Gage, *Colour in Turner* (New York: Praeger, 1969), p. 110.

5. Ruskin, *Modern Painters*, I, 2:4, 258.

6. Ruskin, *Modern Painters*, I, 2:4, 258.

7. Ruskin, *Modern Painters*, I, 2:4, 258–9.

8. Ruskin, *Modern Painters*, I, 2:4, 260.

9. Ormond, *Du Maurier*, p. 68.

10. Richard and Roslyn Warren, *Helmholtz on Perception, its Physiology and Development* (London: John Wiley and Sons, 1968), p. 72.

11. Warren, *Helmholtz*, p. 71.

12. Warren, *Helmholtz*, p. 72.

13. Fleming, *Young Whistler*, p. 99.

14. Francis Seymour Haden, *Surgical Instruments: Report of Awards Made at the International Exhibition of 1862* (London, 1862), p. 14.

15. Warren, *Helmholtz*, p. 72.

16. J. Reeves Traer, "On the Photographic Delineation of Microscopic Objects," *Journal of the Photographic Society*, 5 (1858), 55.

17. Claudet, "La Photographie dans ses Rélations avec les Beaux-Arts," *Gazette des Beaux Arts*, Sér. 1, 9, No. 2 (1861), 112. He also writes: "La fabrication des lentilles nécessaires aux appareils d'optique a fait ressortir l'habileté et le savoir des meilleurs opticiens qui, dans leurs efforts pour fournir à la photographie les instruments les plus parfaits, ont été forcés d'étudier les lois de l'optique avec plus d'attention qu'ils ne l'avaient fait précédemment. En perfectionnant les lentilles photographiques, ils ont fait de nouvelles découvertes qui ont eu déjà d'importantes applications pour la construction des télescopes, des lorgnettes et des microscopes." (p. 111.)

18. Beaumont Newhall, *The History of Photography* (New York: The Museum of Modern Art, 1964), p. 83.

19. Ruskin, *Modern Painters*, I, 2:4, 273.

20. Thomas Armstrong, Letter to J. Pennell, Sept. 22, 1906, LC PC. Armstrong wrote: "In early life Whistler was so short-sighted that he had to put up his eyeglass to see if his shoes were clean. I have seen him do it many a time. This accounts for something in his painting, but is puzzling to make out how he saw all the details there are in some of his Thames etchings."

21. Whistler left his glasses for repair in Paris under the name James Abbott in May 1863, perhaps to cover his artistic identity. He asked Fantin to pick them up. Letter to Fantin, May 1863, (mfm. 825–9) LC PC.

22. B. Sickert, *Whistler*, p. 66.

23. Gil Blas, Letter to J. Pennell, July 19, 1903, LC PC. Blas wrote: "Il était d'une extrême myopie et, pendant le dîner je le vis remplacer une demi-douzaine de fois son éternel monocle, dont la vapeur des plats troublait la limpidité. Au dessert une pile de petits ronds de verre s'élevait près de son assiette."

24. Walter Sickert, "Round and About Whistler," in *A Free House* (London: Macmillan and Co. Ltd., 1947), p. 11.

25. Pennell, *Life*, 1, 5.

5. WHISTLER'S FIRST DRYPOINTS

1. Whistler, Letter to Charles Sissler, n.d., Rosenwald Collection, National Gallery of Art, Washington.

2. Seymour Haden, "Mr. Seymour Haden on Etching," *The Magazine of Art*, 2 (1879), 224.

3. Haden owned the most important of these, including the *Omval*, B.209, and *Six's Bridge*, B.208. The latter was used as the model for Haden's etching, *Egham Lock*, H.16, 1859. *Sotheby*, 1891, Lots 389 and 387.

4. Pennell, *Journal*, p. 92.

5. Pennell, *Journal*, p. 91.

6. Pennell, *Journal*, p. 90.

7. Pennell, *Journal*, p. 93.

8. This etching was exhibited in the Royal Academy in 1860 under the title, "M. Astruc, Rédacteur du Journal l'Artiste." Algernon Graves, *The Royal Academy of the Arts. A Complete Dictionary of Contributors and their work from its foundation in 1769 to 1904* (London: Henry Graves and Co. Ltd. and George Bell and Sons, 1906), VIII, 249, No. 901.

9. Haden, *Rembrandt* (1895), p. 8.

10. Bürger, *Manchester*, p. 234.

11. Jowell, *Thoré-Bürger*, p. 224, and f.n. 32.

12. He called it "une estampe introuvable qui suffirait à elle seule pour faire entreprendre le voyage de Manchester à un curieux." (See f.n. 9 above.)

13. Thomas, *Catalogue*, No. 56.

14. Whistler made a drawing of Fantin dated Dec. 20, 1859, and inscribed "— 14° de froid," now in the Louvre, Cabinet de dessins.

15. The identity of this sitter was confused until Howard Mansfield clarified the matter in 1914 in an article "Concerning a Whistler Portrait: 'Mr. Mann' or 'Mr. Davis'," in *Print Collector's Quarterly*, 4, No. 4 (1914), 383–91. Mr. Joshua H. S. Mann and Mr. Davis were both friends of Whistler at this time, and knew each other well. The identity of the sitter was confused by Ralph Thomas.

16. J. Pennell, "Whistler's Prices and the Prices of Whistler," TS, p. 9, LC PC.

17. Pennell, *Journal*, pp. 95–6.

18. No record appears to exist which would indicate the number of impressions taken. A note on the mount of an impression of *Arthur Haden* in the Boston Public Library indicates that this plate was rare and was intended for private circulation only. It is known that Whistler gave Drouet three impressions of his own portrait, one of which Drouet gave to Becquet who promised to leave it to the Museum at Besançon (Pennell, *Journal*, p. 91).

6. WHISTLER'S THAMES ETCHINGS OF 1860–1

1. They were *Monsieur Astruc, rédacteur du journal l'Artiste* (No. 901), *Thames—Black Lion Wharf* (No. 902), *Drypoint—portrait* (No. 903), *W. Jones, Limeburner, Thames Street* (No. 943), and *The Thames, from Tunnel Pier* (No. 944) (Graves, *Royal Academy*, VIII, p. 249).

2. Du Maurier, Letter to his mother, Oct., 1860, in Daphne du Maurier, *The Young George du Maurier: A Selection of His Letters, 1860–1867* (London: Peter Davies, 1951), p. 16.

3. Bill Henley, quoted in Ormond, *Du Maurier*, p. 93.

4. Pennell, *Life*, 1, 84.

5. Whistler, Letter to Fantin, July, 1861 (mfm, 821–4) LC PC.

6. Ralph Thomas, *Sergeant Thomas and Sir John E. Millais* (London: A Russell Smith, 1901), p. 12.

7. Pennell, *Life*, 1, 85.

8. The note in the passport includes the following list: "Lime house 10, Tunnel pier 2, Black Lion 8, graveur 2, Thames Police 20, Tyzach." (The latter can be identified as *Eagle Wharf*.)

9. Du Maurier, *Letters*, p. 27.

10. Du Maurier, Letter to his mother, January, 1861, in Du Maurier, *Letters*, p. 28.

11. Whistler was elected to the Junior Etching Club in 1859, and attended the meetings of May 2, Nov. 7, 1860, and Jan. 2, 1861. ("Minutes of the Junior Etching Club," entries for May 2, 1860, Nov. 7, 1860, and Jan. 2, 1861. Victoria and Albert Museum.)

12. J. Wa and H.H.T., "Photography," *Encyclopaedia Britannica*, 1911, ed., p. 521.

13. Pennell, *Life*, 1, 86.

14. Ralph Thomas wrote in the margin of his copy of Wedmore, *Whistler's Etchings: A Study and Catalogue*, p. 23, "my father got Whistler to put the figures in." See Ch. 1:7 f.n. 4.

15. Du Maurier, *Letters*, p. 38.

16. Mrs. Whistler, Letter to Whistler, May 12, 1862, GUL BP 11 Res 1/149.

7. ATMOSPHERE AND POETRY

1. These were: *Thames from New Crane Wharf, Mons. Oxenfeld, Littérateur, Paris*, and *The Thames, near Limehouse*, Graves, *Royal Academy*, VIII, p. 250.

2. Carl Barbier "The Société des Trois," in *J. M. Whistler*, ed.

Frederick A. Sweet, exh. cat. (Chicago: The Art Institute of Chicago, 1868), Introduction.

3. Now in the Bliss Collection, Boston Public Library.

4. Edwin Edwards, *Old Inns. Second Division—Eastern England* (London, 1880), Introduction.

5. George Somes Layard, *The Life and Letters of Charles Samuel Keene* (London: Sampson Low, 1892), p. 38.

6. Mrs. Ruth Edwards, Letter to the Pennells, n.d., LC PC.

7. This may be seen in the British Museum, Department of Prints and Drawings.

8. Du Maurier wrote to his mother in June saying that he and Armstrong, who had been planning a trip to Hampton Court in May where they were to share rooms, had postponed the trip for lack of a break in the weather. He wrote "weather has been wretched for the last week and is now." Du Maurier, *Letters*, p. 45.

9. Fantin, Letter to his parents, July 5, 1861, Grenoble.

10. Du Maurier, Letter to Isabel, July, 1861, in Du Maurier, *Letters*, p. 53.

11. Mrs. Whistler, Letter to Whistler, Aug. 3, 1861, GUL BP 11 Res 1/147.

12. Fantin, Letter to his parents, July 23, 1861. Grenoble.

13. Fantin can be seen in *Between the Poplars, Sunbury,* and *Fantin at St. George's Hill,* while Whistler can be seen in *Whistler Sketching at Moulsey Lock.*

14. An inscription on an impression of *Sketching No. 2* in the New York Public Library reads "figure possibly S.H.".

15. Mansfield, who may have had an opportunity to consult Haden or Mrs. Edwards on the order of these plates, interspersed *The Punt* and *Landscape with Fisherman* with plates which appear to have been made at Sunbury. His order is as follows: *Encamping,* M. 82, *The Storm,* M. 83, *Landscape with Fisherman,* M. 84, *Sketching No. 2,* M. 85, *The Punt,* M. 86, and *Sketching No. 1,* M. 87. It is not possible to say that any of these plates with the exception of *Encamping* was made at Sunbury, but it seems very likely that they were.

16. "Minutes of the Junior Etching Club," entry for Jan. 2, 1861.

17. Martin Hardie, *Frederick Goulding: Master Printer of Copper Plates* (Stirling: Eneas MacKay, 1910), p. 24.

18. Whistler, Letter, *New York Tribune,* Aug. 16, 1880, GUL BP 6A/40.

## 8. The Politics of Publication, and the Growth of Personal and Professional Rivalries

1. Du Maurier, *Letters,* p. 104.

2. Baudelaire, "Painters and Etchers," in Mayne, *Art In Paris,* pp. 221–2.

3. "Minutes of the Junior Etching Club," entry for Apr. 24, 1864.

4. Whistler, Letter to George Lucas, June 26 [1862], Art Institute of Chicago. The plates were undoubtedly the Thames subjects later published as part of the "Thames Set."

5. "Minutes of the Junior Etching Club," entry for April 24, 1864.

6. Baudelaire, "Painters and Etchers," in Mayne, *Art In Paris,* pp. 221–2.

7. Mayne, *Art In Paris,* p. 217.

8. Translated by Mayne, *Art In Paris,* p. 220. "Tout récemment, un jeune artiste américain, M. Whistler, exposait à la galerie Martinet une série d'eaux-fortes, subtiles, éveillées comme improvisation et l'inspiration, representant les bords de la Tamise; merveilleux fouillis d'agrès, de vergues, de cordages; chaos de brumes, de fourneaux et de fumées tirebouchonnées; poésie profonde et compliquée d'une vaste capitale."

9. Whistler, Letter to Fantin, Sept., 1862 (mfm. 772–4), LC PC.

10. Fantin, Letter to Whistler, Oct., 1862, GUL BP 11 L/27.

11. See Druick and Hoog, *Fantin Latour,* no. 40, p. 139. The etching in question was entitled *The Two Sisters,* 1862.

12. Janine Bailly-Herzberg, *L'eau-forte de peintre au dix-neuvième*

siecle: *La Société des Aquafortistes (1862–1867),* I (Paris: Léonce Laget, 1972), p. 42.

13. Fantin, Letter to Whistler, July 19, 1863, GUL BP 11 L/31.

14. Bailly-Herzberg, *Aquafortistes,* I, p. 47.

15. Burty, "Aquafortistes," p. 190.

16. Du Maurier, *Letters,* p. 197.

17. Whistler, Letter to Fantin, 1863 (mfm. 850–2), LC PC.

18. Haden, Letter to Delâtre, June 29, 1863, M. S. Department. The text of the letter reads as follows: "Mon cher Mons. Delâtre: Mons. Fantin (qui j'espère à l'intention de venir nous voir) passeras chez vous demander renseignements sur la route de Newhaven—et pour se charger des eaux-fortes que vous avez pour nous. Ainsi, donc, aussitôt que l'arrivée de cette lettre ayez la bonté de me faire emballer—1° La Tirage de 50 livraisons—2° Les vingt impressions de ma maison de campagne—3° Toutes les placques que vous avez à nous—c'est-à-dire—Les eaux-fortes publiés . . .

La longue planche (à moi) 1

La dame lisant 1

Le chien—1

Petit intérieur de Montmartre—1

Annie assise—1

Votre portrait (barbe effacé)—1

Le verre à Vin—1

La pointe sèche d'une femme à la fenêtre 1

En tous—21

4° aussi tirez nous 12 impressions de chacque [sic] un de ces planches (excepter la pointe sèche de Whistler) sur le papier verger-volant avec une marge.

5° aussi envoyez moi autant de papier verger d'une bonne qualité et coleur que vous [puissez] me procurer.

6° Un peu de ce beau noire que vous m'avez promis

7° La note des dépenses que vous avez eu la bonté de faire pour nous—afin que je pourra vous envoyez l'argent de suite. Nous voulons les planches seulement parceque, ayants finis plusieurs autres, nous voudrions conserver tout [ensemble] et parceque nous espérons plut [sic] tard vous tenter venir les imprimer ici. Whistler travail bien. Entre outre nous nous projettons 4 Livraisons de 12 pl: chacque des vues [prises] sur la Tamise de la source jusqu'au la mer. Cela fera 48 planches—intéressantes car notre rivière est vraiment drôle.

Avec moi il désire beaucoup de choses à [ta] part—à vous et à madame—et vos chers enfans [sic]. Seymour Haden." Sir Francis S. Haden Letters, 1864–1902, Rare Books and Manuscripts Division, The New York Public Library, Astor, Tilden and Lennox Foundations.

It is not possible to identify all the plates mentioned in this letter with certainty, but they appear to refer to the following:

1) "Le tirage à 50 livraisons." Conceivably Haden's *Egham Lock,* H.16, which was published in the *G.B.A.,* XVII (1864), p. 358.

2) "Le vingt impressions de ma maison de campagne": Haden's *Mytton Hall,* 1859, H.14.

3) "Les eaux-fortes publié—13"—Whistler's "French Set". "La Longue planche (à moi)"—probably Haden's *Out of a Study Window,* H.18, 1859.

"La dame lisant"—probably Whistler's *Reading in Bed,* K.28.

"Le Chien"—probably Whistler's *The Dog on the Kennel,* K.18.

"Petit intérieur de Montmartre"—probably *The Rag Gatherers,* K.23.

"Annie assise"—Whistler's *Annie Seated,* K.30.

"Votre portrait"—Whistler's *August Delâtre,* K.26.

"Le verre de vin"—Whistler's *The Wine Glass,* K.27.

"La pointe sèche d'une femme—à la fenêtre"—probably Whistler's *Finnette,* K.58.

19. Whistler, Letter to Fantin, Jan. 5, 1864 (mfm. 797–802), LC PC.

20. Whistler, Letter to Fantin, Jan. 23, 1864, (mfm. 797–802), LC PC.

21. In the *New York Tribune,* Jan. 2, 1890 (see Haden File, Dept.

of Prints and Drawings, Museum of Fine Arts, Boston) is an article which reads: "How these etchings were first made known to the public through Mr. Burty's catalogue, in 1864, is a story as familiar as the extraordinary success which attended their publication in Paris and London."

22. Philippe Burty, "L'Oeuvre de M. Francis Seymour Haden," *Gazette des Beaux Arts*, Sér. 1, 17, No. 3 (1864), 272.

23. Burty, "Haden," 275.

24. Will, Jan. 31, 1866, LC PC.

25. Colnaghi, Letter to Anderson Rose, Feb. 2, 1866, LC PC.

26. Rossetti, Letter to Anderson Rose, April 7, 1866. LC PC.

27. Whistler, Letter to Fantin, 1867 (mfm. 836–45), LC PC.

28. Fantin, Letter to Whistler, May, 1867, GUL BP 11 L/33.

29. There is extensive correspondence pertaining to this incident which is summarized here in the Birnie Philip Collection at Glasgow University Library.

30. Mrs. Whistler, Last Will and Testament, June 14, 1867. LC PC.

31. Philip Gilbert Hamerton, *Etching and Etchers* (London: Macmillan and Co., 1868), dedication page.

## CHATER THREE

### Whistler and Aestheticism, 1867–81

1. WHISTLER'S TRANSITION FROM REALISM TO AESTHETICISM

1. Fantin, Letter to Whistler, Aug. 5, 1859, GUL BP 11 L/26.

2. Pennell, *Life*, 1, 69.

3. Whistler, Letter to Fantin, July, 1861 (mfm. 821–4), LC PC.

4. Hélène Toussaint, Marie-Thérèse de Forge, and Alan Bowness, *G. Courbet 1819–1877*, exh. cat. (London: Arts Council of Great Britain, 1978), p. 36.

5. Courbet. Letter to his father, Nov. 17, 1865. Quoted in Georges Riat, *Gustave Courbet* (Paris: H. Floury, 1906), p. 228.

6. Sickert, "Round and About Whistler," p. 15.

7. Whistler, Letter to Fantin, May 1863 (mfm. 825–9), LC PC.

8. Whistler, Letter to Fantin, 1865, (mfm. 833–5), LC PC.

9. Pennell, *Friend*, p. 116.

10. Du Maurier, Letter to T. Armstrong, Oct. 11, 1863, in Du Maurier, *Letters*, p. 216.

11. *New York Sunday Sun*, March 22, 1903, LC PC.

12. Dante Gabriel Rossetti, *The Collected Works of Dante Gabriel Rossetti*, ed. William M. Rossetti (London: Ellis and Elvey, 1890), p. 84.

13. Pennell, *Life*, 118.

14. Whistler, Letter to Fantin, 1865 (mfm. 833–5), LC PC.

15. For a discussion of Whistler's relationship with Moore, and for an understanding of this period, see Robin Spencer, "James McNeill Whistler and His Circle," M. A. Report, Courtauld Institute, University of London, 1968.

16. Thoré-Bürger wrote "Et qu'est-ce que ça signifie? On n'en sait rien. On ne comprend pas, on admire. Telle est la magie de l'art, tel son suprême résultat." See Thoré, *Salons*, p. 88.

17. See Marcus B. Huish, "A Few Explanatory Words in Relation to the Famous Ionides Collection Formed by the Late Mr. A. Ionides, Greek Ambassador," in the *Ionides Collection of Antiquities from Boetia, Tanagra, and Asia Minor* (London: Christies, March 13 and 15, 1902), p. 2.

18. Marcus Huish, *Greek Terracotta Statuettes* (London: John Murray, 1900), p. 4.

19. J. A. M. Whistler, "Mr. Whistler's Ten O'Clock," reprinted in *The Gentle Art of Making Enemies* (London: William Heinemann, 1890), p. 159.

20. For general information see R. A. Higgins, *Greek Terracotta Figurines* (London: The British Museum, 1969), pp. 23–5.

21. Whistler, Letter to Fantin, May, 1867, (mfm. 836–45), LC PC.

22. Rebeyrol, "Thoré," p. 197.

2. THE LEYLAND YEARS

1. Pennell, *Journal*, p. 97.

2. Mrs. Whistler and Whistler, Letter to Leyland, Aug. 23 (1870), LC PC.

3. Whistler set out to make Leyland and his wife, their three daughters and their son "live in [his] portraits as Philip IV and his family live in the portraits by Velazquez." Pennell, *Journal*, p. 99.

4. Whistler, Letter to Leyland, (by November) 1872, LC 4/3194–6 PC.

5. Lady Archibald Campbell, Letter to the Pennells, Oct. 13, 1906, LC PC.

6. Whistler, Letter to Delâtre (from Speke Hall), Jan. 22, 1873, LC PC. The instructions from Whistler read as follows: "Je vous ferai chercher et rendre les six planches de chez moi pour que vous puissiez les faire de suite polir et me les envoyer avec deux autres—maintenant dites moi aussi comment mêlez-vous votre acide pour mordre. J'ai oublié—en quantités égales n'est-ce-pas—c'est-à-dire moitié eau et moitié acide nitrique."

7. Whistler, Letter to W. C. Alexander, Feb. 1, 1875, Print Room, British Museum. Quoted by permission of the Trustees of the British Museum.

8. Bouillon, "Bracquemond," pp. 98–9.

9. Pennell, *Journal*, p. 117.

10. Leyland, Letter to Whistler, July 17, 1877, L-121 LC PC.

3. THE PUBLICATION OF THE "THAMES SET" AND THE LATE THAMES ETCHINGS

1. Mrs. Whistler, Letter to Mr. Gamble, May 6, 1869, GUL AM 1962 W 49.

2. Pennell, *Life*, 1, 153.

3. Whistler, Letter to Ellis (from Speke Hall), 1870, LC PC.

4. Written on verso of the letter cited in no. 3 above.

5. See *Symphony in Grey and Green: The Ocean*, Y. 72, which was begun in 1866 and finished in the early 1870s.

6. Margaret MacDonald, *Whistler, The Graphic Work: Amsterdam, Liverpool, London, Venice*, exh. cat. (London: Thos. Agnew and Sons, 1976), p. 13.

7. For the most part, the titles of the published set are those used in the Kennedy catalogue. However, there are a few discrepancies: "Wapping Wharf" was renamed *Thames Police*, "Wapping" was renamed *Rotherhithe*, and "The Fiddler" was renamed *Becquet*.

8. "A Whistle for Whistler," *Punch*, June 17, 1871, p. 245.

9. Mrs. Whistler, Letter to Julia, Nov. 3, 1871, LC PC.

10. There is a Whistler mezzotint of a lady standing, full length, in profile in the Birnie–Philip Collection at Glasgow University Library.

11. Quoted in Pennell, *Life*, 1, 213.

12. This incident took place, according to Whistler, during the summer of 1877. It is recounted in Pennell, *Life*, 1, 214. The press could have become rusty with a year of disuse, but it is likely that Whistler had not used it for several years. The last recorded use of it can be found in Alan Coles's diary when he saw Whistler and Howell printing on Oct. 9, 1874, LC PC.

13. Pennell, *Journal*, p. 122.

14. Pennell, *Journal*, p. 186.

15. Whistler, Letter to Mrs. William Whistler, Sept. 26, 1878, GUL Rev. 1955 W/5.

16. This information was supplied by Robin Spencer and Nigel Thorp. I am very grateful to Dr. Thorp for drawing my attention to the Hedderly photograph.

17. Pennell, *Life*, 1, 281.

18. See M. Lee Wiehl, *A Cultivated Taste: Whistler and American Print Collectors*, exh. cat. (Middletown, Conn: Davison Art Center, 1983), p. 22 n. 13.

19. Goulding, Letter to the Pennells, Sept. 9, 1906, LC PC.

20. Whistler, Letter to Anderson Rose, Jan. 23, 1879, LC PC.

21. Margaret MacDonald has discovered documentation to prove that Whistler's mistress Maud had two children by Whistler in the late 1870s. She is about to publish this information.

22. This idea was originally proposed by Margaret MacDonald in *The Graphic Work*, p. 19.

23. The question of the Japanese prints in Whistler's collection before the White House sale remains unresolved. However, it is known that he owned this particular print, thanks to an exchange of correspondence between George Halkett and the Pennells. See Halkett, Letter to Pennell, April 2, 1907. LC PC, and Halkett, Letter to Pennell, April 27, 1907, LC PC.

4. WHISTLER IN VENICE

1. Ledger Book A, p. 100, GUL BP. The subscribers included Whistler's lawyer, J. A. Rose, and the print dealers P. and D. Colnaghi, Knoedler and Co., and Marcus Huish.

2. Leyland, Letter to Whistler, Aug. 17, 1876, LC PC.

3. Whistler, Letter to Alan S. Cole, Sept. 3, 1876, LC PC. Mrs. Whistler enclosed one in her letter to Mr. Gamble, Sept. 8, 1876, LC PC.

4. *The Academy*, Sept. 2, 1876, quoted in Robert H. Getscher, "Whistler and Venice," Ph.D. Thesis, Case Western Reserve University, 1970, p. 6.

5. Quoted in Getscher, "Whistler and Venice," p. 28. This clipping is preserved in one of 16 vols. of press clippings, I, 91, GUL BP.

6. Cole, "Diary," Sept. 7, 1879.

7. Minute Books of the Fine Art Society. Minutes of Sept. 9, 1879, Fine Art Society, New Bond Street, London.

8. Whistler, Letter to George Lucas, Sept. 13, 1879, Maryland Institute, Baltimore. Published by John A. Mahey in "The Letters of James McNeill Whistler to George A. Lucas," *Art Bulletin*, 49, No. 3 (1967), Letter XVII, 254.

9. Whistler, Letter to George Lucas, Sept. 13, 1879.

10. Lucas, *Diary of George A. Lucas*, p. 481.

11. Maud Franklin, Letter to George Lucas, Oct. 23, 1879, The George A. Lucas Collection of the Maryland Institute College of Art, on indefinite loan to The Baltimore Museum of Art. Published by Mahey, "Lucas," Letter XVIII, 254–5.

12. Getscher, "Whistler and Venice." Getscher has examined all the copper plates and has put forward a theory of dating the Venice etchings based on the type of copper plate used. He has developed this useful theory with great thoroughness, pp. 33–43.

13. Minute Books of the Fine Art Society, Minutes of Dec. 8, 1879.

14. Whistler, Letter to Deborah Haden, Jan. 1, 1880, The George A. Lucas Collection of the Maryland Institute College of Art, on indefinite loan to The Baltimore Museum of Art.

15. Huish, Letter to Whistler, Jan. 14, 1880, GUL BP 11 13–5.

16. Whistler, Letter to Huish, n.d. (Jan. 1880), GUL BP 11 c/8.

17. See the annotated sales catalogue in the B.M. Print Room. The F.A.S. subsequently published the cancelled plates.

18. Whistler, Letter to Howell, Jan. 26, 1880, GUL BP 11 18/52.

19. Whistler, Letter to Brown, n.d. (Jan. 1880), GUL BP 11 13/6.

20. Getscher, "Whistler in Venice," pp. 33–43.

21. Otto Bacher, *With Whistler in Venice* (New York: The Century Co. 1908), p. 14.

22. Bacher, *Whistler in Venice*, p. 93.

23. Bacher, *Whistler in Venice*, p. 172.

24. Bacher, *Whistler in Venice*, p. 108.

25. Bacher, *Whistler in Venice*, pp. 112–13.

26. Pennell, *Life*, 1, 267.

27. Whistler, Letter to Brown, n.d. (1880), GUL BP 11 Res. 18d/154.

28. Bacher, *Whistler in Venice*, p. 113.

29. John Ruskin, *The Stones of Venice: Introductory Chapters and Local Indices for the Use of Travellers while Staying in Venice and Verona* (New York: D. D. Merrill Co. 1879), p. 144.

30. Whistler, Letter to Mrs. Whistler (from Venice), (1879–80) Freer Gallery of Art, folder no. 176.

31. Whistler, Letter to Howell, Jan. 26, 1880, GUL BP 11 18/52.

32. Mortimer Menpes, "A Personal View of Japanese Art," *Magazine of Art*, 11 (1888), 195–9.

33. Harper Penington, Letter to Whistler, March 12, 1903, GUL BP II P/24.

34. Joseph Pennell, "Whistler as Etcher and Lithographer," TS, P. 13, LC PC.

35. Pennell, "Whistler as Etcher and Lithographer," p. 1.

36. I would like to thank Jacob Bean for this information.

37. Mortimer Menpes, *Whistler as I Knew Him* (London: Adam and Charles Black, 1904), p. 24.

38. Menpes, *Whistler*, p. xx.

39. Repr. in Peter Ferriday, "Peacock Room," *Architectural Review*, 125, No. 749 (1959), 413.

40. Cole, "Diary," entry for Dec. 4, 1877, LC PC. Lecoq had taught this method to Fantin and Legros.

41. Bailly–Herzberg, *Aquafortistes*, I, p. 6.

42. Eugenia Parry Janis, "Setting the Tone—The Revival of Etching, the Importance of Ink," in *The Painterly Print: Monotypes from the Seventeenth to the Twentieth Century*, exh. cat. ed. Colta Ives (New York: Metropolitan Museum of Art, 1980), p. 11.

43. Janis, "Setting the Tone," p. 6 fn. 36 and 37.

44. Janis, "Setting the Tone," p. 14.

45. Haden, "About Etching," (1866), p. 160.

46. Getscher, "Whistler and Venice," pp. 66–73. Robert Getscher was the first to connect Lepic's experiments with Whistler's artistic printing.

47. Béraldi, *Graveurs*, IX, p. 144.

48. Janis, "Setting the Tone," p. 22.

49. Now in the Baltimore Museum of Art.

50. Bacher, *Whistler in Venice*, p. 117.

51. Bacher, *Whistler in Venice*, p. 118.

52. Hiroshi Yoshida, *Japanese Wood-Block Printing* (Tokyo: Sanseido 1939), p. 86.

53. Brown, Letter to Whistler, Oct. 1, 1880, GUL BP.

54. Whistler, Letter to Brown, Oct. 25, 1880, GUL BP 111F/2.

55. Huish, Letter to Whistler, Oct. 19, 1880, GUL BP 11 13/12.

56. Whistler, Letter to Mr. and Mrs. William Whistler, Oct., 1880, GUL Rev. 1955 W/56.

5. THE "FIRST VENICE SET" AND THE FOUNDING OF THE PAINTER–ETCHERS

1. Whistler, Letter to Dr. & Mrs. William Whistler, 1880. GUL Rev. 1955/W.56.

2. Whistler, Letter to Dr. and Mrs. William Whistler, 1880. LC PC.

3. Hardie, *Goulding*, p. 49.

4. Pennell, *Life*, 1, 290.

5. For a discussion of Whistler's influence on other etchers, see Robert Getscher, *The Stamp of Whistler*, exh. cat. (Oberlin: Allen Memorial Art Museum, 1977).

6. Menpes, *Whistler as I Knew Him*, p. 91.

7. Hardie, *Goulding*, p. 52.

8. Pennell, "Whistler's Prices," p. 18.

9. Pennell, "Whistler's Prices," p. 18.

10. Menpes, *Whistler*, p. 95.

11. Menpes, "On the Printing of Etchings," *The Magazine of Art*, II (1880), 331.

12. Hyatt Mayor, Letter to the author, Nov. 9, 1976.

13. Bacher, *Whistler in Venice*, pp. 155–6.

14. Getscher has carefully analysed the selection from the point of view of subject and format. He points out that when the etchings were hung in December, they were arranged in the sequence 1, 12, 9, 7, 11, 5, 4, 3, 2, 10, 6, and 8.

15. Pennell, *Journal*, p. 187.

16. Whistler, Letter to Marcus Huish (Nov. 28 or 29, 1880), LC PC.

17. Pennell, *Journal*, p. 187. Note: the Pennells are inconsistent with respect to which of the two Venice exhibitions gave rise to this episode. In the *Journal* it is said to have taken place in conjunction with the exhibition of 1880, but in the *Life*, 1, 311, it is said to have taken place in conjunction with the 1883 exhibition.

18. The reviewer for the *St. James Gazette,* quoted in Getscher, "Whistler and Venice," pp. 216–18.

19. The reviewer for the *Daily News,* quoted in Getscher, "Whistler and Venice," pp. 216–18.

20. The reviewer for *The Globe,* quoted in Getscher, "Whistler and Venice," pp. 216–18.

21. Millais, Letter to Whistler, n.d., 1880, GUL BP 11 M/100.

22. Whistler, Letter to Bacher, March 25, 1881, Freer Gallery of Art, folder no. 177.

23. Pennell, *Journal*, p. 252.

24. The battles with T. R. Way and Sir William Eden followed directly upon the death of his wife in 1896, and were viewed by his friends as a means of alleviating grief.

25. Seymour Haden, *The Art of the Painter–Etcher. The First Presidential Address to the Royal Society of Painters–Etchers for 1890* (London: Deprez and Gutekunst, 1890), p. 6.

26. Whistler, Letter to Menpes, n.d., LC PC.

27. Whistler, Letter to Otto Bacher, March 18, 1881, GUL BP 111 B/1.

28. Whistler, "La Suite," in *The Gentle Art*, p. 59.

29. Whistler, Letter to the Committee of Painter–Etchers, May 10, 1881, Freer Gallery of Art, folder no. 187. "Pecksniffian" is an adjective invented by Whistler to describe Haden and first appears in correspondence at the time of the battle between the two men in 1867. It is taken from Charles Dickens's character Pecksniff, described in Ch. 2 of *Martin Chuzzlewit* (1843–4). Pecksniff was "a moral man, a grave man, a man of noble sentiments and speech" who "had a Fortunatus's purse of good sentiments in his inside which, "if they were not actual diamonds which fell from his lips, they were the very brightest paste and shone prodigiously." All the world said "Behold the moral Pecksniff!" Despite the fact that he was an architect, "he had never designed or built anything; but it was generally understood that his knowledge of the science was almost awful in its profundity." He took on students as a means of support, and "his genius lay in ensnaring parents and guardians, and pocketing premiums." Whistler undoubtedly identified with Tom Pinch, the young man taken in by Pecksniff.

30. Pennell, *Journal*, pp. 187–8.

31. Fine Art Society, *Minute Books,* entry for March 23, 1881.

32. Dorothy Menpes, "Reminiscences of Whistler," *Studio* 29 (1903), p. 250.

33. Menpes, *Whistler*, p. 100.

34. Whistler, Letter to Huish, March, 1881, GUL BP II 13/40.

35. Huish, Letter to Whistler, Aug. 13, 1881, GUL BP 11 13/27. Holgate's name was also suggested.

36. Whistler, Letter to Huish, Feb. 22, 1882, GUL BP 111 F/3.

37. Menpes, *Whistler as I Knew Him*, p. 91.

38. Pennell, *Journal*, p. 122.

39. Quoted by Getscher in *The Stamp of Whistler*, p. 206.

40. See "Mr. Whistler's Venice Etchings: Some Account of their Final State," *Pall Mall Gazette*, Nov. 2, 1891.

# CHAPTER FOUR

## The Late Etchings, 1881–1903

### 1. THE LONDON ETCHINGS OF THE 1880s AND THE EXHIBITION OF 1883

1. Getscher, *The Stamp of Whistler*, p. 139.

2. Greaves was prone to falsify the dates on his work. For a discussion of the date of this etching, see Getscher, *The Stamp of Whistler*, p. 144.

3. See the interview with "Mr. Whistler's New Etchings" in the *Pall Mall Gazette*, March 4, 1890.

4. Mary Cassatt, Letter to Pennell, Sept. 12, n.d., LC PC.

5. Clunn, *Face of London*, p. 34.

6. Clunn, *Face of London*, p. 284.

7. Pennell, Letter to Mansfield. Sept. 25, 1908. Pierpont Morgan Library. Pennell said that there was a group of Sandwich plates which he thinks were made after the Naval Review. These have not yet been positively identified.

8. Whistler, Letter to Mrs. Huish, 1883, GUL BP 11 c/18.

9. Whistler, Letter to Waldo Storey. Feb. 1, 1883, Pierpont Morgan Library.

10. Pennell, *Life*, 1, 311.

11. Whistler, Letter to Waldo Storey, n.d. (1883), LC PC.

12. John Rewald, *Camille Pissarro: Letters to his Son Lucien* (London: 1943). Letter of Feb. 28, 1883, pp. 22–3.

13. Clipping from the *Advertiser*, March 18, 1885, Haden Clippings File, Boston Museum of Fine Arts.

14. Pennell, *Journal*, p. 231.

### 2. THE "SECOND VENICE SET" AND THE JUBILEE ETCHINGS

1. Menpes, *Whistler as I Knew Him*, p. 96.

2. Whistler, Letter to Dowdeswells, n.d., Rosenwald Collection, Letter 17. Library of Congress. The other details of the publication of the "Second Venice Set" mentioned in this section are taken from the Dowdeswell Correspondence in the Rosenwald Collection.

3. Whistler, Letter to Dowdeswells, n.d., Rosenwald Collection, Letter 39. Library of Congress.

4. Whistler, Letter to Dowdeswells, n.d., Rosenwald Collection, Letter 37. Library of Congress.

5. Haden, "Mr. Seymour Haden on Etching," p. 188.

6. See Ch. 3:4, pp. 183–4.

7. Bacher, *Whistler in Venice*, p. 295.

8. Bacher, *Whistler in Venice*, p. 115.

8. Bacher, *Whistler in Venice*, p. 115.

9. Whistler, Letter to Dowdeswells, July 27 [1886]. Library of Congress. Rosenwald Letter 49.

10. Dowdeswell "père" enclosed this note in his letter to Whistler, n.d., Rosenwald Collection, Letter 68 Library of Congress. Whistler sent it on to Sickert who dealt with the matter.

11. Dowdeswells, Letter to Whistler, n.d., Rosenwald, Letter 68, Library of Congress.

12. Whistler, Ledger Book a, GUL BP II.

13. Dowdeswells, Letter to Whistler, July 16, 1887, GUL.

14. Pennell, *Life*, II, 62.

15. Pennell, *Life*, II, 66.

16. Pennell, *Life*, II, 67.

17. Pennell, Letter to Mansfield, Oct. 17, 1906. The Pierpont Morgan Library.

18. Whistler, Letter to the Rt. Hon. Smith, First Lord of the Treasury, Dec. 1, 1887, LC PC.

19. Kennedy, Note on the occasion of the Jubilee, LC PC.

## 3. Etchings of Brussels, Touraine and Amsterdam

1. *Brussels and its Environs, Handy Guide* (Bruxelles: A. De Broek, ed.) n.d. [*c.* 1890–1910], pp. 84–6.
2. Pennell, *Life*, II, 82.
3. Theodore Duret, quoted in Pennell, *Life*, II, 82–3.
4. Whistler, Letter to Waldo Storey [1887], GUL BP III s/6.
5. Kennedy. Letter to Whistler. Feb. 4, 1888, GUL BP II 37/
6. Among the works published at this time were L. de Laborde, *La Renaissance des arts à la cour de France*, Paris, 1886; L. Palustre, *La Renaissance en France*, Paris 1879–85, and H. von Geymuller, *Les du Cerceau, leur vie et leur oeuvre*, Paris 1887.
7. Whistler, "Ten O'Clock," p. 143.
8. I am extremely grateful to Prof. W. McAllister Johnson of the University of Toronto Fine Arts Department for discussing with me the nature of the light and the character of the architectural ornament of Touraine.
9. Whistler, Letter to Charles Hanson, Aug. 25, 1888. LC PC.
10. Charles Hanson, Note, n.d. [1888], LC PC.
11. Whistler, Letter to Charles Hanson, June 13, 1888. Rosenwald Collection, Library of Congress.
12. Ledger Book a, GUL BP.
13. Howard Mansfield, *Whistler in Belgium and Holland* (New York: Knoedler and Co., n.d.)
14. Whistler, "Ten O'Clock," p. 136.
15. Pennell, *Life*, II, 84.
16. Pennell, "Whistler's Prices."
17. Pennell, *Life*, II, 85.
18. Sickert, "Round and About Whistler" from *A Free House!* (London: MacMillan and Co. Ltd. 1947), p. 11.
19. Whistler, Letter to Huish, Sept. 3, 1889, LC PC.
20. Beatrice Whistler, Letter to Kennedy, Sept. 29, 1889. GUL BP II 37/11.
21. "Mr. Whistler's New Etchings: A Chat with the Master," *Pall Mall Gazette*, March 4, 1890.
22. Pennell, *Life*, II, 86.
23. Whistler, Letter to Brown, 1890, GUL BP.
24. Whistler, Letter to Robert Deaulliarme, March, 1893. Quoted by Michael Liversidge in "A Note on States by Whistler," *The Print Collector's Newsletter* XIV:5 (Nov.–Dec. 1983) 160. The letter is in the possession of Prof. Liversidge.
25. Whistler, Letter to Brown (1892), GUL BP c/31.

## 4. The Paris Etchings

1. See Wiehl, *A Cultivated Taste: Whistler and American Print Collectors.*
2. For a discussion of the special nature and problems of transfer lithography see Katharine Lochnan, "Whistler and the Transfer Lithograph: A Lithograph with a Verdict," *The Print Collector's Newsletter*, 12:5 (Nov.–Dec. 1981), 133–7.
3. Pennell, Letter to Mansfield, Oct. 17, 1906, The Pierpont Morgan Library. Regarding the dating of many of the Paris etchings Pennell wrote, "I am afraid no-one will ever get the dates of the etchings unless he left a list—which I doubt."
4. There are 9 studies of Loie Fuller *c.* 1895 in the Birnie Philip Bequest, GUL.
5. Whistler, Letter to Kennedy, Feb. 4, 1894, LC PC.
6. Whistler, Letter to Way, Sept. 30, 1892. LC PC. Whistler writes, "I have been busy with some new etchings of Paris—about which more anon."
7. Pennell, *Life* II, 137.
8. Pennell, "Whistler as Etcher and Lithographer."

9. Pennell, "Whistler as Etcher and Lithographer," pp. 20–1.
10. Short, Letter to Whistler, Sept. 18, 1892. GUL BP II S/37.
   "2 parts Chlorate of potash
   10 parts Hydrochloric Acid
   88 parts water"
   Short added that he had been using it at double strength (44 instead of 88 parts water).
11. Pennell, *Life*, II, 142.
12. Pennell, *Life*, II, 143.
13. Pennell, *Life*, II, 144.
14. Pennell, "Whistler as Etcher and Lithographer," 20–1.
15. Pennell, *Life*, II, 145. Pennell is inconsistent on the subject of the regrounding of the Paris plates, and he may or may not have known what Whistler did with them. In "Whistler as Etcher and Lithographer," he maintained that Lamour did reground the plates "without the least trouble," and that Short also regrounded some of them.
16. Pennell, "Whistler as Etcher and Lithographer," p. 22.
17. Kennedy, Letter to Whistler, July 18, 1899, GUL BP II 37/24.
18. Pennell, *Journal*, p. 78.
19. Pennell, *Journal*, p. 81.
20. Whistler, Letter to Kennedy, Jan. 8, 1894. LC PC.
21. Whistler, Letter to Brown, Aug. 1894. LC PC.
22. Whistler, Letter to Brown, Aug. 7, 1894. LC PC. Recorded in Ledger a, GUL.
23. Kennedy, Letter to Whistler, July 12, 1895, GUL BP II 37/81.
24. Pennell, *Journal*, p. 16.
25. Whistler, Letter to Lady Haden, n.d., LC PC.

## 5. The Corsican Etchings

1. Pennell, *Life* II, 217.
2. Whistler, Letter to Pennell, April 3, 1899.
3. Howard Mansfield, "Whistler as A Critic of his Own Prints," *Print Collectors' Quarterly*, 3 (1913), p. 387.
4. Pennell, *Journal*, p. 53.
5. Pennell, *Life*, II, 213.
6. For a more detailed account of Whistler's Corsican trip see Margaret F. MacInnes (MacDonald), "Whistler's Last Years Spring 1901—Algiers and Corsica," *Gazette des Beaux Arts*, s. 6:LXXIII (May, 1969), 323–42.
7. Whistler, Telegram to J. Pennell, Dec. 12, 1900, LC PC.
8. Pennell, *Journal*, p. 207.
9. Whistler, Letter to Miss Rosalind Birnie-Philip, March 15, 1901, GUL BP Res. 19/29. Quoted by MacInnes, p. 335.
10. Whistler, Letter to Elizabeth Pennell, April 6, 1901, GUL BP II Res. 19/34. Quoted by MacInnes, p. 335.
11. These last two plates were printed after Whistler's death in an edition of 27 impressions by Nathaniel Sparks for Miss Birnie-Philip in 1931.
12. Pennell, *Life*, II, 266.
13. Whistler, Letter to Miss Birnie-Philip, April 6, 1901, GUL BP II Res. 19/34. Quoted by MacInnes, p. 338.
14. Brown, Letter to Whistler, Nov. 15, 1901, GUL BP II 13/223.
15. Whistler, Letter to the Secretary of the Friends to Save Hogarth's House, Nov. 22, 1901, GUL BP II 38/36.
16. Whistler, Note, GUL BP II 38/50.
17. Pennell, *Life*, II, 283.
18. Pennell, *Life*, II, 277.
19. Pennell, *Life*, II, 293.

# SELECTED BIBLIOGRAPHY

Because of the volume of literature relating to Whistler, this bibliography contains only those works referred to or depended on in the text.

## MANUSCRIPT SOURCES

Anon. Etching Club Minutes and Accounts, 1838–1885. 6 vols. Victoria and Albert Museum Library.

—— Minutes of the Junior Etching Club, 1857–1864. Victoria and Albert Museum Library.

Cadogan, Jean K. "Alphonse Legros: A Modern *Peintre Croyant*." TS of a Lecture delivered Jan., 1972. Boston Public Library, Print Department.

Frazier, Arthur H. "Whistler's Father—Topographer Extraordinary." TS. Freer Gallery of Art.

Getscher, Robert H. "Whistler and Venice." Ph.D. Thesis, Case Western Reserve University 1970.

Klein, John R. "The Prints and Writings of Francis Seymour Haden." M.A. Report, Courtauld Institute, University of London, 1978.

Lochnan, Katharine A. "Whistler's Etchings and the Sources of His Etching Style, 1855–1880." Ph.D. Thesis, Courtauld Institute, University of London, 1982.

Pennell, Joseph. "Whistler as Etcher and Lithographer." TS. Pennell Collection. Library of Congress.

—— "Whistler's Prices and the Prices of Whistler." TS. Pennell Collection. Library of Congress.

Pennington, Richard. "The Etched Work of W. Hollar—A Descriptive Catalogue Based on the Hollar Collection of Dr. S. T. Fisher of Montreal." 15 vols. TS., 1972. Fisher Rare Book Library, University of Toronto.

Spencer, Robin. "James NcNeill Whistler and his Circle." M.A. Report Courtauld Institute, University of London, 1968.

## PUBLISHED MATERIAL

### 1. *Whistler*

Anon. "A Whistle for Whistler." *Punch*. June 17, 1871, 245.

—— *Catalogue of porcelain and Other Works of Art and Objects of Antiquity the Property of J. A. M. Whistler*. London: Sotheby, Wilkinson and Hodge, Feb. 12, 1880.

—— "Mr. Whistler's New Etchings. A Chat with The Master." *Pall Mall Gazette*, Mar. 4, 1890.

Bacher, Otto. *With Whistler in Venice*. New York: The Century Co., 1908.

Barbier, Carl Paul. "The Société des Trois." In *Whistler*. Exh. cat., ed. Frederick A. Sweet. Chicago: The Art Institute of Chicago, 1968, pp. 41–4.

Bénédite, Léonce. "Artistes Contemporains: Whistler." *Gazette des Beaux Arts*, Pér. 3, 33, No. 575 (1905) 403–10; Pér. 3, 33, No. 576, 496–511; Pér. 3, 34, No. 578 (1905), 142–58; Pér. 3, 33, No. 579, 231–46.

Dodgson, Campbell. "Two Unpublished Whistlers." *Print Collectors Quarterly*, 7 (1917), 217–20.

Donnelly, Kate, and Nigel Thorp. *Whistlers and Further Family*. Exh. cat. Glasgow: Glasgow University Library, 1980.

Duret, Théodore. *Histoire de J. McN. Whistler et de son oeuvre*. New ed. Paris: H. Floury, Editeur, 1914.

Ferriday, Peter. "Peacock Room." *Architectural Review*, 125 No. 749 (1959), 407–14.

Fleming, Gordon. *The Young Whistler, 1834–66*. London: George Allen and Unwin, 1978.

Getscher, Robert H. *The Stamp of Whistler*. Exh. cat. Oberlin: Allen Memorial Art Museum, 1977.

Grieve, Alastair. "Whistler and the Pre-Raphaelites." *Art Quarterly*, 34 (1971), 219–23.

Hardie, Martin. "The Technique and Etchings of Charles Meryon and James Abbott McNeill Whistler." *Proceedings of the National Picture Print Society*, 3 (1937–8), 33–6.

Key, John Ross. "Recollections of Whistler." *Century Magazine*, 75 (1908), 928–32.

Kobbé, Gustav. "Whistler in the U.S. Coast Survey." *The Chap Book*, 8:12 (1898), 479–80.

Laver, James. *Whistler*. London: Faber and Faber, 1930.

Lazelle, H. M. "Whistler at West Point." *Century Magazine*, 90 (1915).

Liversidge, Michael. "A Note on States by Whistler." *The Print Collector's Newsletter*, 14 (Nov.–Dec., 1983), 160.

Lochnan, Katharine A. "Whistler and the Transfer Lithograph: A Lithograph with a Verdict." *The Print Collector's Newsletter* 12 (Nov.–Dec. 1981), 133–7.

MacDonald, Margaret. *Whistler, the Graphic Work: Amsterdam, Liverpool, London, Venice*. Exh. cat. London: Thos. Agnew & Sons, 1976.

—— "Whistler: The Painting of 'the Mother'." *Gazette des Beaux Arts*, Pér. 6, 85, No. 1273 (1975), 73–88.

MacInnes, Margaret F. (MacDonald). "Whistler's Last Years. Spring 1901—Algiers and Corsica." *Gazette des Beaux Arts*, 6, 73 (May, 1969), 323–42.

Mahey, John A. "The Letters of James McNeill Whistler to George A. Lucas." *Art Bulletin*, XLIX, No. 3 (1967), 247–57.

Mansfield, Howard. "Concerning a Whistler Portrait: 'Mr. Mann' or 'Mr. Davis'." *Print Collector's Quarterly*, 4, No. 4 (1914), 383–91.

—— "Whistler as a Critic of his own Prints." *Print Collector's Quarterly*, 3, (1913), 367–93.

—— *Whistler in Belgium and Holland*. New York: Knoedler and Co., n.d.

Menpes, Dorothy. "Reminiscences of Whistler." *Studio*, 29 (1903), 245–57.

Menpes, Mortimer. *Whistler as I Knew Him*. London: Adam and Charles Black, 1904.

Parry, Albert. *Whistler's Father*. New York: The Bobbs–Merrill Co., 1939.

Pennell, Elizabeth Robins. *Whistler the Friend*. Philadelphia: J. B. Lippincott, 1930.

—— *The Life of James McNeill Whistler*. 2 vols. 3rd ed. London: William Heinemann, 1909.

—— *The Whistler Journal*. Philadelphia: J. B. Lippincott Co., 1921.

Pressly, Nancy D. "Whistler in America: An Album of Early Drawings." *Metropolitan Museum Journal*, 5 (1972), 125–54.

Rutter, Frank. *James McNeill Whistler: An Estimate and a Biography*. London: Grant Richards, 1911.

Sandberg, John. "Japonisme and Whistler." *Burlington Magazine*, 106, No. 740 (1964), 500–7.

—— "Whistler's Early Work in America, 1834–1855." *Art Quarterly*, 29 (1966), 46–59.

—— "Whistler Studies." *Art Bulletin*, L (1968), 59–64.

Schaff, Morris. *The Spirit of Old West Point*. Boston: Houghton Mifflin, 1907.

Scott, William. "Reminiscences of Whistler Continued. Some Venice Recollections." *The Studio*, 30 (1903), 97–107.

Sickert, Bernhard. *Whistler*. London: Duckworth, 1908.

Spencer, Robin. "Whistler and Japan: Work in Progress." In *Japonisme, An International Symposium*. Ed. for the Society for the Study of Japonisme. Tokyo: Committee for the Year 2001 and Kodansha International Ltd., 1981, pp. 57–80.

Staley, Allen, ed. *From Realism to Symbolism: Whistler and his World*. Exh. cat. New York: Columbia University, 1971.

Stubbs, Burns A. *Paintings, Pastels, etc. . . . Original Whistleriana in the Freer Gallery of Art*. Washington: Smithsonian Institution, 1967.

Sutton, Denys. "Un Monsieur rare, prince en quelque chose." In *An Exhibition of Etchings, Dry Points and Lithographs by James McNeill Whistler*. Exh. cat. London: P. and D. Colnaghi, 1971, pp. iv–xi.

—— *James McNeill Whistler*. London: Phaidon, 1966.

Sweet, Frederick A. *J. M. Whistler*. Ex. cat. Chicago: Art Institute of Chicago, 1968.

Teall, Gardner C. "Whistler's Father." *New England Magazine*. NS 29 (1903), 235–9.

Thomas, Ralph. *A Catalogue of the Etchings and Drypoints of J. A. M. Whistler*. London: J. R. Smith, 1874.

Way, Thomas R. and G. R. Dennis. *The Art of James McNeill Whistler*. London: George Bell and Sons, 1903.

—— *Memories of James McNeill Whistler*. London: John Lane, 1912.

Wedmore, Sir Frederick. *Whistler's Etchings, a study and catalogue*. London: 1886.

Whistler, Anna Mathilda. "The Lady of the Portrait. Letters of Whistler's Mother." *Atlantic Monthly*, 136 (1925), 319–28.

Whistler, J. A. M. *The Gentle Art of Making Enemies*. London: William Heinemann, 1890.

Wiehl, M. Lee. *A Cultivated Taste. Whistler and American Print Collectors*. Exh. cat. Middletown, Connecticut: Davison Art Center, Wesleyan University, 1983.

Willey, Day Allen. "Whistler's West Point Drawings". *Book News Monthly* 30 (1912).

Young, Andrew McLaren and Henning Bock. *James McNeill Whistler*. Exh. cat. Berlin: Nationalgalerie Staatliche Museen, 1969.

Young, Andrew McLaren. *James McNeill Whistler: An Exhibition of Paintings and Other Works*. Exh. cat. London: The Arts Council of Great Britain, 1960.

2. *Haden*

Anon. *Catalogue of Meryon's Etchings Formerly Owned by Sir Francis Seymour Haden*. New York: H. Wunderlich and Co., 1901.

—— *Catalogue of the Miscellaneous Etchings Formerly Belonging to Sir Francis Seymour Haden*. Part I. New York: Kennedy and Co., 1911.

—— *Collection of Prints and Drawings formed by Francis Seymour Haden, Esq*. London: Sotheby, Wilkinson and Hodge, June 15–19, 1891.

—— "Mr. Seymour Haden's Etchings." *Scribner's Monthly*, 20 (1880), 586–600.

Boulton, William B. "Sir Francis Seymour Haden, P.R.E." *Scribner's Magazine*, 35, No. 3 (1905), 491–504.

Burty, Philippe. "L'Oeuvre de M. Francis Seymour Haden." *Gazette des Beaux Arts*, Sér. 1, 17, No. 3 (1864), 271–87, and No. 4 (1864), 356–66.

Dodgson, Campbell. "Quarterly Notes" (Letter from Haden to Philippe Burty). Trans. W. Westley Manning. *Print Collector's Quarterly*, 11, No. 4 (1924), 377–9.

Haden, Sir Francis Seymour. "About Etching." *Fine Art Quarterly*. NS 1 (June, 1866), 145–60.

—— *About Etching*. Exh. cat. London: The Fine Arts Society, 1879.

—— *The Art of the Painter–Etcher. The First Presidential Address to the Royal Society of Painter–Etchers for 1890*. London: Deprez and Gutekunst, 1890.

—— *The Art of the Painter–Etcher. The Second Presidential Address to the Royal Society of Painter–Etchers for 1891*. London: Deprez and Gutekunst, 1891.

—— *Catalogue of the Etched Work of Rembrandt*. Exh. cat. London: Burlington Fine Arts Club, 1877.

—— *The Etched Work of Rembrandt True and False*. London: MacMillan and Co., 1895.

—— "Mr. Seymour Haden on Etching." *The Magazine of Art*, 2 (1879), 188–91; 221–4; 262–4.

—— *The Relative Claims of Etching and Engraving to Rank as Fine Arts, and to be Presented as such in the Royal Academy of Arts*. London: Deprez and Gutekunst, 1890.

—— *Surgical Instruments: Report of Awards Made at the International Exhibition of 1862*. London, 1862.

Koehler, S. R. Letter "Mr. Seymour Haden's Lectures." *Boston Daily Advertiser*. Dec. 9, 1882.

Laver, James. "Seymour Haden and the Old Etching Club." *The Bookman's Journal and Print Collector*, 10 (1924), 87–91.

Nash, Ray. "Rembrandt's Influence on Seymour Haden, Whistler, and the Revival of Original Etching." *Printing and Graphic Arts*, 2, No. 4 (1954), 61–9.

3. *General*

About, Edmond. *Nos artistes au salon de 1857*. Paris: Hachette, 1858.

Anderson, William. "A Japanese Artist, Kawanabe Kiosai." *Studio*, XV (1898–9), 29–38.

Anon. *Brussels and Its Environs, Handy Guide.* Bruxelles: A. DeBroek, ed., n.d. [c. 1890–1910].

—— *Catalogue of the Art Treasures of the United Kingdom Collected at Manchester in 1857.* Exh. cat. London: Bradbury and Evans, 1857.

—— *Catalogue of a Collection of Antiquities from Boetia, Tanagra, and Asia Minor formed by the late Alexander A. Ionides and now the property of E. H. Cuthbertson, esq.* London: Christies, Dec. 10, 1912.

—— "Edwin Edwards". *T.P.'s Weekly,* Jan. 6, 1905. Edwards' Clipping File. New York Public Library Print Department.

—— *The River Thames from Oxford to the Sea.* London: T. Nelson, 1859.

d'Argencourt, Louise and Douglas Druick. *The Other Nineteenth Century: Paintings and Sculpture in the Collection of Mr. and Mrs. Joseph M. Tanenbaum.* Exh. cat. Ottawa: The National Gallery of Canada, 1978.

Bailly-Herzberg, Janine. *L'Eau-Forte de peintre au dix-neuvième siécle: La Société des Aquafortistes (1862–1867).* 2 vols. Paris: Léonce Laget, 1972.

Blanc, Charles. "De la gravure à l'eau-forte et des eaux-fortes de Jacque." *Gazette des Beaux Arts* Ser 1, 9, No. 4 (Feb. 15, 1861), 193–208.

—— *Les Trésors de l'art à Manchester.* Exh. cat. Paris: Pagnaire, Libraire-Editeur, 1857.

Boime, Albert. "The Instruction of Charles Gleyre and the Evolution of Painting in the Nineteenth Century." In *Charles Gleyre ou les illusions perdues.* Exh. cat. Winterthur: Kunstmuseum, 1974.

Borcoman, James. *Charles Nègre, 1820–1880.* Ottawa: National Gallery of Canada, 1976.

Bouillon, Jean-Paul. "Remarques sur le japonisme de Bracquemond." In *Japonisme, An International Symposium.* Ed. for the Society for the Study of Japonisme. Tokyo: Committee for the Year 2001 and Kodansha International Ltd., 1981, pp. 83–108.

Bürger, William [pseud.] Théophile Thoré. "Rembrandt au Musée d'Amsterdam." *L'Artiste,* 7, No. 4, (July 25, 1858), 182–8.

—— "Revision du catalogue des tableaux du Musée de Paris— Ecoles allemande, flamande, et hollandaise." *L'Artiste,* 7, No. 4 (March 14, 1858), 173.

—— *Trésors d'art exposés à Manchester en 1857 et provenant des collections royales, des collections publiques et des collections particulières de La Grande Bretagne.* Exh. cat. Paris: Jules Renouard, 1857.

—— "Un Mot sur l'eau-forte." In *Nouveau traité de la gravure à l'eau-forte* by A. T. Potrémont (pseud. Martial). Paris: Cadart, 1873.

Burke, James D. *Charles Meryon: Prints and Drawings.* Exh. cat. New Haven, Conn.: Yale University Art Gallery, 1974.

Burty, Philippe. "La Gravure et la lithographie à l'exposition de 1861." *Gazette des Beaux Arts* 10 (1861), 172–9.

—— "La Gravure au salon de 1866." *Gazette des Beaux Arts,* Sér. 1, 21, No. 2 (1866), 184–94.

—— "L'Oeuvre de M. Charles Meryon." *Gazette des Beaux Arts* Sér. 1, 14, No. 6 (1863), 519–25; Sér. 1, 15, No. 1 (1863), 75–88.

—— "La Photographie en 1861." *Gazette des Beaux Arts,* Sér. 1, 11, No. 3 (1861), 241–9.

—— "Salon de 1863: La Gravure et la lithographie." *Gazette des Beaux Arts,* Sér. 1, 15, No. 2 (1863), 147–60.

—— "La Société des Aquafortistes." *Gazette des Beaux Arts,* Sér. 1, 14, No. 2 (1863), 190–2.

Castagnary, Jules. *Salons 1857–1870.* Paris. Bibliothèque Charpentier, 1892.

Champfleury (pseud. Jules Husson). "Du Réalisme: Lettre à Madame Sand." *L'Artiste,* 16, No. 5 (1855), 1–5.

Claudet. "La Photographie dans ses relations avec les beaux-arts." *Gazette des Beaux Arts* Sér. 1, 9, No. 2 (1861), 101–14.

Clunn, Harold P. *The Face of London.* Rev. ed. London: Spring Books [1950–60].

Desnoyers, Fernand. "Du Realisme." *L'Artiste,* 16, No. 5 (1885), 197–200.

Druick, Douglas and Michel Hoog. *Fantin–Latour.* Exh. cat. Ottawa: National Gallery of Canada, 1982.

Du Maurier, Daphnie, ed. *The Young George du Maurier: A Selection of his Letters, 1860–7.* London: Peter Davies, 1951.

Duranty, Edmond. "Edwin Edwards: Peintre et aquafortiste." *Gazette des Beaux Arts* Pér. 2, 20, No. 5 (1879), 438–42.

Edwards, Edwin. *Old Inns. Second Division—Eastern England.* London: 1880.

Eidelberg, Martin. "Bracquemond, Delâtre and the Discovery of Japanese Prints." *Burlington Magazine,* 123, No. 937 (1981), 221–7.

Faucheux. "Exposition de la Société Française de Photographie." *Revue Universelle des Arts,* 5 (1857), 69–79.

—— Rev. of *Musées de la Holland,* by W. Bürger. *Revue Universelle des Arts,* 8 (Oct. 1858–March 1859), 177–80.

Fould, Achille. "Address to the Prize Winners of the 1857 Salon." In *Realism and Tradition in Art 1858–1900: Sources and Documents.* Ed. and trans. Linda Nochlin. Englewood Cliffs, New Jersey: Prentice-Hall, Inc., 1966, pp. 3–4.

Gautier, Théophile. *Société des Aquafortistes.* Intro. Paris: Cadart, 1862–3.

Graves, Algernon. *The Royal Academy Exhibitors: A Complete Dictionary of Contributors and Their Work from its Foundation in 1769 to 1904.* 8 vols. London: George Bell and Sons, 1905.

Hall, Mr. and Mrs. Samuel Carter. *The Book of the Thames.* London: Virtue and Co., 1859.

Hamerton, Philip Gilbert. *Etching and Etchers.* London: MacMillan and Co., 1868.

Hanson, Anne Coffin. *Manet and the Modern Tradition.* New Haven and London: Yale University Press, 1977.

—— "Manet's Subject Matter and a Source of Popular Imagery." *Museum Studies, Art Institute of Chicago,* 3 (1968), 63–80.

Hardie, Martin. *Frederick Goulding: Master Printer of Copper Plates.* Stirling: Eneas Mackay, 1910.

Hauptman, William. "Charles Gleyre: Tradition and Innovation." In *Charles Gleyre, 1806–1874.* Exh. cat. New York: Grey Art Gallery and Study Center, New York University, 1980.

Higgins, R. A. *Greek Terracotta Figures.* London: The British Museum, 1963.

—— *Greek Terracotta Figurines.* London: The British Museum, 1969.

House, John. "The Impressionist Vision of London." In *Victorian Artists and the City.* Eds. Ira Bruce Nadel and F. S. Schwarzback. New York: Pergamon Press Inc. 1980.

Huish, Marcus B. "A Few Explanatory Words in Relation to the Famous Ionides Collection formed by the late Mr. A. Ionides." In *The Ionides Collection of Antiquities from Boetia, Tanagra and Asia Minor.* London: Christie's, March 13 and 14, 1902, pp. 1–5.

Huish, Marcus B. *Greek Terra-Cotta Statuettes.* London: John Murray, 1900.

Hunter, Dard. *Papermaking: The History and Technique of an Ancient Craft.* 1943; rpt. New York: Dover Publications, 1978.

Ionides, Alexander C. *A Grandfather's Tale.* Dublin: The Cuala Press, 1927.

Ionides, Luke. *Memories.* Paris: Herbert Clarke, 1925.

Ives, Colta. *The Great Wave.* Exh. cat. New York: Metropolitan Museum of Art, 1974.

J. Wa and H. H. T. "Photography." *Encyclopaedia Britannica.* 1911 ed.

Janin, Jules. "Baden." *L'Artiste,* 7, No. 4 (1858), 193–364.

Janis, Eugenia Parry. "Setting the Tone—The Revival of Etching, the Importance of Ink." In *The Painterly Print: Monotypes*

*from the Seventeenth to the Twentieth Century*. Exh. cat. ed. Colta Ives. New York: Metropolitan Museum of Art, 1980.

Janson, H. W., ed. *Catalogues of the Paris Salon, 1673–1881*. 60 vols. New York: Garland, 1977.

Jowell, Frances Suzman. *Thoré-Bürger and the Art of the Past*. New York: Garland Publishing, 1977.

Lacambre, Geneviève. "Les Milieux japonisants à Paris, 1860–1880." In *Japonisme, An International Symposium*. Ed. for the Society for the Study of Japonisme. Tokyo: Committee for the Year 2001 and Kodansha International Ltd., 1981, pp. 43–57.

Lacambre, Genevieve, et Jean, ed. and trans. *Le Réalisme* by Champfleury. Paris: Hermann, 1973.

Lalanne, Maxime. *The Technique of Etching*. rpt. of *Traité de la gravure à l'eau-forte 1866*. Trans. S. R. Koehler, 1880. New York: Dover Publications, 1981.

Lamont, L. M., ed. *Thomas Armstrong, C.B.: A Memoir*. London: Martin Secker, 1912.

Layard, George Somes. *The Life and Letters of Charles Samuel Keene*. London: Sampson Low, 1982.

Lepic, Vicomte Lodovic Napoléon. *Comment je devins graver à l'eau forte*. Paris: Cadart, 1876.

Leslie, Charles Robert. "Professor Leslie's Lectures on Painting." *The Athenaeum*, No. 1060 (1848), 191–4; No. 1061 (1848), 220–3; No. 1062 (1848), 247–51; No. 1063 (1848), 270–4.

Lucas, George A. *The Diary of George A. Lucas: An American Agent in Paris, 1857–1909*. Ed. Lilian M. C. Randall. Princeton: University Press, 1979.

Lumsden, E. S. *The Art of Etching*. 1924; rpt. New York: Dover Publications Inc., 1962.

Maas, Jeremy. *Victorian Painters*. London: Barrie and Rockcliffe, The Cresset Press, 1969.

Maberly, Joseph. *The Print Collector*. London: 1844.

Mack, Gerstle. *Gustav Courbet*. London: Rupert Hart-Davies, 1951.

Mantz, Paul. "Artistes Anglais: Charles Leslie." *Gazette des Beaux Arts* Sér. 1, 4, No. 3 (1859), 177–84.

—— "Trésors d'art exposés à Manchester par M. W. Bürger." *L'Artiste*, 7, No. 2 (1857), 122–5.

Mayne, Jonathan, trans. and ed. *Art in Paris, 1845–1862*. By Charles Baudelaire. London: Phaidon Press Ltd., 1965.

—— trans. and ed. *The Painter of Modern Life and Other Essays*. By Charles Baudelaire. London: Phaidon Press Ltd., 1964.

Melot, Michel. "L'Estampe Impressioniste et la réduction au dessin." *Nouvelles de L'Estampe*. NS. Nos. 19–24 (1975), 11–15.

Menpes, Mortimer. "A Personal View of Japanese Art." *Magazine of Art*. 11 (1888), 192–9, 255–61.

—— "On the Printing of Etchings." *The Magazine of Art*. 12 (1889), 328–31.

Naef, Weston. *After Daguerre: Masterworks from the Bibliothèque Nationale*. Exh. cat. New York: Metropolitan Museum of Art, 1980–1.

Newhall, Beaumont. *The History of Photography*. New York: The Museum of Modern Art, 1964.

Nochlin, Linda. *Realism and Tradition in Art, 1848–1900*. In *Sources and Documents in the History of Art*. Ed. H. W. Janson. Englewood Cliffs: New Jersey, 1966.

Ormond, Leonée. *George Du Maurier*. London: Routledge and Kegan Paul, 1969.

Osborn, Capt. Sherard. "Japanese Fragments." *Once a Week* 3 (1860) 33–7; 110–12; 157–61; 201–5; 260–6; 313–16; 383–8; 437–44.

Pennell, Joseph. *The Graphic Arts: Modern Men and Modern Methods*. Chicago: University of Chicago Press, 1920.

Plarr, Victor G. *Plarr's Lives of the Fellows of the Royal College of Surgeons in England*. London: J. Wright and Sons Ltd., 1930.

Prinsep, Val. "A Student's Life in Paris in 1859." *Magazine of Art*. 28 (1904), 338–42.

Rewald, John. *Camille Pissarro: Letters to his Son Lucien*. London: Pantheon Books Inc., 1943.

Reynolds, Sir Joshua. *Discourses on Art*. Ed. Robert R. Wark. 1797; rpt. New Haven: Yale University Press, 1981.

Riat, Georges. *Gustav Courbet*. Paris: 1906.

Robinson, Lionel. "The Private Art Collections of London: The late Mr. Frederick Leyland's Collection in Prince's Gate, Second Paper." *Art Journal*, 54 (1892), 134–8.

Robison, Andrew. *Paper in Prints*. Washington: National Gallery of Art, 1977.

Rossetti, Dante Gabriel. *The Collected Works of Dante Gabriel Rossetti*. Ed. William Michael Rossetti. London: Ellis and Elvey, 1890.

—— *Rossetti Papers 1862–1870*. London: Sands and Co., 1903.

Rothenstein, William. *Men and Memories: Recollections of William Rothenstein, 1872–1900*. London: Faber and Faber Ltd., 1931.

Ruskin, John. *Modern Painters*. 6 vols. 6th ed. London: 1857.

—— *The Stones of Venice: Introductory Chapters and Local Indices for the Use of Travellers while Staying in Venice and Verona*. New York: D. D. Merrill Co., 1879.

Sayre, Eleanor and Felice Stampfle. *Rembrandt, Experimental Etcher*. Exh. cat. Boston: Museum of Fine Arts, 1969.

Schapiro, Meyer. "Courbet and Popular Imagery: An Essay on Realism and Naiveté." *Journal of the Warburg and Courtauld Institutes*, 4 (1940–41), 164–191.

Sickert, Walter Richard. *A Free House!* London: Macmillan and Co., 1947.

Sloane, Joseph C. *French Painting Between the Past and the Present: Artists, Critics, and Traditions from 1848–1870*. Princeton: Princeton University Press, 1951.

Spencer, Robin. *The Aesthetic Movement*. London: Studio Vista, 1972.

Stewart, Basil. *Japanese Colour Prints*. New York: Dodd Mead and Co., 1920.

Surtees, Virginia. *The Paintings and Drawings of D. G. Rossetti (1828–1882)*. Oxford: Clarendon Press, 1971.

Sutton, Denys. "Venezia, Cara Venezia." In *Venice Rediscovered*. Exh. cat. London: Wildenstein, 1972, pp. 5–19.

Thomas, Ralph. *Sergeant Thomas and Sir J. E. Millais*. London: A. Russell Smith, 1901.

Toussaint, Hélène, Marie-Thérèse de Forges and Alan Bowness. *Gustave Courbet, 1819–1877*. Exh. cat. London: Arts Council of Great Britain, 1978.

Traer, James Reeves. "On the Photographic Delineation of Microscopic Objects." *Journal of the Photographic Society*. 5 (1858), 55.

Vallet-Viriville. "Notes pour servir à l'histoire du papier." *Gazette des Beaux Arts* Sér. 1, 2, No. 4 (1859), 222–236; Sér. 1, 3, No. 3 (1859), 153–168.

Warren, Richard M. and Roslyn P. *Helmhotz on Perception, its Physiology and Development*. London: John Wiley and Sons, 1968.

Weisburg, Gabriel P. *Bonvin*. Paris: Editions Geoffrey-Dechaume, 1979.

—— "François Bonvin and an Interest in Several Painters of the Seventeenth and Eighteenth Centuries." *Gazette des Beaux Arts* Pér. 6, 76, No. 1223 (1970), 359–365.

—— et. al. *Japonisme: Japanese Influences on French Art, 1854–1910*. Exh. cat. Cleveland: Cleveland Museum of Art, 1975.

—— "Philippe Burty: A Notable Critic of the Nineteenth Century." *Apollo*, 91 (1970), 296–300.

—— *The Realist Tradition: French Painting and Drawing, 1830–1900*. Exh. cat. Cleveland: Cleveland Museum of Art, 1981.

White, Christopher. *Rembrandt as an Etcher*. 2 vols. London: A. Zwemmer, 1969.

Williamson, George C. *Murray Marks and his Friends*. London: John Lane, 1919.

# INDEX